Bill O'Shaughnessy

As a Westchester neighbor and old friend . . . I am a great admirer of Bill O'Shaughnessy's pithy editorials.
—Nelson A. Rockefeller

A lot has been written and spoken about Rockefeller . . . all the great commentators rushed to eulogize him. But O'Shaughnessy's tribute was the most accurate and thoughtful.
—Daniel Patrick Moynihan, U.S. Senator

The "Rockefeller years" were so eloquent and personal. Only someone who really knew Nelson as O'Shaughnessy did, from his perch at Nelson's favorite radio station, could have said it so well.
—Henry Kissinger

[O'Shaughnessy's] commentaries represent the skillful narration of the human drama of our time.
—Richard M. Nixon

Anything Bill O'Shaughnessy touches or writes turns to gold. His book is something I'm going to want to buy . . . and I'm sure every New Yorker will want to read it too.
—Governor George E. Pataki

Bill's broadcasts about Mario Cuomo were some of the most exquisite pieces of political writing I've seen or heard.
—Former Mayor of New York John V. Lindsay

It only labors the obvious to observe that no one comes within miles of O'Shaughnessy in word-smithing. His ability to tug at the heart with words is *sui generis*.
—Former New York Governor Malcolm Wilson

I applaud Bill O'Shaughnessy's intelligent editorials concerning broadcasters and their reluctance to speak up about Free Speech. So many remain silent, and it is alarming. His is a brave stance.

—Howard Stern

In this brilliant collection, Bill O'Shaughnessy gives us the gift of times we've never known . . . when giants walked the land in the heart of the Eastern Establishment.

—Jimmy Breslin, Jr.

My favorite ingredient in O'Shaughnessy's broadcasts is the zesty seasoning of meaningful vignettes about real people in actual, relevant situations. He beautifully sustains his celebrated stature as a commentator of insight, wit, charm, and uncompromising honesty, as well as overwhelming persuasion.

—Congresswoman Nita Lowey

Future generations will thank Bill O'Shaughnessy for his spirited and eloquent defense of Walter Cronkite and Frank Stanton . . . and for rallying the broadcasting industry to our cause.

—William S. Paley, CBS founder

I respect Bill O'Shaughnessy's courage and cherish his friendship.

—Walter Anderson, editor, *Parade*

Gutsy! He's like the most raucous voice on Hyde Park Square . . . and he's my neighbor.

—Ossie Davis

All the dazzling and appealing characters of the Golden Apple come alive in these stirring commentaries from Westchester, the very heart of the Eastern Establishment.
—Kenneth Cole, fashion designer

Bill O'Shaughnessy is the greatest speaker in the Outback. I mean Westchester . . . not Australia!
—Lowell Thomas

O'Shaughnessy broadcasts in an informal, conversational style that brings his clear, cogent points directly to his listeners.
—Ogden Rogers Reid, president, Council of American Ambassadors

WVOX's editorial about the attempted assassination of His Holiness was deeply touching and reflective of O'Shaughnessy's characteristic sensitivity.
—Sirio Maccioni, Le Cirque 2000

. . . The national prototype of the suburban voice.
—Broadcast Management College Textbook

Bill O'Shaughnessy puts one face to the world when they can see him, but he hides his special spirituality and quality until he puts pen to paper and articulates his thoughts and hopes to change the world from behind his microphone. This charming, somewhat unbelievable Irishman is a dying breed.
—Donald V. West, editor-at-large, Cahners Magazines

AIRWAVES

AIRWAVES

A Collection of Radio Editorials from the Golden Apple

WILLIAM O'SHAUGHNESSY

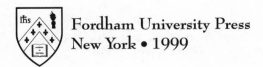
Fordham University Press
New York • 1999

ISBN 0-8232-1904-6
ISSN 1522-385X
Communications and Media Studies, no. 3

Library of Congress Cataloging-in-Publication Data

O'Shaughnessy, William.
 Airwaves : a collection of radio editorials from the Golden Apple
 / William O'Shaughnessy. — 1st ed.
 p. cm. — (Communications and media studies ; no. 3)
 ISBN 0-8232-1904-6 (hc). — ISBN 0-8232-1905-4 (pbk.)
 1. United States—Politics and government—1945–1989.
 2. United States—Politics and government—1989–
 3. Freedom of speech—United States. 4. New York
 (State)—Politics and government—1951– 5. Westchester
 County (N.Y.)—Politics and government Anecdotes.
 6. Politicians—United States Biography Anecdotes.
 7. Westchester County (N.Y.) Biography Anecdotes.
 8. Editorials—New York (State)—Westchester County.
 I. Title. II. Series.
 E839.4.084 1999
 974.7'043—dc21 99-21445
 CIP

Unless otherwise indicated, all photos are from the author's collection.
The frontispiece illustration appears courtesy Frank Becerra.

Printed in the United States of America
03 02 01 00 99 5 4 3 2 1
First Edition

To
JOHN THOMAS O'SHAUGHNESSY
March 28, 1940–May 5, 1998

When they're coming up the back stairs . . . this was the one you wanted with you. And for his fifty-eight few, but full, years I was the only one in the world entitled to call him "Brother."

Contents

Special Acknowledgments

THESE ARE THE ONES "WITHOUT WHOM"

Every writer, every broadcaster, every soul deserves a *Cindy Hall Gallagher*. She has been my friend and confidant for twenty-five years, during which she has worn many hats and borne too much responsibility—while I was out chasing stories and rainbows. Cindy has been my amanuensis, secretary, comptroller, even chairman of our company. The office boys, secretaries, and disc jockeys call her "Mother Glue." I call her indispensable and essential. Cindy's shrewd judgment, loyalty, and devotion have seen me through all the seasons of my life. And I'm grateful once again for her marvelous and patient help with *Airwaves*.

Mrs. Gallagher and her brilliant young associate, *Matthew Deutsch*, spent many months going through my archives, arranging material, and preparing manuscripts. The entire project owes a great deal to the organizational skills of young Mr. Deutsch who, as a brilliant and dedicated fledgling broadcaster, began in our intern program just a few, short years ago. Matt worked his magic on countless files in the Whitney Radio archives and newsroom while *Don Stevens*, another talented, young manager of rare gifts, kept the office going and both radio stations on the air. In all this, they had considerable assistance from *Mrs. Ronni Sifer*, my executive secretary and office manager.

Nancy Q. Keefe, the distinguished writer-in-residence of Manhattanville College, came roaring in like the cavalry to save this project early on with her unique genius and considerable talent. When she is not lecturing me or her students (including a few governors and cabinet secretaries), Mrs. Keefe, a former star and feature columnist for Gannett, now travels the world. Her wisdom, insight, and friendship have been so important to me over the years. She is uniquely pos-

sessed of what our friend Jacques Le Sourd, the national drama critic, calls "an exquisitely tuned Bozo Meter." She can spot the flaws in any character, and the weak spots in any manuscript. Mrs. Keefe is a great writer, editor, teacher—and friend.

All my various pronouncements and battles concerning First Amendment rights for broadcasters, performers, and journalists have been informed by the wise counsel and brilliance of several great statesmen of our tribe: *Don West*, senior managing editor of Cahners Magazines, has used his bright, fine mind to bail broadcasters everywhere out of many a scrape with government bureaucrats. Don West is my muse and mentor on all the great communications issues. We are both disciples of the late Sol Taishoff and his son Larry, who were devoted to a free electronic press.

Ward Quaal, the legendary gray eminence of my profession, has been generous and unstinting with his advice and encouragement. Although Mr. Quaal counsels presidents, he has never forgotten his roots in radio—or those days when he ran WGN in Chicago. He is our greatest statesman.

Erwin Krasnow, the former chief general counsel of the National Association of Broadcasters (which I once served as chairman of public affairs), is now a powerhouse Washington attorney who brings wisdom and wit to his thoughtful suggestions about communications issues. He has been steering me toward enlightened positions on complex issues for several decades.

Harry Jessell and *John Eggerton*, the current editors of *Broadcasting and Cable*, are superb journalists and commentators about broadcasting, regulatory, and communications issues. Their influence in Washington is considerable—as is my gratitude for their friendship and support.

I also have high regard for *Patrick Maines*, the intelligent and gifted president of the Media Institute, a Georgetown-based think tank that has done valuable work on First Amendment issues.

I'm grateful thus to all the above mentioned. But my senior and most valued counselor for the past 30 years has been *Joseph Reilly*, president of the New York State Broadcasters As-

sociation. Joe is a formidable and greatly respected presence in our state capital. As spokesman for the broadcasters of the Empire State, Reilly has been a tremendous ally in all my own First Amendment initiatives and battles. Every governor of New York for the last three decades will confirm my high opinion of this charming, articulate Irishman who–single-handedly–got cameras in the courtrooms all over this land with the outrageous suggestion that the people have a right to know what's occurring in the halls of justice.

Most broadcasters are at swords point with their local cable operator (read: competitor). But I have been blessed by wonderful relationships with TCI Cable and Cablevision. *Bob Rosencrans* (one of the founders of C-SPAN), *Ira Birnbaum, Myles Rich, Ralph Kebrdle,* and the incomparable *Charles Dolan* and his Cablevision associates have allowed me the privilege of their podium. Never once did they edit or try to temper any of my enthusiasms.

For the basic necessities of my business life, I am grateful to *Paul H. Lenok,* who left a huge multinational practice to build "small to medium sized companies." He did some stellar work with Whitney Radio, despite my erratic stewardship.

All our enterprises and my pronouncements have been the beneficiaries of the guidance, protection, and counsel of two extraordinarily gifted lawyers: *Jeffrey Bernbach,* himself an author, and one of the best advocates anyone could have for any proposition; and *Frank Connelly, Jr.,* who is possessed of a towering reputation in Westchester.

Permit me also to acknowledge my great gratitude to *Saverio Procario* and his colleagues at Fordham University Press. I went to a Jesuit high school, and once again, the Jesuits are exhibiting some inexplicable confidence in the product of my meager brain by affixing the imprimatur of this great publishing house to this collection. *Anthony Chiffolo,* a superb editor, has invested time, patience, and great skill at cleaning up my act. Fordham University Press enjoys a tremendous reputation in the literary and academic worlds. *Loomis Mayer,* Fordham's production chief, and *Cormac Boyle,* the marketing whiz, are two reasons why.

The idea—and much of the inspiration—for this book came

from a failed baseball player with too many vowels in his name. I bless the day I met *Mario Matthew Cuomo*. A teacher, scholar, and orator of uncommon ability, the fifty-second Governor of New York, Mario is the most impressive public figure of my day and age. Most Americans know the power of his words and the sweep of his oratory; Nancy and I know the sweetness of his generous heart. I greatly value his friendship and confidence. Indeed, quite the nicest appellation I've ever received was when this extraordinary individual of such great gifts called me "Brother Bill." I am convinced that future generations will discover anew his stunning speeches and pronouncements about contemporary moral and political issues—and marvel that there *was* someone. But please don't hold his friends against this great and good public servant. The man and his ideals I shall ever treasure and remember.

In my business of words, concepts, notions, and themes, I suspect we all want our ideas to prevail. I hope the reader will find some passages herein that will make a little bit of sense. That would please me. But the approval I seek here, as in everything I do, can be bestowed only by my four spectacular children. I have been so uniquely blessed, and I beg only a slight "author's privilege" to allow me to tell you a bit about my four kids, each one more attractive than the next. *Matthew*, age thirty, is a senior vice-president of Whitney Radio. *David*, twenty-eight, is a television producer and manager of business affairs of Miramax. *Kate*, twenty-six, is a social worker and counselor on the West Coast. *Michael*, seventeen, is completing his education when he is not reading newscasts at one of our radio stations. My children grow in wisdom with every passing day. They each know of my pride in their accomplishments and my great satisfaction when I am treated to reminders of the fine, generous souls they have become.

And one more. I make my living with words—usually "inartfully," awkwardly, imprecisely, as you have observed. But how do I find the words to tell of my gratitude for the presence of *Nancy Curry O'Shaughnessy* in my life? She is a beautiful and dazzling creature who enriches and ennobles the lives of everyone she encounters. As she goes home with me, I am

constantly astonished that she has chosen to cast her lot with a Bill O'Shaughnessy. She could have done much better. Even Mario Cuomo was struck by Nancy's goodness, generosity, and dynamism. After meeting her for the first time, the governor observed, "Sometimes, God puts angels in our path, Brother Bill." I agree.

FRIENDS OF BILL

I have been fortunate to enjoy the support, friendship, and counsel of countless individuals in all walks of life. So many great souls—smarter, wiser, and possessed of far greater gifts than I—have tolerated my enthusiasms. Many have even gone out of their way to encourage and identify with my professional activities. You could search the world and not find better friends than: Bob Abplanalp, Dean Abrams, Cindy Adams, J. Lester Albertson, Harry Albright, Jr., Mel Allen, David Allyn, Lynne Ames, Captain Joseph Anastasi, Ernie Anastos, Walter Anderson, Senator Warren Anderson, David Annakie, Bob Armao, Rick Atkins, Father Terry Attridge, Phil Austin, Whitney Balliett, Charles Barton, Henry "Jeff" Baumann, Frank Becerra, Kelly Beem, Rocco Bellantoni, Jr., Richard Rodney Bennett, Tony Bennett, Max Berking, Hilda and Bill Berkowitz, Randy Berlage, Henry Berman, Richard Berman, Robin and George Bernacchia, Karen and Jeffrey Bernbach, Jerry Berns, Congressman Mario Biaggi, Ira Birnbaum, Joseph Biscoglio, Lou Boccardi, John Bodnar, Jack Boyle, James Brady, Noam Bramson, John Branca, Paul Braun, Jimmy Breslin, Stefano Briganti, Alexander Brooks, James Brown, Les Brown, Colonel Paul Bryer, Peg and George Burchell, Johnny Burke, Barrett Burns, Colin Burns, Sr., Jodi and Jonathan Bush, William "Billy" Bush, William Butcher, Robert Callahan, Bob Cammann, Jimmy Cannon, Joseph Wood Canzeri, Paul Capelli, Bob Capone, Governor Hugh Leo Carey, Leslie and Peter Carlton-Jones, Jim Carnegie, Oreste Carnevale, Michael Carney, Dr. Margaret Carreiro, Bill Cary, Father Joseph Cavoto, S.A., Bill Cella, Ken Chandler, Anthony Chiffolo, Sir Harold Christie, Bill Clark, Bobby Clark, Monsi-

gnor Eugene Clark, James Mott Clark, Richard McC. Clark, Lynn Claudy, Gayle and Linden Clay, Nick Colabella, Anthony J. Colavita, Nat "King" Cole, Dr. Robert Coles, Michael Collins, Pat Collins, Peggy Conlon, Frank Connelly, Jr., Monsignor Edward Connors, Katherine Wilson Conroy, Tom Constantine, E. Virgil Conway, Burton Cooper, Tony Corvino, Richard Cotter, General Richard Crabtree, D. Bruce Crew III, Guido Cribari, Bill Cunningham, Andrew Mark Cuomo, Christopher Cuomo, Maria Cuomo Cole, Governor Mario M. Cuomo, Matilda Raffa Cuomo, Ambassador Walter Curley, Bernard F. Curry, Jr., Cynthia and Bernie Curry, Connie Cutts, Senator Alfonse D'Amato, Fred Danzig, Richard Daronco, Martha Dale (and Eddie Fritts), Marvin Dames, Ossie Davis, Morton Dean, Ruby Dee, C. Glover Delaney, George Delaney, Tom Delaney, Dee DelBello, Jerry DelColliano, Cartha "Deke" DeLoach, Matt Dennis, Matt Denti, Joe DePaolo, Steve Dershowitz, Abramo DeSpirito, Matthew Deutsch, Fred Dicker, Bernie Dilson, Joseph Paul DiMaggio, Lynn DiMenna, Dr. Joseph DiPietro, Dave DiRubba, Charles Dolan, James Dolan, John E. Dowling, Hugh A. Doyle, Brother John Driscoll, Sean Driscoll, Florence D'Urso, Lawrence Dwyer, David Dziedzic, John Eggerton, Jean T. Ensign, Jinx Falkenburg, Kevin Falvey, Bill Fanning, Frederic Fekkai, Giancarlo Ferro, Mike Finnegan, William FitzGibbon, Thomas Fogarty, John Fosina, Dr. Richard Fraser, Justice Samuel Fredman, Louis Freeh, Judy Fremont, Michael Friedman, Richard Friedman, Edward Owens Fritts, William Denis Fugazy, Mario Gabelli, Judge Joseph Gagliardi, Bernard Gallagher, Cindy Hall Gallagher, Jim Gallagher, Jack Gardner, Marina Garnier, Ira Gelb, Leon Geller, Dr. Irwin Gelman, Harold Geneen, James Generoso, Arthur Geoghegan, Edward "Ned" Gerrity, David Ghatan, William Gibbons, Phil Gilbert, Jr., Dick Gidron, Fred Gioffre, Louise and Anthony B. Gioffre, Marvin Goldfluss, Larry Goldstein, Terry Golway, Peter Goodman, Joan Gordon, Laurel and John Gouveia, Murray Grand, Robert Greene, Teddy Greene, Phil Guerin, Tony Guest, Thomas Guida, Denny Haight, Pete Hamill, Anne Harmon, John Harper, Ron Harris, Gordon Hastings, Cindy and Carl Hayden, Mark Hedberg, George Helm, John Hennessy, Jr., Joyce Hergen-

han, Ernest Hickman, David Hinckley, Milton Hoffman, Philip Hollis, Napoleon Holmes, Gary Horan, Ed Hughes, Bob Hyland, Tim Idoni, Brett Inman, Dennis Jackson, Senator Jacob K. Javits, Marian Javits, Harry Jessell, Jimmy the Doorman at Bergdorf's, Jim Joyce, Judy Juhring, Ralph Kebrdle, Mel Karmazin, Milton Kael, Gerald Keane, Nancy Q. Keefe, Ed Kelly, John Kelly, Irving Kendall, Walter Kennedy, Guy King, Claude Kirchner, Marv Kitman, Sam Klein, Fred Klestine, Jack Knebel, Erwin Krasnow, Rainer Kraus, Pete Kreindler, Dr. Bernard Kruger, Bill Kunstler, Marguerite Lascola, George Latimer, Connie Laverty, Rita LeDuc, Louis Lefkowitz, Paul Lenok, Jacques LeSourd, Father Peter Levierge, Arthur Levitt, Lava Libretti, John Lindsay, Richard Littlejohn, Father James Lloyd, Jack Loftus, Jim Lowe, Nita and Steven Lowey, Charles Luce, William Luddy, General of the Armies Douglas MacArthur, Gavin K. MacBain, Egidiana and Sirio Maccioni, Bill McKenna, Marco, Mario, and Mauro Maccioni, Edwin McDowell, Sue McMillan, Margaret Maier, Patrick Maines, Tony Malara, Nick Manero, Jim Mann, Anne and Wellington Mara, Squeegie Mangialardo, Jim Mann, Tom Margittai, Archbishop Renato Martino, Val and Nick Mastronardi, Colonel Jim May, Walter May, Kevin McCabe, John McCain, Brother James McCarthy, Bernard McCoy, Susan and John McDonnell, Edwin McDowell, J. Raymond McGovern, Father Felix McGrath, O.F.M., Kevin McGrath, Bryan McGuire, Sandy McKown, Bill McElveen, Patrick McMullan, Susan Meadow, Dennis Mehiel, Mabel Mercer, Robert Merrill, Edwin Gilbert Michaelian, Joseph, Rose, and Mario Migliucci, Ray Miles, Cay Miller, Elmer Miller, Luther Miller, Mark Miller, Roland Miller, Clif Mills, Jr., Philip Milner, Dr. Richard Milone, Peter Mintun, Garry Moore, Walter Moore, Tom Moretti, Billy Morley, Arthur H. "Red" Motley, Senator Daniel Patrick Moynihan, Liz Moynihan, John Mullaney, Thomas Mullen, Judge William Hughes Mulligan, Joe Murphy, Jimmy Neary, Edward Noonan Ney, Julian Niccolini, Alex Norton, Richard Novik, Jack O'Brian, John Cardinal O'Connor, John J. O'Connor, Madeline Cuomo O'Donohue, Paul O'Dwyer, Buzzy O'Keefe, Monsignor Jack O'Keefe, Rita O'Mara, Noreen O'Donnell, Paddy O'Neill, William O'Neill, Frank Or-

lando, Admiral Andrew O'Rourke, Cara Ferrin O'Shaughnessy, Catherine Tucker O'Shaughnessy, Julie and Jack O'Shaughnessy, John O'Shaughnessy, Laura O'Shaughnessy, William Mac O'Shaughnessy, Jim O'Toole, Judge Tom O'Toole, Christiana Oakes, William Olson, Nick Orzio, Dean Richard Ottinger, Dick Osborne, Bob Packwood, Len Paduano, Bruno Paganuzzi, William S. Paley, Richard Parisi, Rev. Everett Parker, A. J. Parkinson, Richard Parsons, Ron Patafio, Governor George E. Pataki, Libby Pataki, Gregg Pavelle, Augie Petrillo, Jeff Perle, Alex Philippidis, Albert Pirro, Jeanine F. Pirro, Senator Joseph Pisani, Richard Pisano, Caryl and William Plunkett, Cole Porter, Tom Poster, Frederic B. Powers, Frances Preston, John Pritchard, Saverio Procario, Jim Quello, Ken Raske, M. Paul Redd, Dr. George Reed, Rex Reed, Cary Reich, Ambassador Ogden Rogers Reid, Carol Fernicola Reilly, Joseph Reilly, Phil Reisman, Steven Reitano, Eric Rhoads, Miles B. Rich, Monica and Vinny Rippa, Eddie Robbins, Governor Nelson Aldrich Rockefeller, Happy Rockefeller, Tom Rodgers, William Pierce Rogers, Tim Rooney, Robert Rosencrans, Kyle Rote, Justice Alvin Richard Ruskin, Howard Samuels, Irv Samuels, Louis Sandroni, Edwin K. Schober, William Scott, Paul Screvane, John Scroope, Harold Segal, Bill Sella, Nino Selmaj, Tony Serao, Benito Sevarin, Hugh Shannon, Michael Scott Shannon, Wilfrid Sheed, Thomas Sheehy, Val and Judge Preston Sher, Dan Sherber, Gary Sherlock, Jami Sherwood, Bernard "Toots" Shor, Bobby Short, Norman Silver, George Simon, Francis Albert Sinatra, I. Philip Sipser, Frances and John Smith, Jan Johnson Smith, Jeremy Smith, Sally Bedell Smith, Walter "Red" Smith, Bruce Snyder, Jane Wharton Sockwell, Andy Spano, Brenda Resnick Spano, Nick Spano, Jerry Speyer, Rob Speyer, John Spicer, General Joseph Spinelli, Jeffrey Sprung, Sheila Stapleton, Andrew Stengel, Stuart Stengel, Don Stevens, Martin Stone, Edward O. "Ned" Sullivan, Arthur O. Sulzberger, Ellen Sulzberger Straus, Frederic Sunderman, Laurence Taishoff, Sol Taishoff, Chris Taylor, Eddie Taylor, Steve Tenore, Ann Wharton Thayer, Harry M. Thayer, Jeanne Thayer, Thomas Courtney Thayer, Walter Nelson Thayer, Paul Thompson, Donald Thurston, John Tolomer, Father Emil To-

maskovic, Neal and Tolly Travis, Diane Straus and Carll Tucker, Jr., Mayor Joe Vaccarella, Joe Valeant, Jerome A. Valenti, John Van Buren Sullivan, Lionel VanDeerlin, John Vasile, Linda and Roger Vaughn, Bonnie and Nick Verbitsky, Carl Vergari, Alex Von Bidder, Mario Wainer, Judge William Walsh, Frank Ward, John Ward, Claudia and George Wardman, Jane Wharton, Rosemary and William Weaver, Walter Weiss, Charles Wendelken, Bruce J. White, Ambassador John Hay "Jock" Whitney, L. H. "Hank" Whittemore, Ronny Whyte, Alec Wilder, Governor Malcolm Wilson, Rabbi Amiel Wohl, Fran Wood, C. V. "Jim" Woolridge, Leigh and Frank Young, and John Zanzarella.

Foreword

Bill O'Shaughnessy is one of our great under-appreciated commodities. Everybody knows how charming and glib he is. He's been given accolades for being a big radio man. I've known him a long, long time. He is a lover; he really, truly is a lover. I understand he can do his thing commercially, and this is often a very difficult world. But he is a lover. That's not an easy thing to be—and be accepted for it. He's a person who believes that you ought to try to make things better for everybody. He doesn't do it perfectly, but nobody works harder at it and nobody does it better than he does. He loves the word "sweet," and it's an intelligent, strong person who—unabashedly—is in favor of sweetness. I am! I have worked it into every speech I've ever written. And part of the reason is O'Shaughnessy. He gives us the constant inspiration to take the terrible turmoil of this place and try to add to it a little bit of—*sweetness*. To the extent that I succeeded at all is largely because of Bill O'Shaughnessy.

He's a special friend of mine, and we call him "Brother Bill." The Squire of Westchester is intelligent and highly talented, as he's proved by running his two excellent radio stations so successfully. He's also an especially gifted writer and speaker. He has eloquence, charm, dash, good looks—Lord knows how far he could go in this republic if, somehow, he could overcome his terrible shyness!

Bill O'Shaughnessy can't describe a scene as well as Breslin. He's not as "easy" a writer as Pete Hamill. But when he's "on his game," O'Shaughnessy is better than anyone on the air or in print. I've urged him for years to seek a wider forum for his talents.

MARIO M. CUOMO

Introduction

This is a collection of the self-described "rantings and ravings" of one of the most colorful and masterful independent radio broadcasters in America. Actually, you will find here some of the most poignant, vividly portrayed, and emotion-laden short stories ever written for the airwaves, under the guise of being "editorials of the air."

Some of these are personal portraitures painted in exquisite colors and shadings, with all of the dramatic lighting effects of the most accomplished photographer. Some are the quiet renderings of an understated drama, true to life and rich in human emotion, like that of a celebrated playwright.

The broadcaster is William O'Shaughnessy, who took a nondescript radio station—WVOX in New Rochelle—and turned it into what the *Wall Street Journal* has described as "the quintessential community radio station in America," "the Voice of the People," or "Vox Populi," as he likes to call it. He also turned it into his "bully pulpit" for making the pronouncements, giving the views, and telling the stories that have made him famous—many of which are included in this book.

Among other things, O'Shaughnessy is the "point man" for the broadcasters of America on "Freedom of Speech." He's the one they tap to turn on the eloquence in defense of our most precious freedom, even in the face of attacks spurred by the on-air antics of "shock jock" Howard Stern.

He's the one who took the unpopular side against Tipper Gore, the vice president's wife, in her efforts to censor rock lyrics. And he's the one the broadcast industry enlists in its recurring fights to stay free of the shackles of the Fairness Doctrine.

One of O'Shaughnessy's most famous stories about the First Amendment fights concerns the phone call he received from the legendary William S. Paley of CBS television, from

a phone booth as he was about to board an ocean liner. O'Shaughnessy had spent six weeks working with Ogden Reid to save Walter Cronkite and Frank Stanton from being thrown in jail for their part in bringing the Pentagon Papers to the American people. When they finally won their congressional battle against crusty, old West Virginian Harley O. Staggers and others who were hell-bent on trampling broadcasters' First Amendment rights, Paley called to say, "Future generations will thank you for this, Bill."

But O'Shaughnessy derives the most pleasure out of just covering his beat: Westchester County, also known as the "Golden Apple." Westchester is the home or the crossroads for aspiring politicians, captains of industry, publishers, bankers, and businessmen, as well as celebrities and entertainers of the first magnitude. Bill O'Shaughnessy is at home with them all—at Le Cirque, the Four Seasons, the "21" Club, and, on weekends, the American Yacht Club or Winged Foot. Indeed, many of these "affluent influentials" have become personal friends, as well as the subjects of his on-the-air musings.

O'Shaughnessy is a Kennedy Democrat who became a Rockefeller Republican. With his silver hair and fashionable haberdashery, he looks every inch the Westchester patrician. However, he is quick and proud to say that he "spent fifteen years trying to get that marvelous Italian fellow from Queens—Mario Cuomo—into the damn White House."

In spite of the fact that he has rubbed elbows with most of the high rollers and potentates of the last three decades, O'Shaughnessy still finds magic in the doings and deliberations of those he affectionately calls the "townies"—the people who have roots in the community and who are the ones who really make things go: Teddy Greene, the colorful councilman; Alvin Ruskin, the hard-working mayor; the ward healers and saloon keepers—the "real" people. As Bill likes to say, he loves "to celebrate the genius of those who toil in obscurity amidst all the wealth and influence" that abounds in Westchester, those "unsung heroes of quiet philanthropy and generous heart" you would never read about in the *New York Times:* Alex Norton, the hospital administrator; Hugh Doyle; and Jennie Murdy, the bachelor girl who lived alone in a row

house and dedicated herself to the love of her life, the Republican Party.

They're all here—from Jock Whitney, Toots Shor, and Sirio Maccioni to Nelson Rockefeller, Shipwreck Kelly, and Vin Draddy; from the mighty to the menial; big issues and small. And all brought to life through the keen discernment and eloquent expression of William O'Shaughnessy. Take a ride into this wonderful world of humor, high drama, and human emotion he calls *Airwaves*.

FRANK NARDOZZI
President,
Metro Suburban Communications

Part I: Nelson Aldrich Rockefeller

Nelson Aldrich Rockefeller was Governor of New York and Vice President of the United States. We covered the exploits of this vivid and zestful man for twenty years.

In the Back Seat on Election Eve

'Twas the night before election day, and Nelson Aldrich Rockefeller had only a few hours to go. Earlier in the day, a Rockefeller campaign manager called our station from Albany with a request, because WVOX was the first radio station in New York State to endorse Rockefeller for a third term. The caller from Albany, figuring the election might be won or lost in the suburbs, wanted to know if the radio station could clear some time on election day for last-minute messages from Nelson Rockefeller to his neighbors.

We scheduled the mini-programs, which were to be personal, last-minute pleas for support from the governor, directed to the people in his home heath. Arrangements were made for Rockefeller to record the programs at Albany airport, where he would feed his message on the Tele-Voice recording mechanism. But this plan had to be abandoned because the governor ran into heavy crowds in Albany and about fifteen hundred boosters at the airport.

When we remembered that the governor would make the traditional election-eve stop at Ratner's on Delancey Street, a WVOX mobile unit was dispatched from New Rochelle to the Lower East Side. With New York City Transit Commissioner Jack Gilhooley in charge of arrangements for the rally, the governor arrived to sample blintzes with Senator Jacob Javits and Attorney General Louis Lefkowitz. About two thousand people, mostly Puerto Ricans, were on Delancey Street to meet him.

Across the street and down one block, at Republican headquarters, the business of politics was going on, as Nelson Rockefeller had only a few hours before he would have to submit to the will of these people. Two local politicians sat in little partitioned offices, listening to complaints and dispensing fa-

vors to the people who live on the mean streets on the Lower East Side. A black soldier was home on leave, for example, and he wanted a transfer. A Puerto Rican lady's heat had gone off, and could someone put pressure on the landlord? An old Jewish woman wanted a job for her husband.

After eating the blintzes for the television and cameramen (and some apple sauce and part of a potato pancake, which had been thrust on him by a paying customer), the governor left Ratner's. Outside on the street the crowd had been building for Jack Gilhooley, and now they were worried about Ratner's glass windows. Warren Gardner steered a tired Rockefeller toward a rotating amber light on top of our shiny new Pontiac Safari station wagon. It was white and looked rather like an ambulance, but for the Bodoni bold lettering: "WVOX—Voice of the People of Westchester." The governor was swept past a beaming Gilhooley and shoved into the back seat of the WVOX mobile unit parked at the curb.

With that, our vehicle started to rock back-and-forth and sideways as the people in the street banged their fists on the roof. We were surrounded by thousands of people yelling, "Good luck, Rocky! We're with you, Señor Rocky!" Gardner barked to the driver, a WVOX news intern, "Get the hell out of here." When I reached across the governor and started to roll up the window, Rockefeller stopped me and said, "This is the last night, Bill, I'm all right"—and he reached out to touch more hands.

Robert Douglass, the governor's special counsel, fought his way through the crowd that had engulfed the mobile unit. He knocked on the window and said, "I'm going, Governor. I'll see you tomorrow, sir." Then Douglass looked at Rockefeller and said in a low voice, "Uh, good luck, Governor." Rockefeller said, "Thank you, Bobby. I'll see you tomorrow. We'll be all right."

Retreating to the edge of the crowd, the governor's young aide kept watching the rotating amber light on the roof of our radio car, as his patron and mentor drove off in the back seat.

As Gardner and a WVOX engineer checked the levels on two separate tape recorders, we handed the governor a dispatch that had moved on the UPI news wire earlier in the day. In it

he read that the Republican chairman of Nassau County, State Senator Edward J. Speno, predicted that Rockefeller would get several thousand fewer votes in Nassau than he had the last two times. Anger flashed through the governor's blood-shot eyes until we told him that Robert Curcio, the GOP chieftain in Suffolk, had heard about Speno's poorly timed remarks and had said, "They haven't even been able to hold a decent rally in Nassau since Carlino left." The governor looked a little better and said, "Bobby's right."

The governor then grabbed the microphone in his swollen right hand as the WVOX radio car headed uptown behind about six other cars. When his voice cracked, we offered him some Life Savers, which he declined. Instead, he fished in the pocket of his rumpled English suit and came out with a tin box of throat lozenges. Taking one, he launched into his message to his neighbors in Westchester—which now has, in addition to all the big homes and estates, close to nine hundred thousand people. "We've got a lot of problems in this state—and in the suburbs," he said. "The railroads have got to be saved. I hope my neighbors in Westchester might agree we've made a definite start to solve these problems."

Fortunately, the governor's voice held up. He was going good—and so was our radio car. As the cars ahead of us swung left somewhere around 14th Street, the mobile unit kept heading north while the governor recorded his program. When the crew found themselves alone on lower Park Avenue, with the Governor of New York in the back seat, the driver hit the gas. Rockefeller interrupted the recording to say, "Listen, cowboy, although they're *ahead* of us, *we're* the lead car—ya know what I mean? *They'll* find *us*. I don't want any crackups on the last night!"

Eventually, the governor's aides doubled back, and when the recording-session-on-wheels was finished, Rockefeller got out at a cafeteria on lower Park Avenue and plunged through a revolving door. He thanked the broadcasters from his home county and said, "It may very well be won or lost in the suburbs."

November 1966

Election Day Dawns

I've done variations of this editorial every election day for the last thirty-five years.

Election Day in Westchester.

The day of decision dawns.

After all the rhetoric, after all the debate, the charges and countercharges—after all the promises, platforms, and posturing, comes your turn. For only fifteen precious hours, which began at six o'clock this cold morning, until nine this evening, comes this opportunity—the franchise only Americans enjoy to such an extraordinary degree—to favor or reject those candidates, proposals, and propositions that will present themselves when you enter the voting booth.

To some, this is a civic duty and a privilege, almost a sacred rite we can perform only in the autumn of the year. To others—the majority, in fact—this is merely a chore, an annoyance best left to others. And that is a tragedy.

So, on this election day, allow us only the plea that *you*, at least, not stand off as so many others do, in their frustration or smugness, and leave it to someone else to decide these things.

Most of the contests this year are for local and county offices. The candidates and their views are not as vivid, perhaps, as those we encounter in federal or state elections. But, they are just as important—perhaps even more so.

I take my leave this morning by recalling the words of Ogden Nash. We broadcast them every year to remind us what it is we are about this day. Nash wrote: "They have such refined and delicate *palates*, they can find no one worthy of their *ballots*. And then, when someone terrible gets *elected*, they say, 'That's just what I *expected!*' "

So, if you're of a mind to say, "They're all jerks" or "I'm voting 'none of the above,' " you might not get what you *expected*. You will, however, get what you *deserve*.

Please vote today. It's about everything. A lot of people gave up a lot to give us this opportunity, this privilege.

Until nine o'clock tonight.

We'll find out how well you did when the ballots are counted tonight on WVOX at 1460, and on WRTN at 93.5.

November

The Governor and the Garbage

Suppose you had four political commentators sitting at your breakfast table this morning, and suppose each of them professed a passing interest in national politics. Chances are, each of the four would want Governor Nelson Rockefeller to "save" us from someone or something. One might hope Rockefeller would "save" us from Ronald Reagan. The second might want the man from Pocantico Hills to "save" us from the man from Texas: Lyndon Johnson. The third would be certain the governor could "save" us, and the English language, from George Romney. And if we were the fourth, we might join our other three friends and tell you we have always admired Nelson Rockefeller because, in the long pull, he's the only one who can "save" this nation from the junior senator from New York: Robert Kennedy.

The moral of this little mythical confrontation at your breakfast table is that everybody wants Rockefeller to "save" us from someone. But now our governor has ended the sanitation workers' strike, and he has this big trouble with the newspapers and the political commentators. Over the weekend, he was raked through the presses of the *Daily News* and the *New York Times*.

John V. Lindsay, the Mayor of New York, is "responsive" to the press, as our colleagues like to put it. He schmoozes with Jerome Wilson and Ralph Penza of CBS, with Gabe Pressman of NBC, and with Johnny Parsons of ABC. Lindsay makes them feel good and so almost every newspaperman in New York and every television commentator is coming at you to question the courage of Nelson Rockefeller. They question the courage of a man who went up against those who wanted Barry Goldwater to be President of the United States. And you can just remember today, on the birthday of Abraham Lincoln, that his party wanted you to elect Barry Goldwater as president and only Nelson Rockefeller had the guts to try to stop it.

No, ladies and gentlemen, accuse Robert Kennedy of opportunism, but not Nelson Rockefeller. If one theme or strain has appeared time and again during his administration, it has been courage—courage coupled with vision and imagination. We believe the Mayor of New York's daredevil attitudes and foolhardy stand were not the answers to violations of the Taylor Law. Perhaps someone someday should stand up to narrow, self-seeking union leaders, but we don't believe eight million people who are about to drown in their own swill and garbage should be endangered for the sake of "fiscal prudence." We agree with the labor leader Harry Van Arsdale: Rockefeller did Lindsay a favor. If just one child had stumbled out of a tenement and eaten some of the rotting and putrid garbage, Lindsay would have had an awful tough time explaining to some mother that teaching the unions a lesson was more important than all that garbage piled on the streets of New York.

And what if Rockefeller had brought in the troops to break the union? Well, we guarantee you, newspaper editors in Moscow and Hanoi would have had a field day with that throwback to the early part of this century. So this is one for the governor.

And although he needs no consolation from us, we might recall today the words of the man whose birthday we celebrate. Abraham Lincoln said, "If ever there be a proper time for mere catch arguments, that time is not now. In times like the present, men should utter nothing for which they would not willingly be responsible through time and in eternity." Both Lindsay and Rockefeller fought for principle. Rockefeller got the garbage off the street.

February 12, 1968

Hope Springs Eternal

The merchant princes of our city were sitting at a service club meeting, saying they want to form a picket line and protest against something—anything at all. They just want to march right out and protest. These Westchester business chieftains are sick about what is happening at Columbia University. They are "up to here" about Rap Brown and how far this disrespect for law and order is going to go. In this springtime of 1968, when a little sunshine lingers across our evenings until as late as 8:00, these men are saying they might even vote for George Wallace for president.

Alvin Ruskin has been saying this might happen in the country, when people are going to be so damn fed up with all this business that some wild reactionary will come riding out of California or Arizona or someplace. And other men like Ruskin are worried about the counter-reaction breeding deep in the gut and fabric of this country, and that some wild demagogue is going to come on the scene, wave the flag, and talk about a return to moral virtues.

The four or five men running for President of the United States these days know about this. Hubert Humphrey is talking about a politics of happiness and joy; the junior senator from New York, Robert Kennedy, is spreading his special brand of demagoguery throughout the Midwest; and Richard Nixon is, well, hanging on for dear life. So the people are actually talking about making George Wallace President of the United States.

But there is hope. Nelson Aldrich Rockefeller of Westchester got up earlier this week and said he was going to run for president. Although he made a speech that went over everyone's head, he didn't resort to demagoguery. He looked right at you and used intelligent, graceful words, which is the only way he knows how to do it. He used big words, but he looked right at you, which is something Nixon cannot do. When

Nixon comes here to campaign, walk up to him and say hello—and he will call out your name, smile, and look right over your shoulder.

Although we've urged Rockefeller to use staccato phrases and smaller words to accommodate the television news editors, he can't tolerate Tammany Hall or Robert Kennedy demagoguery. Rockefeller can only look right at you and say he is concerned about his country.

He's late with this, very late. But we've supported him in the past, and we support him now. Maybe selecting a guy for president because he is courageous, he can look you in the eye, and he won't resort to emotionalism are weak reasons. But we've said it before and we say it again: if it were our country and we could pick *one* man to run it, we'd pick Nelson Rockefeller.

May 3, 1968

Reports from the Republican National Convention

A MAN TO SUCCEED ABRAHAM LINCOLN

The First Commentary

(Miami Beach) It is hot in Miami Beach, where the party of Abraham Lincoln has come to pick a man to run for President of the United States. The sun, hanging over Biscayne Bay and causing the water to be eighty-nine degrees, is not refreshing. It's hot.

Delegates—1,333 of them—have come to the Republican National Convention from all over the nation, but they all look curiously like Gerald Ford and Les Arends. And lest we forget, one in three of these delegates was there four years ago, in San Francisco, when this major political party nominated a man named Barry Goldwater to be President of the United States.

The Ripon Society, a liberal Republican group, didn't surprise anybody in this city when they said the typical Republican delegate is white, Protestant, belongs to the Chamber of Commerce and the American Legion, and is a Mason or an Elk. They have come to this city where, incidentally, 80 percent of the permanent population is Jewish, from remote little towns that you never heard of. They have come here to pick a man to succeed Abraham Lincoln and Dwight D. Eisenhower. But to look at them, you get the feeling they might just nominate a man to succeed Barry Goldwater.

Nelson Rockefeller knows this. He knows that time is running out—and Happy Rockefeller, in all this madness, just rolls with it all with a kind of lovely grace. Her husband, the Governor of New York, will work for three more days to give these white, Protestant members of the Chamber of Commerce, the American Legion, and the Elks from Iowa a choice.

Mrs. Rockefeller asked a WVOX reporter Saturday night what was going to happen and he said, "Well, you might have a chance on the third ballot or the fourth or the fifth." He did not tell her the second ballot might be as tough as the first for Nelson Rockefeller, because the governor of California is expected to come on like a tornado on the second ballot if it gets that far. Ronald Reagan will come on this way because one of three delegates here in Miami remembers San Francisco four years ago. And then everyone will wait to see if this Republican Party will move to Rockefeller as they waited four years ago for it to turn to William Warren Scranton, the governor of Pennsylvania.

These delegates have a lot at stake. Why, there are countless postmaster positions in Iowa alone. And now in Miami, they are surrounded by suggestions about what they ought to do at this convention: rent a boat? take in a nightclub? "Vote for me—Don't vote for him." But most of them are upset about a man named Joe who owns the best restaurant in Miami Beach. It's called Stone Crab Joe's, and even if you're white, Protestant, and come from Dubuque, you have read a guide book that tells you about Stone Crab Joe's, because it happens to be the best restaurant in town. But Joe is so impressed with these people that, when he heard they were all coming to town, he went on vacation.

And so Nelson Rockefeller can only wait. He knows now that Governor Spiro Agnew of Maryland is going to endorse Nixon. He knows that Governor James Rhodes of Ohio is doing what he did four years ago—waiting until the night before, only to nominate Barry Goldwater.

It is going to be so close for Rockefeller, they were saying last night, that Governor Walter Hickel of Alaska could decide this thing. And so, Stone Crab Joe notwithstanding, all is not bleak because, instead of Les Arends and Gerald Ford picking the nominee, a man named Hickel from Alaska could choose the successor to Abraham Lincoln.

But it sure is hot in Miami Beach in August.

August 5–8, 1968

Long Odds . . . and Governor Cargo

The Second Commentary

(Miami Beach) Nelson Rockefeller was in a hurry until he got to Miami. Everyone around him was in a hurry. The people who were working for him in Westchester were in such a hurry that a man named Morton Pechter, who owns a bread company, sent out letters asking for money for Rockefeller, but Pechter forgot to sign them. You are really in a hurry when you forget an item like that.

But now in Miami, Rockefeller has slowed down and is hanging on. He can just sit and arch his eyebrows and watch Richard Nixon's wife on television, sitting in the front row with her daughter and David Eisenhower and that hard, tight smile that she uses. After one night in town everyone is beginning to sag, as the party of Abraham Lincoln chooses a presidential candidate. The air-conditioning kept failing all day yesterday in a suite taken by George Hinman, Rockefeller's closest adviser. And if Hinman cannot get cool in Miami Beach, no one can. Delegates from Westchester are mixing manfully with these people from Georgia who wear sport shirts and tassel loafers and show what barbers call skin-on-skin over the ears. People like Ed Michaelian, Doug McCallum, Norman "Bud" Stone, and Jean O'Brien are standing in line to eat, and they must walk a country mile under hot television lights to go to the bathroom.

The delegates—and the entire nation, in fact—had to watch last night as John Lindsay chopped his words off too sharply. Lindsay is magnificent in the ghetto when it is hot and stinking and tense—and when it counts. But as we reported yesterday, the Ripon Society, a liberal Republican group, says that the typical delegate to this convention is white, Protestant, and belongs to the Chamber of Commerce, the American Legion, and the Elks—and that one out of every three was there in San Francisco when this party picked Barry Goldwater to run for President of the United States. In front of these people in Miami Beach, Lindsay sounds as if he has spent a summer taking speech lessons at Sarah Lawrence College in pristine Bronxville.

But nobody in the convention hall last night could hear what Lindsay—or the other speakers, for that matter, who were even worse—had to say. They did see a courageous move by Governor Cargo of New Mexico, who got up and said that he had a tough primary fight himself and, while he thought Rockefeller would be an excellent president, he was releasing his delegation and announcing today that he was supporting Richard Nixon.

So, Nelson Aldrich Rockefeller has only one more day of this in Miami Beach, where hope is fading fast—so fast that of his top aides, only Malcolm Wilson, the lieutenant governor, is remaining steadfast in saying that Nixon can be stopped. Others are saying that it's a one-in-ten chance for the Governor of New York. Those are long odds for Miami Beach in August.

August 5–8, 1968

It Was the Same on All the Channels

The Third Commentary

(Miami Beach) Last night it went just right for Richard Nixon—and it went just right for all the people from Georgia. And those people from the Midwest who came across the plains to Miami Beach are happy this morning.

But can you imagine the ghettos of Cleveland, Detroit, Newark, and, for that matter, our own Mount Vernon, when they wake up today to learn that one of two major political parties in our country nominated Richard Nixon? Despite all the warnings—despite the signs—it happened in this city at two o'clock this morning.

Jimmy Breslin, a writer who has been with the poor and writes eloquently about them, sat with us for a while on the floor of the convention hall. Breslin was using four-letter words until he saw my wife, and then he just said, "What's the use? Goldwater. Now this."

Everyone is still in the sack this morning except, of course, Nixon, who is on his way—to something. He will need a vice

presidential candidate to help him get there, and we were kept awake last night because the telephone in the room next to ours started ringing as soon as it was made unanimous for Nixon. Deputy Mayor Robert Sweet of New York is in that room next to us, and that might mean John V. Lindsay. Last night Harvey Rothenberg of New Rochelle, a millionaire who is a dollar-a-year assistant to Lindsay, said, "John couldn't turn it down—if they asked him."

But last night belonged to Richard Nixon, and it was like a dream. They were rioting in North Miami and Governor Claude Kirk went racing up Collins Avenue to have a little look at what the colored folks (as they are called down here) were up to. As Breslin, who worries about big city streets, sat swearing at the Georgia delegates with their sport shirts and crew cuts and tassel loafers, word spread on the floor that the colored folks just might march on the convention because of Richard Nixon—and oh, dear!

Later, in another part of town, three Rockefeller supporters—John Hay Whitney, former ambassador to England; William Paley, chairman of CBS; and Walter N. Thayer, president of Whitney Communications—sat in penthouse suite number one at the Eden Roc watching it happen on television. Paley has a clicker with his name engraved on it, and CBS had installed a television set with three screens in this suite. So the CBS chairman sat there working and waving the clicker. But it was the same on all the channels—Richard Nixon was being nominated to run for president by the Republican Party while they rioted a few miles away.

August 5–8, 1968

The Colored Folks Are Congregatin' Again

The Fourth Commentary

(Miami Beach) Nelson Rockefeller sat in a room on the fourteenth floor of the Americana Hotel in Miami Beach yesterday afternoon. He knew exactly as much as you did when Richard Nixon moved to the battery of microphones to anoint Spiro

Agnew. George Hinman and a few of the governor's top aides were in the room with Rockefeller and his wife.

No one moved when Nixon threw up the name Agnew. No one spoke. And then everyone in the room—along with Rockefeller—groaned and said, "Oh, no." Happy Rockefeller, who wanted John Lindsay to have the chance for the vice presidency, was beside herself. She has been remarkable throughout this incredible week, but Spiro Agnew, who had stood with her husband just a few months ago, was too much for Happy Rockefeller. She wept, which is why she looked like a ghost of herself on television last night.

The news spread quickly through this flimsy, gaudy city made of cinder block laid down on a mango swamp. At the Beau Rivage, next to the Americana, Daniel Jackson Evans, the Governor of Washington State who stood up for Rockefeller and all that this party should mean, was at the pool with his wife, Nancy. Evans gave the keynote speech to this convention and is on the cover of this week's *Time* magazine. But now, in this town that exists for the people in America who look and think like Strom Thurmond, Evans was explaining to the pool attendant that he would like to charge a towel to his room number. "E-V-A-N-S."

As we moved about the city last night, we heard lots of reasons offered for Nixon's decision. Some said it was a deal with Strom Thurmond. But there are men—wealthy and powerful men—who move in these circles. They work with all of them, Nixon as well as Rockefeller, Charles Percy and William Scranton and Douglas Dillon. These men have known each other for years, and the educated guess of these powerful, behind-the-scenes king-makers (although they would never say it publicly) is that Nixon has a great suspicion and distrust of wealth and breeding. They argue that John F. Kennedy just terrified Nixon, and they carry this on to suggest that this is why he would not pick an attractive guy like Lindsay or Mark Hatfield or Percy. One prominent national Republican told us, "Look, the guy only had an hour of sleep . . . and this is quite typical of Dick. He's always right on the small ones, but he's just beautiful when it comes to the major decisions."

Maybe so, but Richard Nixon and Spiro Agnew will repre-

sent the Republican Party in November. They will come to Westchester, and we'll be listening hard when they tell us what they'll do for the cities in our southern tier. For snipers were at work in Miami, where almost everyone drives a white Cadillac to complement their deep, wealthy tan.

The police chief down here was saying that he could have prevented a lot of the looting, but that every time he dispersed the colored folks, every time the chief got 'em spread out, Claude Kirk, Jr., the governor, would get up and make a speech—and then the colored folks would start congregating again and trouble would start. The townsfolk aren't talking about Nixon and Agnew; they're talking about the shooting and the looting. But it's obvious that the Republican Party can't yet hear the sound of anarchy in our cities.

August 5–8, 1968

Advice for the President

To the Honorable Richard M. Nixon
The White House, Washington, D.C.
Copies: Gen. Alexander Haig, Bryce Harlow, Peter Flanagan,
Ray Price, and Rosemary Woods

Dear Mr. President:

Radio Station WVOX endorsed you last year, but we really have no credentials that entitle us to offer advice and counsel to the president at this difficult time in the life of your administration and in the history of this republic. You must choose a Vice President of the United States. It is not an easy decision, Mr. President. Although everyone has an idea of what you should do, the decision is yours alone.

Because we love our country, we will support your choice. But we really hope you will do something bold and brave and courageous and splendid, and just pick the best man for the job. Henry Kissinger, the Secretary of State of the United States, and the architect of your spectacular foreign policy, has given you a name. General Alexander Haig has given you the same name. Joe Alsop, in last week's *Newsweek*, gave you the name. Yesterday's *London Daily Mail*, in a front-page editorial, suggested there is only one man with the international experience capable of filling the post. Governor Nunn of Tennessee sent you a telegram late yesterday afternoon, Mr. President, with the same counsel. So did Peter Peyser of Westchester.

They and many others all across the country are trying to tell you that Nelson Aldrich Rockefeller is truly the most capable man in America for the job. Take anybody else you're considering and compare him with respect to vision, courage, stamina, zest, imagination, and brilliance—and you have to come up with Rockefeller.

It should not matter, Mr. President, whether a man will be

"acceptable" to the Democratic Congress. They are going to have to do what is best for the country—just as you have to do what is best for the country. The first step is for you to pick the best man, and then we will all look to Congress to do the same—regardless of party.

In our view, you can't negotiate this one, Mr. President; you can't finesse it. There is no middle ground. You just have to pick the one individual with the best equipment, the most brainpower, the broadest experience. Nelson Rockefeller has been a dynamic Governor of New York. God knows what a mess this state would be in without him. And a lot of people in both parties seem to think Governor Rockefeller is the man for our nation. We agree with them. You've had some awful appointments and some brilliant ones: Elliot Richardson was a great appointment; so was Kissinger.

Do the right thing on this one, Mr. President.

<div style="text-align: right">October 12, 1973</div>

Nelson Leaves Albany: Rockefeller's Last Press Conference as Governor

At exactly 11:29 A.M. yesterday, the eleventh of December, in the historic Red Room of the State Capitol, Nelson Aldrich Rockefeller walked to the rostrum with that marvelous upbeat way he has about him, gave a nod forward, raised his eyebrows, and resigned as the forty-ninth Governor of New York State. "We are living in critical times," he said. "After long and careful consideration, I have concluded that I can render greater public service to the people of New York and the nation by devoting myself to the work of two bipartisan national commissions." As he spoke, huge likenesses of his predecessors hung on the walls of the Red Room, looking down on him: Charles Evans Hughes, Hamilton Fish, and Martin Van Buren—Governors of New York, amazing men, looking down at one of their own. One of them, Theodore Roosevelt, peered over his monocle as Nelson Rockefeller went out of Albany with style, wit, humor, and great class.

People are saying that our national leaders could use a little grace and class. There, in that room, once again, was our neighbor from Pocantico Hills appearing in the natural, easy, candid, remarkable way that was bred into him. Nelson Rockefeller has never been one for fiery, demagogic, stem-winding speeches. And yesterday the governor stood there in the lights as a man of deeds instead of words, leaving to others to assess his spectacular record of almost fifteen years.

A pretty woman in a yellow dress passed around a summary of Nelson Rockefeller's historic accomplishments. Yet, as he took his leave, this special man would not dwell on the "leg-

acy" of his leadership. The national press had tried to pull him
down into the muck and mire of Watergate—and they would
have succeeded with anyone but Nelson Rockefeller. "Are
we," he asked, "each one of us, cutting corners in our own
lives? Have we perhaps lost a sharp focus in our own affairs
and on the fundamental ethical and moral issues of the day?"

Nelson Rockefeller never faltered yesterday, as he stood in
the lights talking about our future as a people and as a nation.
As he looked down from the podium behind the great seal of
the State of New York for the last time, there was sincerity in
his voice. He thanked his associates, and he saved his final
word for you and the people of the State of New York, who
gave him what he referred to as a "unique opportunity for
public service."

And that was it. He left the podium, sat down on a chair next
to Happy Rockefeller, kissed her, and said "Hey, sweetie." It
was left for Lieutenant Governor Malcolm Wilson of Yonkers
to get up and, in his own classical way, cite "the litany of your
achievements, Nelson." Then Wilson, the eminently decent,
God-fearing man, who will become the fiftieth Governor of
New York next Tuesday, stepped into the spotlight for the first
time, as Nelson Rockefeller was moving off the Albany stage.

Malcolm Wilson is a Fordham orator who will surprise
some of the national press with his ability, skill, and bril-
liance—but not his neighbors in Westchester, who know and
admire him. So, for the first time in fifteen long years, the
reporters gathered around the lean, gentle lieutenant gover-
nor—the man who will next week assume one of America's
most important political offices—as he stood there with his
proud and beautiful wife, the former Katherine McCloskey.
For the first time, you noticed a bit of make-up on Malcolm
Wilson for the television cameras. But then, moving in closer,
you saw the familiar narrow black tie and the falling-down
socks and the scotch-grain wing-tip brogans—and you knew
this was the same natural man who talks to people about a
"bounteous Creator" who has "generously endowed" our
state. And you know the sudden fame which is now his would
not shake the steady man who will replace Nelson Rockefeller
as governor.

But this was Nelson Rockefeller's moment, and as you took a sentimental trip back down the Hudson River and came across the Tappan Zee Bridge, you noticed the late-afternoon sun falling on the water from over your shoulder out of the western sky. It seemed focused, that sun, high on a hill above Sleepy Hollow, on a place called Kykuit. It is a Dutch word meaning "overlook," and it is where Nelson Rockefeller lives and dreams those marvelous dreams of his. It was bathed in sunlight yesterday afternoon, waiting for the return of the most exciting man of our times.

In 1966, I'm reminded, he finished his campaign for governor answering questions in the backseat of a WVOX mobile unit. And yesterday, seven years later, in his farewell, he gave the first question of his final Albany press conference to Steve Osborne—and he gave the last one to me. We talked about Theodore Roosevelt, whom Nelson Rockefeller likes to recall as a "fabulous and zestful man," a phrase that easily applies to himself.

This is a meager tribute for the man who gave us a lot of exciting and graceful moments and who, among others, inspired our local station to the cause of good government. But we have strong and sure feelings that the best is yet to come from the great squire of Pocantico Hills.

December 12, 1973

Nelson Rockefeller: The Best Man for the Job

Nelson Aldrich Rockefeller of Pocantico Hills, and a former member of the Westchester County Board of Health, walked into the Oval Room of the White House at 10:04 A.M. yesterday, and, suddenly, the government of the United States of America had more than good intentions. Once again, it had something called *style*.

This extraordinary man, who is as much at ease with Meade Esposito of Brooklyn as he is with Jock Whitney of Manhasset or Henry Kissinger of Washington, did something for this nation last night that the television commentators could not put into words. He lit up that Oval Room! You could see it and feel it in the way the leaders of our government welcomed Rockefeller to a high new estate he has deserved for so long.

Stanley Tupper, a former congressman from Maine, said it so well last week in Bangor: "If you held a civil service exam for the job, Nelson Rockefeller would get it." But there were no exams—there was just Gerald Ford, the President of the United States, coming into that room with the best man for the job—and the president grew ten feet before your eyes. When you saw all this taking place in his office, you resolved to straighten out the next hippie-dippy pseudo-intellectual from Scarsdale who takes a crack at Grand Rapids, Michigan. Although Pete Hamill will write a nasty column about these proceedings, and Barry Goldwater, John Lindsay, and Jesse Helms of North Carolina are not feeling too good about this moment in our history, old, patrician Averell Harriman, the diminutive former mayor of New York Abraham Beame, and even Senator Chuck Percy forgot their own ambitions, put aside partisan politics, and wished Nelson Rockefeller well. All over Westchester yesterday there was an excitement in the air. Max Berking, the decent and kindly Democratic chairman, said it was a good thing.

At the county airport, employees of Wayfarer Ketch, the mini-airline owned by Time, Inc., Chase Manhattan, and the Rockefeller family, had the governor's overpowered Grumman Gulfstream II out of the hangar at the crack of dawn. Joseph Canzeri, the governor's shrewd and devoted advance man, was preserving Gerald Ford's intentions by suggesting that Whiskey Kilo 100 was destined for Bar Harbor, Maine.

George Berlinger of Purchase, New York, was on the phone predicting the market would go up, as it did. Walter Nelson Thayer of Rye, an "Eastern liberal" and publisher and patron of the Ripon Society, who ran the presidential campaign of Dwight Eisenhower, was saying that it was a wonderful thing, and actually wrote a letter to the White House for the first time in a long while.

Frank Garito, the mayor of New Rochelle, and Bob Greene, the labor leader, were telephoning the news to people who care about this country and who have watched Rockefeller up close and know what a fabulous, zestful man he is. In Washington yesterday, standing before the lights at a press conference, the "Old Pro," as James Reston calls him, met the Washington press. The questions were rough and tough, and the air crackled with excitement, but there was no tension, no hostility, no meanness, no sweaty jowls, no talk of subpoena, no referring to himself in the third person, like Nixon. As the eyes danced and the blocky shoulders moved, you cheered for this neighbor of ours the way you cheer for Pancho Gonzalez, Henry Aaron, and Gordy Howe.

This was important stuff in Washington, which will go down in our history books. The government and our democracy within a republic are serious matters, not to be treated lightly. Thus it is probably not proper to compare the drama in the Oval Office to sports, which Jimmy Cannon called "the toys of a nation." But for some, as Rockefeller moved to the center stage of our nation yesterday, it was like watching Stan Musial, Joe DiMaggio, or Allie Reynolds playing baseball. Here was one of the most able men of our time who says prayers with his young sons, Mark and Nelson, before breakfast on the terrace of Kykuit, the Rockefeller home. And here was the last

of the high rollers who talks about "winding down" his life-
style, as he did in a WVOX interview just a few weeks ago.

All of a sudden, there was a grace, candor, and confidence
abroad in the land. Americans had stopped watching for mar-
shals at the door. It was exciting again all over the country,
just as soon as Whiskey Kilo 100 climbed into our Westchester
skies yesterday and headed southwest—toward Washington.
Gerald Ford calmed things down in the nation and got us on
the right track—and now Nelson Rockefeller will help him
throw it into high gear. You can bet on it.

 August 21, 1974

Pigeons and Politics in Washington

When an eagle falls, pigeons rule the sky. The late Jimmy Cannon, one of America's finest sportswriters, made this trenchant observation many years ago.

Sadly, it is all too appropriate to the situation that will develop in our nation if the Congress does not move promptly to confirm the president's nomination of Nelson Rockefeller as vice president. A group of small, mean, narrow men, led by conservative Jesse Helms of North Carolina, is trying to deny our nation the services and talents of the amazing, zestful, and capable former governor of New York. As a journalist and as a former broadcaster and commentator for the Tobacco Radio Network, Helms is of me and mine, but his identification with this ridiculous charade going on in Washington and in the public press is not worthy of the enlightened people of North Carolina. Truth to tell, one of the most distinguished newspaper editors in North Carolina told us recently that many citizens in his home heath consider Helms to be "an embarrassment" to North Carolina, the most sophisticated of our Southern states.

There is not a man in Congress whose reputation would not wilt in the face of the extreme partisan scrutiny that Rockefeller is enduring. Yet, he has given many years of dedicated service in the cause of this nation. He has used the resources of his considerable purse to attract and keep men and women of quality and ability in government service. He has heeded the oft-quoted biblical admonition about the camel and the eye of the needle, the rich man and the kingdom of heaven. Everyone runs the risk of being damned if they don't; Rockefeller is damned because he did. This reverse double standard of justice is not becoming to the Congress. Rockefeller has given millions to focus attention on our uncertain future. He has

rewarded those who have selflessly assisted him in his own selfless pursuits. He has admitted his mistakes, truthfully, candidly, and publicly.

Remember that the people of New York elected Rockefeller as their governor because, for all his money, he was down-to-earth, a proven leader, and a skillful executive. President Ford delighted the thinking people in America by reaching out for the best man for the job. Rockefeller is dynamic, able, and bright. He is a man of great vision, purpose, and dedication.

We believe Helms and the others involved in the attacks on Rockefeller might be motivated by nothing more than plain, simple jealousy. Ability, judgment, and accomplishment should be the issues, not dollars. If the petulant partisan attacks on Rockefeller don't quickly subside, there is a real chance that no man or woman of worth or means is likely to be persuaded to public service in America.

When an eagle falls, pigeons rule the sky. If we allow the likes of Jesse Helms to bring down Nelson Rockefeller, it will be a sad day for America.

October 16, 1974

The Vice President and the Good Old Boys

On board Air Force Two, Vice President Nelson Rockefeller, the former Westchester County Commissioner of Health, went into the Deep South to get to know some of the Good Old Boys. The great squire of Pocantico Hills took his "non-campaign" to Mobile, Alabama, on the Gulf of Mexico, which is as far south as you can go in the very Southern state of Alabama.

Mobile in August is hot and quiet. Not a breeze was stirring when Air Force Two arrived on Tuesday. Yet, Rockefeller came out and bounced down the ramp into the sunshine to meet the proud, gentle, and thoughtful people of the Cotton State. Rockefeller, age sixty-seven, charged the sultry air with his own energy and remarkable personality. While the Alabama politicians in their double-knit suits and vinyl shoes rushed forward, behind a phalanx of Southern belles in hoop skirts, Rockefeller's eyes danced. He waved and smiled. The last of the high rollers was on the campaign trail again.

Yet, the former governor describes his present state as "totally relaxed." Later, at a dinner for sixteen thousand, he waited until the lieutenant governor of practically every state in the union was introduced. He then walked into the Mobile Municipal Auditorium with a wave of his hand and an easy roll of his shoulder. Even the Governor of Alabama had to admire the way the patrician from Westchester approached this place right in George Wallace's own home heath. "You're not so bad!" cooed one of a throng of Southern ladies gathered in front of the dais as Rockefeller signed his name hundreds of times, saying, "Well, thank *you* . . . I'm glad to *be* here!"

Then the crowd hushed—or hushed up, as they say down here—and George Wallace of Alabama introduced our Westchester neighbor to those lieutenant governors, Alabama fat

cats, and hundreds of just plain folks, people we do not see in our neighborhood and know nothing about.

I should tell you, in all candor, that we came here quite prepared to reinforce our dislike of Wallace. But I must report to you that Wallace, who is supposed to be deaf and infirm according to *New York* magazine and the *Village Voice*, was in truth quite graceful, eloquent, and very appropriate to this occasion, which was being monitored closely by the national press. If Wallace stumps this country and comes calling this fall with his Cornelia—she of the teased bouffant hairdo, flashing eyes, black hair, and too much makeup—he is going to raise hell for the Democratic Party.

Then the spotlight was on Rockefeller, and Westchester's zestful favorite son worked hard on this hot night. He talked about solving the energy problem, which "holds the key to economic growth," revitalizing the economy to "achieve full employment," "restructuring domestic social programs to assure individual security in terms of need on a sound fiscal basis."

Truth to tell, I'm not quite sure what this last phrase means, but I think it is what some would call a code. The vice president dropped in a harsh and unnecessary line about a million people going on food stamps every month. However, we may have misunderstood this amazing remark because just then, an old Southern politician approached our table to ask Ann Whitman, Rockefeller's legendary chief of staff, who was also Dwight Eisenhower's amanuensis, for the corks to our wine bottles; he said he was going fishing this week.

So it went, as Air Force Two next took Rockefeller to Columbia. In 1786, the capital of South Carolina was established right in the exact middle of the state, as a compromise between the contending Up Country and Low Country farmers. In Columbia, they sell handguns and boiled peanuts and T-shirts and Dr. Scholls exercise clogs. It is the place Bill Emerson, Jr., who lived in Larchmont and wrote those wonderful columns about the South, now calls home.

Emerson was teaching a class in journalism at the University of South Carolina as Rockefeller stood on the steps of the historic Lace House with Strom Thurmond, who has built

more Army bases and more post offices than any man you know. The Shah of Iran would be proud to call the central post office of Columbia "home"—it is that big and ornate.

Air Force Two then returned to Washington with the lions and elders of the national press. There, "the old winker," as he is known affectionately to his staff in their irreverent moments, put his tired body aboard Whiskey Kilo 100, his overpowered Grumman Gulfstream II, destined for New York. After this long, exhausting day in the deep South, he would counsel this weekend with his "Philadelphia lawyers," as he calls them, to prepare for the Attica hearings.

Who knows if he scored any points with the Good Old Boys. The national press, although it likes him personally, is very cynical. They think he is too conservative these days—and the Southerners still think he's a liberal. But Nelson Rockefeller, our neighbor, just continues to do his thing in these remote places of our nation—"totally relaxed," as he says. But Mobile and Columbia sure are a long way from Westchester.

August 28, 1975

The Party of Lincoln Shoots the Messenger!

We saw it. But we don't believe it.

You will excuse us this morning if we urgently address ourselves to some of our Westchester neighbors who run the television networks of our nation. We refer to Julian Goodman of Larchmont, chairman of NBC; Dick Wald, also of Larchmont and president of NBC News; Leonard Goldenson of Mamaroneck, chairman of ABC; and Elton Rule, whose name sounds like a Mormon's and who looks like a matinee idol. He lives in Scarsdale and is president of ABC. Maybe our words this morning will even carry across the Sound to William Paley himself, the great squire of Manhassett, chairman of the mighty CBS.

You—all of you—are absolutely destroying the Republican Party of the United States! It's as simple as that. If you keep up your shenanigans and show us another brilliant convention like the one we all witnessed last night, the party of Abraham Lincoln will be finished by Friday. You let one of the two major political parties of America disgrace itself on your networks, on that damnable electronic tube that sends reality straight into our living rooms.

First there was Nelson Aldrich Rockefeller, the most able, zestful, and exciting man in America, standing there in front of Rotarians and car dealers from Cedar Falls. If you admire Rockefeller, you had to wince last night when he came on. Our neighbor from Pocantico Hills, the Vice President of the United States of America, stood before these people gathered in high council in Kansas City, and he tried mightily to go beyond these Neanderthals, directly to the people of America. He didn't succeed.

The staccato phrases he used were alien to him, as they always have been. You only had to watch Happy Rockefeller—a

fresh, open, blithe, and beautiful woman. The look of revulsion on her face told you he didn't belong up there in front of those people with the white shoes who look as if they run feed stores in Missouri. He winked and he blinked and he gave that "Yes, sir, thank *you*!" But those demagogic, short phrases that are custom-made for the plastic politicians of the day—and for Mr. Paley's television cameras—do not go well with Rockefeller. He is a bright, sophisticated man, and he has never mastered those short, punchy one-liners. It is a political tragedy, an American tragedy—but it is a fact.

You put Rockefeller in a room alone with Anwar Sadat and Colonel Gadhafi with only his winking eyebrows and his brilliance and candor, and in fifteen minutes off the record, he will come away with more territory than fifty Israeli divisions could win in a year. Yet this man, who has never had the patience for the staccato rhythm, went after Jimmy Carter like a benevolent street brawler. He talked about his "pussy-footing prose" and suggested that the Georgia peanut farmer belonged on "What's My Line"—and his distinguished audience of rednecks waved patronizing signs saying "Thank you, Rocky!" and "18 years of service!"

Then Barry Goldwater's son and heir got up and compared his father to a bust of Robert E. Lee. And Barry Goldwater of Arizona himself stood in the glare of the television lights. This man, who once voted for himself to be President of the United States, slurred his words—and you couldn't believe this was happening before your eyes on the television screens of America. It was bad enough, Mr. Goodman, Mr. Rule, and Mr. Paley, that you earlier showed a former Miss America forgetting the lines of the Pledge of Allegiance. You and your cameras are going to do irreparable harm to our country by Friday night if you keep this up.

Jimmy Carter in Plains, Georgia, must feel very good this morning after watching Goldwater talking as he did twelve years ago about "weak-kneed leaders" and "total disaster for our Republic," only to be followed by Alf Landon, who was introduced as a man who still rides his horse nine miles a day into downtown Topeka. Only Nelson Rockefeller tried to tell them last night in Kansas City to grow and "gain adherents,"

to expand, to reach out, to have vision. But these people looked at him as if he were a man who fell from outer space.

It was sad watching Rockefeller trying to play media politics. It was sadder still watching the Republican Party of the United States open its veins on the entire ABC, CBS, and NBC television networks. And it was all the fault of those damnable media barons and their television cameras.

The great American writer Jimmy Breslin covered the Democratic convention for the *Daily News* and wrote some of the worst columns of his life. So, this time the *News* hired young Jack Ford to report on the GOP. But Breslin, who was in Miami four years ago with them, knows these Republican delegates, as Rockefeller never will. He would have had a field day with this crowd.

Where were you last night, Breslin, when we really needed you? Goodman, Rule, Wald, and Paley were there, and we saw it for ourselves. Damn it.

The Republican Party is rooted in yesterday.

August 17, 1976

Nelson: A Child of the Neighborhood

The phone rang after midnight. Joseph Wood Canzeri, president of the Greenrock Company, which runs the Rockefeller estates, was calling from Pocantico, in the hills above Tarrytown. "Billy, Nelson died last night."

It is bad timing. Saturday is a day for jeans, chores around the house, errands, trips to the dry cleaner and the greengrocer, and shopping at the A&P. It is not the sort of day I feel like getting on the radio to announce that Nelson Aldrich Rockefeller died. He deserves better than our Saturday edition.

But last night Nelson Rockefeller collapsed at his office in New York. He was one of the neighbors' children. All night long, and into these early morning hours, the newspapers and the radio prepared bulletins and obituaries to tell you this fabulous and zestful man's heart had stopped on him. In cold, clinical, medical language, he had a massive heart attack. It would have to be a slammer to take out this particular seventy-year-old man.

This weekend, there will be a great deal written and broadcast in the national media about Nelson Rockefeller. But if you want an objective, arm's-length report, you'd better tune elsewhere, for you'll not get an unbiased version here at his hometown radio station—or from me. We were with him at countless political dinners, dedications, functions—"events," as they called them. Over the years, we rode with him in airplanes, helicopters, and golf carts.

It started with Louis Lefkowitz and Jack Gilhooley, down at Ratner's on Delancey Street in New York City. It was outside the famous, old Jewish delicatessen in a Puerto Rican neighborhood where I first discovered the great squire of Pocantico Hills. As the men from the neighborhood looked on, this patri-

cian—an aristocrat from Westchester—plowed into the crowd
of Hispanic faces that were yelling, "Señor Rocky!"

For over ten years, we followed Rockefeller as he domi-
nated New York State politics—settling garbage strikes, bat-
tling with John Lindsay, building colleges and a great state
university, pushing bond issues, and building roads and ex-
pressways. He was always the best story of the day— even
just sitting up there on the dais at the Westchester Republican
dinners at the old Commodore Hotel with the late Fred Pow-
ers and telling his neighbors, "Good to see *you*! . . . Nice to see
you! . . . Wow . . . you look *faaabulous*!"

He loved to tell about the time old Boss Ward, the legendary
Republican leader, put him on the Westchester Board of
Health. And just last Thursday, as Henry Kissinger spoke at
this year's county dinner, I was reminded of the time Fred
Powers gave him a huge replica of the great Sword of Excali-
bur, which the Wilkinson Sword people had made up. Nelson
Rockefeller, like a kid, just loved it! "Are you suggesting I'm a
great *swordsman*?" he responded.

There were so many nights and speeches and trips, so many
arrivals at the county airport. The governor would come down
out of his Gulfstream in the middle of the night—exhausted.
He might finesse an interview with the networks, but he *never*
waved off a WVOX microphone. And when he left Albany, he
gave us the last question at his final press conference as gover-
nor. We used the occasion to inquire which of his predeces-
sors, of all those staring down at us in the Red Room, had
"inspired" him. Nelson said a lot of great men had been Gov-
ernor of New York, but Teddy Roosevelt had really inspired
him "as a young boy."

And there was the time Air Force Two brought a tired vice
president home from a long trip around the world. As the na-
tional press and television camera crews clamored for inter-
views, the "governor," as we still called him, made straight
for the news crew from our local station.

On this terrible, sad morning, my mind also drifts back to
the time we accompanied him on a swing through the Deep
South. David Broder and I were finishing a drink with Nelson
as Air Force Two, a DC-9, hit the runway with a hell of an

abrupt jolt—landing "hot," as the pilots call it—at Columbia, South Carolina. For a brief, nervous, fleeting moment, Broder and I were reminded of our own mortality. But Rockefeller never even winced. He winked, bounded down out of the plane to meet Strom Thurmond and about fifty Southern belles in hoop skirts, and said, "Wow!"

On this same trip, down on Mobile Bay, Nelson Rockefeller even charmed old George Wallace and his lady, Cornelia. Eastern, patrician, aristocratic, wealthy, Yankee: Rockefeller wowed even the rednecks down South. We saw it; we felt it— and we remember.

Rockefeller could never, of course, make the great, formal speech in front of a television camera. But in a room with a crowd, or one-on-one, he was superb when he was informal. In 1968, in Miami, he had just delivered an uninspired formal speech to the delegates to the Republican National Convention. He didn't come across. But then, after his formal presentation, he joined Walter Cronkite in the CBS broadcast booth for a more informal discussion. The great Cronkite was trying hard to be his usual, objective self when Nelson reached over, put his hand on Walter's arm, and said, "Just a minute, Walter. I'd like to thank you, sir, for all that you do. The way you conduct yourself is an inspiration to me and to our country!" An astonished, but flattered, Cronkite went over like a giant oak!

I will remember lots of moments with this neighbor of ours, but none more than the day just before Christmas 1974, when Nelson Rockefeller walked into the Oval Office to be sworn in as Vice President of the United States. America, which had just been through Watergate, felt good again about itself, having this extraordinary man at center stage for a while. I also remember President Gerald Ford telling us, over drinks in the White House: "Don't worry, Bill. I agree with you. Nelson and I are a good team. He'll be on my ticket—and we're going to win." That, of course, was before Bo Calloway and the mean, narrow Southerners and the Rockefeller-haters started after him. Most men would sell their soul for the vice presidency or to sit in the Oval Office. But Rockefeller—he took himself *out*

of it—with style and class, and with that sense of grace that came so naturally.

On this morning after he died last night in New York City, it is Nelson Rockefeller's sense of humor that keeps coming back to me. I heard him once say, "My lawyer just sued me!" I didn't understand, until Bobby Douglass, his counselor, explained that Louis Lefkowitz, the New York Attorney General, had just brought suit against Mobil Oil.

He was in great, good form at his last public appearance here in the county at Purchase College, where he showed slides of his art collection to a very tony group—members of the Westchester Arts Council. As he quipped, joked, raised his eyebrows, and moved his blocky shoulders, his eyes twinkled. It was vintage Rockefeller. As he greeted this staid, artsy crowd, an exceptionally well-endowed lady—falling out of a plenty revealing dress—came through the receiving line. Nelson's eyes lit up. Then, when he noticed that Joe Canzeri and I had also tuned in on the display, the governor threw a sly, mischievous wink to us—and to Happy, standing next to him—and said to the lady: "Wow! How are you? . . . Yes, sir! Good to *see* you!"

Nelson Rockefeller was a man of great enthusiasm. Although he could find humor in almost any situation, he had to have been hurt by that number done on him and his art reproductions by the reporter in the *Times* last month. And this weekend, I expect James Reston will write a sweet, affectionate column about him in the mighty *New York Times*— while Anthony Lewis, who shares the same page, will predictably find some way to tell us he never forgave Nelson for Attica.

Many Catholics, of course, will never understand Rockefeller's stand on abortion. Indeed, they have already declined to pray for him among the formal petitions on Sunday at Holy Family Church in New Rochelle. But in the same city, the Christian Brothers of Ireland will remember the soul of Nelson Rockefeller at a Mass for fathers and sons at Iona Grammar School.

There was a big, broad range to the life of Nelson Rockefeller. He was a high roller who was as much at ease with the

Emperor of Japan and the Shah as he was with Meade Esposito of Brooklyn or any Yonkers politician. As a wealthy man—as a Rockefeller—he had a lot of material things: Kykuit, the house at Pocantico; an apartment on Fifth Avenue; the place at Seal Harbor, in Maine; and his newest project in the desert near Brownsville, Texas. He would sit at "21" and jet off to Dorado for vacations or with Happy to visit an Italian princess named Letitia in Rome—but he also had great enthusiasm for some of the ordinary pleasures.

I discovered this the night we flew to Cleveland so Rockefeller could campaign for Governor Jim Rhodes. A busy tour had been arranged: television interviews, a visit to the publishers of the *Plain-Dealer*, and a rubber-chicken political dinner. Just before the supper, however, we stopped at a slightly run down Sheraton Hotel, where anti-abortion pickets were screaming outside. The governor's hosts had provided him with the "presidential suite," high above street level where we might retreat for a brief rest stop before dinner. As we cased the room, the governor spotted a portable bar stocked with Dubonnet and milk, which suited *him* just fine. (I personally could have used a Canadian Club!) There also sat a gleaming silver tray of Oreo cookies, all grandly wrapped in cellophane and ribbon. "Wow," said the Governor of New York. "Look at *that!*" And so there we were—sitting in our shirtsleeves, eating Oreo cookies, sipping Dubonnet and milk in the presidential suite—while pickets chanted on the street below. Today, the man has his name on tall buildings in Albany and New York, and has left around this state a lot of soaring architecture that will remind us and future generations of Nelson Rockefeller. But I will think of him every time I encounter enthusiasm and energy and optimism—and every time I see a kid eating an Oreo cookie.

As I sit here at this microphone, I can still hear and almost feel some of the rejection that met the man as he pursued his dreams across so many years, the rich man's son who could have been quite a glorious bum instead.

There will be a huge turnout at Riverside Church next week when the Rockefellers bury their most dazzling son. But as dying is something you have to do all by yourself, there were

no crowds to cheer him last night on 55th Street. In countless radio editorials over the years I've tried to tell you what he has done for our state and for our nation—his accomplishments. They are many and known to you. You can read about them all weekend in the public press, and when you are old, you can see all of it in the history books. But this morning, I merely want to say that I am glad he was our neighbor—and friend. He lit up our lives.

Nelson, you were *faaabulous!*

<div align="right">January 27, 1979</div>

PART II: GREAT SOULS AND COLORFUL CHARACTERS

John "Shipwreck" Kelly: He Always Winked at the Caddy

John "Shipwreck" Kelly was a colorful, swashbuckling, flamboyant figure who enlivened New York nightlife and society circles back in the sixties and seventies. He was Jock Whitney's court jester, and often advised me on all matters of faith, morals—and girls.

The obit in the *New York Times* made him sound like an Establishment type. John "Shipwreck" Kelly was anything but.

He was big and handsome, with a barrel chest and bowling-pin legs, like Babe Ruth. He had an unbelievable smile, and his eyes were friendly as they danced in his face.

Kelly was the biggest, toughest, and fastest running back to ever come out of Kentucky. When he came up to New York in the late thirties, this handsome and agreeable fellow was promptly adopted by the social lions. He was a swashbuckler and a killer with the dames—but Kelly was a man's man. Bank presidents and saloon keepers, as well as debs like Brenda Frazier, who married him, vied for his favor and friendship.

I first saw Kelly at Toots Shor's, sitting at the bar in a fine suit (run up by Jock Whitney's London tailor) and eating apple pie with vanilla ice cream—lots of it. Toots described Shipwreck as "one of two stiffs I'd like to have at my side if I were trapped in an alley. The other one, of course, would be that fellow Sinatra. Ship would need only his two fists—and a few drinks under his belt. Sinatra's arsenal would include a broken beer bottle in one hand and a knife between his teeth. Both would be splendid in that situation, if ya know what I mean."

Kelly was a wonderful pal and court jester to John Hay

Whitney. And it was Jock's widow, Betsy Cushing Whitney, who arranged the memorial service for him. He called Mr. Whitney the "Aga John," often pointing out that "the largest inheritance ever probated in this country" really meant "no father ever left his son more cash!"

The initials embroidered on Kelly's shirts were always JHW, and he lived for the past twenty-five years in Whitney's boat house in Plandome. On the piano was a picture of Shipwreck with his big, bear arm around a smiling Richard Nixon, whom he referred to as "my caddy. He later became president." Kelly was one of the first members (and most people think that meant "honorary") at Eddie Taylor's exclusive Lyford Cay Club in the Bahamas.

Ship's favorite story about Lyford comes from the day he played golf with the Duke of Windsor—the "little king," as Kelly called him. It seems the duke hit a ball toward a certain manor house just off the fairway and summoned Ship to say that he thought he once owned the mansion when he served as governor general of the Bahamas during the great war. Kelly interrupted, saying, "I beg your pardon, Your Majesty. Didn't you own the whole, damn thing at one time?" Somewhat taken aback, the duke replied, "Oh, yes, I see what you mean, Kelly—I guess I *did* have the whole ball of wax, didn't I!"

Another marvelous Kelly story: Brandy and cigars and a roaring fire after a fine dinner at Greentree in Manhasset with Jock and Fred Astaire. Kelly and Whitney got the great Astaire feeling good, and they persuaded him to show them how to "tap and glide." Astaire said, "All right. I'll do it just once. Like this." Later, after Whitney and Astaire retired for the evening, Kelly sat up by the fire, directly under Whitney's master bedroom. "All night I heard thump-thump-thump as Jock practiced tap dancing on my ceiling. I love Jock, but nobody ever said he had any damn rhythm!"

I saw the three of them at Saratoga one brilliant, summer day: Whitney and Astaire (with brown suede shoes and shades on) and Kelly (touting the horses for Jock, while Astaire glided up to the fifty-dollar window to put down the bets between each race.)

I recall a rainy, drodsome day back in the sixties, at Butler

Aviation at LaGuardia, when Kelly was trying to persuade Whitney and Walter Thayer to buy the Sag Harbor radio station. I was dispatched to discourage the deal. Shipwreck arranged to fly O'Shaughnessy and one of our directors, Jim Clark, out to the Hamptons for a firsthand look. As we waited on the tarmac, an old prop-driven plane with the logo "Mario's Flying School" broke through the clouds. The pilot, who had already had a few, taxied up and said, "Beautiful day, Mr. Kelly," as lightning bolts danced in the distance.

After a thrilling flight a few thousand feet above the Long Island Expressway, we circled round and round, trying to find an opening in the clouds. Kelly then told the story of how the financier, Bob Dowling, "broke his back in one of the first Bell helicopters, when it went down— right over there—and he didn't talk to me for a whole year after that!"

Kelly had a piece of one of the first pro football teams with Dan Topping, and he always dreamed of owning a franchise in the new NFL. The closest he came, however, was when he got Whitney and Thayer to look at the New Orleans Saints. At a gathering of the potential investors and their accountants and financial advisers, someone wondered aloud about certain mundane things such as "How would the team get to the stadium—and at what cost?" An exasperated Shipwreck, trying to be on his best "corporate" behavior, bellowed, "They'll get there on a bus, Harry—a big, beautiful, shiny bus—and I'll drive the damn thing!"

I received many calls from Kelly asking me to interview a "great newsman" or a "helluva salesman." When they showed for the interview, these remarkable talents usually turned out to be failed basketball referees—or headwaiters. And there was even a jockey.

Kelly always wintered in Nassau, where he was a legend, striding among the tourists with that big, rolling gait. Back in the 1950s, he actually owned Delaporte Point, near the airport. "Some rich, old girl left it to me," he explained. At night he would make all the parties at Lyford or drink with the Bay Street boys and the likes of the legendary Sir Harold Christie and Harry Oakes.

I recall one evening, shaving in front of the mirror in our

cottage at Lyford, when I heard a commotion among my kids and a great knocking at the door. Kelly had to use the mirror *right then*—as he was going to supper at Babe Paley's. He wanted to show me his outfit: "I scraped up this Manhasset High School T-shirt. Does the damn thing go with a Nehru jacket?" The T-shirt came from a tourist; the jacket was borrowed from a caddy.

Even to this day, the remnants of those Bay Street boys in Nassau tell stories of Kelly's exploits as an undercover FBI operative. He roamed the Caribbean on assignment from the U.S. government and is actually credited with keeping the Germans the hell out of Cuba.

So Kelly was the beloved sidekick of Whitney—and occasionally of William Paley. But he had a much wider circle. This charming, friendly man was the idol of caddies, busboys, and jockeys. The priest who prayed over Shipwreck at his funeral service on September 6 said, "He had a lively, lovely life, and he knew many famous men. But his greatness was that *he always winked at the caddy.*" It is a lovely way to be remembered.

There are a lot of plastic people around, a lot of dullards, and so many phonies. But Kelly was vivid and real—and, always, he made people laugh. He made bored, rich men laugh; he made fancy ladies laugh; he made busboys and pilots and priests laugh. And they always kept a bottle of Fernet Branca for him at the pool bar at Lyford, which opened at 10:00 in the morning. He was a great, colorful character, and a future Damon Runyon or Hemingway or Lardner should do a piece. Start by saying he always winked at the caddy.

October 9, 1986

Louis Boccardi:
The Down-home Press Lord

Down at the corner gas station in Westchester, they know Lou Boccardi has a big job in the city. But they're not quite sure what this quiet, self-effacing man really does for a living . . . or the immense power he has to shape public opinion.

In the 1920s, the grand, incorporated city of New Rochelle, New York, was the home of Frankie Frisch, Eddie Foy, the Seven Little Foys, and a struggling artist named Norman Rockwell. Glen Gray's Casa Loma Orchestra played every night at Glen Island Casino.

Today, it is a different city, and the civic boosters do not often use the phrase "Queen City of the Sound." But even now, Ossie Davis calls it home, as does Ruby Dee. Robert Merrill gets his mail here, and E. L. Doctorow is our writer-in-residence. There is even an extremely rich man, Nat Ancel, who owns a huge furniture company named for a patriot, Ethan Allen. And there are a lot of millionaires absolutely nobody knows about, including Barry Schwartz, who owns racehorses and 50 percent of a textile company that makes blue jeans and underwear. Every morning, this Schwartz from New Rochelle says hello to his partner, Calvin Klein, as soon as he arrives at their office on bustling Seventh Avenue where, together, they make about a million dollars a week. But most of the tony people and the upwardly mobile yuppies in their BMWs and Buick station wagons have gone north—up Route 684 or over into Connecticut. And each night they roar along the Hutchinson River Parkway as we sleep. But New Rochelle, the dowager city, still hangs on as a place for certain discriminating individuals of influence, standing, and high estate.

Many ask why Barry Schwartz and the rest of them live in

this tired, fading Lorelei of a city which belongs in the 1920s. I asked myself the same questions about Louis Boccardi when he came out of his house in the rain last night to go downtown to the public library to talk about his job with the neighbors of the town in which he lives.

Louis Boccardi is president and chief executive officer of the Associated Press. He is the most powerful working news executive and professional journalist in the free world, and he does not live in Bedford or Pound Ridge. Watching him stand there in the glare of hot, white-and-pink lights in our library's amphitheater, you get the idea that Boccardi would not be too comfortable in Cos Cob or Old Greenwich either.

A League of Women Voters banner hung over a table, which also held a single glass of water, as Boccardi presented himself to his neighbors—these ladies with bluing in their hair and not a single smile across their earnest, serious faces. Where, I wondered, were the other lions of our national press on this fall night? Walter Cronkite was in the warmth of the Arizona desert, preparing to go before eleven hundred journalists at a convention. Dan Rather, his successor, was finishing up the CBS evening news in a studio on 57th Street. A. M. Rosenthal of the *New York Times* was at Mortimer's restaurant with Douglas Fairbanks, Jr. Barbara Walters was at Le Cirque. Helen Gurley Brown was at "21." And Mr. Arthur Ochs Sulzberger was at the White House, being called "Punch" by the Prince of Wales.

But here in a public library on a rainy, drodsome night in our town was Boccardi, who signs paychecks every week for fourteen hundred writers, editors, and photographers. Abe Rosenthal and Sulzberger can influence only one newspaper, but Boccardi sends words and thoughts and ideas out to over thirteen hundred papers and fifty-seven hundred radio and television broadcasting stations. He has a bureau in every major city in the world. One of his employees is being held right now by madmen with guns in a remote, hidden valley in Lebanon, and Boccardi has been meeting with prime ministers, kings, ambassadors, CIA operatives, and even—if you have to know—some gangsters, in order to spring his Beirut correspondent, Terry Anderson.

Slowly, patiently, thoughtfully, Boccardi covered all the chapters of his calling for his neighbors: the First Amendment; the public's "perception" of a free press; the proper way to cover a disaster or a madman; the handling of terrorists; invasion of privacy; confidentiality; the national security. Then it was the turn of the women, with their glasses held by lorgnettes, as he stood before them defending Mike Wallace, the *New York Times*, the Gannett chain, William Randolph Hearst, the *New York Post*—and WVOX.

Louis Boccardi spoke easily and politely to his neighbors about "the times we messed up." He stood there like a lightning rod and gathered "grievances" from the ladies who had come out in the rain to put some questions to the chief executive officer of the Associated Press. While Punch Sulzberger stood in a receiving line in Washington next to Nancy Reagan, Louis Boccardi, journalist, talked of "checks and balances" and square, unexciting things with dullness in them like responsibility and democracy. "My profession," he said, "makes it work." At one point in his talk, he addressed these people as "citizens."

I have seen Boccardi rake leaves in his old clothes, but on this night as a warm rain fell over our city and he stood there justifying his existence on this planet, Louis Boccardi was dressed up in his best suit and, predictably, in a neat, white shirt.

Following Boccardi's presentation, the entire audience gathered in an adjoining room for refreshments, which consisted of exactly one jug of cider, one large plastic bottle of Diet 7-Up, and 108 small donuts, freshly baked that day. Boccardi sipped cider from a paper cup, while a woman named Nikki Shelton asked him for a job as a travel writer, as she liked to see the world. I left him standing there defending William Randolph Hearst in front of a Mrs. Feldman from Pelham Road, who heard something very bad about Mr. Hearst in her journalism class at Adelphi in 1940.

In New York, Dan Rather had just arrived at "21" for a late supper. Rupert Murdoch was ordering up his helicopter for an early morning getaway to Columbia County. Jim Hoge, the central casting, handsome publisher of the New York *Daily*

News, was leaving a black-tie dinner on Park Avenue. And at the Associated Press, a reporter who works for Louis Boccardi was pounding on a keyboard, issuing words that would travel over wire machines and up into the night sky to ricochet off satellites and come down to earth again to be read and heard by most of the inhabitants of the free world.

Having performed his little talk about what he does for a living, Louis Boccardi went out of the library and drove his own car straight up North Avenue in the rain, across wet, slippery leaves, to his home. The next time somebody raps our town, I will tell them that Louis Boccardi does not live in Greenwich.

<div align="right">November 15, 1985</div>

Spiro Theodore Agnew:
A Sorry Business

After Spiro Agnew's fall, I saw him on Lexington Avenue one day. Gone were the secret service agents, the advance men, the outriders. Gone, too, was his reputation. He seemed very much alone—like any other businessman on his way to hustle some business in the canyons of Manhattan.

We all winced, all of us, when John Chancellor finished his news by telling us that Spiro Theodore Agnew, the Vice President of the United States, had resigned —"in disgrace."

No other news story will affect us at the breakfast table this morning like this one: not the war in the Mideast, not the Mets. Nothing can ease the sadness every American must feel as a result of the spectacle in a Baltimore courtroom yesterday.

The Vice President of the United States of America had been fined and placed on probation. It wasn't the ten-thousand-dollar fine so much as it was that phrase "placed on probation." The number-two man in our government, the Presiding Officer of the Senate of the United States, "placed on probation" by a judge in Baltimore, Maryland. This judge, who will be an asterisk in our history books, should have fined him fifty or a hundred thousand dollars—and spared Spiro Agnew the humiliation of being placed "on probation."

And then, too, we had to hear about Elliott Richardson of Massachusetts, the Attorney General of the United States, rising in the courtroom to "plead for mercy" for our vice president so that he wouldn't be thrown in jail.

The Mets' glory and the bravery and determination of the Israelis would rouse you on any other day. But this sorry business was all too much for the people of Westchester. Yesterday, a Mount Vernon lady said, "And to think I wanted him to

be president." And a Larchmont man told us: "I don't feel too good about this. I'm, ah, sort of a flag waver—you know what I mean?" But the one we're most concerned about is the lady from Bronxville who said yesterday, "Oh, they're *all* alike. I'm not surprised." "They," of course, meaning politicians, and that's a spillover from the tragedy of Baltimore, which is too bad indeed.

Locally, we have some wonderful, able, and honest men in both parties, who were injured by the shabby and unhappy experience of Spiro Agnew. There are no finer people in any calling than Malcolm Wilson or Alvin Ruskin (who right now is on the platform of the railroad station asking commuters to vote for him) or James O'Rourke or Frank Garito or Fred Powers or Max Berking or John Passidimo or Christine Helwig or Anthony Colavita. They and so many others in Westchester are fine, trustworthy, and stouthearted public servants. But this whole Agnew thing has to touch each of them even as it touches each of us as Americans.

WVOX was there in Miami Beach in 1968 when it all started for Agnew. We carried his words, many of them critical of our own calling over the years. We were thrilled by the pomp and majesty of his office as he roared in one afternoon to an island in the Bahamas to make a speech and to play golf with Doug Sanders and some other broadcasters. It was exciting as he came off the jet marked with the colors of the United States of America.

And we were there at a dinner in Washington a few months ago with Mayor Garito and Marvin Goldfluss, of the Chamber of Commerce, and Steve Osborne, when the vice president tried to put the Republican Party back together. We stood around and exchanged small talk, and Agnew seemed like a regular, decent fellow.

The spotlight was always on this son of a Greek immigrant. But yesterday, while he was resigning "in disgrace," as the television commentator put it, we were all watching a baseball game on television. The Vice President of the United States stood quite alone while he was being fined and put "on probation."

October 11, 1973

Bill Scollon: Help Me with This Kennedy Thing

This is not an editorial. It's just plain personal, because that's what this whole thing is to each one of us, especially if you are Irish. I suppose it's for a political gadfly named Bill Scollon, who lives in New Rochelle, but it's really about John Kennedy, who was killed on us in Dallas, Texas, a little more than a thousand days ago.

Bill Scollon is the only one who can help me handle this thing about President Kennedy, which is at me a lot these days. It creeps up whenever I hear someone talk about Texas. I remember that dreadful day whenever I drive through an underpass, and I can't help the funny feeling I get when I pick up a book in a barbershop and see all the ads for guns.

Scollon helps because he's Irish, too. And John Kennedy belongs to all people, but you have a special claim on him if you were raised by a father who used to tell you Al Smith was the greatest man who ever lived, followed closely by Jimmy Walker and Jim Farley.

Scollon is an advertising man who works in New York, but he hangs around New Rochelle a lot, too. And I think of Bill Scollon when I try to figure what this thing about John Kennedy has done to all of us. Scollon may be the brightest kid who ever came out of New Rochelle schools, because he went right to college at Oxford, which is in England. He's a little guy, and he looks Irish in that his eyes twinkle and he can get excited about things in this blasé world. He makes his money in advertising, and to relax, he designs crossword puzzles for the Gannett newspapers. His soul, however, is committed to politics, and he talks a lot about John Kennedy.

Scollon thinks, for example, that all Democrats are good and that all Republicans are bad. I'm not as sure as Scollon

that all those who claim to have inherited John Kennedy's mantle really deserve it, even if their name is Kennedy. I do agree, though, that a lot of those who will tell you they hate Bobby, his brother, were the same ones who hated John Fitzgerald Kennedy.

Maybe Jimmy Cannon said it for all the Irish in a column in the *Trib* over the weekend. Cannon is a sportswriter who writes about the games men play. Raised on the mean streets of the lower West Side, he was trying out a lovely deception on his readers by suggesting that the Irish really don't require a great team like Notre Dame any more, because they have John Kennedy and they have what he means.

Scollon would understand this, and I hope you do. John Kennedy is all the kids who never went to Deerfield, and even through he went to Harvard and had a lot of money, he happened for all the kids growing up today on mean streets everywhere.

They talk about this thing which is still at us, which is personal everywhere. And they were talking about it at Patrick J. O'Neil's saloon, on Lawton Street, last Friday night. There was an old, retired cop saying he hated the Kennedys, because he knew Honey Fitz, John Kennedy's grandfather—and according to this old Irish cop from New Rochelle, the line stopped with Honey Fitz. He was saying that he hated the Kennedys, and this cop's name starts with an "O."

But for most of us, when Jack made it to the White House, we weren't Micks anymore.

1966

William Clinton:
Our President

Both times Bill Clinton ran for president, I voted for the other guy. I've not been a fan of his over the years, but I tried to save President Clinton from the self-righteous House managers who were hell-bent to impeach him. All during Bill Clinton's presidency I also tried mightily not to dislike him—simply because he wasn't Mario Cuomo.

Castigate him for having Carville, Morris, Thomason, Ickes, Hubbell, Stephanopolous, Ron Brown, and Shalala as advisers. Scorn him for replacing a wonderful, classy man named George Bush. Censure him for encouraging the Evita-like "First Lady" cult nonsense. (President Bush called *his* wife "Bar" or "Barbara.") Criticize him for the calculating and cynical way he has pursued and exploited wealthy Jews and Hollywood types. Demean him for selling overnights in the bedroom where Abraham Lincoln once slept. Fault him for the indiscriminate, shameful use of the Presidential Seal (*five* in *one* picture). Find against him for going to Yitzak Rabin's funeral with the flags flying from the fenders of his limo. Disapprove of him for making every event of his presidency a staged photo event (like last weekend in Israel) with flags billowing and Air Force One looming in the background (also a strategically placed African American military aide at his side). Loathe him because he doesn't have the innate grace and class of a George Bush or a Nelson Rockefeller. Pity him because he doesn't have the great gifts of character and soul possessed by Mario Cuomo. Reprimand him for not recognizing the unseemliness of this whole, damn national calamity, which has made us feel lousy about ourselves. Hate him for treating Washington like some banana republic. Despise him

for having no damn class whatsoever. But don't *impeach* the son of a bitch—because there may . . . one day . . . be . . . a president . . . we *like*.

November 1998

Richard M. Nixon: The Thirty-seventh President of the United States

I could find no magic in Richard Nixon for a good many years. But I came to admire him and was sorry when we lost him in 1994.

NIXON: THE ROCKEFELLERS AND A LITTLE RALLY

Richard M. Nixon had dinner with the Rockefellers, and it had to be the biggest night of his life. I mean, he strode into Pocantico Hills like he was running for president, which he is. Richard Nixon, being a graceful man with some breeding, let Nelson Rockefeller keep his sword.

It was a quick dinner, with really no time to admire the sun setting over the Hudson River. And then the two men, once bitter political enemies, were off with their wives to the Westchester County Center, where the Republican Party staged the best damned rally this county has ever seen.

It was really fantastic when you think about it. Why, there were eleven or twelve thousand people inside and five thousand more outside when Nixon and Rockefeller drove up with their women last night. Inside were Joyce Michaelian, lovely and smiling, Attorney General Louis Lefkowitz, and plenty of judges. It was loud, too, as the "Up With People" group kept singing, and singing, and singing. A really swinging band was also playing, and pictures of Richard Nixon and Spiro Agnew were everywhere. Douglas McCallum, the chairman and leader of the GOP, got up and introduced Edwin Gilbert Michaelian, the county executive.

Now, Michaelian has class. He is brilliant and knows poli-

tics the way Werner Von Braun knows rocketry. So Michaelian conducted a little lesson in warming up a crowd. He's respected mainly for his brains, but last night Ed Michaelian stood up and wailed—and he was very effective. Of course, it was an interesting crowd come to praise Nixon and Agnew right in the heart of the Eastern Establishment. These people at the rally were the kind who gave a bigger hand to George Van Cott, the Conservative assemblyman, than they bestowed on Ogden Rogers Reid or venerable, ailing Senator Jacob Javits.

A real heavyweight champion of the world was there, too. Louis R. "Bud" Mangano of New Rochelle had the sharpest line of the night when he said, "You know this is incredible when Rocky Graziano gets the biggest hand!" And Graziano, who hangs around the bar at Toots Shor's a lot since he left the ring, is on the campaign trail with Nixon now and he got a big hand from this crowd, especially when Michaelian called Rocky a heavyweight (instead of a middleweight). But this crowd would have forgiven Michaelian anything last night.

Ogden Reid came into the press section and was reminded that many of the people there had tried to tell Rockefeller to appoint Reid instead of Charles Goodell to that vacant Senate seat from New York. Reid waded in, unscarred, shaking hands, saying, "Thanks for remembering your friends." And then he went up on the stage and got booed by the same people who lavished applause on Graziano and Van Cott.

And then Malcolm Wilson, who is supposed to be losing his power, got up. Well, the lieutenant governor may be slipping, but every time he glanced just slightly to the side last night, everyone in the entire row he was in, as well as those in the row behind him, almost fell on the floor trying to smile and be seen by Malcolm. When he got up in a baggy, rumpled, ill-fitting suit, he laid great dignity and presence on this crowd and called them "Ladies and Gentlemen." Wilson is the greatest orator Fordham University ever graduated, and a hush came over the people with their "Peace" and "Law and Order" signs.

And then it happened. The noise came up from the rear of the County Center as presidential candidate Nixon came in,

followed by Rockefeller, the Governor of New York. When Rockefeller said "yes, sir" and "terrific," you were back before Miami as he introduced Reid who looked at him the way one patrician looks at another patrician who has done him wrong. And Reid forced a little smile from the corner of his mouth.

As Rockefeller spoke, someone yelled out, and there was tension in the air for a minute as the secret service men tensed up. Nixon looked a little nervous, too, for about thirty seconds. Then Nixon came on and announced what this country is going to get if he is elected president. When the crowd roared, Nixon's hands went up, in his trademark V, and he waved from his wrist. It looked like he might fly.

Now, this being the first time the two men were together since the Republican National Convention in Miami, Rockefeller winced once or twice—but what do you want on the first date anyway? And then Nixon started talking about the "silent majority"—the forgotten majority. In other words, the people who are "fed up."

Nixon really worked out last night. He was dripping wet and supremely confident—and he looked very strong. At one point he actually grabbed the cone-like microphone with both hands and caressed it—fondled it. He fastened on to it and, through it, he called young people "the hope of America." He talked about how great it was to live in America. And then he was finished.

The Westchester Republican Party was his last night as he turned and said to the vanquished Rockefeller, "Gee, this was wonderful." Rockefeller said, "Yes, sir, terrific!" And Happy Rockefeller, who had asked me about my own son, took Nelson Rockefeller's arm, and they went home to be with little Nelson Rockefeller, because that's all they really have now.

From the looks of things last night in White Plains, the Rockefellers will tell their young son one day about the night President Nixon stopped by for dinner—with a little rally afterward for eight thousand people.

September 11, 1968

Nixon: Let, Then, His Deeds Be Eloquent

Today, the Chief Justice of the United States of America will ask Richard M. Nixon to take an oath that will make him the thirty-seventh President of the United States. This afternoon Richard Nixon will hold the same trust that has been held by men named Abraham Lincoln, Thomas Jefferson, Woodrow Wilson, and Theodore Roosevelt.

Our radio station did not support Mr. Nixon at the Republican convention. And, reluctantly, we did not support anyone in the fall election. It is a tribute to Mr. Nixon that he has endured his critics and has had faith in himself and in his ability to lead. So today, we earnestly and sincerely and fervently join all Americans in pledging our support for President Nixon. Today, in the cold, in the city of Washington by the Potomac, he ceases to be the man who defeated Nelson A. Rockefeller, the great governor we so admire. Instead, Nixon becomes President of the United States. If he succeeds in that high office, our nation succeeds.

We've been impressed by his performance during the last few months of transition. We are especially happy that Mr. Nixon has called William Rogers to be Secretary of State, and we admire his choice of Westchester's great Emil "Bus" Mosbacher to be Chief of Protocol. Frankly, we were less than impressed by the designation of Walter Hickel, the Governor of Alaska, as Secretary of the Interior. But we hope that Mr. Hickel may yet prove himself worthy of his high office.

Many local churches in Westchester asked yesterday for prayers for President Nixon. We join in those prayers and respectfully ask that you do the same. President Nixon has promised to "bring us together." He sees himself as a peacemaker, and there is no higher calling to which a man, woman, or president can aspire. He must make peace in Vietnam and, more important, he must make peace here at home. He must reach out to the young. He must help the old and our poor. We can only hope that, starting today, and for the next four years, President Nixon will not be the narrow, partisan man his critics believe him to be. We have to hope that President

Nixon will set bold and magnificent goals for our nation. And let his deeds, then, be eloquent.

But support him as our president. He must have our help, because as Walt Whitman said, "To have great poets, there must be great audiences." So, too, if we would have a great president, we must unite and stand with him.

January 20, 1969

NIXON: ALONE

He was always alone.

Richard M. Nixon, the senior statesman of our American nation, died last Friday evening. The hospital bulletin, which went out to all the world from our neighbor Louis Boccardi's Associated Press, noted that the former president left this life with his family "at his bedside." But as dying is something you have to do all by yourself, Mr. Nixon's departure was quite in keeping with the way he lived. He was always alone.

Exactly one week, to the hour and moment, before this happened, Richard Nixon sat at table number 2 at Le Cirque restaurant in Manhattan, which is owned by Sirio Maccioni. Seated next to him that evening was the automobile magnate Bernard F. Curry of Scarsdale, and Curry's daughter, Nancy. As Nancy Curry is a most beautiful woman, her entrance into the room did not go unnoticed by the former President of the United States.

For the rest of the evening, Nancy and her father talked of automobiles, about which they know a fair amount, and of children and generations, which they also know about. It did not occur to them that Richard Nixon would never again sit on Sirio Maccioni's banquette. But, indeed, he would die in exactly one week, and my colleagues in the public press would rush for their one last chance to kick him around on the occasion of his departure for what former Governor Malcolm Wilson has called "another and, we are sure, a better world."

As the political commentators recounted Nixon's life in their usual, professional, and most objective fashion, one must

note that the word "despised" spewed from their word proc-
essors only slightly more times than "hated" and "reviled."
"Disgraced" has also been pronounced and written with great
regularity in all the newspapers of the republic in the past few
days. I, too, have used these words about Richard Nixon. Back
in the 60s and into the 70s, he really was despised by the East-
ern Establishment and the limousine liberals of New York.
And if you were a young man trying to start an enterprise or
raise up support for a radio station, you would—if you were
lucky—sit at a table for an evening with John Hay Whitney,
William Paley, Walter Thayer, and Jacob Javits and say bad
things about Richard Nixon, who outlived all of them, by the
way. In the end, it came down to numbers—and labels. There
were always more Nixon Republicans than there were Lind-
say Republicans, Javits Republicans, Taft Republicans—or
even, we must acknowledge, Rockefeller Republicans.

You see, I am such an "expert" on all this because Nixon
and I went to the same dentist. He got drilled and X-rayed just
as I did, in the same chair. So, I can get on the radio and tell
you all about his place in history. In this endeavor, I am being
monitored and closely watched by faithful listeners like
Thomas Hory of Larchmont and Ned Gerrity of Rye, who in-
quired of me on Saturday night at the Westchester Country
Club: "Just what will you have to say about Nixon on the local
radio? I mean, given your history and all?"

Well, here it is: *I liked the son of a bitch.* I think we have lost
a great man. (Oh, you shouldn't say that word on the radio!
But this is Nixon we're talking about. And *he* would under-
stand.) I'll leave it to others to do a Mount Rushmore entrance
exam on him. I liked Nixon because he was a scrambler who
could curse and swear and drink with the best of them and,
like Murray Kempton, I don't feel compelled to apologize for
feeling the way I do about the flawed, imperfect, awkward,
struggling man who was buried yesterday.

Over the years, we've seen a lot of Nixon—in Manhattan
and here in Westchester. But the vignette I remember best
comes from a fall afternoon twenty-six years ago: 1968.
Nixon, the presidential candidate, was coming up North Ave-
nue in a gaudy, noisy motorcade. As he made his way slowly

right up the widest boulevard of our city—past Iona College, past the high school, past Wykagyl Country Club, and sitting there on the back of a convertible with that goofy grin and hands waving aloft with the classic Nixon V-sign—he was greeted by large, enthusiastic crowds.

As it approached Mill Road, the motorcade swung to the right and climbed the two short blocks near St. John's Wilmot Church. My infant son, Matthew, and I were on the corner of Fenimore and Wilmot, near that three-way stop sign. There was no one to cheer at this intersection, the crowds and the noise being back on North Avenue—but Nixon was still waving like crazy.

Then, in an instant, the smile came off his face and, realizing he was quite alone, Nixon slid down into the back seat as the motorcade headed up Wilmot toward Eastchester to find some more people who would make him President of the United States.

It is a small story about him. I know some others. But you would not believe me, for instance, if I told you this morning that Richard Nixon was an avid admirer of Mario Cuomo and was, in fact, a keen student of the governor's writings and speeches. Or that they corresponded and spoke often. I don't know if I do more damage to Cuomo or Nixon by revealing this to the world.

There is just one other thing, though. On Tuesday, as Nixon's body was leaving Stewart Air Force Base, Malcolm Wilson, an eighty-year-old man who was once Governor of New York, was out on the St. Andrew's golf course collecting four pars and two birdies. As he walked the fairways at St. Andrew's, Wilson remembered how President Nixon, who was not suspected of having any great love for the Empire State in those days, quietly conveyed one hundred million federal, U.S. dollars so Wilson could fix up New York City's rapid transit system and buy buses for upstate. No other president has been so generous. But you will not read of this in the obituaries dripping with venom and jealousy for the man.

After dying alone in a hospital room in New York last Friday night, Richard Nixon was buried with great pomp and ceremony on the Pacific Coast. In doing so he performed one last

service for America: Richard Nixon knocked Hillary Clinton and her most recent brilliant pronouncement about health-care right off the front pages of every newspaper on the globe the next morning.

So now he's gone—and back here in New York, where he lived his last twenty years, we will remember Nixon. For it was here with us that he pulled that incredible "Lazarus" stunt, rising up from the disgrace of his shattered presidency to become a true world statesman. It was here that he confounded the bastards who hated him. And it was here that he looked at the pretty girls at Le Cirque.

But he was always alone.

Rest in peace, Mr. President.

<div align="right">April 28, 1994</div>

Outside the original Le Cirque on 65th Street and Park, where the author did a lot of "research" for this book, he encountered an enchanting Kate Wharton O'Shaughnessy, who had just enough time to pose for the society photogs for this photo with her proud papa.

The author's three sons: (l to r) Michael, David, and Matthew. *(Leonard Yakir Photography)*

The author with his brother John Thomas O'Shaughnessy, to whom *Airwaves* is dedicated. *(Leonard Yakir Photography)*

The author and Nelson A. Rockefeller. WVOX was proud to be Nelson Rockefeller's "hometown" radio station, and he dedicated the station "to the people of Westchester." *(Gonda Studio)*

Three of New York State's political legends: (l to r) Attorney General Louis Lefkowitz, Governor Nelson A. Rockefeller, the author, and Comptroller Arthur Leavitt. *(Gonda Studio)*

David O'Shaughnessy receives a sports letter from Vincent de Paul Draddy, founder of the Football Hall of Fame and chairman of Izod (the Alligator-shirt man).

His Honor Mayor Alvin Ruskin and the author were great allies. Ruskin served as mayor of New Rochelle and as a justice of the New York State Supreme Court.

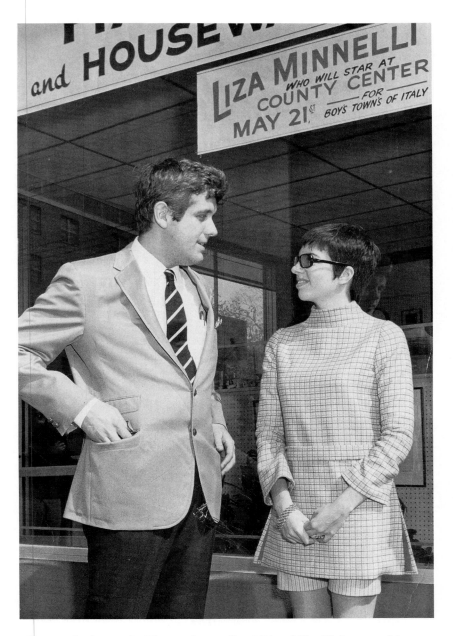

All in a day's work. The author talked Liza Minelli into making an appearance at a hardware store on the way to a benefit. Her husband, songwriter Peter Allen, stayed in the car! *(Robert H. Kuhnke)*

The author covered Robert F. Kennedy's campaign for the Senate despite his "on again/off again" relationship with the candidate.

Governor Malcolm Wilson, the fiftieth governor of New York, was the greatest orator Fordham University ever graduated. He served in New York State government longer than anyone, as an assemblyman, lieutenant governor, and governor. *(Gonda Studio)*

Senator Jacob Javits, the father of the War Powers Act, told the author, "You either believe in the genius of the free enterprise system . . . or you don't." Haughty though he was, Javits was a towering figure in the Senate and in New York State. *(Gonda Studio)*

The author, with his son, David, welcomes New York Mayor John Lindsay. The handsome Lindsay was a frequent visitor at WVOX during his forays into presidential politics. *(Michael Cipriani)*

The author told President Ford, "You know, you really should pick Nelson Rockefeller to come down and help you as vice president!" Ford did select the former New York governor. Rockefeller later stepped aside and returned to his home at Pocantico Hills in Westchester. *(Affiliated Photographic Services, Inc.)*

Douglas MacArthur: The Towers, Another Campaign

Here is a piece I did for my Army newspaper, the Harbor Watch.
*I served "overseas" during my entire military career . . . I was
stationed in Staten Island! I had the three best jobs on the post:
post commander's driver, bartender in the officer's club, and
editor of the post's newspaper.*

New York cabbies will tell you that it's called "The Towers."
They also know that presidents, potentates, and the elite of the
international jet set reside at The Towers.

In residence these days is an old man. Many floors below
him, the rich, beautiful, and delicate debutantes of the current
season are presented to society via cotillion and ball. On the
streets far below, people swirl by—people who inhabit an-
other world from the old man's, people who make up our na-
tion: television viewers, bowlers, drugstore cowboys, golfers,
movie-goers, drinkers, social climbers, mystery-story readers,
jazz buffs, and bums. They live, but life for them is time en-
dured, time wasted, time spent, time remembered; nothing
really happens with their time. They accomplish little of im-
portance, outside of breathing, and that's important only to
them. In contrast, the toys of a nation abruptly become embar-
rassing when you think of the old man. They have never taken
much from General of the Armies Douglas MacArthur, now
eighty-three, yet his name and fame are the birthright of every
American citizen.

Well known are MacArthur's brilliant scholastic career at
West Point, his Medal of Honor, his "I shall return" and "Old
soldiers never die." But who among us knows that he was a
brigadier general when John Fitzgerald Kennedy was born;

that Dwight David Eisenhower was a junior member of his staff in Manila before World War II; that in another war, a young officer named Harry S. Truman never even met Douglas MacArthur, commanding general of the Rainbow (Forty-second) Division in the Champagne-Marne area of France.

Today, while Kennedy is President of the United States, and Eisenhower is retired to Gettysburg and Harry Truman to Independence, Douglas MacArthur is at home in The Towers—and in the hearts of Americans.

Never one for tinsel and clay, the general seldom leaves suite 37-A to attend parties or social engagements. The evening manager at The Towers, who has been on the job for five months now, has never seen the general. Visitors are dealt with by the general's aide and adviser, Major General Courtney Whitney.

The general, as even Mrs. MacArthur calls him, did leave The Towers recently. As Chairman of the Board of Sperry Rand, he appeared at a rare press conference to announce completion of his memoirs. It took him six months of work, which produced a 220,000-word manuscript written in long hand on nine hundred sheets of yellow legal paper. The articulate hero of Bataan and Corregidor made a good showing with the press. Some noticed that he had done that which he so brilliantly attributed to the American soldier in a famous speech: "He has written his own history and written it in red on our enemy's breast."

Having announced his contribution to the written history of the times, the old soldier left the press conference, and the limousine made the short crosstown trip back to The Towers. It disappeared into a private entrance on 50th Street, just off Park; it was in a subterranean garage in the Waldorf. The general got into an elevator and, in almost an instant, the doors slid open at 37-A. General of the Armies Douglas MacArthur was home from yet another campaign. One hour later, the night manager of The Towers reported to work. He has yet to see America's greatest living soldier.

September 1963

Charles Malcolm Wilson: The Fiftieth Governor of New York

Charles Malcolm Wilson served the people and the State of New York for thirty-six years, beginning with his election in 1938 to the New York State Assembly. In 1958, he ran for lieutenant governor on the ticket headed by Nelson A. Rockefeller. Wilson served in that office until Rockefeller resigned on December 11, 1973, and Wilson succeeded to the governor's office.

Rockefeller, restless, seeking a bigger stage, ambitious to run for president, had talked as early as 1964 of resigning as governor. He even discussed it with Wilson over the years. But it was not until a week before he made his speech about resigning within the week that Rockefeller told Wilson that his own time had come.

In many ways, the two men could hardly have been more different. Rockefeller was exuberant, outgoing, worldly. Wilson was scholarly, deferential, given to quoting Latin.

Wilson sought election in his own right the next November, but by then it was not a time for Republicans. The election came in the wake of the break-in at Democratic headquarters in Watergate and subsequent charges that Richard M. Nixon had obstructed justice in trying to cover up the burglary.

Nixon also came under fire for his relations with Bebe Rebozo, a party-giving banker who spent hours listening to Nixon and pouring him drinks, and for preferential treatment of ITT, an early multinational conglomerate. ITT had managed to escape three anti-trust charges through a deal that Nixon's attorney general brokered. Then ITT turned around and offered to subsidize the 1972 Republican convention at San Diego. Later, the stories broke that ITT offered one million dollars to the CIA to help overthrow Salvador Allende, President of Chile.

Nixon resigned as president on August 9, 1974. Wilson was
forced to campaign for governor through all of this and, not
surprisingly, lost the election to Democrat Hugh Carey. Many
years later Mario Cuomo observed that "Carey had the money
and the unions . . ."

WILSON: IN THE HOME HEATH

A lean, wiry man from Yonkers in penny loafers, a baggy, rum-
pled suit, and narrow tie is sitting on a dais in upstate New
York. He yawns in the warm summer night, takes a deep drag
from a cigarette with a white filter, and starts for the micro-
phone when he hears the familiar introduction: "Ladies and
gentleman, it gives me real great pleasure to present our
friend the Governor of the State of New York."

It is a county fair in East Aurora, a political dinner in
Oneonta, a communion breakfast in Deposit. They occur al-
most every day in one of the sixty-two counties of New York.
Nijinsky is dancing in the hallways of Times Square as, once
again, Malcolm Wilson is selling government to these people
we do not see and know nothing about.

Newspapers and radio tell us that Watergate has ruined our
confidence in government. But for thousands of our neigh-
bors—hundreds of thousands of them—the only issue in the
fall election is a humble gentleman from Our Lady of Fatima
parish in Yonkers who tells us, "We have been richly blessed
by a bounteous Creator with magnificent mountains and unri-
valed seashores, beautiful lakes, majestic rivers, and fertile ag-
ricultural land. But New York's greatest asset is its eighteen
million men, women, and children. I know these people—
where they live—in New York's sixty-two counties and sixty-
two cities, including the greatest city in the world, and in our
556 villages and 931 towns."

Malcolm Wilson, the politician, does not excite the promi-
nent writers of our time. Jimmy Breslin, Harriet Van Horne,
and Pete Hamill can find no beauty in his natural and unaf-
fected message. But I have watched him at these minor affairs

in remote places, and I believe that Malcolm Wilson, the person and the man, is one of our major poets. He is certainly one of the most decent political forces that ever confronted the eighteen million citizens of New York State.

It is too early for an endorsement of anybody. But I've been saving up a long time for this squaring of the record about Malcolm Wilson. He is an unlikely hero for this age of glamour and tinsel and phoniness. His short-sleeve shirts, string ties, Speidel watchbands, and ballpoint pens seem to conflict with our hip, Jet Set craving and style. He stands there—polite and courteous, relaxed, easy and gentle. In this uncertain age, he does it his way, as only a deeply religious man can when we are close to destroying our world—a small part of which is his state.

Malcolm Wilson is a man of wit and humor. I once watched him show visitors around the executive mansion in Albany, and when we asked him about one of Nelson Rockefeller's Picasso tapestries, the Fordham University orator begged off by observing that he could maybe advise you on how to paint a barn—but that you ought to ask someone else about "the heavy stuff." Yet, he is a sensitive and cultured man who loves to weave the word "appreeeciation" into every speech. And in these speeches, as he moves across our state these nights, his hands will go into a precise O.K. sign in the manner of a Jesuit priest trying to indicate pure Truth.

In our often smug, effete suburban way, many of us demand and encourage demagoguery and aloofness from our public officials. We thrive on phoniness and insincerity. But there are also people in this state who may know a lot more, and these people relate to a man who is listed in our phone directory—even though he holds the highest office in our state.

As lieutenant governor, he quite rightly ignored the petty bickering in his party and concentrated on being the Presiding Officer of the New York State Senate and lieutenant governor for all those folks who would not trust government but for Malcolm Wilson. And now, as the fiftieth Governor of New York, his magnificent gold and deep blue ceramic cuff links with the Great Seal of New York State are the only signs of power and high office he will tolerate. When he can, he will

drive to those remote meetings. And only when he's forced by a tight schedule will he fly in one of the state's old beaver crop-duster airplanes, which specialize in impossible landings in upstate cow pastures. His official "limousine" is a khaki Dodge sedan with a scramble of letters and numbers on the license plate in place of the number "1" he is entitled to display.

"Your kind invitation has enabled me to meet you here in your home heath," he says. As he moves toward his audience, he always acknowledges Katherine McCloskey Wilson, his wife. As Malcolm moves around the room with his warm and classic oratory, Katherine, a proud, beautiful woman of great dignity and carriage, holds her forearms tightly and relaxes only when she is sure her husband is getting across to tonight's audience in this God-forsaken town. Wilson's slim frame, which seems to be controlled by his shoulders, makes him look younger than his sixty years. When he waves his thumb and index finger across his eyes in front of his hawk nose, and his gentle eyes work, the point is made—and Malcolm Wilson has again sold his kind of government to some more people in his beloved State of New York.

Wilson has been in the service of this state since 1938, when he went to Albany as an assemblyman from the old fifth district of Westchester. Now, after thirty-six years, Malcolm Wilson and Katherine McCloskey are going around again to talk to the people. All summer long, as the *New York Times* and CBS are concentrating on Watergate and ITT and Bebe Rebozzo, Malcolm Wilson of Yonkers will be doing his stuff in the hinterlands. This weekend he will be up again telling people: "I'm wondering what it is that I could say to you in the few minutes of your lives that are entrusted to me while you are in my keeping." He will talk like this to people with grace and sincerity. And on November 6, as the 6:00 news tries to tell you why the Wilson ticket ran so well all across our broad state, think of the graceful man with the hawk nose and the baggy suits who is our neighbor.

July 17, 1970

WILSON: OUR NEIGHBOR

It was winter again, and here he was last night in another grand ballroom. The man—Charles Malcolm Wilson—was the fiftieth Governor of New York. He sat up there on the dais at the Westchester Republican dinner, waiting for them to honor him for what he has done and for the kind of man he is. He is a banker now, chairman of the big Manhattan Savings Bank. He lost to Hughie Carey. But here, late at night, with these people, his neighbors, he was Governor Wilson. Or Malcolm.

He sat there as the party chairman, Tony Colavita, introduced the power brokers and elders of the Republican Party: Joseph Margiotta, Vincent Albano, George Clark, and Bernard Kilbourn. And as Wilson waited, the men who *would* be governor buzzed around the room—Congressman Hamilton Fish, our own State Senator Joe Pisani, and the upstaters, Warren Anderson, Jim Emory, and Richard Rosenbaum. They were all there—and Jack Kemp, too . . . the former quarterback for the Buffalo Bills. He sat next to Wilson.

As Malcolm Wilson puffed deeply on his cigarette, Handsome Jack whispered to Handsome Bruce Caputo, two young men on the make. They talked the politics of the future. Then the room fell silent as the former governor came to speak: "I would betray the sentiment which fills my heart if I did not tell you how glad I am to be here with you and a friend of Tony Colavita." They gave him a Steuben elephant as a symbol of the party he has distinguished for forty years. And then, like a Jesuit orator, he told them "a very brief search would have found a lot of people in this room more *deserving* than I. But a very extensive search would not have found anyone more *grateful*."

Wilson called Kemp "one of the brightest stars in the Republican diadem." And Handsome Jack made a note to remember the warm and graceful observations that Wilson made: "Our county is one of beauty. It has been most generously endowed by a bounteous Creator with lakes and fields and streams . . . but, of course, its most important assets are its *people*."

Here again was the Fordham University orator who came

off the streets of Yonkers many years ago with only his brains and his decency. "All of us are immensely grateful for the blessing of your presence," he told them on this cold January night.

As he spoke like this, everyone in the ballroom watched the dais, and you wondered about all these men who had their eyes on Albany and Hugh Carey's job. But then Wilson, who has been there, took these thousand people, his neighbors, back to grass roots and reminded them about *local* government and the importance of the Board of Legislators. He compared what happened in this country in 1776 with the result in 1980, when Americans said, "Enough!" and elected Ronald Reagan.

As for Reagan, he recalled an old phrase: "Well begun is halfway done. Well begun is President Reagan," Wilson said. The new, eager, young Republicans sat there and listened to him—Handsome Jack and Handsome Bruce and all the others. Some of them can light up a room with their dynamism, style, and looks. But here was this sixty-six-year-old man, a grandfather, talking to his neighbors—touching their hearts and reaching their minds and souls. After Wilson finished, Kemp, with his flashing eyes and good moves, leaned into his speech. He compared Malcolm Wilson to Thomas More, a man who kept his soul and integrity. And you got the idea that Kemp, who was billed as the main event, is starting to understand—and maybe he is more than a jock.

But this was Wilson's evening, a man who meant something special and personal to every one of those Westchester people in Rye last night.

Wilson is a lawyer now, and a banker. The political days, which culminated in his becoming the fiftieth Governor of New York, are all behind him. But Wilson the man, who is the most real and genuine politician ever to come out of Westchester, still looks at people and says, "How are you?"—and *really* *expects* an answer. He still prays for people who are his friends, and worries about them and their marriages and their families.

It seems that everybody these days feels good about our country, because of Ronald Reagan and George Bush. I un-

derstand about all of these things, too. But I also feel good about our state and about the Republican Party and about Westchester, because of this man from Yonkers, Charles Malcolm Wilson, who is our neighbor.

January 30, 1981

THE LEGEND

As the years passed and Malcolm Wilson became the senior statesman of the Republican Party, there developed a sentiment in the Empire State to honor his longevity and service by naming something for the fiftieth governor. A vast tract of land in the Adirondacks was mentioned. And it was also proposed that New York's innovative Liberty Scholarship program be so designated. However, the best idea for an appropriate gesture came from one of Malcolm Wilson's successors—Democrat Governor Mario M. Cuomo—who insisted on the Tappan Zee Bridge (Cuomo had earlier named the New York City Convention Center for Jacob Javits). And so on June 15, 1993, with the overwhelming approval of the Legislature, the magnificent bridge spanning the mighty Hudson River was renamed the Governor Malcolm Wilson Bridge.

It was a grand and glorious day when both governors came to Tarrytown (a few miles from the Rockefeller estates and holdings) to unveil the huge interstate road sign for several thousand of Malcolm Wilson's Westchester neighbors and VIPs from all over the state, only to discover that Governor Wilson's given name had been misspelled: "Malcom"!

The story has grown in local lore and threatens to become one more legend of Sleepy Hollow!

1999

Hugh Leo Carey: A Great Governor

Hugh Leo Carey took his lumps from Jimmy Breslin, who called him "Society Carey." However, I would rather go touring of an evening with Carey than with any politician you'll read about in these pages. He was a great governor and, to his everlasting credit, he kept New York State away from the death penalty, which demeans us as a people.

CAREY: THE MORNING AFTER

When you're "in the media," people ask you questions, all manner of questions. Some are well-intentioned, some are touched with envy—and everyone seems to want to know about Hugh Carey these days.

Was Hugh Carey, the Governor of the State of New York, at "21" until 2:30 in the morning with his pal Jerry Cummins, head of the State Thruway Authority? Was the governor in full flight coming out of P. J. Clarke's the other night? Is he still dating the Ford girl? Was that really your governor sitting behind those shades next to Barbara Sinatra and Bob Wagner in the front row of the Westchester Premier Theatre?

This kind of questioning is usually followed with: "Is he really enjoying being governor—or is he becoming something of a playboy? Has he fallen in with the high rollers?"

First, you should know that this glib and likable Irishman from Brooklyn and Shelter Island somehow managed to become the fifty-first governor of New York without the endorsement of WVOX Radio. We always liked him as a person, but head to head against our Westchester neighbor, Malcolm Wilson, he was not the candidate of our choosing. Still, having managed to squeak through without our blessing and impri-

matur, Carey has, we believe, compiled a very good—and perhaps even an extraordinary—record as governor. We especially admire his courageous stand against the barbaric death penalty, which has no place in the enlightened state of New York. And for the first time, he put into perspective for us those who are party to the killings and bombings in Northern Ireland. There are no "good guys," he reminded us, as long as they are killing and terrorizing people.

These are moral issues. On the practical side, he collaborated in a timely fashion with Robert Greene, chairman of the East Hudson Parkway Authority, and Richard Ottinger to persuade Union Carbide and others to remain and expand in Westchester. This should activate millions of dollars of additional development in the Eastview basin.

And Carey has persuaded to his cause some very able young public servants. Prominent among them are John Dyson, the feisty and aggressive commerce commissioner. And Peter Goldmark and David Burke of Rye have provided first-rate service to our state. Peter Edelman, the youth director, and Peter Berle, the environment commissioner, are stand-outs. William Doyle, the deputy commerce commissioner on loan from private industry, is an impressive young man determined to use sophisticated marketing techniques to help improve tourism in the Empire State. Doyle is a brilliant and scholarly fellow who is going about his job of spending state promotional funds without "fear or favor." And, to the state Power Authority, the governor appointed wonderful Bill Luddy of White Plains, who has distinguished and sustained the Democratic Party in Westchester for so long.

Above all, Carey himself seems determined to restore fiscal stability to New York—city as well as state. He also seems well-advised to encourage Mario Cuomo as an alternative to Mayor Abraham Beame in New York City. And our current admiration for the governor is only enhanced when we see Beame jumping on every popular issue and headline, and scrambling for votes rather than providing real leadership.

From Carey's detractors, you always hear that he doesn't really enjoy being governor. Well, in our experience, he seems

much more interested and thoughtful, and certainly more attentive to his correspondence, than when he first took office.

Perhaps all of this isn't surprising. A few years ago Ray Blanton, the populist Governor of Tennessee who had served in the House with Carey, told us: "He'll surprise you, this fellow." Well, surprise or not, we'd just like to observe that if the Governor of New York does occasionally kick up his heels at night, he certainly seems to be doing the right things when he hits his desk the morning after.

August 11, 1977

CAREY: ENDORSED FOR GOVERNOR

Our Westchester community station was one of the first to endorse political candidates. For example, we proudly supported Nelson Rockefeller, our dynamic and incomparable Westchester neighbor, each time he ran for governor. And with great admiration we stood again with wonderful and scholarly Malcolm Wilson when he ran four years ago.

These are different times, however. Rockefeller and Wilson, both of whom sustained and distinguished the Republican Party for sixteen years, will not be on our ballots this fall. Instead, it will be Hugh Carey against Perry Duryea. We're for Hugh Carey, the Democrat.

The great media barons, most of the press lords, and the financial seers have acknowledged New York City's debt to Governor Carey. And those close to the situation confirm that Carey did, indeed, save New York from bankruptcy. But we support him because he has been good for Westchester— where we live and where most of us now work. No one ever knows who's on first in stormy, brawling Yonkers, the fourth largest city in New York State. But Carey brought a lot of finesse to Yonkers's fiscal problems. And Carey—working with Robert Greene, the flamboyant chairman of the East Hudson Parkway Authority—took the first significant steps toward rebuilding and modernizing Westchester's antiquated and dangerous parkway system.

Carey, as we have seen and heard, saved Nestlés, but he also saved a big chunk of Union Carbide with his timely interest in the revitalization of the Eastview Basin. The Republicans talk now of tax cuts and reductions in government spending, but Carey, the Democrat, was just as tough on excessive spending as the times required. And still he has not cheated on education or the arts. Kitty Carlisle Hart, head of the State Council on the Arts, and the State University trustees will tell you that Carey has more than continued the state's commitment to the arts and education begun by the great Rockefeller.

We've read that Carey is a playboy, "crisis oriented," possessed of a short fuse, and that he often displays a quirky personality. But we find Carey a sensitive and increasingly thoughtful fellow. The logic of the critics and detractors, who call him "crisis oriented" every time he does something positive, eludes us.

The governor has attracted many young and able public servants to his side and to the cause of our state. Kevin Cahill in Health, for example, and Robert Morgado in Management; William Doyle in Marketing; and Robert Spillane, the superb former superintendent of schools in New Rochelle, who is now the number-two man in Education. We have special regard for John Dyson, the state commerce commissioner. Dyson looks as if he could use a good tonic, and he may be abrasive at times, but he's bright and smart. He handled his "I Love New York" campaign skillfully and spends promotional funds, we can tell you, without "fear or favor."

Carey's designation of Mario Cuomo as his running mate gives further cause for optimism. Cuomo is a thoughtful and eloquent man, as well as a sensitive and compassionate politician. There is something special about him.

Carey is so right to oppose the harsh and strident proposals to restore the death penalty. WVOX has tried, without success, to counsel the elders of the Republican Party to reject this eye-for-an-eye pandering to basic instincts. Perry Duryea, the Republican–Conservative candidate, said last week that "the People" have insisted on making an issue of the death penalty. Nonsense! It's Duryea and his fellow Republicans who are

desperate for an issue against a man who has been an extraordinary governor during a difficult time.

Carey is absolutely right-on to bravely oppose the death penalty. Despite the polls, ours is a big, broad state with enlightened and intelligent people. The people of New York are seeing through this cruel death penalty business, which has been urged on us by the Neanderthals of the GOP.

Duryea is, himself, a decent and likable fellow. He has been a fine speaker and minority leader of the Assembly. His running mate, Bruce Caputo, is attractive and ambitious. Neither, however, has produced anything especially exciting or specific in the way of a blueprint for leadership.

We're for Hugh Carey and we commend him to your favorable judgment. He's Irish. He's not perfect. But he is an able and hard-working governor, who loves his family and loves his state. Westchester has done very well by him.

For Governor of New York, WVOX endorses the Democrat—Hugh Leo Carey.

<div align="right">October 30, 1978</div>

Alvin R. Ruskin: We'll Never See Another Like Him

Alvin Ruskin was Mayor of New Rochelle back in the 1960s and then had a long, distinguished career as a Justice of the New York State Supreme Court. He was one of the most sincere, decent, and endearing politicians I ever encountered in public life.

Ruskin: An Unlikely Hero

Alvin Richard Ruskin, the mayor of the tenth largest city in this state, is an imperfect man in an imperfect world. But Westchester will never see another like him.

In just a few days, Nelson Aldrich Rockefeller will accelerate the wheels, which are already in motion, and Alvin Ruskin will realize his dream. His father, whom he adored, was an acting city judge in New Rochelle, and one of Alvin Ruskin's brothers went to Yale and became the first Jew on the board of an important company. His brother, Bobby Ruskin, is in the limelight as John Lindsay's investigations commissioner. But Alvin Ruskin will soon be Judge Ruskin, and that would have made his father happy indeed.

He is a unique man, this Alvin Ruskin, and I believe that our city will miss him. He is a man of style, humor, warmth, and honesty. I have seen him in action with great financiers at restaurants on 52nd Street in New York—trying to drive a hard bargain for our city as we slept and worried about ourselves and our own. I have seen him at the Lincoln Day Care Center, and I have seen little Black children with icing and cake on their faces walk up to him and kiss him, because the other politicians forgot them at Christmas—but not Alvin Ruskin.

Ruskin was magnificent when he had to be. He could do it with pomp, according to rite, and he had great dignity; he gave the job his own stature. Yet, he was a man who lived simply. The car dealer Peter Griffin put it well when he said, "Ruskin's lifestyle and living habits fit the job so very well." That means: where in hell are you going to find an honest man who will work as hard at it as Alvin Ruskin?

I don't know about "lifestyles." I just know that Ruskin could handle a man like Norman Winston, who used to come up here and tell us he had danced with Rose Kennedy at the Plaza only the night before. And our mayor likes to spend Saturday night in his bathrobe with sandwiches from the delicatessen. Other men dream of a good table at "21" or Toots Shor's, but Alvin was happy at Manero's in Greenwich. Contractors and hustlers and sharpie lawyers would come to his office on the eleventh floor of the Pershing Square Building to get him to handle a "contract"—and he would throw them out. He would vote against the son-in-law of his powerful friend Wolfie Duberstein when he had to. And when someone told me, "Check out your friend Ruskin on a certain real estate transaction down on Davenport Neck," and I mentioned it in jest to the mayor—well, frankly, I've never felt like such a jerk as I listened to his denial. I've never again spoken to the guy who touted me on the bogus story.

I can also remember a wheeler-dealer crossing the street at Pershing Square and saying to me as he looked up at the Pershing Square Building: "You know, if that guy Ruskin was smart he could take about fifty thousand a year out of city hall. And if he was just a *little* dishonest, he could pocket about thirty thousand." "In fact," as the advice went, "if Ruskin was just a little shady he could cozy about ten thousand that nobody would ever know about." I listened to this revelation, and I was not surprised when the hustler said, "But this guy must be stupid. He's so damned honest, he'll die broke!" When I mentioned this to our mayor after a few drinks, he got very serious and the tears flowed as he said, "You only take your cuff links with you—your cuff links and your integrity."

And so, as we bid farewell to the mayor and the man Alvin Richard Ruskin, I believe no one ever got close to him. No one

ever got to him. And what a hell of a triumph in this day and age. As our mayor all these many years, he has been a one-man publicist for the virtues of our city while excusing our faults as a people.

There are people in our city with scrambled-egg minds who believe Jews run this city, and yet, I have seen Alvin Ruskin, a Jew, give three Catholic monsignors the biggest night of their lives at testimonial dinners. And for the thirteen thousand dollars we pay him, Alvin Ruskin had to read the mail we sent to the kid who dispatched the letter to the newspaper about the Christmas wreath at the high school. It talked about putting a "special mark" on businesses in our city that are run by Jews. Alvin Ruskin got sick. So did you.

As you look back, there was the time Ruskin got ahold of the reporter from the *New York Times* who had just been rebuffed by the police commissioner and who was about to make a racial incident out of the high school fire. And you remember Alvin Ruskin talking to the reporter saying it was *not* a racial proposition.

I loved Joe Vaccarella, the former Mayor of Mount Vernon. I was thrilled by his style and by the sirens and the flags and the bodyguards and the drivers. But Ruskin heard a different music. His city car got so bad the neighbors made him turn it in for a new one. And the title "mayor" meant he had to let crummy amateur artists hang their awful paintings in his office at city hall and then bring all their relatives to see their works. He did not move like John Lindsay or Nelson Rockefeller, but late at night, at the Thruway diner, there was no one greater or more ardent in his love for New Rochelle than Alvin Ruskin, who is leaving us in a matter of days to become a judge. He is a minstrel whose music was heard and understood in every neighborhood and on every street in our city.

So there you have a few reminiscences about a man named Alvin Ruskin. He is, I believe, an unlikely hero in this day and age. The Mayor of New Rochelle is not nearly, I suppose, as handsome as John Lindsay. He doesn't have the extensive training, background, and breeding of Ogden Rogers Reid— whom, by the way, his father loved and whom he greatly admires. Not one single suit fits him quite right in the collar. But

I believe him to be a most exceptional man. His own splendid integrity has elevated our city and given us strength.

Soon we will have to turn to someone else, as you have heard. And Alvin Ruskin will join the other mayors on the wall of the long hall outside the city council chamber on the first floor of city hall. He has some golden shovels in his office, which I hope they'll let him take. But these are too puny and meager to be his trophies. I believe the kiss from the little Black child at the day care center is a better trophy for the minstrel whose music is heard on every block and in every section of our city. New Rochelle: you will surely miss Mayor Ruskin.

1970

RUSKIN: THE RULE OF LAW

The New Rochelle Bar Association held its sixtieth anniversary dinner in 1993 in honor of Justice Ruskin as he was retiring from the bench. What follows are some reflections about that to which lawyers and judges, like Ruskin, devote their lives.

I never went to law school—or even one day of college. But I've got friends, one in particular, who knows these things and credits everything we are to the law.

What has made our experiment in Democracy so special, so resilient? What has made it endure?

God gave us an abundance of water, agriculture—a mostly hospitable climate—a location in which to build an infant republic. But it's not just these things that have made our nation the toughest and strongest. It's not the place, not the people. It is not even—and this may be blasphemous—not even a Power from above. Or, a power from below. No despot, no ruler, no dictator with a mob of brown shirts made the experiment—fragile, but brilliant and even noble—endure. It is the way they came together, once in this country, under a common set of "Ten Commandments," called a Constitution.

The rule of law is responsible for all that we are. It forms

us and defines us. Everything we are proceeds from it. It has protected and sustained us for two hundred years, the one deviation being the Civil War.

So it's not the place, not the people. The law is the miracle of what we are. The law that formed Alvin Ruskin, the law that we entrusted him to interpret and define for twenty years, the law we allow the other judges to hold in their care and keeping.

The law, however, does not apply to every single case or circumstance, or even, perhaps, to every day and age. So they take this wonderful instrument, the Constitution, and try to lay it over and apply it to each case. They try to fit it to reality.

To work well, the law has to have the restraint that comes with firmness and strength. And it also needs tension to move and bend and be compassionate, firm but flexible, to deal with each new circumstance.

What qualities, then, should we have a right to expect in the men and women we raise up from among us to interpret and define the rule of law? They must have

- Experience
- Intelligence
- Integrity
- Wisdom
- Compassion

Where do you find people with such qualities? Where might a governor who appoints them or those who can elect them find such people? Not in every lawyer.

To whom, then, do you entrust the power to restructure families? To take a business or affect our purse? Who maintains this rule of law? What protects it? What sustains it for two hundred years? Not a rifle or a bayonet. Or a prison cell. Only a good mind accompanied by the precious, sound instinct of men and women who are both wise and good.

Now, if we had to do it all over again, and hadn't studied the history or known about the beginnings and underpinnings of the law, or had not spoken about this with a wise friend who knows the law, I would still presume to say: send us Alvin Ruskin!

It is 1993, twenty years later, and he will step down from an illustrious career as a mayor and as a judge. But I would petition again, on behalf of all of us: make us a Ruskin! I would ask God, or central casting—with all the flaws we can see, or even with those we have not identified—send us a judge with a compassionate and loving touch, with a gentle heart to interpret the law, but with the firmness and power to apply it.

Where do you find these qualities? Not in every lawyer, or even in every judge. But we found all of it and more in the compassionate and caring heart of Mr. Justice Alvin Richard Ruskin.

December 9, 1993

Mims Fredman: The Significant Other Fredman

Samuel George Fredman is a Justice of the New York Supreme Court, a former democratic chairman of Westchester, and one of the preeminent matrimonial lawyers in America. He never liked it when I called him "a nice man in a murky profession." This piece was broadcast when his first wife died in an automobile accident while they were vacationing in Europe. Mims Fredman reminded me of so many other "unsung" wives.

Miriam Imber Fredman died last week in a faraway town with an ever-forgettable name: Horsholm, which is in Denmark. But she lived most of her sixty-three years in White Plains, New York, and her sudden, untimely death made a lot of our neighbors feel terrible. Some of them wept.

A few hours after Mims died, Mario Cuomo was on his private phone, long distance, to a Danish hospital where Samuel Fredman was propped up on pillows trying to tell the United States Consul General about the accident that took his wife in a flaming automobile on a country road. As the governor knows about family and generations and women like Mims, he made gentle, small talk on the transatlantic phone line. And as he did, Cuomo's mind drifted back to the days when no one in Westchester gave him much of a chance in his first run for governor. He went into that primary, which he called an "implausible pursuit," with less than nineteen percent of the delegates. But he had Sam Fredman—and Mims.

The *New York Times* headline called Mims a "clothes merchant," but Rabbi Arnold Turetsky talked of her "dignity" and "strength" and "composure" on Sunday at Temple Israel. These words, however, don't tell us that for forty-one years the

designations of which Mims was most proud were "wife" and "mother"—and, recently, "grandmother." But because these appellations have little currency in this day and age, the headline would have to call her a "clothes merchant." If Sam Fredman had died in that car crash, all the obituaries and editorial writers in these parts would have bombarded us with his accomplishments, which are considerable and already known to you if you live or work in Westchester. Fredman is, by every account and in every telling, the first prominent Jewish political figure in the county. He is also one of the preeminent matrimonial lawyers in the United States. For the last forty-one years he would get up in the morning and walk out the door into a world of craziness in which husbands and wives try to murder each other with words written into court documents called "subpoenas" and "trial motions" and "interrogatories."

It is a nasty, draining business, and the judges who must sit up there in a courtroom and preside over this fury will tell you they're glad a decent, good man like Sam Fredman is in the field as a role model to slow down the sharks and leeches who prey on human misery in this calling. Then each night, Sam would leave behind the wounded egos and selfishness and hatred, and go home to Mims. She was married to one man for forty-one years, and she knew who she was at all times and in every instance. While her famous, flamboyant husband handled the outside, public stuff, Mims handled the essentials: the hearth and home, the family and children. She thus deserves as big a headline as Sam.

In these enlightened days of women's lib and career women and entitlement and self-fulfillment, Mims existed with great serenity and sureness about all the real, lasting values. And, yes, with dignity. I've sat on a beach with Betty Friedan, and I've debated the great issues of the day up on a stage with Gloria Steinem. Neither would understand about Mims. But Sam—who now goes home to an empty house—knows. And so do their sons, Neil and Andy, and their wives and their children's children. The rest of it really doesn't matter.

The Significant Other Fredman was significant indeed. She was a great lady, and she knew who she was.

July 5, 1988

Sirio Maccioni:
Maestro Sirio

Sirio Maccioni is America's greatest restaurateur. This piece was done on the twenty-fifth anniversary of Le Cirque 2000.

With his slim hips and impeccable manners, he came from Montecatini, the spa town in the hills of Tuscany. His name was Sirio, and above the village where he grew up was the most splendid of all the spas, famed throughout Europe along with Marienbad and Baden-Baden, and frequented since the eighteenth century by the grand and leisured. His father was a farmer.

Many years later, moving through the brocaded dining rooms of America's greatest restaurants, people would say that Sirio Maccioni looks like a courtly Italian version of John Wayne. But in those days, some fifty years ago, the young man on the fast Vespa resembled an Etruscan noble as played by Tyrone Power. He observed the rich and titled as they came to take the baths and taste the waters in his hill town. His first job was running the lift in the Hotel Grand La Pace.

The graceful, young Italian with the fierce eyes and restless spirit also charmed a beautiful neighbor girl, Egidiana Palmieri, of somewhat more substantial means and considerable talent in her own right. Miss Palmieri, already known as far away as Florence and Roma for her winsome looks and spectacular voice, was promptly advised by her well-founded family to pursue a promising singing career and to forget the dashing Maccioni fellow, despite his cordial manners and "correct" bearing.

But strong-willed, patient Egidiana had other ideas, and so did Sirio, who proceeded to work his way to America as a dancer on cruise ships, with stopovers in Germany and France. He also assisted in the dining salon and in the ships'

galleys. After the shortest apprenticeship on record, the gifted Tuscan became a captain and, just as quickly, a maitre d' in some of New York's greatest restaurants, such as Delmonico, the Colony, and the Café Pierre.

Egi Palmieri soon joined the rising young star of the restaurant world, rejecting an incredible twenty-five-thousand-dollar signing bonus to tour Italy singing operatic favorites, love songs, and ballads. Her songs would now be sung only for Sirio. They married, and soon followed a Mario, a Marco, and a Mauro, who would all follow their father into the restaurant and hospitality business. To support his growing family, Sirio struggled and sacrificed to open his own restaurant on the corner of 65th Street and Park Avenue. The sign on the door said: Le Cirque.

That was twenty-five years ago in New York City, one tough, unforgiving town. Since then, many fabled eating and drinking establishments have up and disappeared: the Stork Club, the Colony, the Copa, the Latin Quarter, Delmonico, Romeo Salta, Mike Manuche, Jimmy Weston's, and the incomparable Toots Shor, a most glorious place. Le Cirque, however, not only survived, it prospered, becoming the most celebrated dining venue in America. The restaurant with the French name was a perfect stage for its dazzling Italian proprietor from the hill town in Tuscany.

The French restaurateurs never did learn Sirio's magic, and to this day they think it's about food. But Sirio, the beguiling showman who moved like a dancer, gave his patrons other enticements: glamour, style, romance, and, always, *fun*. There are thousands of restaurants abroad in the land, most of them French (and even some pretentious ones with Italian names), but nobody is having any *fun* at their serious tables. Even kings, prime ministers, dictators, presidents, and popes like to have fun on occasion. And so they come to Le Cirque of an evening to be with Sirio, to be fed by him, to be waited on and cared for by Le Cirque's host and ringmaster. He is now the quintessential restaurateur in the American nation and, perhaps, the world. The *New York Times*, *Forbes*, and *Wine Spectator* each bestowed four stars, making Le Cirque, I suppose, a twelve-star restaurant!

But it came time to move and so, two years ago, the Maccioni family transported their genius fifteen blocks south, right into the heart of midtown Manhattan, to the historic Villard House, now part of the New York Palace Hotel. Famed designer Adam Tihany, unable to violate the stately ceilings and walls, designed a "traveling circus" in the Palace Hotel, a "palace" fit for a Sirio. The sign now said: Le Cirque 2000.

It has become the hottest ticket in the hardest town. And so, next Monday evening in The Big Apple, Sirio Maccioni will celebrate Le Cirque's twenty-five spectacular years by having a few thousand of his best, "most correct" friends for cocktails in the courtyard of the stately Villard House. You may expect the King of Spain, the Mayor of Rome, the Cardinal Archbishop of New York (who merely has to walk out the front door of his residence and stroll across Madison Avenue), Nancy Reagan, Rudy Giuliani (another proud son of Montecatini), some people named Churchill, Uzielli, Cuomo, Trump, Ricci, Zanella, Astor, Rockefeller, Kissinger, Liz Smith, Cindy Adams, Zeckendorf, Lillian Vernon, Don Rickles, Molly O'Neil and her brother, the Yankee baseball player, Sulzberger, the publisher, Bernard Kruger, the brilliant society physician, Ruth Reichl, who now "understands" about Sirio, John Mariani, Bill Cunningham, the *Times*'s legendary lensman, Toni Cimino, the flower lady, Paolo Biscioni who runs the Eden, the best hotel in Rome, James Brady, Frank DiGiacomo, Ronald Perelman, Bruce Snyder of "21," Bob Lape, Susan and Jack Rudin, the Brudners, Woody Allen, Nancy Curry, Teddy Forstmann, Lee Iacocca, Sirio's faithful managing director Benito Sevarin, their maitre d', Mario Wainer, and Patrick Walsh, a world-famous surgeon from Baltimore who will receive an especially warm greeting. Sirio also expects Warren Alpert, who owns a little real estate (actually, an entire block) on Park Avenue. As Mr. Alpert dines, usually solo, at Le Cirque every evening, he might pause in the courtyard for just one cocktail on the way to supper at his regular table. There will also be any number of archbishops and ambassadors.

They will come—all of them—to celebrate an endearing and enduring American institution with a French name run by an Italian. Their presence will reflect their affection for the child

of Montecatini who became the most famous and respected restaurateur in the world.

You don't have to take my word for all this, or believe the encomiums heaped on Mr. Maccioni by the public press. Rather, you might want to consult those who presume to compete against the Italian. Greatness in any form almost always arouses envy. But even Sirio's competitors will affirm his genius and confirm his standing and reputation. Bryan McGuire, who heads the invincible "21," says simply, "Sirio is the *best* there is. He deserves his success. He is the most generous man in the business." And Julian Niccolini of The Four Seasons, himself a charismatic dining room dazzler, will swear, "There's *never* been anyone quite like Sirio moving through a room!" Lello Arpaia of Bellini will tell any and all who will listen: "In all my years in New York, there's only *one* Sirio."

Listeners to these radio stations are advised that Maestro Maccioni will soon be moving through a few more dining rooms with his slim hips and easy style. He opens in Las Vegas at The Bellagio on October 15, and the restaurant world is abuzz that London and Paris are next—and maybe even Japan. So you can now just go and read all about the Twenty-fifth Anniversary Cocktail Party in Neal Travis's *New York Post* column on Tuesday next.

Of only this I'm sure: Sirio's sons will be there with their father for the celebration, and Egidiana Palmieri will be home babysitting for the grandchildren—after which she'll probably sing again, just for Sirio.

Happy anniversary, Maestro! *Per cento anni!*

September 10, 1998

Toots Shor's Family: His Regular Clientele

Bernard "Toots" Shor ran a marvelous establishment on 52nd Street in New York City. You never knew who you would encounter at the bar.

As Richard M. Nixon, the President-elect of the United States, got ready to go on television last night to introduce his cabinet, we were thinking about last Thursday, which was a busy day at Toots Shor's saloon on 52nd Street.

Earlier in the week, the *Daily News* had said Toots owes the State of New York something over one hundred thousand dollars in back taxes. But here in his crowded restaurant, Toots Shor, who was once a bouncer and who came off mean streets, looked around at this "family," which is what he calls his regular clientele. Included in that illustrious group is John Charles Daly, whose father-in-law is Chief Justice of the United States of America; Ford Frick; and Paul Screvane, who was almost Mayor of New York. Toots's "family" also includes Edward Bennett Williams, who is a pretty respectable lawyer. And, oh yes, over in a corner, courtesy of Sam Klein, the headwaiter who lives on Garth Road in Eastchester, sat a man named Arthur Goldberg—who is himself a pretty good lawyer. Maybe Toots Shor is not too worried about his troubles with the tax man, because of all the legal talent in his "family."

Toots Shor, who came up from mean streets, sat with a man named William Pierce Rogers just last week in this restaurant in New York. Also in this same establishment, we were discussing politics with one James Breslin, who is a writer of some note—in fact, the only American writer of note whom one can understand. And Breslin was telling us that Nelson Rockefeller had said, "Jimmy, I'd like to give you some memento of our time spent on the campaign trail." This was after

Nelson Rockefeller had left the party of Abraham Lincoln in the outstretched hands of Richard M. Nixon. And Jimmy Breslin looked at us and his friend Fat Thomas, and said he told Rockefeller, "Thanks, you so-and-so. You left me a memento, all right. He's in the White House!" Then, as Fat Thomas laughed and we talked politics and discussed the future of our nation, Toots Shor said, "Hey, come here and meet Bill Rogers!" It was last week in New York, and we did not know that William Pierce Rogers would be named Secretary of State last night by Jimmy Breslin's and Nelson Rockefeller's "memento."

But the purpose of this piece, ladies and gentlemen, is to say that we looked at Bill Rogers and shook his hand. And if it means anything, the man who will be Secretary of State of the United States can look you in the eye at least—which is something we criticized Richard Nixon for not being able to do at one time. Rogers can look you in the eye, and the man who will have a big say about our foreign policy and will be able to get us out of Vietnam, grips your hand and comes on very solid.

We just thought we might pass on this reaction we had to Bill Rogers. It's no reflection on Dean Rusk, who, after all, is from Scarsdale, but when was the last time you saw him doing his drinking at the same bar with Jimmy Breslin and Fat Thomas? A firm handshake and a confident look and solid bearing may be small gifts to recommend a guy to serve as Secretary of State, but in these times, it could help William Rogers.

December 12, 1968

Saloon Songs:
Barroom Philosophy

When Bill Cunningham, the great society photographer of the New York Times, heard about this piece, he opined that there were considerable differences between Toots Shor and Sirio Maccioni. I couldn't find any. A saloon is a saloon.

I have always found great wisdom in saloons. As a young man, I first knew the haze of an evening in Bernard "Toots" Shor's glorious establishment on 52nd Street in Manhattan. Toots had his "kids" back then. Frank Gifford and Kyle Rote were his favorites. But he also had a soft spot for an Irish advertising salesman from Westchester.

At the Toots Shor bar one could earn many valuable lessons about times you never lived. The drinks were strong and the talk was of DiMaggio, Hemingway, Mark Hellinger, Runyon, Bill Corum, Eddie Arcaro, and Grantland Rice. The conversation was vivid and dazzling, and on a good night you would encounter Howard Cosell, William Pierce Rogers (who had a day job as secretary of state), Bob Considine, James A. Farley, Paul Screvane, Jimmy Breslin, Jock Whitney, Walter Thayer, Hugh Carey, Howard Samuels, James Brady, John Lindsay, Sonny Werblin, Jack Whittaker, Jack O'Brien, Jackie Gleason, Edward Bennett Williams, Ford Frick (who would stop in on his way home to Bronxville), and the great Hearst sportswriter Jimmy Cannon. I idolized him. Everyone else tried to copy him, and one night Omar Bradley, a general of the armies, walked in with a circular cluster of *five* stars on his epaulets.

You would also see John "Shipwreck" Kelly eating apple pie on a barstool while Toots ate kosher pickles washed down with Diet Coke. On this occasion, Toots paid Ship Kelly an extravagant compliment by identifying the two toughest guys

he ever met—the ones you want next to you if you're "trapped in an alley." Toots wants Shipwreck Kelly "with his bare fists" and Sinatra "with a broken beer bottle in his right hand."

Other legendary barroom philosophers are Bruce Snyder, an enduring and endearing presence at the invincible "21" Club. Bruce is keeper of the flame for "21" and guards the heritage and tradition of this great old Lorelei with a fierce devotion. He understands about generations and in-laws, and always has a marvelous story to divert you when you are hurting, or just plain exhausted.

Over the years I've encountered some other prescient, sage observers across many other nights in other towns—like Al and George Salerno of Salerno's Old Coach Inn in Tuckahoe. It is the first venue to which every Bronxville husband retreats to reflect on a busted marriage. The Salernos have heard it all, and they listen with gentleness and generosity.

There have been other great saloon keepers during the time of my careful research into these matters: Joe Valeant of Bernie Murray's, for example, in upstate Elmira, who once advised me to sell a farm "due to the health of the owner—the owner's wife will *murder* him if he doesn't unload the damn thing!"

But Joe Valeant has some competition from a steakhouse owner, Tommy Moretti, also of Elmira. And then there's the two brothers named Smith—John and Fran—and their Uncle Squeegie, who know how to liven up the night at Mangialardo's, next to an old freight yard and railhead at the end of the Lehigh Valley railroad in the sad, bleak hills of Pennsylvania near the New York border, where Carl Hayden, the Chancellor of the New York State Board of Regents, goes to drink and eat garlic pizza with his wife, Cindy.

And surely there are no more endearing souls than one encounters at Mario's of Arthur Avenue in the Little Italy-Belmont section of the Bronx. No matter how fast your world is spinning out of control, the Migliuccis—Mama Rose and Joseph—will restore your balance and equilibrium. The ingredient dispensed along with their drinks and Neapolitan food is called *love*. Here you will see Lee Iacocca, Mario Biaggi, Bill Fugazy, some Yankees, and maybe Steinbrenner. You'll

also see a lot of Fordham professors and their students, plus some Westchester high rollers in Jaguars, BMWs, and Range Rovers.

But the greatest of all the barroom poets is Sirio Maccioni. Now when I recently encountered Bill Cunningham, the *Times*'s legendary lensman, on his favorite corner of 57th and Fifth, this great photographer and chronicler of the rich, the famous, and the stylish advised me against comparing Toots Shor and Sirio Maccioni. And although Cunningham is a beloved icon of New York, I still believe a saloon is a saloon, no matter the trappings or the neighborhood—thus Sirio!

Sitting on a barstool with Maestro Sirio at Le Cirque is a thrilling adventure. He is a wise man, provocative, charming, and absolutely accurate in his marvelous commentary about life and people. Here are some late-night pronouncements from the Magnificent Maccioni, who is America's greatest restaurateur. They were flung out into an empty dining room late at night when all the swells had gone home. I retrieved some of them for my notebook as mementos of a delightful evening—or two—spent with the greatest of all contemporary saloon keepers.

The Gospel According to Sirio
Notes of an Evening with Maestro Sirio Maccioni

Ringmaster—Proprietor
Le Cirque 2000

"I think there should be a moment in life when you do what you want to do."

"You should show that you respect people, but also show that you can do without them."

"I resent stupidity. One must have rules. I have rules. One must always be 'correct.'"

"When you ask someone to build you a three-million-dollar kitchen, they ask, 'Are you sure you need it?' I never did all this to prove I am better than the other people in my business. We did it because it was something we had to do. We are

working people: physical work, mental work. And not to be intrusive—that is what we are about."

"One life is not enough to prove yourself."

"I like women who are fun and who don't try to save the world, and men who are 'correct.'"

"There is an Italian saying: if you wake up in the morning and have no pain, you're dead!"

"When anybody can criticize a king or a president, then they are not a king or a president."

"I would never force anybody to be great in life."

"They ask me if I'm religious. Of course I am. But I hate people who only pray when they need something."

"When we fed the pope there were sixteen cardinals at the table. It was on 72nd Street at the papal nuncio's house. The pope is a good eater. He likes fish, he likes rice, he likes pasta. Archbishop Martino, a great, intelligent man—he is the pope's ambassador, so he can only be intelligent—was the host. We went, we cooked—with security from the United States, from Italy, from the Vatican. He is a good eater, the Holy Father. He ate risotto with porcini, and he ate fish. My pastry chef, Jacques Torres, made a replica of the Vatican's St. Peter's Basilica.

"The Pope asked me if it was true we had a three-month wait list for a reservation. I said, 'Holy Father, why don't you come tonight?' The pope laughed and said tonight he was not going to have such a good dinner. Since the Holy Father was talking about 'reservations,' I asked Archbishop Martino what about a 'reservation' up there in heaven. So the archbishop asked the Holy Father, 'Don't you think it would be very nice to have a great restaurant in heaven?' And the Holy Father looked at me and Cardinal O'Connor and said, 'Are we sure— are we sure we go up there?'

"The pope is amazing. He spoke to me in Italian, to my son in English, to the pastry chef in French, and to my executive chef, Sottha Kuhnn, in Thai. Then the Holy Father asked me

if I was a good Christian, or just another Italian who only gets religious when he gets sick.

"You know, in Italy we think because we have the pope— and it's a local call—we sometimes get a little casual and complacent."

"My wife always says, 'If everybody takes care of their own little spot, everything would be O.K.'"

"I'm always scared. But for me to be scared is a point of strength. I don't believe in luck. If someone shoots you, you're unlucky."

"I tell my sons: 'Concentrate on the people. Don't spend time talking to the coat-check girl or the bartender. Don't look outside on a day like this to see if it's raining or snowing. I tell them to look *inside*. The time you spend talking to the coat-check girl is wasted forever.'"

"The Italians always seem to need a tyrant to become great."

"My sons lecture to me. 'You are in America,' they say. 'You have to adjust.' What is going to be with the next generation? There is no class, no style."

"Clinton is not the exception. There are so many stupid men."

"I blame the basketball season on the players. My wife agrees. She went after Patrick Ewing at the restaurant. He is very nice, but she told him he was wrong and she will never go to another Knicks game. And she never will."

"If my sons would marry a woman like their mother, they would conquer the world."

William Butcher:
A Stand-up Guy

For several decades, Bill Butcher was chairman of the old County Trust Company and Westchester's most powerful banker. He was responsible for many of those big corporate buildings on either side of the Cross-Westchester Expressway (I-287). A bridge named for Mr. Butcher crosses over that busy road.

The Establishment of Westchester will meet in high council this very night in the pristine town of Eastchester. The big landowners, developers, industrialists, corporate executives, movers, bankers, and tycoons who populate the Westchester County Association will come together to honor William Butcher, the former chairman of the County Trust Bank.

William Butcher is a special man who has had an enormous influence in your life. You may not know this modest, decent, witty man when you pass him on the street, but he has had a lot to do with how we live in the Golden Apple. Thus, more people will turn out tonight for this William Butcher than for any big-name guest the Westchester Association ever presented—and they have presented Richard Nixon, James Buckley, Donald Kendall of PepsiCo, Art Larkin of General Foods, and Thomas Watson of IBM. Bill Butcher will out-draw all these guys—and he deserves to. Because no one around the county now comes close to him in terms of service and devotion to Westchester.

The others are accomplished men, one and all, faithful, loyal, and true. But Bill Butcher, the son of a social worker from Newark, by way of Cincinnati, has had more of an impact on the quality of suburban life than any of them. And so the clan will gather tonight, and the captains of industry will assemble over Scotch and beef and try to thank him, as will

Nelson Aldrich Rockefeller, who will rush back from a meeting with Richard Nixon to talk about this William Butcher.

But hell, all of these are big shots. It's just too bad Dan O'Brien, the able guy who is running the dinner, doesn't let some working stiff get up and tell how we all owe Butcher because he was the one who got a lot of firms to relocate here and thousands of jobs over the last twenty-five years.

He performed his public service and worked his magic as chief drum-beater-poet of our charms in his own easy style over the years. And as everybody else was wasting five hours on a golf course, Butcher got Continental Baking and Dictaphone on a tennis court. It is a brisk game that everyone is taking up today, but if you want to mix it up with sixty-five-year-old William Butcher on a tennis court, you better be prepared to do something great for Westchester—because Bill Butcher has retired from his bank, but he'll never retire from Westchester.

This is a poor tribute this morning to Mr. Butcher, because you can't get him to talk about himself. We tried all of yesterday morning. He is, as you know, a member of the board of the MTA, and when you mention that, he will tell you he considers Nelson Rockefeller the country's leading statesman because the governor is a "stand-up guy," which is the highest compliment Bill Butcher knows. And he will next spend half an hour discussing the responsibility we all have to "nourish" our environment. You can ask Bill Butcher about those friends who are trying to make him county executive and he will hit you with a line like: "I feel sorry for a political party that's so bankrupt it has to dredge up a sixty-five-year-old guy like me to run."

But if you listen closely to William Butcher and don't let him put you off, you will get the picture of a man who doesn't look back much because he is just beginning life at that magic age of sixty-five, when other men are ready to cash in their chips and live the sweet life. Of his years as a banker he will only say: "Hell, there are a dozen guys at County Trust who will make me look sick in a few years." You really have to poke around and get it from his friends that he is a director of Pace

College, Dictaphone, White Plains Hospital, the School for the Deaf, and the Burke Foundation.

William Butcher has had a greater influence than any man at that Westchester County Association, but he will steer you around and away from himself and tell you about a man named Joe Hughes, his predecessor at County Trust, and how Hughes and *Reader's Digest* and the old Westchester Lighting Company (now Con Ed) and the Macy chain started the organization he distinguished and which will honor him tonight. He will dart and weave and advise you to keep an eye on Ed Weidlein, the head of the Union Carbide complex in our county who, he feels, is starting to emerge as a "real stand-up guy." Also a William Plunkett, Esquire.

"We've got to broaden; there is still a lot of parochial thinking around here. We've got to recognize that New York City exists—we're part of a region," says Bill Butcher. "My game plan is to do something about the mobility of the region—how people are going to move around in a few years." He signed out as Chairman of the Board of the County Trust Bank, and he turned around and opened an office to continue his volunteer work on his "projects." And his talk in that office is of the future. Incredibly, he doesn't dwell much on those days of drama and growth as he moved one of Westchester's leading banks to the one-billion-dollar mark. And he has almost forgotten how he helped finesse IBM into an Armonk apple orchard right past the narrow objections of yesterday. Tomorrow is clearly his bag.

The big companies he lured to our area help pay a lot of our taxes. And fashionable as it is to rap the MTA, we all might just think once in awhile about this sturdy and warm and wonderful man who left the chairmanship of a billion-dollar bank to worry about those trains and roads that take us to work and home again.

William Butcher has already done enough to be called "Mr. Westchester." But this amazing man is still at it and, as they rain down accolades on this fine, bright man, you can look up at him on the dais and be sure that this B tennis player from Fox Meadow will be using that natural way of his to disguise more exciting and daring dreams which he intends for our

future. As one of Westchester's promotional brochures might put it, William Butcher is one of our county's greatest natural resources.

1972

Ossie Davis:
My Neighbor, the Subversive

Ossie Davis lives a few blocks from our community radio station. I will leave it to others to assess and evaluate his contributions to the theater, film, and television. We know him as a neighbor who has a deep and abiding love for his home heath. Ossie Davis and Ruby Dee, his brilliant, talented wife of fifty years, are among Westchester's most beloved citizens. To me, he is only an authentic, living, modern-day saint.

It was a morning in winter, and my shoulders were heavy with the cold. I sat at a kitchen table on Sunday morning and read in the local Gannett newspaper that a policeman of this city called Ossie Davis a "subversive." This particular subversive is described as: "A male Negro, 6 feet and 2 inches, 195 pounds, born December 18, 1927 in Cogdell, Georgia, the son of Charles Kince and Laura Cooper Kince. Attended Howard University, 1935 to 1938. Married to the former Ruby Wallace on 9/19/48. Stage name now: Ruby Dee (a known Communist sympathizer). Three children: Nora, Guy and Lawrence."

And what did this Ossie Davis do to earn his very own file in the police department of the city he has distinguished for so long? He produced a show for a dangerous group called Freedom Riders. In that sinister production was another "known Communist sympathizer" named Pete Seeger, as well as the previously mentioned woman, "Ruby Wallace, a/k/a Ruby Dee."

During this period, when he was a threat to our republic, Ossie Davis "appeared with Dr. Spock" and "spoke in support of the anti-draft and anti-war movement." They even had exact dates. On December 7, 1961, he signed a statement entitled: "Could Westchester Survive a Nuclear Attack?" In 1966 he "sponsored a Voter's March in Washington." On and on.

You felt sick that your police chief was writing and accumulating things like this about a neighbor. And a nice, tidy piece of police work it was, leaving out any mention of other subversive works, such as *A Raisin in the Sun* or *Purlie Victorious*—or any of Ossie Davis's other priceless gifts to the American theater.

As bad as I felt at the kitchen table that Sunday morning, I believe I shall have a great, good laugh about all this when Mr. Davis next comes right through the front door of this radio station, WVOX, which he calls *his* hometown station. It will be fairly soon, I expect, when he will appear in my office to speak a word for one of his *current* subversive causes or to enlist the conscience of our listeners to right some damn, awful thing done to some forgotten and hurting souls in our home heath.

But on Sunday, while the Gannett exclusive story about his most questionable past was being delivered around the county, "the subversive" was actually preaching in one of those big, Black, Baptist churches. As he waited to be introduced to a huge congregation of ladies in their dresses and white gloves, the regular minister called him "an inspiration, the most valuable Westchester citizen of our time, a great American actor, a brilliant playwright and director, and our neighbor." But now we know better, thanks to the official files of our own police department.

I couldn't resist sharing this marvelous story with the governor of my own State of New York, Mario M. Cuomo, who, with all his talk about the poor and homeless, is pretty subversive in his own right these days. So there I was on the telephone Sunday morning, spreading the word about these dazzling revelations concerning a neighbor and just what my police department had to say about Ossie Davis and the former Ruby Wallace. And Mario Cuomo fell silent for a moment and then he said into the telephone: "You know, it really wasn't that long ago." The governor is right. It happened in the good old days, in our city.

January 29, 1985

Anthony J. Colavita: A Legend

Tony Colavita is a former New York State Republican Chairman, and a legend in Westchester. The self-effacing and gregarious politician still passes out business cards that read: "Just A Little Italian Lawyer From Eastchester." He lost his state perch when George Pataki became governor.

COLAVITA: THE SPLENDID SUPERVISOR

Tonight the B'nai B'rith of Westchester and Putnam will honor a gentle man from the Town of Eastchester who is built like a wall and has an "oh shucks" way about him. He is Anthony J. Colavita, and he deserves every single nice thing they will say about him. He is the unassuming and extraordinary politician who is the splendid Supervisor of Eastchester.

Colavita will be there with his Irish wife, the former Margaret McGroarty from New Rochelle, and they will listen to wealthy men pledge money for the wonderful humanitarian work of B'nai B'rith because of what Tony Colavita means and because of what he stands for.

At the age of thirty-seven, Colavita succeeded the legendary Francis X. O'Rourke and has most surely exceeded all the expectations that his patron and late mentor had for him. It started back in the late 1950s when Colavita, a young lawyer who had gone to Eastchester Junior High and then to Stepinac High, wooed and won his blonde Margaret. They took an apartment next to the powerful O'Rourke, who gave him a job as deputy town attorney.

In recent years, Anthony J. Colavita, now Supervisor Colavita, has been a healer in Eastchester. He has united the three robust and diverse villages of Bronxville, Tuckahoe, and East-

chester, and given the town a model local government. He has
used his low-key, unassuming manner to restore Eastchester's
influence on a county level, and if he is not the most influential
Republican in Westchester this morning, he might be after the
fall election.

This past Saturday Colavita worked most of the day in town
hall—and he does that a lot as Margaret can tell you. And al-
though today is a "fun" day for Tony Colavita, which will
begin at 12:30 when he tees off with Bob Bruno, the Pelham
pro, and Lawrence Labriola himself and Billy Cunningham of
the 76ers, Colavita will shrug it all off, move his shoulders in
a roll, and bob his head to change the subject.He doesn't even
have an acceptance speech tonight for the five hundred people
who will come to honor him.

A lot of people in Westchester these days, even some politi-
cians in his hometown, tell us they can't figure Tony Colavita
out. What does he want for himself? Well, we've got news for
them! It's just possible that Colavita puts himself last, that he
is one of those wonderful, selfless people, going about his job.
Already, at age thirty-seven, he is one of the outstanding office
holders in Westchester. We admire him and we believe that
all of Westchester is fortunate to have a leader like him in its
future.

July 23, 1973

COLAVITA: THE NIGHT OF THE LONG KNIVES

One of "our own" is under siege. I refer to one of our former
announcers who, in a previous incarnation, hosted our WVOX
"Eastchester Town Report" program. You may have noticed
the story, right up there on the very first page of the Gannett
newspaper: "GOP Leader Fights Ouster Attempt."

The "GOP Leader" is, of course, the incomparable and re-
doubtable Anthony J. Colavita—Mr. Chairman himself. And
although our credentials are mighty slim in the Republican
Party these days—given our relentless enthusiasms for one
Mario Matthew Cuomo—we have to tell you of our hope that

the Westchester Republican Chairman will prevail in the current intra-party contretemps.

Incidentally, we are assured that Governor-elect Pataki (who even *I* have to admit is making some very graceful and stylish moves these days) is *not* behind the effort in the public press to replace the "Little Italian Lawyer from Eastchester," which is the appellation the affable and personable Mr. Colavita most prefers. No, it appears this is really nothing more exquisite or exotic than an ambitious move by some would-be power brokers and insatiable dynasty-builders who want to expand their fiefdom and who have long been envious of the chairman's continuing success, even in the face of recent Democrat registration gains in the Golden Apple.

A lively column by Milton Hoffman, the county's preeminent journalist, said that Tony clearly deserves to go out under his own steam—and to select the moment and conditions of his departure, should he even wish to yield the leadership of the party he has distinguished for so long.

Incidentally, it's not as though the empire builders have a "class act" waiting in the wings—someone who resembles, say, William Plunkett, who would instantly command great respect in our county and beyond. There are no stellar performers knocking on the door at 214 Mamaroneck Avenue this time. At any rate, we're for Tony Colavita and certainly with even greater enthusiasm when one considers those who've been mentioned in this real or imagined dispute.

There are a lot of unpleasant, nasty people in politics these days, as there are in any endeavor. And there is a lot of anger and meanness abroad in the land. But Tony Colavita is a nice man in a sometimes-murky profession. *He is a politician the way the men of our fathers' time imagined them to be.*

December 7, 1994

John Cardinal O'Connor:
An Irish Priest Makes a
Sick Call

I have come to greatly admire the Cardinal Archbishop of New York. He is a terrific writer and an indefatigable shepherd of the archdiocese. Many is the night I've seen him to his car after we've both "worked" a dinner at the Waldorf. I hope he lives to be 100.

It was hot and the night air was heavy outside the Westchester County Medical Center in Valhalla when the man with silver-rimmed glasses set on a hawk nose drove up in a black Chrysler New Yorker with scarlet-red leather seats, which had been personally selected for him by Lee Iacocca. He was wearing a black suit, winged-tip brogans, and the high, white, round collar of a priest of the Roman Catholic Church. There was a single rose on his lapel. After greeting the nurses assembled in the lobby to meet him, the priest went directly to the intensive-care unit, to the bedside of John Colavita, age twenty-three, of Eastchester.

Every vital sign in Colavita's damaged, young body was being monitored by electronic equipment. Tubes ran in and out of his nose. The priest leaned over him to whisper ancient prayers for the recovery of a young man whose father will be designated the next Republican chairman of New York State. That designation will instantly restore some dignity and stature to that political office. The priest knew all of this and, when he had finished, he paused at the nurse's station to leave a hand-written note for Colavita's parents.

As he stood writing his "Sorry I missed you" note, up the stark and empty corridor came the Honorable Anthony J. Colavita and his wife, the former Margaret McGroarty of New

Rochelle. The Colavitas have been taking turns sleeping in a car as one of them waits by the bedside for some sign, some slight movement, from their son and heir. He was found fifteen days ago by the side of the road after a terrible automobile crash almost killed him. On this summer night, Tony and Margaret Colavita walked down this hospital corridor with an armful of pizzas for the nurses who were helping to keep their son alive.

"I almost missed you," said the Irish priest with the smiling eyes and the red rose on the lapel, a sign of life. And then, as Tony and Margaret Colavita stood there with tears and an armful of pizzas, the priest went off into the hot summer night in the big, black Chrysler with the scarlet-red leather seats.

While back in the room there was a mother, a father, their son lying still, and the smell of pizza hanging in the air, John O'Connor, the Cardinal Archbishop of New York and sometime national media celebrity, was, on this hot, humid night in Westchester and despite all the trappings of his high office, a priest saying ancient prayers for the sick.

July 22, 1985

Arthur Geoghegan: The Townie Banker

Arthur Geoghegan was New Rochelle's preeminent banker for a number of years. He ran one of the last independent banks in the county.

Commodore William Gibbons, a great icon of the sailing world, who is himself of a certain age, was surveying the winter coastline in Rye earlier this week. Mr. Gibbons is a marvelous, witty, zestful character who has been somewhat successful in life. Among his holdings are downtown Rye.

Gibbons's enthusiasms are legendary, and I have been the beneficiary of his generosity. For every time Bill Gibbons sees me at his beloved American Yacht Club, where he is the most popular member and probably the most knowledgeable concerning things nautical, the former commodore marches right up to my table and hands me a crisp one-dollar bill, "to get a *haircut!*"

But on this recent winter day, Mr. Gibbons came up and told me: "New Rochelle lost a friend, O'Shaughnessy. You and I lost a friend." And then he told me that Arthur Geoghegan died the week between Christmas and New Year's. Now, since I read six newspapers every morning, I could not believe I had missed the sad news of Arthur Geoghegan's passing at the age of ninety-one.

But it was indeed confirmed that very afternoon by lawyer Jack Geoghegan, who remembers when his father was the most powerful and influential man in New Rochelle.

Arthur Geoghegan was president and chairman of the old First Westchester National Bank, and he controlled the town from his office in the big building at Lawton and Main. In the days when giants walked the landscape of finance and populated the civic life of Westchester, White Plains had William

Butcher, John Kley, and Tom Langan of the County Trust Company; and Harold Marshall, Fred Sunderman, and Jim Hand of the National Bank of Westchester. And over in the land of Sleepy Hollow, a young realtor turned banker named Bill Olson would soon make his move into the stratosphere of influence. Mamaroneck had Leo Heithaus. Mount Vernon had Walter Moore.

But New Rochelle had only Geoghegan, who was our townie banker. And each day, in every season of the year, Arthur Geoghegan would walk four or five miles, right down North Avenue to his office. It is also known that "Red" Geoghegan, while strolling this big, broad boulevard through the heart of town, made himself and his bank very important in the lives of countless working men and women and families.

Arthur Geoghegan was a member of the Winged Foot Club and the New York A.C. But he was most at home at Paddy O'Neill's saloon on Lawton Street, where he would eat off paper plates and talk to everybody about the city he loved. The only time he left the glorious informality of Paddy O'Neill's was for his weekly lemon squeeze, at the old Schrafft's on Main Street, with Owen Mandeville, the realtor, J. Ray McGovern, the legendary barrister, and William Scott, a handsome man who drove a golden Cadillac. Here at these high councils, over ninety-cent cranberry sandwiches, the business of the town would get done.

Most of the bankers of today would not understand about all this. For they—with a few shining exceptions—are much too busy maintaining their high estate and standing in the corporate hierarchy of remote holding companies, while hiding behind their marvelous technology, ATM machines, recorded messages, and unlisted telephones. But Arthur Geoghegan was a real, live, breathing, caring, concerned, *available* community banker. If you were good for his town, he would back you. It was as simple and easy—and smart—as that.

This was all very long ago. In recent years, Mr. Geoghegan moved up county and rode horses and told stories to his grandchildren. But, every once in a while his mind would drift back to Paddy O'Neill's and lunches with Mandy and McGov-

ern and Scott. They're all gone now, and so is Arthur Geoghegan's way of doing business.

Memo to our news department: He was a lot more than a "retired banker."

<div align="right">January 11, 1997</div>

Theodore R. Greene:
Mr. New Rochelle

Teddy Greene was a controversial, charming, irresistible rogue and a master politician in the Queen City. Many did—but I couldn't hate the guy.

GREENE: THE TOWNIE POLITICIAN

No one was ever neutral about Teddy Greene. There is no maybe in his dictionary, no halfway station, no neutral ground where he has ever walked. If you don't like politicians, you won't like Teddy. And if you dislike politicians, then you really don't understand this country and the way it works—and you surely will never figure out the extraordinary city in which we live.

Politics and Teddy Greene run together. And you can't understand the Honorable Theodore R. Greene unless you acknowledge that he is, first and foremost, a townie politician. Whatever else he is, whatever he has accomplished, it is subordinate to his love of politics, plain and simple. In the mind of Teddy Greene, politics means helping people, talking to them, communicating with them. And you can't do any of these things well unless you first love them. Teddy loved in great abundance.

In his time, in this city, we have had our political superstars, our legends. In our brawling, sprawling past, though, none were as colorful as Teddy. None stirred our passions and emotions as did Teddy. We had some great ones in our day—in both parties. They were fabulous. Teddy was fabulous—and unique. No one brought more energy and enthusiasm to the political calling. He could be a firm, fast friend and, if you were his friend, he never faltered. And he could be a relentless adversary.

But there is something I want you to know about him: Teddy was never mean, never bitter, never vicious, never vindictive. Yet, he was a scrapper. Many of us have been on both sides with Teddy over the years. It's no secret that we prefer to be on his side in any proposition, rather than in the opposition.

But Teddy never held a grudge. You could run a primary or give a talk or broadcast an editorial murdering Teddy, and in retaliation, he would merely give you an appealing grin, that slight, sly smile that always made him look as if he had stolen the cookie jar—or at least the key to city hall.

Many politicians took from their calling. They feigned an interest in the people in the wards, deceived them, and then got out—with an appointment to a no-show job or a state commission. But Teddy kept coming back. Politics was like a mistress whose charms he couldn't shake. The people on the mean streets of his city knew they could go to Teddy with a request. Politicians are different today.

Often Teddy was a lonely runner. He stood alone when he advocated a controversial North–South arterial for New Rochelle, known as the Pinebrook Boulevard–Potter Avenue Extension. That meant you wouldn't have to fight your way downtown via North Avenue, the boulevard of traffic lights.

Hundreds of people came one dark, desperate night to the Henry Barnard School to hear this upstart councilman and to denounce his "wild, reckless" proposals. As Teddy stood before them, there was an overflow crowd outside. He held them at bay with his charm and rhetoric, until the grand moment when he unveiled the giant street maps for their perusal. As he did, a tremendous wind blew through the jammed auditorium, knocking down Teddy's easels and blowing his maps and plans right off the stage. Teddy looked around and said, "I know everyone else is on your side. It looks like God is, too!"

His greatest contribution, perhaps, was his patronage and advocacy of the New Rochelle Outdoor Arts festivals which, in the 1960s, brought thousands of people to our city.

He was a patron of the arts but not in a tony, high-class, establishment way. Teddy helped and encouraged more grubby, rag-tag artists, sculptors, and assorted creative types

than anyone in our city. Many of them had talent that existed only in Teddy's eye—but he helped them, encouraged them, challenged them, championed them.

He couldn't see the beauty, however, in the cupola. Who remembers the cupola?

The late Hughie Doyle and Joe Pisani wanted to preserve this great work that had once adorned the top of the old city hall. They suggested erecting a grand tower at the corner of Main Street and Memorial Highway, on top of which they would display the cupola. Doyle and Pisani had some powerful allies in this sentimental scheme: Jack Dowling, the banker, for example. I even pitched in with a stem-winding, impassioned editorial.

Teddy, however, had a different idea. He politely suggested installing the cupola on a buoy in the middle of the Sound as an inspiration to passing ships in the night. When someone asked how he proposed to get it out to the site, Teddy thought it would be a fine idea if Doyle, Pisani, Dowling, and O'Shaughnessy climbed up on the damn thing and rowed it right out there!

Teddy was a great conservationist and nature lover. He tried to establish a twenty-four-hour, around-the-clock, live-in, female guard to keep an eye on the chipmunks at Ward Acres.

He improved our international relations and became a great favorite of the French. When the delegation from La Rochelle came on their official visit, and our welcoming committee scheduled a thrilling tour of local Huguenot cemeteries, historical markers, and statues, Teddy said, "We'll have none of that!" And he promptly arranged for our visitors to see several Broadway shows and eat at some good local restaurants. When Teddy later visited La Rochelle, it was the greatest landing since D-Day. The mayor kissed Teddy a grand total of ninety-three times at the airport—on the cheek!

Teddy was always running—running art fairs, Chamber of Commerce dinners, class reunions for New Rochelle High School. And it seems he was always running for office.

He was the Harold Stassen of New Rochelle politics—only, Teddy won a few times. In fact, he won most of the time. He served a total of sixteen years on the high council of our city. He was elected first in 1953, when he and Tom Nolan ran a

primary against the organization. And then in 1957 he won again. Then, in 1961, he stepped aside on the advice of his long-time friend Burt Cooper.

But everyone knew Teddy would come back—and he almost did in 1963, when he lost by a heartbreaking thirty-seven votes to Hughie Doyle.

And then in 1965, like Lazarus, Teddy won again.

He won again in 1969. Who compared him to Harold Stassen anyway?

And he ran for mayor so many times, we've lost count. Though he never became mayor, he was Mr. New Rochelle in the minds of thousands.

People outside our city—in Albany, in New York City, and in neighboring states—when they heard you were from New Rochelle, would always ask affectionately and respectfully: "Is Teddy Greene still raising hell down there?" And I can tell you a certain Vice President of the United States and former governor asked me once or twice if Teddy Greene was still "raising hell down there!"

One night, we came to honor him "for the many years he has served our city," as the press release put it. It was really because his friends came as surrogates for the people of this city—all the people he helped over so many years, all those people on whose behalf he interceded at city hall, all those people he persuaded Alex Norton to find room for in the hospital, all those cops he fought to keep on the force, all those people he found jobs for, all those kids he got into Iona College, all the people he did favors for, all the people he tried to help.

Teddy, we know you as a politician—but above all we know you as a friend.

And so this comes not alone from us, but from the entire city: we're glad you're our friend.

<div align="right">December 3, 1979</div>

GREENE: AN ERA ENDS

He was a most colorful, vivid, flamboyant, exasperating, and controversial individual, right out of the mind of Jimmy Bres-

lin or the great Damon Runyon himself. But he really existed—until September, 1988, when he died and took an era with him.

You have to understand there never was a Mr. Big in New Rochelle in those days, and this caused great consternation among the likes of the county executive, Ed Michaelian, and the governor, Nelson Rockefeller, who were constantly trying to figure out "With *whom* do we deal?"

Yonkers had Bill Condon, and in New Rochelle, there were a great many fiefdoms and all power and influence was dispersed. For example, kindly old Elmer Miller ran the newspaper. John Brophy, who died this summer, organized and led all parades in his American Legion hat—and gave the Pledge of Allegiance at every civic function at Glen Island Casino, which was run by Angelo Badolato. Malcolm Wilson, with the number "2" on his New York State license plate, came to visit his daughter Cathy every weekend. Stanley W. Church, the "boy mayor," was always, it seemed, being driven from office only to perform a Lazarus-like comeback "for just one more term, to straighten things out." The Irish women on the south side of town thought Stanley to be quite good looking, as I recall. And some of them even tried to run Mayor Church for the Senate, an idea which faded quickly when it was discovered he might have an opponent. John Driscoll, a Christian Brother, became President of Iona College at the age of thirty-eight, replacing Joe McKenna. The young cleric of brilliant, fresh mind and graceful tongue was called "Jerry" by the Brothers. To everyone else he was "Jack." He became a bright star almost instantly, and the college slipped its parochial bonds to achieve a national reputation.

Tommy Fasso was city judge. J. Raymond McGovern, Bob Fanelli, Les Albertson, and Frank Connelly, Sr., were the power lawyers. Evie Haas, Pauline Flippen, and Sister Dorothy Ann Kelly were the power women, along with Jenny Murdy who lived alone in a row house on Stephenson Boulevard and possessed great clout in White Plains. Hughie Doyle and Joe Evans were on the high council of the city, along with fiery Joe Pisani and David Streger. But Joe Jackson, Nick Donofrio, and Henry Kiernan never made it at the ballot box.

Arthur Geoghegan was the big banker in town and, as such, he got the corner table at Schrafft's on Main Street, where every day he would sit over whiskey sours and those ninety-cent cranberry sandwiches with the realtors Owen Mandeville and Bill Scott. And J. Ray McGovern himself ran statewide with Franklin Roosevelt. McGovern wore white, wool flannel trousers and carried himself with great dignity. Every Tuesday—or Friday (the memory dims)—was Paddy O'Neill's Luncheon Day, when the Establishment headed for Lawton Street to be fed by P. J. O'Neill and his wife, Marge, at the most wonderful tavern that ever existed in all of Westchester. Here at lunch you would see Huntington, the insurance man, Tommy O'Toole, Murph Streger, the Colwells, Bill Sullivan, George Shaw, Marty Traugott, the rich plumber, Judge George Fanelli, George Vergara, Tom Burke, Keith Fulsher, Ned Condon, Ed Flanagan, and Bob Olson. I would go late at night to talk politics with Kirby Scollen and Ken Auletta. But often I would go just to talk and drink with Paddy O'Neill, who was a wise man indeed.

Sal and Tony Tocci were popular in the west end of town, a/k/a the Fourth Ward, and only Hughie Doyle ever went to more funerals or remembered more names than Sal Tocci, who wore a homburg. Jimmy Lennon, Jimmy O'Brien, John DeRario, and Frank Praete fought over matters political with handsome Louis Barone and his top lieutenant, Lewis R. "Bud" Mangano.

Fred Powers was always the class of the fleet, and he became county Republican chairman. He was a wonderful patron of this radio station, and we still feel the sadness of that day when Fred Powers lost his son, Peter, in a car accident on Pinebrook Boulevard.

Scoop Galello ran a bar, the best restaurant was the old Saparito's, and Loretta waited on tables over on Drake Avenue—before she split from Lou. The big political bar, of course, was Cesario's, where Stanley Church held court and where you could observe Alex Norton himself calling everybody "doctor" or, as the night wore on, "commissioner." Willy played the accordion, and Norton grabbed the check for every Irish nurse from the hospital. Norton was the one indis-

pensable individual you wanted on your side in any proposition. He ran the hospital—and no one crossed him. If the fellow you were sitting with happened to have on a Roman collar, Bob LaGravinese would fade the priest a C-note, and Jerry Valenti would put a new roof on his church.

Jack Dowling was a banker and the preeminent civic leader. He, too, liked things done in just a certain way. This became quite clear when he started his own church. George Moten Davis was the big Protestant clergyman, and thoughtful, gentle Rabbi Jacob K. Shankman spoke for all those Jewish families moving in north of Eastchester Road. Albert Fay Hill, a local minister, achieved some notoriety by terrorizing city hall and then left town. Monsignor Temple, who looked like a tall, lean Barry Fitzgerald, was pastor of St. Gabriels. Black activist Napoleon Holmes drove the police commissioners nuts. Their names were Edward Carey, Bill Hegarty, and, for a while, Jim Gordon.

A brilliant administrator ran the schools. His name was Spillane: "Bud" Spillane. Joe McCoy ran yet another bank—the Peoples. Walter "Ding Dong" Bell was the fire chief. Peter Griffin was the big car dealer. He wore blue yachting blazers and talked like Greenwich and New Canaan, where he eventually went, but his brother Bill was more down to earth. Marvin Goldfluss ran the camera store and usually knew everything that transpired at any hour, any place in the city. Lucille Ritacco, a beautiful, young housewife who dabbled in real estate, was just starting to notice the big cars her employer, Sal Cassara, drove. She had ideas of her own.

Entrepreneur Doug Fleming took over Thornton Donovan, a failing prep school, and the Sister Dorothy Ann Kelly Group came into being. Members in good standing included Sidney Mudd, Alfred Benedict DelBello, and PR man David Finn. Bob Cammann ran the Chamber of Commerce, then as now. His arch-rival was a most abrasive fellow named Lewis Fechter, who was protected by Jack Dowling and Sidney Mudd. This Fechter was the development czar, but mostly he antagonized people. John Fosina was postmaster. He put hand-lettered signs on the loading dock outside the main post office—signs that were not exactly written by Winston

Churchill. Fosina could quiet down any civic dinner by bellowing: "Shut the hell up, youse people." The attendees shut the hell up.

The best band in town was The Sunsetters, led by Hank Carletti. Their best tune at those church dances was "Sweet Caroline."

John Kennedy came to town, as did his brother Bobby. And Richard Nixon rode in an open car right up North Avenue. H. Rap Brown and Paul Zuber gave speeches. So did Bill Kunstler, who used to sit in my office late at night, and Paul O'Dwyer, who was a friend of I. Philip Sipser, who was decidedly not a friend of this station. Michelle Aisenberg raged against everything in her severe, humorless way, and Miriam Jackson never met a Republican she liked in that whole time. Wolfie Duberstein gave away a lot of money, and Nat Ancel, who owns Ethan Allen Furniture, made and kept a lot of it. The Joyce family of Overlook Road played their usual holier-than-thou grand game, and Sidney Mudd, their silver-tongued surrogate, made sure nobody messed with the family bottling company. Goombah Sal ran the Mannerly Shop, where Jerry Valenti and Lyman Finkel bought suits, ten at a time. Diane Gagliardi Collins made it to the county board by reminding everyone she was Joe Gagliardi's kid sister.

A youngster with a scrambled-egg mind burned down the high school, which Tony Gioffre, the kindly state senator, got rebuilt in record time. Handsome Frank Garito was up on the family bulldozer dreaming of a political career. So was an energetic young lawyer named Vinnie Rippa, who had married a Cirillo oil heiress. Father Terry Attridge, a young priest with central casting looks, preached every Sunday at Blessed Sacrament. He was a protégé of Charles Wendelken and of Cardinal Cooke. Steven Tenore was studying to be an undertaker. Burt Williams, a weathered, old Englishman, brought soccer to the city and battled with aggressive north-end fathers who wanted to ruin this elegant sport the way they had Little League.

People started noticing a young Italian lawyer from Pelham, and they became convinced that Dick Daronco was destined for great things. Julian Hyman's wife, Jean, or Ruth

Kitchen sang the national anthem at all public gatherings. Rocco Bellantoni, Jr., was probably the best of all the townie politicians. He served on the council in City Hall for just two years and worked so hard he almost lost everything. But he was a dear man, and I am not the only one who misses "Don Rocco" or "Rocky Bal" or "Junior," as he is still called over on Second Street.

Ogden Rogers Reid represented New Rochelle in Congress. He was a magnificent figure in those days, with his WASP, nasal, patrician way and more liberal than 90 percent of his constituents. Joe Slick ran a liquor store with a "38" strapped on his ankle, and one Bill "Tee" Tedesco was involved in everything political, with his trademark furtive, sidelong glance. So was Nicky DeJulio. Of course, there were other politicians of the day, like Burt Campbell—who probably could have gone a long way if his wife had not persuaded him to forsake the demon politics and stay home and make babies.

And quite the brightest, smartest, and most highly principled of them all was Alvin Richard Ruskin, an immensely popular and appealing Republican who built the Mall and got Macy's and then got the hell out of town to become a justice of the New York Supreme Court. Alvin Ruskin was an ornament among this band of characters, and as long as he was around, Teddy Greene would never become mayor. This radio station backed Ruskin because, in all those years, he was the best and the brightest. This, of course, put us squarely in opposition to the Honorable Theodore Greene, who died this past week. Joe Pisani was quite correct when he said on the news that Teddy Greene's passing meant the end of an era.

I've told you what I remember about that time, and I've saved Teddy for last. I recall this about him. He could be a relentless adversary who took every advantage. This was usually provided by a police dispatcher, a few cops, and some City Hall secretaries who reported directly to him. Before every governmental meeting, he would adjust his chair in the City Council chambers to enable him to sit taller and higher than all other officials. He ran art shows and put the entire "Up With People" tour out on David's Island. And he was always running for mayor.

But the thing you remember most is Teddy never carried a grudge. You could murder him on the radio in the morning, and the next day all was forgotten. He had a sly smile and, in recent years, he sat on a bench outside Wykagyl Gardens, regaling rich widows with tales of his exploits. Teddy's last public appearance was at Iona College on September 15, only a few days ago. He had survived several strokes and his complexion was pale, almost yellow—but the eyes danced, even as Bob Feinman droned on about the Constitution. And then, as the breakfast broke and everyone went up to say hello to Brother Driscoll and Feinman, Teddy Greene stood alone on uncertain legs, eyeing the pretty college girls.

I don't think he ever gave up, and it will be a duller place without him.

<div style="text-align: right;">September 23, 1988</div>

Charles John Valenti: Unyielding, Unabashed Patriot

I gave this eulogy for the father of one of our first patrons and benefactors.

As we remember Charlie Valenti, I think it's good to recall this: "Don't let us forget who we are and where we've come from," as Governor Mario Cuomo reminded us. "We are the sons and daughters of giants."

And last week, in New Rochelle Hospital, we lost one of those giants. This particular giant stood all of five feet four inches. He died among us, in the town he loved. His name was Charles John Valenti. He was in his eighty-fifth year, and he is the reason we have come this morning to St. Joseph's to pray—and to remember.

I am a friend of Charlie's family. But I am also, by trade and by calling, a reporter, a broadcaster. And so I should do what I know how to do: report briefly on the life of Charlie Valenti.

He was only an acquaintance of mine. We knew him as Jerry's father and Lynn's father-in-law. We would see him only on festive occasions, important times, happy times at Jerry's house. So I asked around the neighborhood for some more background information about Charlie to give you an accurate picture of the kind of life he led in these streets, in this neighborhood, in our community. This is what I found out about Pop Valenti, the man you lived with and loved. It is a story of a family—and of generations.

"I am a link in a chain, a bond of connection between persons, created by a God who knows what he is about," reminded Cardinal Newman. And so there are sons and a daughter to this story: Joseph, Jerome, Marie, and Andrew,

who gave him a home and love. There are also sisters, brothers, grandchildren—even a great grandchild, Jerome Valenti II. He is very young and never really got to know his great-grandfather. Thus, I hope that one day his parents, John and Beth, will sit with him when he is old enough to understand. And when he asks about his great-grandfather, this is what I think he should be told.

He was born on Christie Street, on the Lower East Side of New York, in a place called Little Italy—where they still carry statues of the Virgin and the Child through the streets on feast days. As a young man, he moved to New Rochelle, and he stayed. That phrase reminds me of a comment his son Jerry once made about a businessman in this county: "He stays." It was, from Jerry Valenti, a high compliment indeed. He stays.

Charles Valenti always lived on Fourth Street, near Union Avenue. It is in a place we call the West End. And off these streets, in his time, came giants: Frank Garito, our former mayor; Mike Armiento, the police commissioner; and the late councilman Rocco Bellantoni, Jr. He married a girl of great beauty, Mary Corona. She stayed with him—and he with her—for sixty-three years. They stayed. They had three children: Marie (whose name is now Marie Nardozzi), Joe, and Jerome.

Charlie was a joiner. He lived life. He was a giver and a participant. So many only take from life. Charlie put a lot back. He worked with his hands and fixed cars for a living. And for a while, he even had his own business. When he was finished with his customers' vehicles, Charlie would fix the cars of his friends. I heard a lovely story, probably true, that when a man named Vincent Generoso prepared to leave this world, he could but barely recall the major events of his life. But he remembered the day Charlie Valenti fixed his Model T and got it working again when no one else could.

More than once Charlie patched up the city's old rickety police launch. And this morning I think it's appropriate that the police department is providing an "official" escort—motorcycles and all—for a man who used to repair their cars in his spare time.

Charlie was a great sportsman and a real fan. One of his

sons told me of those exciting days when Pop would take them to Yankee Stadium and the Polo Grounds to see Mel Ott and Bill Terry. And imagine his pleasure when last year Charlie sat in a private box owned by his son at Shea. He wore his straw hat and his best suit and, instead of traveling on the elevated, he rode there in his son's limousine, with a driver to open the door for him. And instead of a hot dog, Charlie ate a grand dinner in the exclusive Diamond Club. But he had a good time anyway. He would have been so pleased that the great Dodger Ralph Branca is here this morning.

Charlie was, like my father, an Elk and a member of the elite Inner Guard of that organization.

During the 1940s Charlie lost his business, the only time he ever failed. With three children and a wife to support, he went to night school to learn how to fashion and weld gold and silver with his hands. He proudly became a skilled machinist and, for his labor, he was paid sixty cents an hour.

"Don't let us forget who we are and where we've come from" is the message that echoes through our minds this morning. I found out something else about Charlie. He was devoted to his church. This church. St. Joseph's, which appropriately takes its name from a carpenter, a working man, a tradesman. Charlie, as his family, knows, was always here—fixing the manger, arranging flowers, sorting palms on Palm Sunday. And so he lived like this—until eight or nine months ago, when he fell ill.

And something else I should tell you. We didn't read it in the public press, but Charlie, through it all, had a great devotion to the Blessed Mother. He was a robust, straightforward, solid, man's man, and not the least bit shy, which is a trait that runs strong in all the Valentis. Yet, Charlie prayed daily to the same Virgin they parade through the streets of Little Italy. I would like to suggest that this devotion to the Blessed Mother was one of the most becoming things about him.

And I'm reminded of a prediction made by Fulton Sheen himself of what would happen to those who pray as Charlie did. As Archbishop Sheen would have it, when Charlie is face to face, ultimately, with God himself, confronted at last by his

Maker, God will simply say: "Oh yes. Oh yes, I know you. My Mother told me about you."

And finally, a lot of people will think of Charles John Valenti whenever they see a flag fly anywhere over our city. On every day he could—Flag Day, the Fourth of July, Memorial Day—Charlie ran around hoisting the flag of his country over his city. He was an unyielding, unabashed patriot, aflame with love for his country. It is a tradition carried on to this day by Jerry and Joe, and by Charles and John. No job begins at any Valenti project anywhere unless the flag of our nation is flying over the men and women at their labor.

He was a good man. He was always there. He stayed.

Charlie is happy you came today.

And Beth and John, tell that son of yours about his great-grandfather. Don't let him forget who he is and where he came from.

July 23, 1984

Frederic B. Powers: The Townie

Frederic B. Powers was an industrialist and philanthropist who dabbled in politics as Chairman of the Westchester Republican Party. I once heard him admonish Nelson Rockefeller, "Nelson, you're acting like a damn jackass!" This occurred in Rockefeller's own living room. Fred Powers was wonderful to me and mine for many years.

I do not possess the talent or toughness—or the desire, for that matter—to separate myself personally from this morning's editorial, which is about a man named Frederic Powers.

Industrialist, civic leader, politician, philanthropist: Powers was all of these things. He was also my friend and a great patron and champion of this, your own community radio station.

As we attempt this broadcast of what Fred Powers did for Westchester and try to recall the kind of man he was, I feel like a prizefighter who has gone to the well once too often over these airwaves and on this microphone. Nothing I could say would do him justice. He was the mother lode when it came to an awareness of his fellow man. The clergymen use that wonderful phrase "a sense of community." Powers owned it. He wrote the book.

Although he would ride around in that big Cadillac with the famous FBP plates, Powers was basically a "townie." Now, don't get me wrong. Perhaps I should not use that word, because not everyone has the same respect and affection for it as I have. By "townie" I mean someone who has roots in his community, someone who loves his neighbors. For all his directorships and foundations and the Supreme Court judges he made and appointed as Republican leader, Powers was basically a townie. This was his town, and you were his neighbors.

He was a man of elegance and eloquence and style and great wit. He could hobnob with Nelson Rockefeller, whom he admired and loved and once accused of acting "rather like an ass," and at the same time be genuine, dignified, and as down-to-earth as any man who ever lived in our county. When he was Republican county chairman he would sit at those political dinners surrounded by ward-healers from Yonkers, winking and laughing and waving his right hand through the air with the ever-present Marlboro. Waiters, bellhops, cab drivers, paperboys, and garbage men all loved him. And it was fitting yesterday that one of the first callers at George Davis Funeral Home was a cab driver.

Powers had, in abundance, that wonderful and becoming trait of older men who go out of their way to help younger men. And every time I'm tempted to give short shrift to someone seeking my own poor advice, or not take the time to see a youngster trying to break into radio, I try to recall Powers and his splendid example.

By the thousands, they came over the years to his office on Petersville Road, some after his money for a favorite cause, but most for his judgment and advice. He was where you started for ideas or development projects—or radio stations. Although Powers rarely gave you straight-out advice, you would ride home after a session with him, and it would come to you—and the whole thing would be clearer.

Jean Ensign, WVOX's wise and prescient executive vice president who has known Powers a long time, said yesterday that Westchester is losing a lot of giants. "I hope you have young men coming up," she said.

Well, I'm an optimist about this, and I have to assume that we *are* developing future leaders with the style of Fred Powers. But it's going to be a lot tougher, because they won't have this marvelous and extraordinary man to help them start the climb toward splendid projects and great accomplishments.

Powers had been in and out of the cardiac-care unit six times in the care of the world-famous specialist Ira Gelb. We knew he was slipping and in trouble last weekend when his wife, Irene, and son, Fred Powers, Jr., came out the side door of the hospital. Neither looked good. And so you urged them

to try a long shot and retain some wonderful Irish nurse like an Ann Kenny to go in there to check on him just once more.

But it was asking too much of that heart, which had done so much and been so busy in our lifetime. It was too much for even a jolly Irish nurse with a twinkle in her eye, or even the legendary Dr. Gelb.

I really loved this flamboyant, colorful, warm man. So many take and put nothing back. But every once in awhile, central casting sends you a Fred Powers to even things up.

September 12, 1975

Anthony Bruno Gioffre: "Dad, We Want You!"

State Senator Anthony B. Gioffre was a sweet, gentle man who served with great distinction in the New York State Senate.

They are giving dinners and testimonials these fall nights for congressmen, pro football quarterbacks, district attorneys—and really anyone else on the political make. But we shall look forward to one that is being tendered this evening to the son of a grape peddler from Port Chester. His name is Anthony Bruno Gioffre. The man has served us, this self-educated and self-made man, for a grand total of twenty-seven years, fourteen of those years as an official in Port Chester and thirteen as an Assemblyman and New York State Senator.

Tony Gioffre is retiring from public life, as you have heard. The dinner, which will be held tonight at Angelo Badolato's Glen Island Casino By-the-Water's-Edge, is a homespun affair, organized by some men and women who call themselves "Friends of Gioffre." They come from Rye and Harrison, Mount Vernon and Mamaroneck, Larchmont and New Rochelle and White Plains. The one thing they have in common is their love and affection for the gentle man they honor this evening.

His father really did sell grapes to send him to Syracuse University. Tony became a lawyer and an accountant, as well as chairman of the powerful Committee on Cities of the New York State Senate. But the ordinary people who will come to Glen Island tonight by the thousands will appear, not because of what Tony has accomplished or because of the influence he still wields, but because of the kind of man he has always been.

Someone once said, "You know a man by his offspring." And Tony Gioffre is plenty proud that one son, Anthony, Jr., is vice principal of the Horton School; another, Don, is a pros-

perous haberdasher; and still another, Bruno, is a judge. Now if you happen to meet up with any of the children of Anthony and Louise Gioffre, they will talk not of themselves, but of their father and mother. We remember Donnie Gioffre telling reporters one night about his mother: "She's fabulous, sort of lovable, a little Napoleon," he told us with great affection. "She always knew where we were, growing up, and we still go to her for help, even though we're married and have families of our own."

There was some talk in this county a few months back that Tony Gioffre didn't want to engage Michael Roth or Joseph Pisani in a bruising primary. But that is not so. And any one of the young Gioffre boys will straighten you on that right away by recalling Tony's come-from-behind victory over Max Berking. It was never made public, but the reason this man bowed out after twenty-seven years is because of what took place during a family dinner held last spring at a restaurant called the Sawpit. "What shall I do?" asked the senator of his sons assembled before him. And they said, "Dad, we love you. And the people have had you long enough. We want a piece of you now, and your sixteen grandchildren want you. It's *our* turn."

That's how it went. And I suppose you can accomplish a lot of things in life but probably no words are more poignant or important than these. And the next morning, Senator Gioffre called this station and the other media to announce his retirement from the Senate of New York.

So they honor him for the final time this evening. As we sit and watch the applause rain down on this sweet man, we will recall many things—like the day the Mayor of New Rochelle flew to Albany where Tony Gioffre got the legislature to pass a bill, for only the third time in history, which would enable us to waive the formalities so that the ruined New Rochelle High School might be rebuilt eighteen months sooner.

We were there when Tony Gioffre got the powerful Speaker Anthony Travia to move the bill. And I remember Harold Fisher, the speaker's counsel, saying, "Tony, you're the only Republican *or* Democrat we'd do this for so late in the session." And he told us that Tony Gioffre was a man of his word,

a man of honor: "You don't need a contract; a handshake is his bond."

And so Tony will listen to plaudits like these until very late tonight, but I'll lay you even money he'll be there to pass the basket at 10:15 Mass at Holy Rosary tomorrow morning, the way he has always done it. And though he is a Catholic, we will never forget that year the rabbi in Port Chester "endorsed" Senator Gioffre.

There will be only the little people at Glen Island for the tribute. The senator of so many years is going to retire and the big money has a way of forgetting. Those are the guys who buy entire tables at testimonial dinners—and who disappear fast. The joint will be filled this evening with people who have bought one and two tickets. So it will be a rather pure tribute, given for the senator by the likes of Rocco Bellantoni, John Brophy, Sal Generoso, his friends, and his children.

I'm looking forward to it, because I know this son of a grape peddler will be standing there as he does, saying, "My best to the Missus, my regards to the family" as we go through the receiving line. Tony Gioffre is one of the nicest men in politics. That description of him would hold up in any calling.

1972

Frederic Dicker:
One for the Dicker

With this piece, I personally saved the New York Post *so it could continue attacking Mario Cuomo. Since then, the* New York Post *has grown tremendously in wisdom under the enlightened leadership of Ken Chandler, who presides over a stable of talented writers like Jack Newfield, Steve Dunleavy, Neal Travis, Cindy Adams, and Liz Smith. And Fred Dicker, the en-fant terrible of the Albany press corps, is still driving politicians nuts in the state capital.*

It was a typical Albany winter night, filled with blowing snow and sub-zero temperatures. Huddled in the foyer of the Hilton, waiting for one of the three taxis in the entire capital city of our state, was a bespectacled man named Frederic Dicker. As I was on the lobby telephone attending to a matter of most urgent concern to the republic, I directed my driver to take this Frederic Dicker to his home, which is where at night, over a typewriter, he thinks up mean columns about the Governor of New York and every senator and assemblyman in the Legislature of the Empire State.

"This gentleman is the chief Albany correspondent of the, uh, *New York Post*," I yelled to the driver as they went up Washington Avenue in the driving snow, making me feel very good and also very powerful. On the way back to Westchester, Richie said, "Mr. O', who the hell was that strange guy with the glasses? He asked me all kinds of weird questions, like, 'Are you a nice man?' 'Does he pay you well?' 'Who does he have lunch with at the "21" Club?' 'What does he see in Mario Cuomo?'—all within five blocks."

I now attempt to save Frederic Dicker's job so he can continue to ask wonderful questions of anyone who goes near Albany. But first I have to tell you I have seen a newspaper

die—a splendid one called the *New York Herald Tribune*. It happened on August 15, 1966, when a gentle patrician with a heart condition climbed out of his old green Cadillac and took an elevator right up to the ninth floor of a building in Manhattan. And I watched John Hay Whitney standing there in his Davies suit from Saville Row shut down the *Trib* for all time.

Earlier in the afternoon a last cable had come up to New York from the paper's Washington bureau: "TO EVERYONE IN NEW YORK: I WILL INSTRUCT MY SORROWS TO BE PROUD: FOR GRIEF IS PROUD, AND MAKES HIS OWNER STOOP. WILLIAM SHAKESPEARE." And then these words clattered over the wire: "MAY TRUTH IN PRINT, AND HONESTY IN REPORTING, AND INTEGRITY IN PUBLISHING REIGN FOREVER."

If the *New York Post* dies, it will not go out, of course, with any of the same class and style as the *Herald Tribune*. The *Post*, which was founded by Alexander Hamilton, is now owned by an Australian dynamo named Rupert Murdoch. It publishes lurid headlines and pictures of people we have murdered, or who are hurting or in trouble, along with bathing beauties on beaches of places its readers cannot afford to go. It also features the wonderful, timeless prose of that lovely, soft lady Cindy Adams, and valuable musings from one Aileen Miehle, a/k/a Suzy, who goes to parties with rich, anorexic women hoping to catch a glimpse of Malcolm Forbes and Elizabeth Taylor.

The *Post* has no Ken Auletta or George Maksian (who writes of my calling in the *Daily News*, the first paper I read every day). It has no Tom Poster or Larry Cole or Liz Smith or Pablo Guzman or James Breslin, who can string words together that move people. Murdoch's rag has no Mike Winerip or Abe Rosenthal or Jeff Schmalz or Frank Lynn or John O'Connor or Phil Dougherty or Lynne Ames or Jim Feron, like the incomparable *New York Times*. It does not even come out on the newsstands with a bright, thoughtful Nancy Q. Keefe or a Jacques LeSourd or a cranky Milt Hoffman or a sensitive Bill Falk, like my hometown Gannett paper. The *Post* is thus utterly devoid of what Mario Cuomo, the failed baseball player with too many vowels in his name, would call "sweetness."

But it was Dicker who asks nasty questions which keep politicians honest—and sixteen hundred other people with families. And it must be saved from the vengeance of Ted Kennedy and from that Fritz Hollings from South Carolina.

Rupert Murdoch, who has big-time PR flack Howard Rubenstein and power lawyers like Howard Squadron scrambling on his behalf all over town—and with Robert Strauss doing his bidding down in Washington—is not the issue. The *New York Post*, in all its bias and grossness and vulgarity, is a newspaper that is read by hundreds of thousands of people who occasionally find a thoughtful sentence or, even more rarely, an idea that has escaped the better papers. It is put together and printed and delivered by those sixteen hundred people with families who must despise Murdoch although he has not missed a payroll—which brings me to his side in this issue.

Daniel Patrick Moynihan is going to use his considerable brilliance and his fresh, Irish tongue to try to outflank Ted Kennedy in the Congress. And Alfonse D'Amato himself is going down to Washington and merely wreak havoc on some Southern senators who do not care about sixteen hundred people out of work in New York. I hope these two unlikely allies can keep the *Post* going. The death of a newspaper is a bad story.

January 12, 1988

Bill Luddy: The Democrat

Westchester was, for years, a bastion and safe haven for the Re-
publican Party. There were few Democrats in those days—but
Bill Luddy was their leader.

"The man," said Jonathan Swift "who can make two ears of
corn, or two blades of grass, grow on the spot where only one
grew before, would deserve better of mankind and render
more essential service to the country than the whole race of
politicians put together." But he never knew William Luddy,
who announced yesterday that he would retire as Democratic
Chairman of Westchester.

William Luddy of White Plains, County of Westchester, is a
politician the way our fathers imagined them to be. He is of
the party of Franklin Roosevelt, Adlai Stevenson, John Ken-
nedy, and Hubert Humphrey—and he helped all of them.

It is not easy for a man to be a Democrat in affluent West-
chester, but Luddy made it a calling and gave it his own dig-
nity and grace. He led his broken, demoralized party out of
defeat and confusion. With perseverance, guts, wit, candor,
and charm, he made the two-party system in Westchester.
That would be reason enough to mourn his decision to step
down, but he also kept it going. He hung in there. The big
bankers, the utilities, and the contractors did not help with
the money—but he used ideas, words, and passion in place of
dollars.

You remember Luddy back in the 1950s when he would wel-
come young men and women into his small, unpopular politi-
cal party. The Republican Party was run by lawyers in White
Plains and by discreet telephone calls between Harrison, Yon-
kers, and Eastchester. But the young moved toward Luddy for
ideas in those days. And you watched Luddy keep it going
when the bucks got scarce. He gave it his own standing and
stature the year he had to install Democratic headquarters

next to a pizza stand in the urban renewal section across from where the Davega discount store used to be.

He was candid and honest with the press, which is why Milton Hoffman went out of his way in yesterday's papers to be nice to him. You could get a straight appraisal from Luddy on any of his candidates, even if they were less than stellar. And if you wrote a piece murdering one of them, Luddy would call you up after the broadcast to talk to you as if you were an errant son who just didn't understand what he was trying to do.

His finest moment came a few years ago at the Tarrytown Hilton. Luddy was one of three big shots chosen to receive an award from the National Conference of Christians and Jews. The speeches were long, and Luddy did not get a chance to speak until almost 11:00. By that time most of the phonies among the well-heeled crowd had departed anyway, the better to tee off at Winged Foot or Blind Brook the next morning. But Mr. Luddy got up and talked about brotherhood in a way those remaining in his audience had never heard—and it wasn't done in platitudes, but was one-on-one, and he had you living next door to a Jew and across from a Black family.

It was the finest speech on the subject of bigotry and hatred I've ever encountered. Luddy did not use a note. And because he delivered his comments to an almost empty room, there are not many people around who will remember what he said that night. But we will never forget the speech—or the man, William Luddy.

Our reporters would see him, year after year, at the Roger Smith Hotel—in a wretched banquet room of that shabby, rundown hotel—as the results from Republican Westchester came pouring in to defeat him. As Michaelian, MacCallum, and the victorious Republicans celebrated in proper fashion at a posh venue across town, I usually found Luddy working on a Scotch, talking about his Democratic Party, the two-party system, democracy, and America, which had much to learn about these things in 1971.

And there he was making a speech in the dreary Roger Smith at 2:30 in the morning with only one, single college student and his sleepy, bored girlfriend hanging in to listen to

this glorious man. We edged out of the ballroom at 3 A.M., and Luddy was still going strong. And I remember feeling very secure that night about this whole democracy thing as it came off his lips.

Soon Luddy will retire. The one consolation is that Max Berking will replace him. But when Luddy goes, he takes a big chunk of our past with him. His was the Westchester of Ed Hughes, Bill Fanning, Ted Hill, Charley Mortimer, Tex Cooke, Bill Butcher, Fred Powers, Ralph Tyner, Frank O'Rourke, Edwin Gilbert Michaelian himself, Arthur Geoghegan, and Malcolm Wilson. But they were the Establishment, while Luddy stood off and sang his song for the young, the poor, the townies. Your father and the people of the old neighborhood would have understood about William Luddy.

January 19, 1971

Whitney Moore Young, Jr.: National Leader, Mortal Man, Neighbor

Whitney Young, the national civil rights leader, lived in New Rochelle.

Whitney Moore Young, Jr., always believed in what his friend Senator Jacob Javits called "the genius of the free enterprise system."

Young was an extraordinary resident of our city and county, who plowed right into the conscience of the Establishment—and may have done more for Black men and women in our nation than anyone else. We are not forgetting Martin Luther King, Jr., and John Kennedy. But Whitney Young had a different approach, a different style. History may yet show us that he accomplished more in the board room than other civil rights leaders did in the streets. He did not come on, this man, like a Sherman tank or like gangbusters. Instead, he won to his side the big men in our country—and then enlisted them in his cause.

He would inspire men like Nelson Rockefeller and persuade corporate heads like DeWitt Wallace of *Reader's Digest* and Donald Kendall of PepsiCo to appoint African Americans to executive positions of their companies. Other civil rights leaders of his day started at the bottom—in the streets—and worked up, often to the accompaniment of unrest and tumult. Young started right at the top, and he never used his powerful and high-level contacts to his own advantage.

The articulate and soft-spoken man from Oxford Road, whose heart stopped beating on a beach yesterday in Nigeria, was a splendid model and an inspiration to all Americans. "Hang in," he said. "Trust in this country. Work hard and be-

lieve in the sometimes elusive magic of the free enterprise system."

The world was his stage. And yet, at a dinner party a few years ago, attended by William Paley, President Nixon, Henry Cabot Lodge, John Hay Whitney, and others of high estate, he bombarded his dinner companion with questions about Westchester schools and the city government in New Rochelle.

And last year, at the opening of the world headquarters of PepsiCo, we asked him how the giant bottler was doing in hiring minorities. He said they were doing better than most. And then, when he saw Donald Kendall coming, he winked at us and said, "I'm still selling." And then he put his arm around Kendall and walked him out into the sunshine to do a "little selling," as he called it.

The cause of free enterprise as well as the cause of civil rights has lost an eloquent and graceful champion. And Westchester has lost one of its most illustrious citizens.

Young was a classy man. His contributions in terms of self-confidence for his own people were immeasurable. He got his message across to all Americans, but he never stooped to conquer.

He was a national leader, but he was also a mortal man and our neighbor. As such, Young leaves a special family on Oxford Road, which has lost a husband and a father.

March 8, 1971

Joseph P. Vaccarella: Mayor Joe

Joe Vaccarella was Westchester's answer to Fiorello LaGuardia.

When the Honorable Joseph P. Vaccarella was mayor and then postmaster of Mount Vernon, he always seemed to be leading a parade. Nothing about Mayor Joe was ever routine or dull or ordinary during his time in the spotlight. He was a Westchester politician the way our fathers imagined them to be on the mean streets of our boyhood.

And now, as we were getting ready to celebrate the Labor Day weekend, Mayor Joe sat in Nick Yannantuono's Funeral Home on West Lincoln Avenue. He was there for the funeral of Josephine Vaccarella, his wife, who died last week at the age of seventy-nine. Four days earlier surgeons had installed a mechanical device called a pacemaker near his own heart. When Josie died, Mayor Joe checked himself out and took leave of the hospital to give her a proper funeral and to be with his friends.

"I lost my princess," he said to a friend from the radio. "She picked me up from a damn heart attack when I turned white and pale and got me into the hospital and then she went and died herself. . . . I never saw her again."

He is eighty years old now, this man. And all day and into the night the people of Mount Vernon came to be with Mayor Joe and his princess in the funeral home. The ladies came down out of the rest homes, where they are deserted and forgotten, and one of them said, "Joe, she looks beautiful . . . at seventy-nine . . . Joe, she's just beautiful."

They came from downtown, and they came off the streets to shake his hand and kiss him on the forehead and say a Hail Mary over Josephine. The men from the benches in Hartley Park were there, as well as the bocci players. It was almost like an Irish wake where everyone's name ends in a vowel.

Politics, here and everywhere, has changed. Now the effete, young men of the day talk of trends and strategies and issues. With Mayor Joe, there was always only one issue—people— which is to say a man or a woman and their problems. That's what a politician did, that's why he existed. He helped somebody.

Today, we demand our politicians to be good in front of a television camera. Joe Vaccarella conducted his business in one-on-one fashion on Fourth Street in Mount Vernon, and in Hartley Park. And now we elect men like Richard Nixon and Jimmy Carter, who went to three different churches in Plains this past Sunday. We like our leaders cool and calm and controlled. And above all they must have a "plan" that Jim Jensen can understand and describe in twenty seconds.

Joe Vaccarella does not belong with our current collection of politicians or, indeed, with James F. X. O'Rourke, the Republican Chairman of Westchester. One of the recent dues-paying members of Jim O'Rourke's county organization, you may recall, was Nelson Aldrich Rockefeller. And last week this fellow O'Rourke, who is of my own tribe, leaked word to the Gannett paper that Ronald Reagan, a former actor, is the leading Republican candidate to become President of the United States. For good measure, while he was at it, this same James F. X. O'Rourke was also telling people that his GOP associates "preferred" Jack Kemp, a former football player, over Jacob K. Javits, New York's towering and able senior senator.

Vaccarella would not go down so well in this crowd. His fraternity included Al Smith, Jimmy Walker, Jim Farley, and Bill Condon of Yonkers. Vaccarella was colorful, emotional, and passionate, and the people loved him for that. They still do. And on Friday, at Yannantuono's, they were remembering how Mayor Joe painted color and drama into their city and into their drab lives for fifty years. In one rousing campaign— the one in which his campaign manager dropped dead on election night—the big issue against the mayor was the allegation that young Joe Vaccarella had been rousted by the cops and spent some time in the slammer for "brawling" in front

of the RKO Theater—about thirty years earlier. That is what they meant by an issue in Mount Vernon.

And so the street fighter who became mayor and postmaster sat there with his pacemaker and his friends and his memories. When a reporter asked him what he would do now, Mayor Joe said some very unflattering things about one of the individuals running for election to his old job at City Hall: "I just want to stick around long enough to head off that . . . guy. He's a no-good S.O.B." And then he turned to shake more hands and to look at Josie—who did look lovely. It is Labor Day weekend. There should be a parade coming up Main Street and Mayor Joe should lead it.

September 3, 1979

Alex Norton: Robin Hood

It was 1982, and Alex Norton was seventy-five years old.

It is New Rochelle, but J. Ray McGovern and Christopher Murphy and Tommy Faso and Jenny Byrne Murdy are gone. Stanley W. Church is an old man and lives in Florida. Frank Connelly, Sr., the lawyer's lawyer, doesn't practice anymore, and his son and heir is now the most respected attorney in town. Fred Powers, who used to tell Nelson Rockefeller when to go to hell, went off a few years ago and just died after his youngest son, Peter, was killed. And Fred Powers, Jr., carries on the splendid tradition of this extraordinary family.

Although New Rochelle has changed, Alex Norton is still himself, as you will see Friday night at the Country Club of Westchester. The Griffin Boys—Peter and Bill—have gone off to Greenwich with Bob Crabtree. A library where they serve tea stands next door to where Paddy O'Neill's saloon used to be on Lawton Street. It is the place I took myself late at night to talk to P. J. O'Neill and to laugh and to drink. There were people and laughter on Lawton Street then, but now there are books and buildings where Arthur Geoghegan and Murph Streger and Bill Scott and Tom Burke told stories on each other.

So much of this town is gone—most of the Tocci family and Joe Jackson and Nick Donofrio. And down at the College of New Rochelle, self-styled "feminist" lecturers preach their gospel of liberation and entitlement and self-fulfillment, while next door, in an old Lorelei of a building on Hanford Place, two real doctors named Guerin and Fogarty struggle valiantly to save families and repair busted marriages and broken dreams. These men behind the shingle, which says Center for Family Learning, are losing. The feminist lecturers at CNR are winning.

But I am going Friday night to the fancy country club in

Harrison to listen to stories about Alex Norton, who ran our hospital before they started to refer to it as a medical center. I will remind Alex Norton how he hustled every rich guy in the county for over twenty-five years and picked their pockets to build a splendid hospital for anyone who was sick, for the people without influence in the community. He would charm the grieving widow whenever a well-healed husband kicked the bucket, and if you had the poor judgment to go to your Maker without leaving something of considerable value to your hospital, you were "out of order," as Alex used to designate anyone who ever missed an opportunity to help his hospital.

He was the spirit and energy and passion of that hospital, and he did a lot for those wonderful Irish angels of mercy— "his" nurses—who came to our city to care for and love our sick and dying. He would entertain them in a grand and lavish style at the Gaslight Club in New York, and then he would climb up on the stage to belt out tunes with Carl Anthony Vergari, the district attorney. And the Bronfmans, who own Seagrams, are rich today because of this man Alex Norton, who never missed a round or a check.

Alex Norton called you "Doctor" or "Commissioner" no matter who you were, and he was the one man in the entire city you wanted on your side in a tough proposition. He was there when you needed him. And maybe that's about the best thing any of us will be able to say about him Friday night at the fancy country club.

Norton likes cops and nurses and firemen and dieticians and bartenders and waiters and cab drivers. And he was half in the bag the night the ambulance brought in his millionaire friend, Wolfie Duberstein, who arrived flat on his back as Alex urged him to "hang in there, Wolfie. The hospital needs you."

They won't like me telling you this, but John M. Joyce III, the one they call "Mike," has flown Alex Norton's family in from all over the globe to be with this seventy-five-year-old man who left our city five years ago. Joyce III is the son of Joyce, Jr., the one who wears pigskin gloves. They are a nice family and a rich family, and I will be watching Friday night

when Alex Norton, after a few drinks, gets Mike's father, the one they call "Old Man" Joyce, over in the corner and whispers to him about giving another hundred thousand to the hospital. This will occur, because Norton is sure young Mike went for *round-trip* tickets for the Norton kids and grandchildren and, having thus assured himself that his family is home free, Alex Norton will hustle money for the hospital. It's just what he does. And Jack Joyce will give him another check, because it is what he does.

The White Plains crowd will not understand about Alex Norton and about our town. Al DelBello would not understand—and I hope he does not come. But a Sam Fredman and a Bill Luddy would catch the drift. And Mario Cuomo and Malcolm Wilson or Bill Olson, the banker, would pick up on Norton, and they would understand a little. So would Tony Colavita and Guido Cribari and Tom Dolan. Also the likes of Vin Bellew.

But remember, it is 1982. Hegarty, the police commissioner, is gone, and Bud Spillane has gone off to run the schools in Boston. Walter Bell is around, and so is Charles Librett and Les Albertson and Bob Fanelli. And John Fosina, the postmaster, still writes memos like Alexander Haig. Alvin Richard Ruskin, the mayor, is a big Supreme Court justice, and Bert Campbell is still a kind, nice man. But Hughie Doyle is gone.

The hospital, which is now a "medical center," runs like a top, and George Vecchione is quiet, solid, and about the best of his calling today. He has bought a lot of computers and fancy equipment with the money Alex Norton raised, but they still have some skillful doctors and dedicated nurses who smile when you're hurting.

Cesario's, where Stanley Church presided and where Norton performed, is now called Saparito's. Ben Mermelstein is still our judge, and Elmer Miller and Evie Haas are around. Sidney Mudd still sounds good, but Teddy Greene is sick, and Jack Dowling, the banker, beat back a slammer of a heart attack last year. So did our decent, respected new police commissioner, Mike Armiento. Jack Driscoll, the Christian Brother, is the most exciting act in town, and he is now the

preeminent fund-raiser of our heath. But Paddy O'Neill's, where I used to go late at night to laugh and drink, is gone. It is 1982, and Alex Norton is seventy-five.

May 11, 1982

Monsignor Edward Connors:
The Priest Who Sings

Monsignor Ed Connors lives in retirement at the Stepinac residence in White Plains. Although his eyesight is failing, he still says Mass at Our Lady of Sorrows Church. And he can still carry a tune.

On Sunday mornings in our pristine New York suburbs, the doors of Catholic churches are flung open to receive the faithful, most of whom, during the week, do their actual, heavy lifting with the Franciscans, in hushed tones and quite anonymously, at St. Francis of Assisi Church on 31st Street in Manhattan. Even the Governor of New York says, "We love the Franciscans, because they forgive us, gently and generously." Thus are occupied for purposes of salvation, the guilt-ridden castle Irish of Scarsdale, Bronxville, Eastchester, and New Rochelle—at least during the week.

But on the Day of Obligation, every Sunday, the action is at the Immaculate Heart of Mary Church in Scarsdale, where we are confronted in our rectitude, smugness, and fine clothes by a seventy-two-year-old Catholic monsignor named Edward Connors.

This is about Ed Connors, who has been a priest for forty-six years, according to the ancient rite. They come, these castle Irish, on cold winter mornings, to hear the old priest. And there are many ladies in mink coats who used to lunch at the Winged Foot Golf Club, until Donald Trump brought Marla Maples around. In some of the front pews you will see entire families with names like Rooney, Murphy, O'Hara, and Curry. In recent years, they have had to sit cheek-by-jowl with Indian, Hispanic, and Asian people, who also know something special is happening when this Monsignor Edward Connors steps out to open his arms and heart during the homily, which used to be called the sermon.

This must be called to your attention, you see, because a lot of clergymen and almost all the priests of my personal holy Roman Catholic Church resemble the rest of humanity when called upon to get up in front of a crowd. It is not a lovely thing to behold—or listen to. So it is a most unusual occurrence to encounter an actual person with a Roman collar who can take words and string them together in sentences that are always intelligent—and often lyrical.

Connors has been around awhile. He had several high-profile jobs with the Archdiocese of New York: superintendent of schools, spiritual director of St. Joseph's Seminary, and vicar of Westchester. Some years ago, they even made him a monsignor, which is a step removed from bishop—but he doesn't use the designation, preferring just "Father Connors."

When he is not saying Mass or doing parish work, Father Connors dispatches subtle, thoughtful notes to all sides in the abortion battle, trying to get the zealots of both camps to a common ground in order to curtail the number of abortions. It is this endeavor which recommends him to Mario Cuomo.

Father Connors is probably not as close to His Eminence John J. O'Connor, the present cardinal archbishop, as he was to his predecessor, Terence Cooke. But on local cable television and in interviews in the public press, Father Connors is an ardent defender of Cardinal O'Connor's stewardship. He's like this in private too. I once heard him, over a drink, tell George Bush's brother: "You should know how hard the cardinal works. We had neighboring rooms at the seminary last year, and I used to see the fatigue and exhaustion when he came home late at night from his ceremonial rounds. Often I saw His Eminence sitting alone eating a peanut butter sandwich at midnight in his T-shirt. He's quite a human guy, with a wonderful sense of humor."

Over the holidays just passed, Father Connors stood right in front of the altar of his Scarsdale church, avoiding the towering pulpit to his right, and addressed people who were empty and groggy from the commercial Christmas and the New Year's holiday, which is another "Hallmark Hall of Fame" day on the phony, meaningless calendar of our years. This is some of what he said: "I listened to a Jerome Kern lyric, 'I told

every little star,' and I wondered about that One Star, the Star of Bethlehem. God is often not the God we expect him to be. He came in poverty and weakness and in suffering, attended only by smelly shepherds. Human life has an intrinsic dignity of its own, a purpose. We find Christ in the events of life and in our human relationships. It is about music—the music of the heart. In songs we are not looking for scientific accuracy. Christ is a paradigm, a framework, a model, a Master Plan for human living. The Star of Bethlehem is a star of faith to illuminate your journey. Listen for the music of the heart. This is the song we sing. This is what we tell every little star."

As an out-of-control three-year-old strolled across the altar in front of him, Father Connors, without missing a beat, also told his rich Catholic parishioners: "When the song of the angels is stilled, when the star in the sky is gone, when the kings and princes are home, when the shepherds are back with their flocks, the *real* work of Christmas begins: to find the lost, to heal the broken, to feed the hungry, to release the prisoner, to rebuild the nations, to bring peace among brothers, to make music with the heart."

All this without notes.

Then, moving from one side of the altar to the other, edging closer to his flock, the old priest spoke these words: "This Christ, I tell you, is not what we expected. We find him not in a palace, but in a cave. He comes not as a warrior king, but as a tiny, powerless infant. He is a strange kind of king who now has a manger and one day, a cross, for his throne. But he *keeps* his promises. We can *trust* him."

As Ed Connors talks, his hands come up from his sides and go out to his audience, palms open, as if trying to explain all the things he knows about a carpenter's son attended only by smelly shepherds at his birth. The kindly eyes in his seventy-two-year-old face are a graceful and appropriate accompaniment to the music on his lips.

We hear about the smelly shepherds only at Christmas—but Ed Connors knows a lot of songs.

January 6, 1993

Nancy Q. Keefe:
She's Still There

Nancy Q. Keefe is the distinguished writer-in-residence of Man-hattanville College. Her wisdom, insight, and friendship have been so important to me over the years.

Nancy Q. Keefe, the pre-eminent journalist during our time in Westchester, is throwing herself a party on Saturday night to celebrate just being alive. A better reason I could hardly imagine—for this Mrs. Nancy Q. Keefe is absolutely so damn special.

You may recognize the woman by another name. Some of the haters who call on our "Westchester Open Line" radio program to register their great, unqualified lack of admiration for her wonderful, bright newspaper columns refer to the Larchmont lady simply as "that goddamn Nancy Keefe." This appellation is usually delivered without pause or breath.

Well, Mrs. Keefe is still around after having confronted, five years ago—and every day since—the cancer a woman fears most. She did this with the help of her husband, Kevin, her kids, and more than a few friends. I can tell you of one in particular—the former head of the Cancer Society in Queens: Matilda R. Cuomo, who had the state health commissioner of the day personally threaten to revoke the charter of John Spicer's magnificent Sound Shore Medical Center in the event anything should happen to Mrs. Keefe. And Matilda Cuomo's husband, who has nothing else to occupy his time, was not a pretty sight himself, worrying about the illness of the woman who "reads" *him* better than anyone in the national press.

I, of course, being a fair-weather friend, could not deal with any of it. So I closed my ears to any talk of Nancy Keefe's operation or things like radiation or chemotherapy. I did this by refusing to take Cuomo's calls inquiring about her condi-

tion, and I even crossed the street when I saw Miriam Curnin, the mayor, or Nita Lowey, from Congress, because I just knew they would want to talk about the terrible thing that befell Nancy Keefe. But unlike those caring and concerned souls, I was out in La-La Land for most of it. For you see, it was for me simply *unacceptable* that Nancy Keefe should cease to be around—in my morning paper three times a week, and in my life all the time.

So this "survivor" business was a solo flight, which the woman did without any brave words or prompting from Bill O'Shaughnessy, who was nowhere to be found, because he is basically a selfish person who could not accommodate even the slightest suggestion that Nancy Keefe might not exist to make me think, and smile, and even on occasion cause me tear-duct problems with the graceful words that come out of her head and through her fingers onto a typewriter to be laid down in a newspaper that lands on my sidewalk at 5:30 in the morning.

Which reminds me that two fellows who really *should* re-joice in the lady's accomplishment are a Mr. Ken Paulson and one Gary Sherlock. They run the mighty Gannett Suburban newspaper company which, if anything should happen that might leave Mrs. Keefe unable to continue her columns three times each week, would almost surely find themselves presiding over a new entity known as The Gannett Westchester *Bowling Alley*! She is that strong and that good, as I expect Paulsen and Sherlock know without any prompting from me.

Of course—and I must at least attempt some objectivity about Keefe—she does have some major character flaws. The lady does not listen to me when I attempt to lay magnificent stories at her doorstep that might help one of my friends and thus increase my own importance around here. That is *one* great failing of the woman. Another is that she does not automatically like every Republican—which will hold her back in this county.

And her worst trait is that she sometimes *worries* about those she covers and writes about. Like when she told Mario Cuomo that she did not want a good man like the governor for president, because you couldn't do it and—are you ready for

this?—*keep your soul*! So, because she worries about some aging, failed baseball player's *soul*, there goes our invitation to the White House! Maybe even an ambassadorship for the Honorable Kevin Keefe!

But I guess the woman does the best she can with the limited talents God gave her—those unique gifts she brings to her writing, which include intelligence, toughness, integrity, and that commodity only Mario Cuomo, among men, speaks of these days, called *sweetness*.

It's hard for me to be objective about Nancy Keefe. I like her writing, and I love the woman.

Those of you who don't, check Sunday's paper. *She's still there!*

June 10, 1994

The author's former partner, Harry M. Thayer. Together they acquired the Herald Tribune Radio Network from Ambassador John Hay Whitney. Thayer was a vivid figure in the Hudson Valley and once served as general manager of the Philadelphia Eagles. (*Robert H. Kuhnke*)

WNEW all-stars: (l to r) William B. Williams, the author, Gene Klavan, and Dee Finch, in the legendary "Make Believe Ballroom" studio in Manhattan.

John Van Buren Sullivan, the last majordomo of WNEW. New York Giants coach Allie Sherman is at right. The author eulogized Jack Sullivan as "the last great broadcaster with style." At left: Ed Sherman. *(Gonda Studios)*

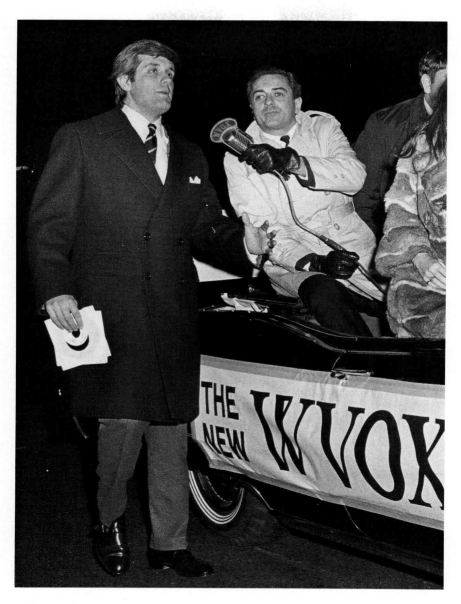

The author, with John Haidar, broadcasting live from a parade. Events like this were opportunities to get out of the studio and meet the people in order to raise support for the station, which the *Wall Street Journal* has called "America's quintessential community radio station." *(Robert H. Kuhnke)*

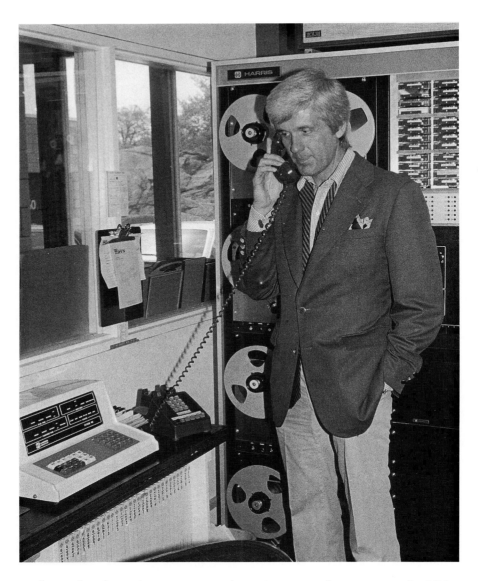

The author launches WRTN as the only non-rock station on the FM
dial in the sprawling New York market. O'Shaughnessy took a nos-
talgia format and "classed it up" as "the country club sound."
(Grzegorz Rogínski)

The WVOX crew covering the Westchester Golf Classic. While other radio stations concentrate on football and baseball, "the voice of Westchester" gave lots of airtime to major golf and tennis tournaments at Winged Foot and Westchester Country Club.

The Mothership: WVOX and WRTN headquarters in Westchester. The building was designed as a class project of the Columbia University School of Architecture.

The author and the legendary saloon-keeper/restaurateur Toots Shor at a party for Bob Considine, the author of *Toots*, a tome about the New York nightlife that has all but disappeared.

William B. Williams (l) and café saloon singer Hugh Shannon. The author eulogized both men. The WNEW disc jockey and the café society performer were icons of the entertainment business in the seventies and eighties.

The author with Dick Clark and his wife. Clark and his partner, Nick
Verbitsky, have radio as well as television interests. *(Mautner)*

Nancy O'Shaughnessy with Sirio Maccioni, America's greatest res-
taurateur. Though the French still think it's all about food, Maestro
Sirio adds style, dynamism, and glamour at Le Cirque 2000.

The priest who sings, Monsignor Ed Connors. His sermons inspire the author and thousands of his Westchester neighbors.

Vincent Bellew:
The Bard of the Real People

Vin Bellew was a high school coach, bank chairman, and columnist for the Martinelli weekly newspapers. He wrote with his heart on his sleeve.

Eastchester has the strongest sense of community among all the towns, villages, and hamlets we are privileged to serve. And until this past weekend, Eastchester also had Vincent Bellew.

Vin was the quintessential "townie" in one of the few Westchester places that hasn't forgotten where it came from. In Eastchester, there is no Starbucks where people in designer jeans drink hazelnut café latte. But there is a volunteer ambulance corps, fire department, and almost a hundred civic associations and fraternal organizations. Patriotism and love of country are the national religion of the place. Eastchester is relentlessly, unabashedly, and resolutely Middle America.

It was here in Eastchester that Vincent Bellew lived out his eighty-four years. He died over the Memorial Day weekend, and I feel a tremendous sadness about the passing of this dear, sweet man. For among his enthusiasms were these radio stations.

The local newspapers recited for you his many achievements: coach, teacher, banker, bank chairman, recreation superintendent, civic leader. Vin was also one of our favorite writers. He wrote of his neighbors as if they were the most important inhabitants of the planet. Week after week in the Eastchester *Record* he exalted the everyday accomplishments and celebrated the milestones of the ordinary, struggling men and women of his home heath in columns filled with passion, admiration, and love. Vin wrote with his heart on his sleeve in an extravagant style as dated as the sentiment that came from

his mind and heart. He created words that were strung together into paragraphs that made people reflect and smile—and sometimes cry.

While other writers squandered their talents on the so-called great issues of the day, Vin wrote of Little League fields, the Eastchester Ambulance Corps, Memorial Day parades, flags, banners, band concerts in the summer, cemeteries, hero cops, volunteer firemen, Italian civic associations, high school graduations, Mike the Barber, Harry Truman, Ed Michaelian, Andy O'Rourke, Nat Racine, the cadets at West Point, Nelson Rockefeller, Cornell's Hardware, Vinnie Natrella, his wife, his students, his teachers, his daughter, his son, his town.

The only pedigree you needed to qualify for this man's imprimatur was a street address in the zip code 10709. He wrote of priests and nuns, and of nurses and doctors who still make house calls in the middle of the night. He celebrated Eagle Scouts and Big Brothers, and he loved books and snowfalls and blizzards and the flowers that come with the springtime of the year. This bard of the simple folk noticed everything, and he gave us the gift of times we never knew: when Tuckahoe was a quarry and trucks brought coal to warm us in the winter and wagons dispensed blocks of ice to cool us in the summer.

Those of pretense and standing and high estate were not deemed worthy of his pen. Vin could find no magic in the lives of those who merely use Westchester as a bedroom, the ones who take and put nothing back. His love and attention were reserved only for the townies and their children.

His editors referred to the product of his generosity and genius as "columns." Rather, I think, they were love sonnets that resemble, more accurately, the written history of life in Eastchester for the last fifty years. And as we recently suggested to Mary Angela and Robert Bellew, they must be preserved. Some merchant prince or banker or rich individual should promptly dispatch scholars to go through Vin's lovely legacy and publish his reminiscences and reflections for future generations.

All his life, Vin tried to tell us what we had. But all I can

think of, as I sit at the microphone this morning, is what we lost.

And I'm also recalling a marvelous, but all too true, observation by the auto magnate B. F. Curry, who is also my father-in-law. He said: "It seems like people are dying these days who aren't supposed to."

Vin would have loved the line.

May 29, 1996

Vincent de Paul Draddy:
InVINcible Draddy

Vincent De Paul Draddy founded the Football Hall of Fame in Canton, Ohio. There is a sports arena named for this generous, attractive man at Manhattan College in the Bronx, and an indoor ice rink at the Canterbury Prep School in New Milford, Connecticut. He made the Izod shirt into a status symbol of the 1960s. I last saw him coming down the staircase at "21" and heading straight for a good-looking society dame selling chances for a tony charity. Vin Draddy flipped her a C-note.

Saturday night is the only time to have a party. The hilltoppers and the WASP elite conduct their excuses for a party during the week. But if you are Irish, the only decent, really respectable time to party is Saturday night. This, then, is about a New Rochelle boy who made good, and about a party he gave himself.

It was thus entirely fitting and quite proper that Vincent de Paul Draddy should celebrate his birthday and his retirement on January 31, 1976, a cold, Saturday night.

Vincent Draddy lives in Harrison now, on the grounds of the Westchester Country Club, and he is the number one benefactor of the Football Hall of Fame in Canton, Ohio, where one day his neighbor, Wellington Mara, will be enshrined. But anybody who goes way back in our city of New Rochelle knows that this town also owns a substantial piece of this amazing man.

Back in the early 1920s, Vincent Draddy came off Sickles Avenue to become one of the greatest football players in the history of New Rochelle High. Fifty years ago, he was a big, tough, handsome, Irish, townie kid who played end, fullback, and halfback on our Purple Wave teams in 1923, 1924, and 1925. The headline writers of the day called him "InVINcible

Draddy," and one write-up of the 1926 New Rochelle–Mount Vernon game started "Draddy 7, Mount Vernon 0." He was the biggest, fastest charging player of his day, and they made him captain of the Purple Wave.

After setting records for New Rochelle, some of which still stand, Draddy went on to become captain of Manhattan College. New Rochelle's hometown legend next charged into Seventh Avenue, where his genius, imagination, and charm enabled him to build a small David Crystal company into an international giant. Those Izod and Lacoste and Alligator trademarks made him a millionaire.

Last week *Women's Wear Daily* announced that Draddy was retiring from the clothing field, but nobody at his party Saturday night was making any predictions beyond that. His staff thinks "Big Daddy," as he is known very discreetly and affectionately, will still be active as a sportsman and philanthropist.

And so on Saturday night, 125 people—great squires, high rollers, and heavy hitters—came in black tie and formal evening wear to the Westchester Country Club to be with the New Rochelle boy who made good. No one knew which birthday they were celebrating. Draddy himself has been spreading the word for months at the "21" Club that it was his fifty-fifth. The smart money, however, was on the number sixty-nine or seventy.

It was a hell of a party. John Raitt came up from the Broadway show *Jubilee* to sing and, with Stan Rubin's Tiger Town Five playing society music, the aging Lorelei, which is Westchester Country Club, really rocked. But I saw it as an Irish party, and all the giants and elders of retailing, banking, and communications couldn't spoil it. When an Irishman makes it big, he can go one of two ways. Some, like the Buckleys, become castle Irishmen and resemble WASPs if you leave them alone long enough. Others, like Vincent de Paul Draddy, from Sickles Avenue by way of New Rochelle High School, enjoy the "finer things," but never forget who they are. He will raise money for Israel and make speeches and run fund drives for hospitals and colleges—and he will sit at "21" at a better table than even Aristotle Onassis used to get. And last Saturday

night Vincent Draddy sat at his own birthday party in the Westchester Country Club, discussing the great issues of the day with merchant princes and telling about the "special obligations" and responsibilities which are unique to the Irish. He wore a black tie, and he looked very successful, but he still has the look and the lilt and the style they wrote about on his page in the yearbook fifty years ago. And when you are crowding seventy, you want to look and think like him—especially if you're Irish.

February 3, 1976

Edson Arantes do Nascimento: Pele, the Teacher

I have never seen an athlete of such uncommon grace and skill as Pele. Before Michael Jordan, there was this dazzling Brazilian who taught the world soccer.

Jimmy Cannon called sports "the toys of a nation," and many have tuned them out in recent years. But all of us, whether we follow them or not, can take considerable pride in the New York Cosmos team, which yesterday became champions of the North American Soccer League.

This has been the breakthrough year, as the *New York Times* called it, for soccer in America, and the credit belongs not alone to the generous bankroll of Warner Communications, but mostly to a joyful, graceful man named Edson Arantes do Nascimento. We know him as Pele.

Pele is a real, genuine, original, true, simple star in every sense. There is more joy, eloquence, and grace in this man they call the "Black Pearl" and the "King of Soccer" than you will find these summer days in the entire Yankee Stadium.

To understand why soccer is growing, you only have to visit Yankee Stadium. Where once Joe DiMaggio, Mickey Mantle, Whitey Ford, and Allie Reymonds performed in the afternoon sun, you'll now find surly, introspective, self-centered businessmen playing for their lawyers, business agents, and accountants—uncaring and oblivious to the fathers and sons who have paid to see them compete. In fairness, our Westchester neighbor, Robert Merrill, the great singer, disagrees with us about this. He maintains that today's Yankees are really a good, if misunderstood, bunch of fellows. But to many, the New York Yankees, league leaders or not, have become sullen, dour, colorless imitators of the great Yankee legends of old.

And then there is this Black Brazilian, the one they call Pele, who yesterday went out a winner. You knew it would happen that way when it started to rain just before halftime. In the swamps of New Jersey, they call this "Cosmos weather," and when Giorgio Chinaglia, the big, exciting center forward from Italy, headed the winning goal into the net, Pele became almost like a child in his joy.

Watch as Franz Beckenbauer, the proud German known as "the Kaiser," makes his graceful and classic moves. Behold even the cocky twenty-one-year-old Steve Hunt, who earlier this year gave thirty-five thousand people a glorious Rockefeller salute with his middle finger after the crowd got on him for an error. And when you do watch them, it is not hard to understand about soccer and those thrilling vibes that run back and forth between the players and the spectators in this international sport.

But the New York Yankees wouldn't know about any of this—except for Billy Martin. And so yesterday, on a hard, erratic playing field in the Pacific Northwest, Pele won the American championship for those youngsters in Larchmont and the Bronx, in Pelham and Rye, who are just discovering the lovely game he has distinguished for so long—the game he taught us. And can you imagine what Pele said in the dressing room after yesterday's championship, his final championship: "God has been good to me. I can die now." Could you imagine Reggie Jackson saying that—through his lawyer?

There are no more good sportswriters around. Jimmy Cannon is gone and Jimmy Breslin writes now of murderers and politicians. We wish Jimmy Cannon could have told us about Pele and what he means to our children—and *why*. More than athletic ability, we think it has to do with basic simplicity, eloquence—and joy.

August 29, 1977

Bert Williams:
Mr. Soccer of Westchester

Soccer came roaring into the suburbs back in the 1970s, and Bert Williams was one of the heralds of this graceful sport from Europe.

I wish Jimmy Cannon were still around. I would have him get on this radio station today and do this piece for you about Bert Williams, the old soccer coach.

In this country in the 1970s, there was a rich, beautiful Brazilian man named Edson Arantes do Nascimento. Our children called him Pele. In those halcyon years, other great international soccer players came to America to perform. The Ereteguns—Ahmet and Nashui—persuaded Franz Beckenbauer, the graceful, poetic German, to come over from Europe, and a flamboyant, spectacular Georgio Chinaglia left Italy for the Meadowlands. Even the majestic Johann Cruyff departed Holland for a few, brief cameo appearances on the playing fields of these shores. But the Black man, the one they called "the Pearl," was the greatest of them all. He inspired a whole generation of kids who were not big enough or strong enough to play basketball or football.

But Pele, as great as he was—and he may well have been the most awesome, thrilling athlete of the time—was really only a performer, a dancer. If soccer was ever to take hold in our nation, it had to happen in our neighborhoods, and there had to be a Bert Williams to choreograph it.

He was Mr. Soccer of Westchester. He was a teacher of our neighbors' children, and he taught our youngsters as much about this lovely, elegant sport as any of the international, professional stars. Bert gave the game to thousands of boys and young men, one at a time, patiently and lovingly. He was head soccer coach at our high school and then at Iona College, and it was always a struggle. Macho Irish and Italian fathers at

Iona Prep and elsewhere wanted their sons to play football. And Bert had to fight for those young boys who would never grow up to be big garbanzo bone crushers like Marc Gastineau or Refrigerator Perry.

Bert Williams was a lonely man fighting for this refined sport, which rewarded speed, quickness, agility, and grace in lieu of brawn, bulk, toughness, and meanness. When soccer started to catch on in Westchester, he had to fight off suburban fathers who wanted to organize the sport for themselves, just like the Little League. There was more than one confrontation between Coach Williams and gung-ho fathers who would leap out of their Jaguars and Mercedes to run up and down the sidelines and scream at their sons as they had done earlier at their business associates. Bert tried to protect our children from our awful, relentless, competitive instincts, and from our aggressive, hostile behavior. When they tried to organize and institutionalize soccer, and even to segregate it by neighborhoods, he kept the focus always on one fast, gutsy kid in shorts coming down the pitch and making a move on goal.

Bert was clearly an instructor of more than soccer. He taught suburban fathers as much about behaving on the sidelines as he taught their sons and heirs about moving on the field. It was marvelous to behold. And as brains, skill, and quickness were the only gifts required to excel, girls could play at this game. Bert Williams encouraged a woman now known as Ann Thayer to start the first girls soccer team in our city. He fought City Hall and took on the politicians to get more playing fields and umpires, and he nagged at athletic directors and college presidents to put more money into soccer.

And even after major league, professional soccer lost its cachet when Henry Kissinger no longer came in his helicopter to watch the Cosmos at the Meadowlands, there was still this soccer coach, every spring and fall, out on the field with his arms around some slim kid, teaching him how to read the goalie's eyes and how to use his left foot. On Saturday mornings he would be on this radio station, talking up soccer. But he was at his best showing that kid to move a ball across midfield toward a soccer goal.

November 8, 1985

Marty Servo:
Memories Are Trophies

I sometimes think I squandered half my life covering civic dinners at Glen Island. Many were organized as tributes to politicians. But not always.

Marty Servo sat in a gin mill on Saturday afternoon on Drake Avenue in New Rochelle. It's called Ring 30, and Scoop Gallello runs it—and it's where the fight crowd hangs out in our town. Scoop Gallello had brought Marty Servo all the way from Pueblo, Colorado, to be honored at a big dinner, which was being tendered for him at Glen Island Casino.

And, now, on Saturday afternoon, they had Marty Servo sitting on this chair in the middle of the barroom floor at Scoop Gallello's place, where they have go-go girls on Saturday nights. The skills are gone from Marty Servo. The years absconded with them, and time is the embezzler—and cancer. But Marty Servo holds onto the prizefighter's dignity that the thief, cancer, can't locate. And this dignity about the former Welterweight champion is all he has left, and it is becoming extinct in this generation of effete young men.

This dignity is what Marty Servo brought to Scoop Gallello's gin mill and to our city Saturday. It is all he has left, but it's genuine and rare, "unshatterable" as a diamond—and as precious, if you were a world's champion. The rings of many towns are dappled with the crusted stains of Marty Servo's blood. And Chico Vejar, who works for Dave Osterer, was talking to Servo about how it used to be.

Memories are the trophies of life, and on Saturday, Marty Servo knew he would be honored at Glen Island that night. He also knew that Barney Ross and Packey O'Gatty were honored last year, and he knew they were both dead now, just one year later. His heart, beating inside the body like a fierce

panther, blinded and caged, seemed incapable of moving the cold blood through the arteries of Marty Servo's rebellious and cancer-ridden body. His mind operated as though it were another man's head. The legs were disobedient and created the illusion that Servo was using stilts.

They had a sign up on the wall, and Scoop was selling Al Volpe's hit record of "Forgive Me" for just sixty cents. The sign said, "All donations accepted"—here in this tavern with the go-go girls—"for a fighting champion."

The kids of today don't know what Marty Servo means. They don't know, because a young man in his twenties came in. He needed to cash a check and he needed a shave. Scoop Gallello was behind the bar, and this kid in his twenties bit down hard and asked Scoop to cash him a check for fifty-nine dollars drawn on the account of a company called the R.E.C. Corporation. The kid brushed past Marty Servo sitting there and, as Scoop gave him fifty-nine dollars, the kid asked if there was a convention—and some of the Ring 30 crowd just looked at him. It was a good thing the kid left when he did.

Marty Servo coughed—he coughed real hard and lit up one of those new, longer-length cigarettes that they hawk in the jazzy TV commercials with a man's beard going up in smoke. And Servo was telling Chico Vejar that he fooled all the doctors who said he would never walk again, and he banged the legs hanging over this chair and said, "They're dead, you know, just dead weight." Meanwhile, calls were coming in from all over: another old fighter calling in to find out how to get to New Rochelle from Newark by train.

Later on at Glen Island, they were bringing money up to Marty Servo—hundreds and hundreds of people. And the smoke was very thick from these very long cigars. It was the loudest, noisiest crowd we've ever seen at Glen Island, as Ed Dooley, the boxing commissioner who was KO'd by Ogden Reid, got up to talk.

Mayor Alvin Ruskin was there, too, and he was talking nice about a man named "Iron Horse" Joe Sturino. It was so noisy that only a John Fosina or a Joe Vaccarella could have quieted them down. And Hughie Doyle rounded up twenty shipmates to salute Marty Servo, which is the kind of thing Hugh Doyle

does if you were in the Coast Guard and in trouble. And, as a matter of fact, Doyle would probably do it for you if you were just in trouble—period.

The young high school kids and college students sitting around your breakfast table this morning may be bored with this piece about a man they've never heard of named Marty Servo. But if they understand about Marty Servo, you've raised quite a kid who'll realize some day that memories are trophies: the trophies of life.

1967

Nick Manero:
The Man in the White Hat

*Many Westchester youngsters were practically raised at Man-
ero's restaurant in Greenwich, Connecticut. It was one of Amer-
ica's first steak houses.*

This is a restaurant review, a very personal restaurant review.
But I'm not very good at restaurant reviews, ever since Cliff
Weihman, the millionaire from Pelham, ruined every restau-
rant for me when he said, "The best restaurant is the one
where they know you the best."

For me, flat-pocketed or flushed, it has always been Nino's
in the country, or "21" in the city. But I am a son of my mother
and father, and I can remember birthdays at Manero's in
Greenwich, the singing waiters, the Coke "cocktails" loaded
with cherries, the parfaits. And I can remember the man with
the big chef's hat, Nick Manero.

In those days, Bud Collier, the original Superman, would
be there. Of an evening, you would see Claude Kirchner, the
star of early television, and Mel Allen, the "Voice of the Yan-
kees." But most of all I remember Nick Manero—and so many
long years later, I took my own, young family to Manero's.

In the old days, we had to scramble for a parking space on
Steamboat Road. Now there is a big, ample, well-lit parking
lot down the street from Manero's package store, Manero's
restaurant, and Manero's meat market. Inside the restaurant
on a Sunday night in October, there is a line. Ken is still the
bartender; Daisy passes out menus; Smitty is the manager;
and Frank, who has been there for eighteen years, still waits
on tables with Dino, who is nice to the children. The other
waiters are younger. Nick Manero, Jr., also known as Nicky,
clearly runs the place. The onion rings are still too greasy; the
garlic bread is too fierce; the steak is superb.

Early in the evening, the crowd looks "touristy," but as the night wears on, it gets sweller. The Greenwich crowd, the locals, and the country squires with their pastels come in. And still there is the old man. Nicky has been assuring the faithful: "He'll be here soon." And Smitty has been promising: "I'll bring him right over." So, after awhile, here in Manero's on a Sunday night in October, when other men his age are retired, there comes the smiling man with the glasses and the tall, white chef's hat.

Nick Manero is older, damned near eighty, but the eyes are bright. His patchwork golf slacks are impeccably tailored, and the handkerchief in the hip pocket is poised with the same élan. He hasn't played golf in two years, which means a lot of caddies have had to fire their accountants. The step is slower, but the old man with the big white chef's hat still works the tables. Each kid gets a knock on the head, and the girls get a wink. The waiters are still unflappable in this family restaurant. The kids still get their Coke "cocktail" before you get your shooter. And Al from the meat market still comes through to see who's there after his long day.

Were this a legitimate restaurant review, I would have to disqualify myself. Manero's is beyond stars or ratings. It is a part of me. It is a part of all of us when we were young.

I love the old man in the white hat—and I stayed away too long.

October 9, 1978

Tocci, Jackson, and Now Jimmy Lennon

The old Irish women of my father's generation would leave you nothing with their old wives tales if you let them. It came off their sainted lips as gospel that disaster and tragedy were sure to be visited not once or twice but *three* times. I remembered this gloomy prediction of my boyhood when I heard that Jimmy Lennon, the leader of the Civil Service Employees Association, died this week. He was the third one all right.

Tony Tocci, Joe Jackson, and now Jimmy Lennon: an Italian, a Black man, and an Irishman. Three men from New Rochelle who loved the town and who gave it more than they took from it. Three labor leaders: Tony Tocci, Joe Jackson, and Jimmy Lennon. Three men with influence far beyond their home heath. They messed in everything, these men—politics, unions, civic works.

Men die every day who go to their Maker without fame or reputation. Their passing is a private matter for their immediate families. The obituary writers struggle for details and affiliations with worthy causes and charitable organizations. With Tony Tocci, Joe Jackson, and now Jimmy Lennon, they didn't have to struggle. The fabric and landscape of the city is covered with the good works and achievements of these three.

The three of them were brick walls of men and their ample girth showed the ravages of too many civic and political dinners.

Tocci . . . Jackson . . . and now Jimmy Lennon.

Damn it that those old Irish women are right.

February 12, 1981

Napoleon Holmes: The Advocate

Nap Holmes drove the politicians and cops crazy, always stick-ing up for someone in trouble. He also spent a lot of time at our radio station, pleading for his cause du jour.

If Napoleon Holmes did not exist, our community would have invented him. He was—and continues to be—a champion and advocate for the poor of our city, the forgotten, the misunder-stood, the despised, the friendless, the hurting, the afflicted—and especially and always, those in trouble. Like a heat-seeking missile, he is drawn relentlessly, inexorably, and surely to the side of those who have no defender, those who are without hope, those in this city who have no standing or high estate. This man sings for the little people, on the street corners, in our neighborhoods—and I cannot imagine this town without him.

First of all, he is aptly named: NAPOLEON! Napoleon Holmes: a strong, vivid name for a strong, vivid leader! Could you imagine if his father, in a moment of fancy, had named him "Timothy" (no disrespect, Mr. Mayor!) or "Sandy" (or to you, Judge!) or "Fred" or "Bill"? No, Napoleon is just fine for this warrior, this advocate, this windmill-tilter, this trouble-maker. Napoleon will do quite well, thank you.

I inquired of Hugh Price, our neighbor who is head of the National Urban League, what the proper, respectful "designa-tion du jour" might be for a Black man or woman these days. He said it's all "irrelevant" now anyway, because he has been called six different things in his lifetime, which is our lifetime. From Colored to Negro to Black to African American, and now to just "American," which is how it was meant to be and how it should always have been.

I don't know about the national "politics" and nuances and

rivalries and fiefdoms of the civil rights movement. I only know that during my time on earth, in my city, the NAACP was the most active, the most intelligent, the most effective instrument for change, for fairness, for equality. While the NAACP—nationally—helped push open the doors to integration and led the way to the passage of the Civil Rights Act of 1964, the Voting Rights Act of 1965, the Fair Housing Act of 1968—while all this was going on in Washington or Albany or some other place—Nap Holmes was here, out on our streets, advocating, preaching, encouraging, pushing, nudging, suggesting, pleading, stirring things up and calming them down.

For example, he was down at City Hall in the corridors of power (and more often than not, on the sidewalks outside City Hall), marching, picketing, screaming for change and simple fairness. He was in our courthouse, at the side of our young, those who could not afford the big lawyers in the Pershing Square office building or down from White Plains. He was at the newspaper, with Elmer Miller and Walter Anderson and Phil Reisman and Bill Cary, demanding coverage—and at WVOX, the radio station, insisting that his point of view be heard. Our editors and executives have had countless calls and visits from Holmes, always about someone else—never for himself or his own family. His "projects"? "Get this fellow in a nursing home." "Get this woman, a widow, in the hospital." "Get this youngster in college—or in the civil service or in the police department or into church!"

What Napoleon Holmes was, ladies and gentlemen, and what he is to this day, is an advocate—an advocate whose legacy of fighting for unpopular causes will shine over this city like the Northern Star, giving direction and guidance to civil rights leaders—and civil servants—well into the next century.

On Friday, just a few days ago, in the rain of New York City, I went, alone and unannounced, to a campaign appearance of the governor, just to see how well he was doing. He was doing fine, but in that rain last Friday, Mario Cuomo, another fighter of conscience I greatly admire, said these words: "Everything I know of value or worth started as something unpopular. We believe in grand aspirations. And we don't believe in pulling up the gangplank."

If we need any more inspiration we should keep in mind one of the marvelous descriptions of the NAACP that came out of the civil rights movement. It describes both the organization and its instrument—the man you honor, Napoleon Holmes: "The NAACP's quiet, effective struggle is like the power of the sun. True power never makes any noise. The sun is powerful. It doesn't argue with the nighttime. It just smacks the nighttime right out of the sky!"

1991

Evie Haas:
A Very Good Lady Is Watching

Evie Haas was everywhere apparent as a volunteer for damn-near every worthy cause. She was also a regular at our St. Patrick's Day broadcasts. She adopted WVOX early on.

Evie Haas died last week. She was a bachelor girl, as the women of my mother's time called them. Miss Haas was a townie lady in every sense of the word, and among her passions were her church, her friends, and her beloved New Rochelle. And as she was also known to enjoy a cocktail of an evening, I liked her very much.

You thought Evie Haas would always be around, because she was always around. Her enthusiasms included our community radio station. She knew all the announcers and came to all our broadcasts, usually armed with an "announcement" for her church or one of the civic organizations that enjoyed her favor. Kay Patterson and Bill Cary of the *Standard Star* will confirm that Evie was also a weekly visitor to the city room of our local newspaper for much the same purpose.

I was sad when word of her passing was relayed to me on the Via Veneto on a spring day in Italy last week—sad that I was out of town and that we would never hear again from this marvelous old gal. But then in our mail over the weekend, postmarked "28 April," came a flyer for "The Fifth Annual Car Wash and Plant Sale" sponsored by St. Luke's Lutheran Church, to be held this Saturday, May 9, from 9:00 A.M to 1:00 P.M., on Eastchester Road. It was signed, "Evie Haas." A note added: "Also . . . please don't forget: Plants for Mother's Day."

Dispatching this most recent public service announcement for her church had to be about the last nice thing Evie Haas did during her time in our city. It wasn't the first.

The good, it would appear, really does live on after all.

That car wash starts at *9:00, this Saturday, at St. Luke's on Eastchester Road*. And don't forget the plants for Mother's Day. I have a feeling a very good lady is watching to see that you do the right thing.

May 5, 1998

Jenny C. Murdy: She Came Away with All the Votes

Jenny Murdy lived in quiet obscurity in a row house, but she had enormous power up in White Plains, the county seat.

Sometimes you get sick of politicians. You get sick of them because of the way their hands sweat and because of the way they stand too close to you when they talk. It is even part of the folklore of our country that they are a corrupt, evil lot. But if this is really so, how do you ever begin to explain a Jenny Murdy?

Jenny is still, at eighty-one, a politician, and last night she came away with all the votes. This old woman, who cannot see, threw a party for herself. Oh, Teddy Greene helped get it going, but Jenny C. Murdy was on the phone yesterday making "damn sure" the right people showed up. They were all Republicans last night, and they all go back a long way with Jenny C. Murdy.

Edwin Gilbert Michaelian, the County Executive of Westchester, stood in the basement of a bank on North Avenue last night and set the tone for Jenny's party. "It is a sentimental night," said Michaelian, "and filled with nostalgia." Michaelian was surrounded by a lot of people who keep an eye out for this old dame. There was Lenny Rubenfeld, who is the only judge I ever met who is loose and at ease with the people he must judge. He's going to the Supreme Court soon. And there was the lean and ramrod-straight surrogate, Otto Jaeger—and your lawyer will tell you how important he is, because the surrogate gives out the plums. And there was elegant, articulate George Burchell from Mamaroneck, who is a judge, and Frank Connelly, the great lawyer who knows as much as any of them. And they were all sending love waves at Jenny Murdy.

But Jenny's inner circle was there, too. And Michaelian probably will not talk to me for a good long time, but I should tell you this. Because Jenny Murdy cannot see, and she's eighty-one years old, she has a nurse, and Julian Hyman, the lawyer, keeps her checkbook balanced. Everyone helps out—including Michaelian, who, several times in the past year, has told his pals that he is going to play golf and instead has driven to New Rochelle to take this old girl to his eye doctor. And Michaelian will not like this to be publicized, but that's the way he is, and that's the way these suburban Republicans are when one of their own is in trouble or sick—or old.

Arthur Geoghegan, the bank president, was talking about old age while they guided Jenny Murdy around the room to talk to her friends. And Arthur Geoghegan the bank president, who still walks a couple of miles to work every morning, said last night that the worst part of getting old is that you reach a certain point and "you don't have anyone to get into trouble with anymore." And Jenny C. Murdy will like that when she hears it this morning.

She came on in eighteen hundred and eight-eight—the year of the Great Blizzard. New Rochelle was an unincorporated town at the time, and a man named David B. Hill was Governor of New York. There was no county executive, and there was no mayor as we know him today in Jenny Murdy's city. The man who is the mayor today, Alvin Ruskin, said that Jenny Murdy would always fight for the little people, and that's enough to recommend her. The really astute politicians know that people think of Republicans as squares and millionaires and well buttoned-up bores. But Jenny Murdy gives the name some better meaning. There is not a Democrat in our county who has her style and class. At eighty-one, she had all these big shots there last night at a party she gave for herself.

And some of them even brought presents! It was like an Italian wedding when somebody fixed this box up to look like a silver bowl to receive the little "remembrances" as they were called.

I mean, it really makes you stop and wonder if politicians are really all that bad. James O'Brien sat with his wife last night who wept because she did not like the idea that Jenny

might be getting old one day. Jimmy O'Brien, a powerhouse in the second ward who weighs in at about two hundred twenty-five pounds every Sunday morning, showed up with rolls for Jenny Murdy. And Burton Cooper, who owns bus franchises somewhere and who has a wife who is a sculptor and who is a big partner in a big law firm, goes to see old Jenny on weekends.

Last night was a lovely and sentimental night, Michaelian said. Even Teddy Greene and Alvin Ruskin, who are not exactly "tight" with each other, were cordial in honor of Jenny. Bill and Diane Collins and J. Raymond McGovern himself, the former comptroller of the state, and Joe Evans and Bob McGrath, the young in her party, were there with the old woman. Indeed, Jenny Murdy had a lot of people to get into trouble with last night.

And so we run the risk of her calling up this morning like she calls the politicians. Jenny, after she hears all of this, will get on the phone and say, "Listen, O'Shaughnessy. What the hell's going on at that radio station?"

Happy Birthday, Jenny.

<div align="right">August 22, 1969</div>

J. Raymond McGovern:
"Buy Them a Drink!"

J. Raymond McGovern was a powerful lawyer with a statewide reputation. He was comptroller of New York State.

J. Raymond McGovern, who will be buried at midday, when the sun is overhead in our Westchester skies, was a great man. He was also a friend, champion, and advocate of WVOX Radio. Thus, we will allow the other media to tell you of his illustrious feats and legendary deeds on the state level. We knew him better as a wonderful friend who simply could not resist helping you if it was in his power to help.

Tall, courtly, well-dressed, and beautifully tailored, his mind keen and alert, J. Raymond McGovern, a senator and comptroller of the Empire State, did more for this city and county than we perhaps realize. When he died, they put his obituary on page 10, but J. Ray McGovern and his kindness, thoughtfulness, and generosity will outlive any of those world figures mentioned on page 1.

Often we would stop in at his law offices on Huguenot Street, and he would be dictating to his secretary in the open office just off the lobby. We would try not to disturb him. But McGovern's rich, strong voice would call out, "Come in here, my boy." We would talk about politics and about his state and about the city. He would always mention Malcolm Wilson and what a fine, decent man the governor is. And he would always inquire after this radio station: "How is it doing? Is this fellow helping you? Can I do anything?"

He was that kind of man. He helped his community station get started—and he helped keep us going. But McGovern helped a lot of causes and a lot of people. Sometimes, he would call and say: "Listen, O'Shaughnessy, I want you to try to help so and so. He's a good fellow." That was the highest tribute Ray McGovern could give you.

He was a very successful lawyer and a man of "probity," as Monsignor Thomas Moriarty will put it when he preaches over him at Holy Family today. McGovern would sit at the old Schrafft's on Main Street with Arthur Geoghegan, the bank chairman, and Bill Scott, the realtor, and Owen Mandeville of Larchmont. And while other men of their times and station sat at country clubs, they would discuss great issues over the ninety-cent special Monte Cristo sandwich with cranberries on the side.

And then these men would walk, or saunter, down Main Street, and give it some style and brightness and kindness. McGovern was the spiffiest and most debonair. He talked to everybody.

And when his beloved wife, Elsie, died three weeks ago, and you asked how Ray was taking it, Arthur Geoghegan and Bill Scott told you: "Don't worry about Ray. He's a real pro."

It's like another old friend said: "McGovern would walk into a bar in the old days and, when the bartender would point out some individuals who had been working to defeat him right in his own city, McGovern would give a wave of the hand, smile, and say, 'What the hell. Buy them a drink.'"

Just three weeks ago, McGovern walked down the middle aisle of Holy Family, behind his wife, as Governor Malcolm Wilson and his wife, Katherine, watched. This morning, as he goes down the center aisle for the last time, we will remember his great style—and so much more.

<div style="text-align: right;">March 16, 1974</div>

Howard DeMarco: My Story

I've attended too many funerals . . .

There is a quiet place. It is in the part of the city the townies refer to as the West End. The politicians call it the fourth ward. There are machine shops and sweatshops there, where they make dresses, and delicatessens where you can get Italian sausage and good bread.

The Italians, the Portuguese, and some Mexican families live near the oppressive, relentless hum of the eighteen-wheelers rushing along the thruway from New England to New York City.

It is the place where Frank Garito started his political career on his way to becoming mayor, and where Rocco Bellantoni, Jr., who was the hardest working councilman the city ever had, rides a bulldozer now to pay off his campaign debts. He got more votes in this area than any other Republican who ever ran for the job but, because his name ends in a vowel, they did not vote for him north of Eastchester Road. In all this noise and din, in all this color and life, there is a quiet spot: Beechwood Cemetery. It is where they buried a cop named DeMarco last week.

Meaney, the Patrolmen's Benevolent Association president, and Michael Armiento, the police commissioner, will not like to hear Howard DeMarco referred to as a cop. DeMarco was one of the brightest men in the department, and he rose through the ranks to become a commissioner. So all the elders of the town, in their dark suits, came to his wake and came on Thursday to Beechwood Cemetery to bury DeMarco in a quiet spot.

John Brophy and Joe O'Brien were there by the hole they dug in the earth, and Nicky DeJulio was there. They came not because Howard DeMarco was a commissioner of police, but because they are townies and because his address, the place

he went home to each night, said: New Rochelle. Three ranks of cops stood there and saluted his widow, Maureen DeMarco, because she was married to a man who was one of them. A bugler played "Taps" as Armiento handed the flag to Maureen DeMarco.

Len Paduano, the eminently decent mayor, stood and cried. And Joe Curtis, the recreation chief, and Sam Kissinger, the city manager, watched all this. Bill Hegarty, the former police commissioner, stood off, alone, shaking his head to let you know that he had not expected to get a call in Grand Rapids informing him that Howard DeMarco had died last week in Sloan-Kettering Hospital in New York City. After a hundred people moved forward to put carnations on the coffin, Howard DeMarco's widow, children, and mother got in a big, black car to leave the place where they buried him.

A senior officer dismissed the three ranks of his colleagues, the Marine honor guard withdrew, and the police honor contingent, with silver battle helmets, was dispersed. A fleet of gleaming Kawasaki motorcycles were jump-started as, one by one, blue-helmeted troopers slowly left the cemetery.

Later, down at Vinnie Rippa's Dockside Restaurant, Florence Salomone and Rosemary McManus, the newspaper editors, were having lunch, and a man named Proudian, who is a businessman, sat with his wife and talked about Howard DeMarco. They recalled what no one in the town knew—not even his children. Howard DeMarco had a form of cancer, one with a mean, nasty name. And as the Proudians talked about this, a man came up and said he had never really gotten to know DeMarco, until recently. This fellow told of meeting Howard DeMarco in a bar in April. As the story goes, the man had just seen his estranged wife and sons and a daughter buying him a birthday card. I think it was up in the Big Top store in the Wykagyl section. Well, anyway, the way I understand it, this fellow and his wife are in the middle of a bitter divorce, and he was telling Proudian, the businessman, how he walked, somewhat uncertainly, into Saparito's Restaurant after seeing his wife and kids, and how he was standing at the bar, not in very good shape and very much in need of a drink.

And as he stood there, a big, bulky guy named DeMarco

came off a stool at the far end of the bar and pushed the troubled man with family problems into the back room at Saparito's. And for twenty minutes, the police commissioner, the cop who would live for only another month and a half, sat and listened and talked about life and broken dreams. The police commissioner had a badge in his pocket and a gun on him, but he was talking in the back room of this restaurant with the gentleness of a priest, a rabbi, or a guidance counselor.

And when they had finished the lemon squeeze, the man, who was feeling a lot better about things in his own life, told Howard DeMarco that he was getting skinny and inquired why he was losing so much weight. DeMarco, who had cancer and would live for another month and a half because he was just about out of white corpuscles in his body, said he was fine and told the man with the busted marriage to take care of himself and to live for his children.

All over town last week, everyone had a Howard DeMarco story. This was mine.

June 7, 1982

Rocco Bellantoni: "You . . . the Best!"

Rocco Bellantoni served briefly as councilman. He was a "Runyunesque" character who operated out of a delicatessen in the west end of New Rochelle.

It's Friday, the sixteenth of March, and I will be glad for spring. First, however, I have to tell you about yesterday and about what happened in our city.

The Honorable Rocco Bellantoni, Jr., a/k/a Rocky Bal or just plain Bellantoni Junior, stood me and the city manager up for lunch yesterday. The former New Rochelle councilman and West End political leader was somehow unavoidably detained, you see, by a massive heart attack, which slammed against him and killed him as he lay alone yesterday morning in George Vecchione's New Rochelle Hospital.

We've told you before how important the man was to his town. He was out of Damon Runyon, Ring Lardner, and Jimmy Cannon. He was just as colorful and, if you'll allow me, just about as heroic as any character created in their minds over a typewriter. He was, for a while, the hardest working city councilman—and this takes nothing away from Alvin Ruskin, Hugh Doyle, Donny Zack, or Joe Pisani. He was also the most compassionate councilman New Rochelle ever had.

Rocco had an enormous capacity and talent for friendship. And all afternoon and late into the night they were recalling stories about the man in the saloons and in the neighborhoods of the city. Generoso, the haberdasher from downtown, and Armiento, the born and bred police commissioner, and Donny Zack, the junior high school principal, and DeJulio, the politician and greeter: they all walked around in the Westchester sunshine with this terrible, sinking feeling deep inside them when they heard about Rocco Bellantoni.

Frank Garito, the former mayor, was coming down from Boston. And Sam Kissinger, the city manager, was on the phone. Over in Mount Vernon at the headquarters of J. A. Valenti Electric, a man named Napoleon Holmes, who made quite a stir during the civil rights battles, was in the office of Jerome Valenti, the president of this big firm, and tears appeared on the cheeks of both of them.

Former state senator Anthony Gioffre canceled appointments with some paying clients of his law firm to go over to a club in Rye where they sat and drank and talked about their marvelous, appealing friend, Rocco.

Alvin R. Ruskin, a Justice of the New York State Supreme Court, was presiding at a divorce trial in the Westchester County Courthouse, a place where husbands and wives go to kill each other—legally and all according to the law. Ruskin was watching all this when Edward Storck, his law clerk, motioned for him to come down off the bench so he could hear that Rocco had died alone in a hospital at the age of forty-nine.

Leonard Paduano, the decent and gentle man who is the current mayor of the city, broke down and cried in his office at City Hall.

At the *Standard-Star*, our newspaper, June Shetterer, the sensitive reporter who writes lovingly about the ones we lose, leaned into her typewriter yet another time. The words appeared across the top of the front page in last night's paper. And a bright, young reporter named Fjordalisi was on the phone, asking around about this Bellantoni for a piece in tonight's paper. Nothing Shetterer or the young reporter or any of us, including O'Shaughnessy, can produce will capture for you what Bellantoni meant and who he was.

He was, straight out and simply, the most generous and extravagant man any of us have ever met. He earned his keep in a lot of ways—at a deli on Second Street where the Portuguese and Mexicans have moved in with the Italians. He had a piece of a small trucking company, and he would fix up old houses and rent them. In his salad days, he drove around in a big, white Seville, which had the license plate "ROCKY" on the back.

But when he was on the city council, he almost went broke

by working at the people's business full time and ignoring the wishes of his neighbors who only elected him to a part-time position. He never learned how to be smart about politics and, as a result, his businesses suffered. They say he tended bar and helped out in a place called Giovanni's, but I'm glad I never saw him there. And none of us saw him the night last month when he collapsed from heart tremors on his way to the mayor's inaugural ball at Nick Auletta's Glen Island Casino. He would not have wanted us to see this either, and so he checked himself quietly into the hospital.

When it was going good, he loved limousines, and he could throw around money. I think he probably knew just how to get to jai alai up in Bridgeport of an evening. And he surely dazzled more than one lady at those ornate roadside clubs down in Fort Lee by the George Washington Bridge, where he would go to relax and have fun and dance.

I once sat with him in Nelson Rockefeller's box at Saratoga, and I sat with him in an old dusty pickup truck as I listened to his latest scheme for repairing a busted marriage. I also saw him ride a bulldozer, but I was afraid to climb up on it with him.

There were lots of girls, but his mother was the only woman in his life. And when Mama Bellantoni died, Rocco went into a long period of mourning from which he never fully recovered. After his defeat in the 1980 election, he spent his days just being Rocco Bellantoni. He passed the time helping people, trying to reconcile husbands and wives, straightening out young, street-smart, tough, townie kids in the fourth ward, and feeding hungry people. Even if he didn't like you, he would look at you and say, "You . . . the best!" He risked his political career to help Mario Cuomo, who was not of his political tribe but, somehow, you knew these two heard the same music.

Back in the early 70s, some women went to him (we called them girls in those days) to start a softball team in the city. Rocco, the big, dumb "feminist," found the dough and admonished them to be careful when sliding into home plate, and to be alert at all times to the possibility of a bean ball.

A few weeks ago at Giancarlo Ferro's restaurant in Bedford, Rocco got good and mad at me for telling Lynne Ames of the *New York Times* about the time the city marshal hired Rocco's

trucking company to help evict a family. When Bellantoni arrived on the scene and saw what was happening, he reached in the pocket of his work pants and peeled off thirteen one-hundred-dollar bills to square the family's back rent.

Rocco took sides and helped his friends, and he could probably be tough in a proposition. But yesterday, the city manager and the police commissioner were saying that Bellantoni was a "pushover . . . a soft touch . . . and a sucker for a sentimental song." But we knew all this, and more.

A few years ago, while sitting as a member of the high council of the city, this child of the streets of the West End, this big, spectacular, generous man, decided he wanted to pray—in a church. However, in as much as he was not exactly a familiar face at St. Joseph's, his neighborhood parish, he hesitated lest someone think he was "getting religion" just to garner votes. You will recall we have had a few politicians in this town who worked five different Masses every Sunday, one in each parish. So the Honorable Rocco Bellantoni, Jr., for the last several years, met his Maker, secretly and stealthily, at out-of-the-way churches where he was not known. This is a pretty personal thing I know about him, and I wasn't sure I should tell you about it on the radio this morning—about this marvelous character who had to sneak into church so as not to ruin his reputation.

That reputation, I think—nay, I'm sure—is pretty secure around here. Even through the last few, lean years, when some of his friends fled and some of his own turned against him, the wonderful things he did kept coming back to remind you about him.

And yesterday, Jerome Valenti, the big, rich businessman, was saying that they should name something for Rocky Bal. You will be hearing more about it on this station, where we will remember him for a long time. And every time I get down on this damn town, I will remember it was Ballantoni Junior's town—at least for forty-nine years.

Rocco. You . . . the best!

March 16, 1984

The beautiful Chapel at Sound Shore Medical Center was later dedicated to Rocco Bellantoni, Jr.

John Brophy: Leading the Parade

John Brophy led every parade in southern Westchester for twenty-five years. I can still hear the music coming up the street behind him.

John Brophy never studied Latin or went to the university and, thus, he would take no offense if you called him *sui generis*. For John Brophy of New Rochelle is truly unique unto himself. He has a face that might have belonged to a sergeant in the old Irish Republican Army, when they used to ambush British troops moving down through Glen Maloor or Glendalough. But our John Brophy is not blowing up any statues of Lord Nelson. He's too busy worrying about the people of the City of New Rochelle.

Brophy has fun doing for others. He's not too big on the fancy charities we have in this county, where you have to be born into the right family in order to help your fellow man via the very social and most phony charities. Rather, Brophy is a bread-and-butter man. He's a tireless worker for the Salvation Army, because they give people food for their stomachs and clothing for their backs rather than cocktails and lawn parties attended by a lot of wealthy stiffs in black ties. That's the route John Brophy goes—and that's why we like him.

Brophy runs every parade in this town, except when we marched to choke the city's economic vein. And John doesn't buy the anti-Vietnam stuff. He flies with the American Legion. We remember a parade that John ran last year, around Thanksgiving. Somebody got the bright idea of having another wonderful old man, Jim Grady, sing the "City Alive" song while perched on top of a trailer truck. They even had a band. But the band was on a different truck, which was supposed to stop in front of the reviewing stand. Now the cold night air

got in Jim Grady's tonsils, and he was about as far out of key as you can go—and the mobile orchestra was hitting clinkers, too. John Brophy almost said some very bad things, which a grand marshal of a parade is not supposed to say, especially with a lot of kids around.

Brophy is the world's champion sucker for lost causes. When someone has a good cause and they get turned down by everyone else, they go to John Brophy. He gets on the phone and calls a few friends, which means he might call about a thousand people, and Brophy pulls it out of the fire.

He's fiercely loyal, and when somebody asked him why he was such a big Teddy Greene fan, John said, "Teddy is a man of his word," which is a very good reason to like a politician in this day. He's a glorious old gent, John Brophy, and now he's wound up about Flag Day, which is today—this very day.

We hope John Brophy sees a lot of flags flying today. He'll be very happy about that. And, as for us, we can't resist telling you that every time we see a flag, we think of John Brophy, who always shows up in the cold, mean, early hours at the Draft Board in the Pershing Square Building to send our kids off to Fort Dix and Vietnam. They go early, very early, but John Brophy has never missed a "sendoff," as he calls it. He actually gives these kids comb-and-brush sets and prayer books and a handshake. He also gives them something to fight for—and something to come back to.

What a beautiful coincidence that Flag Day just happens to fall on the birthday of John Brophy, who always seems to be coming up the street at the head of a parade.

June 14, 1967

Glenn Miller at Glen Island: Like It Used to Be

Glen Island Casino still sits right off the shore of New Rochelle on the edge of Long Island Sound. It reverberates now with political speeches, fund-raising pitches, and loud weddings. But if the walls had ears, they'd remember throbbing to the sound of Glenn Miller and some of the mellowest music America ever danced to.

Angelo Badolato remembers. He is a big man, who looks as if he may have started as a bouncer like Toots Shor. Then he grew up to own the place. In 1965, when America was headed in a whole different direction musically and socially, Badolato wished for the way it used to be.

Maybe Angelo Badolato's problem is Westchester's—or even America's—as well. He was sitting in his big office in Glen Island Casino "by the water's edge," as his ads say. It was Sunday, the first day of the new year. The night before, the music of Glenn Miller was played again in the place it was born.

Back last August, it looked real good for Badolato. He got a bright idea and booked Buddy DeFranco and the Glenn Miller Band. Angelo wrote out a check for thirty-five hundred dollars to bring back big-band music for New Year's Eve at Glen Island. Then he coughed up almost two grand to advertise a New Year's Eve "like it used to be."

To Badolato, "like it used to be" was when Glenn Miller himself played from eight till three in the morning, playing the music that got us through a world war. The Glenn Miller Band and a girl vocalist worked for Angelo one night in 1937, for a big two hundred dollars—to be split among fourteen sidemen and the vocalist. That was how it used to be around here in those days—seven hundred people came and stood close to one another, danced, and had fun.

Then, last night, nearly thirty years later, with two networks broadcasting live from Glen Island—and Buddy DeFranco and the Glenn Miller Orchestra and the booze and the noisemakers and Long Island Sound right outside—only three hundred people showed up at the place by the water's edge.

On Sunday, in his office, Badolato was still talking about how "it used to be," and he was showing the contract Glenn Miller signed in 1937 to work for two bills. Badolato talked about Les Brown and his Duke Blue Devils, about Mal Hallett's band, about Larry Clinton and Glen Gray, who put the famous old New Rochelle Casino on the map with his Casa Loma Orchestra. And do you remember Shep Fields and his Rippling Rhythm?

When the championship football game came on yesterday afternoon, this big man was thinking about the Log Cabin up county and Donahue's in Jersey. And he said they are pushing roads through where all these lovely joints were. IBM is in Armonk where the Log Cabin once was.

This is a nation of old young men—effete young men—who bowl and watch television, and who have young bodies but are old young men. They do not dress up or move across dance floors next to pretty girls any more. On Sunday, in his office at the historic Glen Island Casino, nobody had the heart to tell Angelo Badolato that another place in Westchester had standing room only on New Year's Eve because they brought in a troupe of female impersonators.

But Badolato's not complaining, because the man gave three hundred people in this town a New Year's Eve "like it used to be." Unless, of course, you counted the house.

January 1966

To Bathe the Sweat

The rich and those of high estate in Westchester have their beach clubs and private swimming pools. It's quite a different proposition for the poor on a hot summer day.

Last week's mail brought a fancy brochure from the Westchester County Department of Parks and Recreation. On page after page, you read about all the wonderful facilities we provide for the citizens of our beloved wonderful world of Westchester. There's a huge reservation in Pound Ridge, for example, which is in Northern Westchester. And there is something over near Peekskill and several golf courses and a few swimming pools. And it is—this fancy brochure—testimony to a great problem that everyone seems to want to ignore, except the people who sweat in our hot summers, people who don't make enough money to belong to private beach clubs. And our civil rights leaders seem more interested in symbols than in getting a place for our people to swim and enjoy God's sunshine.

It has to be considered a disgrace that New Rochelle doesn't provide one public swimming pool for our seventy-six thousand hot, steaming citizens. And when you ask them about this at City Hall, they will tell you that we have Hudson Park—and people who tell you about Hudson Park sit up in the north end of the city in living rooms and dens that are bigger than the few hundred feet of swimming area down at Hudson Park.

And this great city of ours is building enclosed shopping malls, while our people drown in their own sweat caused by honest toil. And no politician in New Rochelle wants to talk about bathing facilities for the poor, because that means getting the residents of Davenport Neck stirred up—and they're the people who humiliated a cowardly city council last year, except for the courage of a Bob McGrath and the patience and breeding of a city manager named Fuerst.

God gave our city about nine miles of natural coastline and shore front, but the poor and middle-class people have only a few hundred feet of it called Hudson Park. They sit and talk about us in wealthy areas of this county, like Rye and Bronxville, and concerned people say this is the great shame of Westchester—that you have the very rich who have everything and you have the very poor who must go to Sherwood Island to swim in the earth's water or to Compo in Westport, where they rack you four bucks to park a car if it has Westchester plates. And these people in Bronxville and Rye ask you about this, and they ask you about Ed Michaelian and Alvin Ruskin and Hughie Doyle and the other good ones. And you give up alibiing for them on the question of swimming and recreation.

And you remember a speech you made months ago at a communion breakfast at Saint Gabriel's Church, and the old monsignor who came up to you at the end and said, "Young man, new buildings are one thing. Get my people a place to bathe the sweat from their bodies."

Send your fancy brochure to the old priest, gentlemen, and tell him how great our recreation facilities are. We don't believe you.

June 20, 1967

Angelo Giuseppe Roncalli: Pope John XXIII

Last year, as Nancy and I toured the underground crypt at St. Peter's, in Rome, where all the popes are buried, I overheard another tourist tell his young son, "Look . . . this was the 'Good Pope.'"

There were reams of it—some phony, most heartfelt and sincere.

Angelo Giuseppe Roncalli, son of poor peasants, who looked like Yogi Berra, had died. The great and the near-great of journalism took a crack at eulogizing him who needed none.

The two best tributes were made by Morris West, writing for *Life*, and Emmet John Hughes, a contributor to *Newsweek*. West was very good. He is an Australian who has written two highly respected and popular books centered around the world of the Vatican. *Life* carried his straightforward and moving description of the peasant pope; it captured the simplicity of John XXIII and the deep sadness of mankind at losing the gentle prelate.

Said Morris West: "I am very close to tears as I begin to set down these words. What can I say of a man so manifestly good, so manifestly the victim—or is it the victor—in a drama of divine irony whose poignant prayer, as he lies stricken, is not for the salvation of his own soul but for the salvation of a work began in the name of God? I have no dignity in the Church. I have no personal merit to commend me for the task of writing a eulogy, save perhaps this—that I am, in the spirit, a stumbling son of Angelo Giuseppe Roncalli."

Morris West concluded: "Will they canonize him, officially, a saint in the calendar? In a way, I hope not. For my part, I do not want to see him idealized by a Vatican painter, lit by a

thousand candles in St. Peter's, reproduced in plaster and gilt, and sold to pious pilgrims. I want to remember him for what he has been—a loving man, a simple priest, a good pastor, and a builder of bridges across which we poor devils may one day hope to scramble to salvation."

The world was also treated to a constant flow of magnificent words uttered by the Holy Father. None, however, caught the real John XXIII quite like those reported in *Time*, the weekly newsmagazine. The story goes that the pope and a young North American archbishop were discussing the political and diplomatic skills sometimes required to deal with the Vatican hierarchy. Said John XXIII: "My son, when you stand before Jesus Christ, he is not going to ask you how well you got along with the Roman Curia, but how many souls you saved."

As written: "There was a man sent from God whose name was John."

But to the Son of a carpenter, one suspects the Good Pope was just always—Angelo Giuseppe.

June 1963

PART III:
MARIO MATTHEW CUOMO

I had heard stories about a gifted Italian politician from Queens who spoke in elegant paragraphs. And when I encountered Mario Cuomo in the lobby of our radio station—he was then lieutenant governor—I knew instantly that he was very special. Jimmy Breslin and Jack Newfield have written much better pieces about this extraordinary man. These are my findings.

Reality with a Red Rose

In 1982 the race for Governor of New York was wide open. Hugh Carey was not seeking re-election, and Mario Cuomo, the articulate, graceful lieutenant governor, decided to make the run, as did Edward I. Koch, who had beaten Cuomo five years earlier to become Mayor of New York City. This set up a bruising battle within the Democratic Party.

First came the convention in June, at which the party regulars backed Koch. But Cuomo won enough votes to force a primary. He had already been traveling through New York as secretary of state and lieutenant governor, meeting the family of New York, as he would come to call it, on his home turf.

Cuomo touched something in people such as Miriam Jackson, the Democratic stalwart and party workhorse from New Rochelle, and Samuel G. Fredman, lawyer, Democratic county chairman, leader in the Jewish community, and later a judge of the State Supreme Court of New York. Also in a lot of other people.

Our thoughts this first week of summer are upstate in Syracuse, where Mario Cuomo fights for his political life and for the soul of the Democratic Party. In this task, he will come up against a man called Koch—Edward Irving Koch—who is the Mayor of New York. The bosses and elders of the Democratic Party are almost certain to designate Koch to run for governor. He is colorful, a media event, a winner; he is quick, diverting, and funny. Koch is also cutting and cruel. He plays to the worst instincts of people with his pandering and vengeance in the matter of the death penalty.

In other times, delegates to this state convention would bring forth Franklin Roosevelt or Herbert Lehman or Averell Harriman or Al Smith. But it is 1982, and the Democratic Party is just as confused and lost as the rest of us—and so it will choose Koch as the "official" designee, because David

Garth, the media manipulator and political wizard, assures them Koch is a stronger media event. Koch will raise millions from his realtor friends in New York. Not as many as he saved them. But they will not forget what he has done *for* them or what he can still do *to* them even if he should lose the race for governor.

We're for the other man—Mario Cuomo, the lieutenant governor. He speaks in paragraphs while Koch speaks in headlines. He makes sense while Koch makes jokes. He makes us think, while Koch makes news. He talks of love and reconciliation, while Koch talks of vengeance and punishment.

Koch is the best horse David Garth has ever had. But William Haddad, the Cuomo campaign director, faces the same problem we have now in trying to tell you about Cuomo, the mediator and, yes, the good man.

It is almost impossible to package this fine, bright man, the philosopher whose name ends in a vowel. But Cuomo has been in Westchester a lot in recent months, and we detect the old stirrings again among the party faithful here. Wonderful, grandmotherly Miriam Jackson is moving around again, under her sunbonnet and using Yiddish phrases, to tell people about this son of Italian immigrant parents who would be governor. And Sam Fredman, the famous matrimonial lawyer, who is himself a decent man in a murky calling, accused Cuomo of being a "mensch." "A 'mensch?' " said Cuomo, "How nice, that's the way you lose!"

Mario Cuomo stood there the other night in a baggy, rumpled suit with a rose and a lawyer's vest. His watch looks like a Timex deluxe. As he began to speak to the Westchester Democrats, the orchestra leader reached over and tried to smooth the jacket pocket on Cuomo's blue suit. The only style the man has is in his mind and on his face. Even Fredman, who is a master politician, is stumped. "Cuomo is a real, decent man. I want people to know him for what he is," Fredman said.

Later, Cuomo appeared at a party for Dick Ottinger. Gary Hart, the senator from Colorado who wants to be President of the United States, stood waiting while Cuomo spoke. Although Hart has been around a lot, you could see him warm to Cuomo.

It happens everywhere whenever someone stops to *listen* to the man. It happened again at a dinner for four hundred people who had come to honor the Rev. Calvin Sampson, pastor of Shiloh Baptist Church in New Rochelle. Jesse Jackson, the preacher, was the guest speaker, and Ossie Davis, a marvelous human being and a neighbor, was to introduce Jesse Jackson. Jackson and Davis are as strong in front of a crowd as any two men in America. A tired Cuomo approached the microphone to talk to four hundred Blacks who had come to be inspired, but not to hear a political speech. And on the dais, Jackson, the preacher who moves around the country pretty good, whispered to Ossie Davis, this Cuomo is no lightweight.

We predict that Koch and his realtor friends will find this out soon enough. The smart money guys, the movers and shakers at the bar of "21," tell you Koch will win. Their main slam against Cuomo is that "he won't deal . . . you can't *do business* with Mario." But can you say anything better than that about a politician in this day and age?

"This is a hard business," Cuomo, the politician, told us. "It's easier when you have something to believe in," Cuomo, the philosopher, reminded us. In this day of media events, practically every politician is something less in person than he appears to be on television. Reality, as they say, is a downer. But then along comes Cuomo, who is stronger, one on one, than his image on television.

All his fellow Democrats have to do is *listen*. Or they could just go ahead and let Garth pick the next governor. The word is getting around about this Cuomo. The old stirrings are there, in the Democratic Party, and in the land.

June 22, 1982

Cuomo and the Moonbeams

On Sunday afternoon, Henry Kissinger, the rich Republican author and television commentator, stood in the elegant living room of Peter Flanagan's country house in Purchase telling marvelous, witty stories. Mario Cuomo of Queens was in Bill Haddad's office in New York writing a last-minute appeal to registered voters of another political party, those Democrats who could make him their nominee for Governor of New York.

Now, other candidates in this strange political season hire paid flacks, like David Garth and Rubenstein, to string words together for them. The candidates then push these words through manufactured smiles. But Cuomo would handle his own appeal. The words would be coming out of his own mind.

But not even Cuomo the candidate knows how to capture Cuomo the man in thirty seconds. And so yesterday, the words came across the paper off his pen—tight, precise, factual, and dull. One hundred neat little words aimed at convincing you that Ed Koch is a good, colorful mayor who would be a terrible governor.

On his feet talking to poor people, Blacks, Hispanics, or to a man out of work, Cuomo is as good as we have in this country today. He reaches those people as precisely as Henry Kissinger zeros in on the rarified wavelength of Peter Flanagan's rich, conservative country squire neighbors here in Westchester. "There is a place for believers," Cuomo says. It is as thrilling as anything the Madison Avenue crowd could push together for this final week. "The Democratic Party is a party of hope. Koch preaches fear and speaks of death, while I speak of *life!*"

I asked Pete Hamill, the street-smart writer of the poor and of the city, if Cuomo was really as good as we have heard. "He's better," said Hamill, "but I'm afraid they can't package this particular politician in thirty seconds. The trouble with the son of a bitch is he really *believes*."

I don't know what Mario Cuomo has decided to say in his final appeal to the Democrats of New York State. He may go with the dull litany he read aloud yesterday while Bill Haddad stood over him with a stopwatch, counting off the precious seconds, up to thirty. I hope he will just look up from the paper and lean into the microphone and say he has done what he could to help this party find its soul and now it's up to you. "There *is* a place for believers," he should tell them. "There *is* hope!"

A lot of people are rooting for Cuomo. Sam Fredman, the former chief of the Democratic Party in Westchester, who is now chairman of the Westchester Jewish Congress, heard the Italian from Queens defending Israel the other night. Fredman said: "I only wish I, as a Jew, could do as well."

Belle D'Onofrio and Lucy Veteran, two Democratic workers with lots of miles on them, were telling reporters that they can't really explain it, but "something is happening. The old stirrings are there again. This fellow is as good and as bright and as fine as anything we've seen in years."

However, the *Daily News*, which would have you believe it is the paper of the people of New York, is against him. The *New York Times*, the best paper in the world, is for Koch, too. And so is William Paley's flagship television station, WCBS-TV. Each of these instruments of communication is run by people who do a lot of business in New York City and an angry Mayor Koch could be somewhat dangerous to their corporate health. It has to do with property taxes and abatements and printing plants and labor unions; with Robert Wagner and Frank Sinatra and Harry Helmsley and Lou Rudin and Steve Ross and Jimmy Robinson of Amex.

And Hugh Leo Carey—Governor Carey—in his thousand-dollar suits, is for Koch, sort of. I say this because Carey is of my tribe. I know him and I like him and he didn't look too good as he stood up with Koch on the TV last week.

It is probably futile to broadcast this kind of piece the Monday before the great primary. Anyway, I don't believe in miracles anymore. And yet . . . and yet this Italian from Queens nags at me. He is what politicians were before they wore thousand-dollar suits. He is what the party of our fathers used to

be. But, forget it. The big realtors in New York and Hugh Carey and the *Times* and WCBS-TV are never wrong. Koch will probably clobber Cuomo and his moonbeam crowd of liberals.

In this day, the Democrats wear thousand-dollar suits just like those Republicans having drinks and fawning over Henry Kissinger up at Peter Flanagan's house in Purchase. But, the question lingers: is there a place for believers? We'll know Thursday night.

September 20, 1982

Cuomo beat Koch in that hard-fought primary, which set up a bruising race against millionaire Lewis Lehrman in the general election. Cuomo won that one too . . . and was on his way to becoming a national figure.

An Implausible New Year's Day

It was beautiful and bright, that first day of 1983, out of season for winter. Even upstate New York threw off its dullness and gray pallor. When you saw Bella Abzug smiling and coloring her cheeks with extra rouge at the New Baltimore service area on the thruway, you knew something special would happen this day farther on up the Hudson Valley.

This, then, is how I spent New Year's Day, and what I saw and heard. It started with Bella Abzug in a thruway service area south of Albany. It ended with Hugh Leo Carey, a former governor, drinking a Molson's in a Windham ski lodge and saying he is glad he is not governor anymore.

Everything else that happened that day belonged to Mario Matthew Cuomo. The day was his, having been earned across eight years and thousands of nights and hundreds of lonely rides up and down the thruway, with his butt against a small, flat, hard board to relieve the relentless pain in his back.

I have always been pretty straight with you and those seated around your breakfast table. But for almost a year now, as the listeners of these broadcasts know, it has been increasingly difficult for me to be entirely objective about a certain politician from Queens whose name ends in a vowel and who is a member of a political tribe quite different from my own.

So, up front: I *like* Mario Cuomo. I like his style. I like the stuff he is pushing off from his bright, fine mind and from his heart. I am nuts about his wife, who is a sheer, pure, natural force. And I like his family, too. I like almost everything about this attractive and appealing man, who is a politician the way the men of my father's time imagined them to be. I like his music. Thus, any comments I might make on the radio about what happened in the capital city of our state when this man became governor ought to be greatly suspect. In point of fact, we were there on Saturday only because he prevailed in what he himself has called "an implausible pursuit." Which means

Cuomo was rejected by his own and rose from the rebuke of the elders of the Democratic Party, which he distinguished for so long. He won against their official designee, Edward I. Koch, the enormously popular Mayor of New York, and then he went out and beat a man who spent fifteen million dollars to defeat him. You cannot spend more money to buy an election in the State of New York, and Lewis Lehrman may even sue his ad agency for not purchasing more time on the airwaves in the final week. As Cuomo said, his victory was implausible. But it happened.

And now in Albany, this day, there were American Indians and Mayor Koch and Engie Carey, who is married to Hugh, and flags and an orchestra and a chorus with young, Black faces, and pomp and ceremony, and Al DelBello, the lieutenant governor. There were, however, no realtors from New York. The big bankers and moneymen of the state and the power brokers and fat cat lawyers were elsewhere—so were all the people at the bar at "21" who had written off this man who became governor of the only state in the nation that really matters.

Hugh Carey was there Saturday in the Empire State Plaza, which he had graciously—and characteristically—renamed for Nelson Rockefeller. And Carey, in only a few hours, would be in the lodge at the base of Windham mountain telling them why he is glad he is not governor anymore. No one believed him.

But earlier that afternoon, as he waited for the new governor, you had to remember that if Carey did nothing else, he kept this state from becoming New Jersey or Texas or Virginia, which are places in this country where they kill human beings with lethal injections as part of their tidy and functional capital punishment programs.

As this day belonged to the man from Queens, an aide to the new governor, Tonio Burgos, gently and kindly helped Carey and his wife depart from the state Capitol building before the crush. And then it was time for the inaugural address of Mario Cuomo. To the sound of cannon fire outside and flanked by state troopers, Cuomo came at last to become Governor of New York. He appeared in the corner, in the far reaches of the great hall, and he moved through the crowd and down the

aisle with the easy grace of the natural athlete that he is. And as the applause rose, he stopped and found a retarded child and a woman in a wheelchair, ignoring all the elders and powerbrokers.

As he began his talk to the people of the state, many of us who have seen him on a flatbed truck in the Garment District or on lonely street corners were concerned that he might be distracted by the sophisticated electronic TelePrompTer or just overwhelmed by the moment and by the sweep and architecture of the building that bears Rockefeller's name. And it did take him a while to get rhythm into his words and sentences in front of these three thousand people. Those who love the man knew he has sounded better out on the streets, and some in the audience began to despair when he seemed to be relying on that damn TelePrompTer to either side of him. He went on like this, without music and without poetry to his opening remarks.

And then Mario Cuomo became Mario Cuomo. It happened about five minutes into the speech: "I want to talk about the *soul* of the administration." And then everything this man is exploded all over the room. "I would rather have laws written by Rabbi Hillel or by the good Pope John Paul II than by Darwin. I would rather live in a state that has chipped into the marble face of its capitol these memorable words of the great Rabbi: 'If I am not for myself, who is for me? And if I am for myself alone, what am I?'" He then continued with "I am the child of immigrants," and went on to speak of his parents, going back sixty years, to tell how his mother, Immaculata, arrived at Ellis Island to join her husband, Andrea, who had come before her.

"Remember who we are and where we came from and what we have been taught." To some, it was philosophy; to him, it was a battle plan, a blueprint for a government.

"And no family that favored its strong children or failed to help its vulnerable ones would be worthy of the name. And no state or nation that chooses to ignore its troubled regions and people, while watching others thrive, can call itself justified," Cuomo said.

As he talked like this about the poor and the weak in our

society, hard-nosed political veterans sat with glistening eyes. Bill Haddad, his campaign manager, who has been with Jack and Bobby Kennedy, fought back tears. Samuel Fredman, the famous Jewish leader and matrimonial lawyer, who is a good man in a murky profession, gripped the hand of his wife, Mims. Even Andrew Cuomo, Mario Cuomo's son and heir who is supposed to be such a big, tough guy, clenched his teeth and bit his lip as he watched his father talk about the Family of New York.

And then Cuomo pulled himself again from the TelePromp-Ter for one last thought, which came up from his gut and out of his heart. And no one in Albany on that first day of the New Year will ever forget what he said: "I ask of all of you, whatever you think of me as an individual, to help me keep the moving and awesome oath I just swore before you and before God. Pray that I might be the state's good servant and God's too."

That would have been enough for the history books and for the front page of the *New York Times* or the archives of the capitol. But Cuomo had to add this: "And Pop, wherever you are—and I think I know—for all the ceremony and the big house and the pomp and the circumstance, please don't let me forget."

In the stilted beginning of this first inaugural address, Cuomo had directed himself to President Reagan and the syndicated columnists. But in the end, as he spoke from his heart to Andrea Cuomo, the Italian laborer who became a greengrocer in South Jamaica and who had a son who is now our governor, he became the most compelling political figure in the nation today.

When he was finished, Cuomo stood in the receiving line, next to Matilda Raffa and their children, for three hours. I left Albany to go down to Windham Mountain to have a drink with Carey. But that night, and all the way back to Westchester with my own sons, I thought of the greengrocer's son. The way he talked about the homeless and the infirm and the destitute kept coming back to me.

There is no one in this country quite like Cuomo, and on New Year's Day of 1983, he became the Governor of New York.

Implausible or not.

January 4, 1983

The Cuomo Book

There was to be a press conference to introduce another new book. The author was not even there yet and already there was talk of "family" in the air—about parents and children and generations.

It was a Saturday morning with a spring rain falling on Manhattan. Robert Bernstein, the tall, elegant chairman of Random House, waited for one of his authors in the big, paneled conference room high in a glass building on the East Side. Bennett Cerf used to run this place. Now he looks down from a large oil painting with that marvelous whimsical squint we remember from television.

It is Bernstein's turf now, and the chairman of this great publishing house, the grandson of Litvak Jews, talked about his grandfather who, it seems, was quite a brave man in Lithuania during the time of the Nazis. The talk then turned to his newest Random House author who has written of a father named Andrea, a laborer who became a greengrocer. He had a son who became the Governor of New York, just like Franklin Roosevelt and Nelson Rockefeller. That son, Mario Matthew Cuomo, has now written a book.

So, as the reporters and cameramen adjusted their minicams and microphones in the bright, hot lights, Bernstein moved among them. Croissants and muffins and clear, strong coffee were on a sideboard, all of it being so plentiful and completely free that the reporters ate a lot from the Random House larder as Bernstein talked up the new book. Because the politicians they usually cover for a living throw a box of doughnuts on the desk, the reporters were receptive. The publisher has done this little spread for the likes of Gore Vidal, E. L. Doctorow, Norman Mailer, Truman Capote, and James Michener. This time, he waited for Andrea Cuomo's son.

"Do you think this book will sell?" asked Bernstein. "He's quite a marvelous man, isn't he?" He was also late this busy

Saturday morning in New York, stuck in traffic at one of the East River crossings the Queens people know all too well.

And then, at about 10:30, his heralds began to appear: Andrew, his son and heir; Fabian Palomino, the one he calls "Professor," who goes back with him; Tim Russert, the shrewd, street-smart counselor to the governor; and Harvey Cohen, a deputy commissioner. They lived part of this book with him, and it was right for them to be here. And then Mario Cuomo came into the room and sat again before the lights and the cameras as the questions began. The New York reporters probed and poked for an angle and a tidy headline to please their editors and tantalize their readers and viewers.

They tried to get him to say something—anything—about Mayor Edward Koch. But as always with this particular politician, there was no easy, tight, neat headline. They have covered Cuomo, some of them, for years, and still they haven't learned how different and special he really is. The book is special, too. And that's what I want to tell you about.

The Diaries of Mario M. Cuomo: The Campaign for Governor: Like the man who wrote it, the book is difficult to define, hard to categorize. It is, at once, a political book, a travel book, a mystery book, a religious book, a history book. I can't label it. But this I assure you: *Diaries* is a haunting, powerful, disturbing, demanding, and, ultimately, joyful book.

Mayor Koch has recently produced his own book—a marvelous, glib, slick, entertaining piece of work, a quick read. Cuomo's book is anything but. As you go through *Diaries*, you will find lots of famous political names strewn about. It's heady and fascinating to read the governor's observations about all the movers and shakers in the political world. But you won't find here any glibness or, indeed, any meanness of spirit in Cuomo's retelling of his setbacks and his triumphs. His betrayal at the hands of former Democratic chairman Dominic Baranello is one of the most touching examples of Cuomo's generosity of spirit, as he worries about Baranello's health on the very day he was deserted by the political warlord.

Diaries is a political book, all right. But the thought occurs that it is also a travelogue, even a mystery story. It is the jour-

ney of one man's soul over a two-year period. And his search for Mario Cuomo is much more compelling than his pursuit of the governorship. You sit with Cuomo in the lonely hours of the night, and you greet the cold light of early dawn with him, as he struggles to put some meaning to the implausible and tumultuous events which culminated in his upset victories over Koch and Lewis Lehrman.

The recollections of his late father are haunting and almost lyrical as, again and again, the governor returns to his familiar theme—family—and his admonition, "Don't let us forget who we are and where we've come from," echoes through the pages. Some entries are absolutely devastating, as Cuomo confronts death or, what Teilhard de Chardin, his favorite philosopher, calls the "diminishment" we all suffer as we get older. The reader will also find five of the governor's speeches, including his brilliant and soaring inaugural address delivered in Albany on January 1, 1983.

As you read Cuomo's book, you keep remembering something Ken Auletta of the *Daily News* said: "He's awesome . . . he's so damn bright, it's scary . . . sometimes you have to get away from him." There are passages in the book that are so insightful and sensitive they almost make you want to flee. But when you've finished, you're glad you stayed the course. Awesome or not, everything this man is, is in this book.

Politicians are not supposed to write or even think like this. Cuomo will discourage a lot of writers—and even a few broadcasters—from ever going near a typewriter again once they discover what this son of a greengrocer has done to the language. This book, which Cuomo says he wrote only for himself and was never meant to be published, has almost preempted the arena of the written word around here. Maybe some of the New York writers and Albany political correspondents will want to try baseball now that Cuomo is working their side of town.

I think you will enjoy this book and the penetrating insights, which flow so effortlessly and candidly from the governor's fine, intelligent mind and generous heart. It may not sell as well as the Koch book, but this I know: *The Diaries of Mario*

M. Cuomo will be read and treasured long after other recent books are forgotten.

After the press conferences in New York on Saturday, the chairman of Random House was trying to think of a place to take the new author to dinner, someplace where they could celebrate the publication of a new book. The publisher was gently advised not to take this author to a grand place like the "21" Club or Mortimer's. Bernstein said: "Very well then, I think we'll celebrate with a fine dinner at Le Perigord. The chef will do anything for me there."

Out on East 50th Street, in the rain, Cuomo stood and talked with his son, Andrew, and Palomino in order to unwind and disengage himself from this business of selling books. And then, Captain Joe Anastasi, of the state police, put him in an unmarked car, which moved out through the rain in the direction of the East River, toward Queens and home. Cuomo the writer was again Mario Cuomo the governor. And still the son of Andrea Cuomo. Now all he has to do is get through a dinner at Le Perigord.

I'm going to buy his book for my family and friends. And then I think I'll read it again—for myself—when I'm alone, late at night, before the dawn, when the Bible and the Tums don't work. It's that good.

April 18, 1984

The Hound of Holliswood

The Constitution demanded toleration. It said no group, not even a majority, has the right to force its religious views on any part of the community.

Our Constitution provides that there are areas the state has no business intruding in, freedoms that are basic and inalienable. In creating this common political ground, it created a place where we could all stand—Episcopalians, Catholics, Jews, atheists—a place where we could tolerate each other's differences and respect each other's freedoms.

And Jesus, answering the question of a lawyer in language to be understood by all, said that the law and the prophets, their wisdom and vision and insight, their teaching about religious obligation and stewardship, were all contained in two commandments: "You shall love the Lord your God with all your heart, and with all your soul, and with all your mind. You shall love your neighbor as yourself."

That is the law, as simply as it can be expressed—for both the stewards and those in charge, for both the governed and those who govern them.

MARIO M. CUOMO

Mario M. Cuomo has done it to me again. He has made me think, which is an exercise I try to avoid, especially in the summer. You might say I run from it, or you might just say I run. I get up on my Honda motorcycle; I go to the beach; I yell at my children; I listen to Scott Shannon and Mr. Leonard on

the radio; I buy summer tomatoes and eat good, sweet corn from the farm stand in Water Mill. I do not think.

But now, in August—and practically across the entire summer—Cuomo, whom I personally and single-handedly elected Governor of New York, has got me doing heavy lifting with my sunburned brain.

Of course, there are others who will claim all the credit for Cuomo living on Eagle Street in Albany, New York, where on hot summer nights he dreams up these big, disturbing, unsettling observations about the great issues of the day that ruin my summer.

I did this by telling every editor and businessman at the bar of the "21" Club that Mario Matthew Cuomo of Holliswood, Queens, could not possibly be elected. He *should* be elected, I said, but he will not win because people do not think and miracles do not happen in the real world when you have Rupert Murdoch, the *New York Times,* the *Daily News,* and CBS against you. This is known as my "have-such-little-faith" strategy, and I use it whenever I am confronted with implausible, risky propositions requiring bravery on my part or some confidence in my neighbors, a/k/a the electorate.

I told them that the brightest and best candidate—this son of a greengrocer from Queens who speaks in elegant paragraphs instead of shrill headlines—didn't have a prayer in our grand and cynical Empire State. Which brings me to Cuomo—*my* governor. I elected him to build roads and bridges, to sign bills and balance budgets, and to protect me from acid rain, just like Averell Harriman and Herbert Lehman and Nelson Rockefeller and Malcolm Wilson and Alfred E. Smith. I did not elect him to get me to think—and certainly not to think about the separation of Church and State.

But he started this thing with the Archbishop of New York and I, great prophet and prognosticator that I am, must now step in and finish it off with some more great pronouncements over these airwaves. Here, then, is what *I* believe on the subject. It will be known forevermore as the "gospel according to O'Shaughnessy."

I am a Catholic. I was born to this Church founded by a carpenter's son. It is, I think, the most useful and, for me, the

most effective way to get to the God, the Truth, the Integrity, the Happiness, we all seek in so many ways in everything we do. It is not the only way.

I thus believe in an understanding, forgiving, relentless, outrageously loving God, who lives in the words and works of his ministers, priests, bishops. Even in me.

I also believe God uses other messengers, like my friend Amiel Wohl and the other rabbis of our county. He works through the impassioned pleadings of the Black Baptist ministers Calvin Sampson and Vernon Shannon—and every time my neighbor Ossie Davis opens his mouth.

But I am a Catholic, and the voices I hear louder and more clearly than all the others are those of priests and brothers who baptize, teach, counsel, understand, and occasionally inspire. Or, as Mario Cuomo would have it, just simply love. John Joseph O'Connor is one of them—their boss—and he is an archbishop of my Church.

None of the priests or brothers had to tell me that abortion is a terrible thing. I do not need the Reverend Father Terrence Attridge, one of the most thoughtful and pastoral of these clerics who works for the archdiocese, to tell me, as he did last week, that the day a woman has an abortion is the worst day in her life. He knows this, because women have told him as much—after the awful fact. My feelings on abortion come not from a church, but from deep inside, from a place that is mine. I believe it is a capital crime to destroy an embryo in the womb. I am for life—in every way, in every issue, in every case. I detest the death penalty, and I abhor the starvation and slaughter of rootless, homeless people by governments.

I would like someone to speak up, intelligently and forcefully, for the rights of the unborn. It can be Mario Cuomo, the *citizen* from Queens—and he has done that, quite eloquently. But it can't be Mario Cuomo, the governor, *my* governor. Nor can the battle against abortion be left to those modern-day zealots of my tribe known as the "right-to-lifers." Nothing is more obscene than abortion, except perhaps if you consider those "baby-killer" signs that the right-to-lifers waved at Mario and Matilda Cuomo at a college graduation in our city a few months ago.

Far more effective is the tactic used by Mrs. Robert Abpla-
nalp of Bronxville, who, with her friends and her husband's
generous purse, supports the three pregnancy-care centers to
provide help and counseling for young women. The strategy
here is called love.

The dilemma is no more complicated or simple than this:
how do you provide for any woman the right of sovereignty
over her own body, while also acknowledging the most basic,
fundamental right to life of a fragile fetus, a child struggling
to be born in that body? That's awesome stuff for government
to mess with.

These difficult questions of death and killing won't go away,
and to make sure they don't, I have John J. O'Connor. He is
my archbishop, just as Cuomo is *my* governor—and O'Connor
is doing *his* job, forcefully and well.

As you may have observed, there has been some "dialogue"
between the archbishop and the governor on these matters. It
has, until now, all been done in the public press and through
interviews and press releases. Here is my view of that dispute.

There is no dispute. The Archbishop of New York is right to
speak out against the evil of abortion. He speaks for me and,
I'm sure, for Someone I'm trying to find in all of this. There is
no greater issue than killing—period. As a son of the Church
and as a citizen of New York, I don't like it when people go
after my archbishop (read columnist James Breslin) or my
governor (read the right-to-life zealots and Archie Bunker
types).

I extend to both O'Connor and Cuomo the right to advise
me on the great moral issues. But Cuomo can't impose his
morals or beliefs on me, and O'Connor can't tell me how to
vote.

Now that I have installed Cuomo behind that big desk
where once Theodore Roosevelt sat, he speaks for Jews, Prot-
estants, squash players, ballroom dancers, break dancers,
and, of course, for me. When he makes a pronouncement in
front of the arms and great seal of the State of New York, he'd
better not speak as a Catholic, because someone else could be
at that desk between those two flags—and that someone else
could be an atheist or an agnostic or a nudist or a Seventh

Day Adventist or a Christian Scientist or a Mormon or a Buddhist, and I would not like it one bit if they started coming on to me about their personal beliefs.

I'm glad to report that in a week or so my governor and my archbishop will meet—alone, together, one on one, man to man. That is the way it should have been all along. That archbishop has met with Senator D'Amato, Mayor Koch, and the New York press, three times. He will now meet with my governor. And when he does, His Eminence John J. O'Connor will find a bright, fine, loving son of the Church, and one who is trying so hard and so relentlessly to be the splendid governor I elected him to be. The cardinal will find himself confronted with a man whose favorite poem is "The Hound of Heaven": "I fled Him, down the nights and down the days; I fled Him, down the arches of the years." He will also be meeting someone who struggles with it all, and who knows his way down to St. Francis Church on 31st Street, confessions heard 7:30 A.M. to 7:30 P.M. Ask Cuomo about this and he will tell you, "How can you beat the Franciscans? Three Hail Marys for a homicide!"

O'Connor and Cuomo: it will be good for them to meet alone, without their handlers and advisers and posturers, and without the trappings of their high offices.

The archbishop and the governor: there is a special place for each of them.

As for Cuomo, the Hound of Holliswood, who makes me think in the summer, I wish he would take up a sport.

August 20, 1984

Matilda

Matilda Raffa Cuomo was First Lady of New York for twelve years. Her husband, the governor, once called her "the single most effective instrument of his success." I found this extraordinary woman to be a sheer, pure natural force.

Matilda Raffa Cuomo, the First Lady of New York, came to Westchester this week. She arrived in the rolling hills of Yorktown on a stunning Indian summer day. It was warm and splendid as her huge, whirling helicopter eased down in front of what used to be a Jesuit seminary. A stark, simple cross still stands over the main building, but the sign on the lawn these days says "Phoenix Academy." And although the Jesuit priests are gone, the work of salvation still goes on inside those big, brick buildings.

Phoenix Academy is now a haven for hundreds of high school youngsters who have been rescued from the turmoil of New York's mean streets. These teenagers have come here to try to complete their high school education free from the ravages of drug abuse. When the school, a branch of Phoenix House in New York City, opened its doors to these troubled children, the good citizens of the Shrub Oak section of Yorktown, as housewarming presents for their new neighbors, thoughtfully sent over no less than twenty lawsuits, with each of the legal briefs trying to find a better way to avoid saying that exact, marvelous phrase "not in our backyard."

Matilda Cuomo came almost alone to this place, minus the outriders and advance men who accompany her husband everywhere these days. She came as a housewife and a mother. A few months ago, Nancy Reagan was here in beautiful designer clothes, the flashbulbs popping and an impressive retinue befitting the wife of the President of the United States. It was a grand event and widely heralded in the public press. But here on this sunny, autumn day, the former Matilda Raffa

of Holliswood, Queens, came only with more of the unsettling talk we hear always from her husband's lips about a family of New York. This is some of what she said on that Indian summer afternoon:

The drug problem: I'm here, because we felt the best way to really find out about this terrible problem is to get into treatment centers and talk to the children. They know the problem. They live the problem. Children are alone a lot. What we're seeing is the breakdown of the family. We can see abuse, but neglect is insidious. Neglect is a mother not feeding them or clothing them in the winter or supervising them. These children are suffering tremendously. It's easy to say, but children must be, holistically, well. They have to believe in themselves. They have to have faith. I don't care what faith, but they need something to hold on to, so they don't bow to peer pressure. Their family structure is not like that old-fashioned family we think of. If youngsters can summon that will power and have the strength within them to say "I have to take care of myself," and even be a little selfish and say, "This is bad for me," then maybe they can get on with their lives.

The family concept: It's very basic. You have a unit. You have total well-being. You have a structure where one can relate to another. It comes when parents sit down with their children, like together at dinner. Only, they're not doing it too often these days. That give-and-take is where a child learns his self-evaluation. They can relate to the other members of the family. There is a wonderful belonging, a security, a feeling that I'm somebody in this unit, this family. And that support system stands with them for a very long time in their lives. My husband relates that to the family of New York in such instances as the traditional schism between upstate and downstate. Your problems are our problems; in the end we all suffer. Not everybody has that strong family, and that's why I come to these treatment centers.

On parenting: I'm animated with these children on the outside. On the inside, I get very depressed. I just talked to a young girl whose mother was too permissive. She was her "best friend." She let her daughter do whatever she wanted. Her mother loved her too much. A youngster just told me as much right in front of her mother! Imagine! Here is a parent who thinks she is doing the right thing to keep her child happy. But we can't be that friendly with our children. We have to have the authority, and be very firm. Take my Christopher. He just got his license to drive, and he is one, unhappy boy. His father won't let him drive. He's sixteen, and that's so young. He's blaming me for the whole thing—that he can't drive. Why do the mothers get all the blame? [laughing] But I'm so proud of Chris—and we'll talk about it. [Chris Cuomo is now a political commentator for FOX news.]

Her son, Andrew: Andrew is very good at this campaigning business, and I'm proud of him, too. When he is criticized in the press, it bothers me as his mother. I've always had a great feeling of admiration and respect for the children of politicians, because they do suffer. It does affect them. Their whole life changes. Now, some cynic can say that goes with the territory. But does it for the children? Why should the children have to suffer? Andrew happens to be my child. He's not the candidate. That's what I keep telling myself. People should refocus that criticism. We don't believe in negativism. I don't like it. If I don't find a rationale for something, it bothers me more. I just don't find a logic in attacking a candidate's children. What they're trying to do is grope, for reasons of their own, for publicity and, when you extend that to the children, that's unfair. [Andrew Cuomo is now U.S. Secretary of Housing and Urban Development.]

Her husband: I make sure my children sit down with their family once a week. We listen to each other. The governor is a great listener; he always has been. That's why he's so bright. We have our own opinions. He got a lot of flack

from my daughter, Madeline, on the age-twenty-one
drinking law. Even Christopher has his say. My husband
made a point that maybe we should up the driver's licens-
ing to age eighteen to make it standard all over the state.
The governor is very conscientious. He has been for
thirty-two years. I should have seen the handwriting on
the wall when I married him. You're going to get one hun-
dred and ten percent from this man. He sits; he reads;
he researches; he puts his all into his job. He treats the
government like it's his own business, like you're taking
taxpayers' money out of his own pocket! I respect him
because he's consistent! He demands respect. For as long
as I've been with the man, he sticks with his principles.
He's got that wonderful professorial demeanor about
him. He's a great teacher. He can make you understand
complex issues—without emotion. I respect him.

Her own life: I have no regrets—none. I stayed home with
my children. I took a masters, and I taught school a little.
I raised my family. I only regret that the time went too
fast. My children grew up too fast. And now I'm hoping
my granddaughter doesn't grow up that fast.

Her official work finished for the day, Matilda Cuomo waved
goodbye to the children and to the girl whose mother was too
nice to her. Alone, she climbed back up into the big helicopter,
with the great seal of the State of New York on its cabin door,
and flew home to cook dinner and make sure Christopher
Cuomo does his homework.

October 22, 1986

*Matilda Cuomo now heads Mentoring, U.S.A., and has recently
published* The Person Who Changed My Life, *a collection of
first-person tributes by famous people about those individuals
who inspired them to change their lives.*

Cuomo Steps Out

I make my living at it, but I do not like bulletins or the sound of Louis Boccardi's Associated Press wire machines getting speeded up in our newsroom. Those nasty little bells, which herald the bulletin, usually mean bad news. But on Thursday night, February 19, 1987, it was O.K. The bells signaled that Mario Cuomo was Mario Cuomo again.

And yet here they are, all my colleagues in the New York press, rushing to their word processors for the "angle" on why the governor did what he did. I read them all and now, with the advantage of three days, I am here this morning with *the inside story* as only the great O'Shaughnessy can give it to you.

I see this, frankly, as very *personal*. In one brilliant move, in the studios of a competing radio station in New York City, Mario Cuomo effectively ruined forever my chance to be Chief of Protocol of the United States of America, chairman of the FCC, or at least ambassador to Ireland.

He did it for me. There is no other logical reason why Cuomo would deprive this nation of the pleasure of watching a dialogue between himself and the Honorable George Bush, who played first base for Yale, or with Representative Jack Kemp, who has a perfect Buffalo haircut, beneath which the ups and downs of the Dow look like I-formations.

I mean, I was all ready to see a New York rabbi, Israel Mowshowitz, give the invocation in January 1989, in the capital city of our nation. I could almost make out the Italian from Queens, with the blocky shoulders and too many vowels in his name, standing on a cold platform, raising his right hand with that St. John's ring high in the air, saying, "I, Mario Matthew Cuomo, do solemnly swear . . ."

For the last several months, he has been going to small dinner parties in Manhattan with swell and powerful people like Abe Rosenthal, Shirley Lord, and Felix Rohatyn—fat cats who talk of clever and witty things. He has had to be nice to big

Democrat money people in California and New Orleans, and climb into airplanes, which took him across the country despite his tired, baggy eyes and relentlessly painful back. His speeches and pronouncements were skillful, tailored, practiced, rehearsed, and perfect—eminently *suitable* for the occasion. There were messages in them for the syndicated columnists Mary McGrory, David Broder, Evans and Novak. But there was nothing there for Mario Cuomo. There was no music.

For months, he listened to his political mechanics and the great Democrat warlords who tried to speed him up. Then last week, alone, he gathered himself and listened to Mario Cuomo, the son of Andrea Cuomo, who came from Italy, alone.

The national press and our neighbors across the country know him only by the elegance of his tongue. But New Yorkers know better. They know what occurs when he sits alone on the third floor of that big house on Eagle Street, where once Franklin Roosevelt lived. What happens here in the early morning hours by the cold light of dawn is why we re-elected him governor by more votes than we gave the Roosevelts, Grover Cleveland, Thomas E. Dewey, Charles Evans Hughes—or even our magnificent and vivid Westchester neighbor, Nelson Rockefeller. Cuomo has always done his best work alone. And when he sits and churns and struggles with it all, it is, for a few of us in the media, a much more beautiful and compelling story than the chronicling of his accomplishments.

And so he's back at work this morning, worrying about the health of a secretary named Pam Broughton; jousting with legislators Warren Anderson and Fred Orenstein and Mel Miller; compromising, cajoling, and just *being* governor of the only state that matters.

I used to think that Rockefeller had more style and charisma than Cuomo. We loved Nelson. There was no one quite like him and, for twenty years, he pumped dynamism and energy into this state. But Cuomo, by his example as well as by his utterances, is working in places where politicians aren't supposed to go. He is thus staying the course with a sweetness and sensitivity which becomes all of you who put him where

he is. He is—there is no other way to put it—the most *loving* governor we've ever found. And when he walked away from all the political pros and their flattery and enticements, he became, for me, the same Mario Cuomo who sat in my office at this radio station five years ago telling me gentle and hopeful things about family and children and generations.

And now that we have him back in Albany, the betting here is that he will climb into that RV camper he has requested the state to give him and will drive straight down the Warren Anderson–Clarence Rappleyea Expressway—route number 80. And when he comes to the confluence of the Chenango and Susquehanna Rivers, he will head due west on Route 17 into the afternoon sun to visit some of those upstate villages he carried two to one.

One night after work, I hope he will seize the rare moment, when Major Martin Burke of the New York State Police is not looking, to skip down the back stairs of the capitol and head straight for Barnaby's Bar, to sit for an evening with Professor Fabian Palomino over negroni cocktails (⅓ vermouth, ⅓ vodka, and ⅓ Campari), and talk about a family and children and a state he dearly loves.

And if Lewis Rudin and James Robinson III and David Rockefeller, who collects beetles and money, will not try to take him to any more fancy French restaurants, I hope he will stay home of an evening to crank up his record player and listen again to "Stranger in Paradise" and "Polka Dots and Moonbeams" with the former Matilda Raffa.

There is another song I'm saving for him. It's by an Englishman and it's called "Alone Again—Naturally." It's best listened to in the small hours of the morning over that desk on the third floor at the mansion on Eagle Street.

A few weeks ago, Mario Cuomo found some lines which never made it into his state of the state address: "Look into yourself, and find what you find, and keep what you find. For there is within you, a voice which is more powerful than the noise of all the parades."

He found that voice. Like I told you, he does some of his best work alone.

February 24, 1987

Don't Run, Mario!

I have a troubled, confused mind about some of the great is-
sues of the day. This will come as no surprise to those of you
who tolerate my ravings here on the radio each morning. It
is about the economy, about presidential politics—and about
Mario Cuomo. The confusion in my meager brain goes beyond
new car sales, housing starts, the GNP, and unemployment
figures. It is somewhere out there beyond the reach of the
stock market, which is the playground of an elite few.

What ails America, my own personal country, is not the
value of the dollar abroad or the possible failure of our bank-
ing system. The whole damn mess—the problem—is not some-
thing you can reach out and touch. It concerns the *spirit* and
the *soul* of a struggling republic. The newspapers and televi-
sion commentators focus on charts, graphs, and downward
spirals or the pronouncements of narrow, limited politicians
who don't understand either. The media of the day should for-
get about Star Wars and smart bombs rained down on desert
rats like Saddam Hussein and Moamar Gadhafi. These are
easy stories to file.

A sense of disconnectedness is the real issue, as I see it. It is
a big, sprawling, awkward word, devoid of romance or glam-
our. But it is slowly tearing apart the America we love and
pray for on this Thanksgiving Day.

How do you get at the *spirit* of the country? You get there, I
think, only with *love* . . . and by that other peculiar word
Cuomo uses that so unsettles the plastic, macho politicians
abroad in the land with their red ties and their transparent
eagerness and ambition: *sweetness*.

It is not Cuomo's way with words or his oratory that recom-
mend him, or even the genius of his bright, fine mind. Ulti-
mately, the governor brings to all of this only a decency, a
goodness, and an ability to feel people's pain. George Bush, in
his cigarette boats and golf carts, will never understand.

"You can make us sweeter than we are," the governor told two thousand broadcasters recently. Some of my colleagues, who will never understand his music, were uneasy hearing this particular word from a big, strong failed baseball player with too many vowels in his name. Real men don't talk like this—and certainly not governors. Or presidents.

So *I don't want Mario Cuomo to run for president.* There, I've said it! My *mind*—read, dwindling purse—does. But my *heart* is not in this game. Of only this I'm sure: Mario Cuomo is operating on a level far beyond every other contemporary politician. He doesn't know it yet, but he has even gone beyond being Governor of New York. The stuff he is selling and what he is about are not shaking hands at factory gates in Cleveland or playing word games with cartoon-like Sam Donaldson or prickly, brittle, bespectacled George Will.

Cuomo is the only public person who can go inside people, to places where politicians rarely get and few belong. He may yet be the greatest Supreme Court justice in this history of our democracy . . . or the Thomas More of our century. But he doesn't need Air Force One as his vehicle to get there, or the oval office as his podium. Cuomo needs only himself, and so does the nation. I care not about the forum, the setting, or the venue. I would even take him from behind that big, ornate desk at the state capitol and strip Cuomo of his robes and mantle and high estate and send him out into the streets with the people in their restlessness, confusion, hurting, pain, and hopelessness.

The place for Cuomo is not in the editorial boardroom of the *New York Times* or jousting with a lightweight like Dan Quayle. As I see it, his *ideas* will prevail, even if he were to spend the rest of his days standing down at the bar at "21" singing "Danny Boy," like his predecessor Hugh Carey.

This is lousy, political, and tactical advice with which, in one grand gesture, I hereby alienate all the political operatives who are chanting, "Run, Mario, run!" But he doesn't belong with Fortune 500 fat cat executives, dazzling them with economic theory. The governor doesn't need to do one more position paper or show up for one more photo opportunity. He needs only to remember another Thanksgiving night a few years ago, when the heavy, electronic gates at the governor's

mansion at 138 Eagle Street slid open to let out an old, un-marked Chevrolet. No troopers, no reporters, were in the automobile as it headed for a Protestant men's shelter in a run-down, drodsome section of Albany known only to the poor and the homeless. It was a sad, alien place, which might have been reconstructed in the mind of William Kennedy, the great Albany writer.

The Governor of New York was behind the wheel with his young son, Christopher, the only passenger. A father and his son were on a mission this night to deliver sixty pumpkin pies, which had been run up in the kitchen of one Matilda Raffa Cuomo.

And on the lonely Albany street, Mario and Christopher Cuomo unloaded all sixty pies, carefully, one after the other. Just as they completed their sweet task, the executive director of the shelter came running out to insist that he be allowed to tell the Governor of New York all about the wonderful workings of the shelter. He was especially proud of their efficient procedure for delousing the men before they entered the premises. After the impromptu tour, an unsettled governor and his young son sped back to the mansion.

This little vignette, which comes drifting back to me on this Thanksgiving Day, tells everything about Cuomo. Anyone else I know would have felt very good about the nice gesture of delivering pumpkin pies to the homeless. Some would have had photographers present; others would have merely leaked it to the press. But back on Eagle Street, the light in the tiny office on the second floor burned late into that cold night. And after his own family had retired, their stomachs filled with the good food of Matilda Cuomo's holiday table, Mario Cuomo sat alone, wondering and churning and struggling about those lost, lonely souls he had encountered earlier on the dark side of our capital city.

And so this Thanksgiving Day, my only hope is that this good, sensitive man will somehow slip the bonds of his high office, instead of sitting at his desk tonight trying to best the pundits.

There goes our invitation to the White House, Nancy.

November 28, 1991

Immaculata Cuomo

Immaculata Giordano Cuomo died last week. The woman was born ninety-three years ago in Tramonti, just outside Naples, in the Provincia di Salerno.

There was a grand funeral Mass for Immaculata Cuomo in a place called Jamaica. And as it is in the 718 area code, where I am not so big and important, the former Nancy Curry and I departed from Westchester so early in the morning that we arrived almost an hour and a half before the family of Immaculata Cuomo. We did not want to drive on the wrong parkway and wind up in a place like Ronkonkomo or Far Rockaway beyond this strange borough over the bridge.

The Cuomos lived for years in this borough of Queens, and many of the old women of the neighborhood came to the Immaculate Conception Church to pray along with some rich and privileged people. The titled and those of high estate moved right to the front of the church. The old women in black sat off to the side. Robert F. Kennedy, Jr., and his mother, Ethel, who know about the black and protocol of funerals, sat somewhere in the middle of the beautiful Catholic church, which the locals call the "cathedral."

Especially as this was to be about the mother of Mario Cuomo, I sat as far back from the altar as I could possibly get so I would not have to be exposed to any of the sadness the governor brought with him as he came to pray for his mother in this church before they buried her. But even way in the back, Nancy and I could hear the hymns and the prayers of the funeral Mass. This is some of what we heard and felt in the great church on that spring day in Queens.

For a woman who came to this country with only an address of a husband who came before her, there were ten priests of the holy Roman Church. One of the priests was president of St. John's University. But the main celebrant was an old Irish priest who told the mourners: "She was very much, shall we

say, of the old school. Her life was one of hard work, altruism, a deep and vibrant faith, which she transmitted, almost by osmosis, to her children. We talk of family values. Her life was the authoritative text on the subject. She took life with simplicity and gratitude." And then the priest quoted St. Paul: "Eye has not seen, ear has not heard, and neither has it entered into the mind of man, what God has prepared for those who love him."

The next to speak was Margaret, a granddaughter of Immaculata Cuomo. Margaret, a grown woman with a daughter of her own, spoke simply with a childlike beauty as she told exquisite personal stories about her grandmother.

And then the youngest son of Immaculata Cuomo went up on the altar to explain his mother. He has spoken with power and grace and eloquence on many subjects all over the world. But this was for the one he called "Momma," and you leaned forward to hear him say: "I tried to write a speech. I wasn't able to. I mean, what do you say? Especially after the devastating beauty of Margaret's remarks. Momma was so strong, so dignified, so intuitive. Every mother is wonderful and glorious, I know. Yet, even after you carve away the excess, you know this one was special. She used to regret her lack of education. Maybe it's better she didn't know cybernetics from a salami slicing machine—or megabytes instead of the struggle for survival. She was better with her intuition than you were with your education and intelligence. She knew only this—that no one could have assembled all this magnificence and all this complication if it wasn't going to come out all right in the end. She knew this, and you could not have a mother like this without being awestruck by her strength. She was not of a world where Porsches are parked next to BMWs. I have written and spoken about Momma and Poppa. Many of the stories are in the public domain. I think of Poppa, who wrote sermons in the sand at the beach with his hands. We remember the charity of their souls and the largeness of their hearts. I only want to quote from the Book of Proverbs: 'Her value is far beyond pearls. Her husband, entrusting his heart to her, has an unfailing prize. She brings him good all the days of her life. She rises while it is still night and distributes food to her

household. She has strength and sturdy are her arms. She reaches out her hands to the poor and extends her arms to the needy. She is clothed with strength and dignity, and she laughs at the days to come. She opens her mouth in wisdom and on her tongue is kindly counsel. Her children rise up and praise her. Give her a reward of her labors, and let her works praise her at the city gates.' "

The governor finished his simple tribute with, "So, laugh for *us*, Momma. The years are behind you—and try to make a little room for us."

Mario Cuomo then sat down. And when they blessed the body of his mother and finally bid her to rest, he went straight back to work at his office at the Willkie, Farr, Gallagher law firm. He is the son of Immaculata Giordano—and Andrea Cuomo.

Outside the church, the talk was of her dignity and sense of humor. I discovered something of this when I encountered Immaculata Cuomo in a Bob's Big Boy restaurant on the New Jersey Turnpike several years ago. She was on the way to Washington for the wedding of her grandson, Andrew, to a daughter of Robert and Ethel Kennedy. As I came upon Mrs. Cuomo, I inquired: "Excuse me, but are you *Rose Kennedy*?" Without missing a beat, this marvelous woman said: "Now stop that, Bill O'Shaughnessy. You know very well who I am. And *I* know who I am."

May 1, 1995

PART IV: TO LIFE

Hunting = Killing

This commentary was broadcast following the schoolyard shootings in Jonesboro, Arkansas; Pearl, Mississippi; Springfield, Oregon; and West Paducah, Kentucky. Sadly, these were only a prelude to what occurred in Littleton, Colorado, this past spring.

I realize it is probably unfair to blame these tragic episodes solely on the rural culture which elevates and exalts hunting and is so fiercely protective of its firearms. Perhaps we might even assign some blame to a president who sets a wonderful example by ordering up bombing runs over a European city while refusing to take on the NRA here at home. Or politicians right here in New York State who restored what Mario Cuomo has called "our most solemn official killings," a/k/a the so-called death penalty.

Violence is the culprit. Violent games, violent sports, violent toys, and violent movies with violent heroes. But as Cuomo warns, "Ultimately, we are the problem. We allow the violence. We stir the demons that torment our deranged and make it easy for them to find and use instruments of death."

There is enough blame to go around.

The Grammar School Killers: So Near and Yet So Far

We are killing our young, and nothing I can say on the radio in wonderful, pristine Westchester will make it any easier to understand that the shooters are themselves children.

Sadly, it's all so predictable and, in the aftermath, we have bereaved parents of the killers who cannot resist the lure of the media's siren song. Suddenly, they become somebody who is called from the dullness of their lives to share their awful celebrity with the whole world: "Put on your best get-up for CNN or Matt Lauer, because they want to talk to you about

why your kid carried a rifle to school and cut down some of his classmates." And we see the truck driver who proudly announced to Matt Lauer that he always spoke to his son "once a week . . . no matter what."

We hear constant references to the "popular culture," but the popular culture north of Poughkeepsie and west of the Hudson is completely different from what it is here in the suburbs.

The latest killing happened in an alien land of denim, six packs, food stamps, trailer parks, chicken wings, fish fries, fast food, neon lights, happy hour every night, Ford and Dodge Ram pickup trucks, and weddings with cash bars where a dance with the bride requires that you drop a dollar bill in a bridesmaid's waiting basket.

This is not about African or Hispanic kids struggling in the ghetto fifteen minutes to the south of us. These shootings occurred in rural America, populated by people who go to chicken-and-biscuit country social suppers and ham dinners at the firehouse. The men have beards and bellies formed by Rolling Rock, Old Milwaukee, or, on a good night, Silver Bullets. Many "drive truck" for a living, and their overfed, overstuffed women push loaded baskets down the aisles of IGA markets while screaming at shoeless children with blonde, dirty hair.

Many in the population belong to militias, the KKK, the Masons, the Elks, the Moose, and the local gun club. They give their sons names like Chad, Lance, and Brett, and they teach them about killing at an early age. All of which is witnessed by ignored younger sisters named Tiffany, Brittany, and Charlene.

The first to die at the hands of young rural shooters are the rabbits—then wild turkeys, squirrels, dove, pheasant, and quail. Next are the hawk and other birds of the air. Then comes deer season and, in many communities, all commerce halts, all education is suspended. Even the courthouses, the libraries, and the post offices close for the autumnal slaughter. Anything that moves is fair game in the rites and protocols of hunting: horses as well as ducks in a pond. And if a dog is "runnin' deer," it's "O.K. to shoot 'im."

The youngsters who now gun down children are raised in a culture that instructs them to ride country roads in pick-up trucks with gun racks mounted across back windows and high beam spotlights with which to stun deer foraging for food in bleak, barren fields on the edge of a wood line.

Television is routinely blamed for the violence in our society, but this is fantasy violence. On film, on a screen, into a living room. But it takes face and form and becomes real when macho fathers and grandfathers teach a kid how to march at dawn into a wood lot to stalk and kill an animal. They call it hunting, the least honorable form of war on the weak. It is on these cold mornings that children first learn the technique and protocol of killing. Some, as early as age six, are given camouflage pants and battle fatigues and are presented with BB guns, lethal sling shots, bow and arrows, and pellet guns. Thus armed, they go, hand in hand, stealthily and proudly, with their fathers, uncles, and grandfathers, to shooting ranges. They are taken deep into the woods and instructed in the proper way to decoy or distract or lull an animal prior to shooting it to death. They are tutored in the proper way to crouch, aim, and squeeze the trigger, and how to allow for "Kentucky windage" and to handle the recoil against your shoulder. All this so they are ready when an animal appears in the crosshairs of a magnifying scope.

It's all about power for people who don't have any—and it teaches children that life is not valuable. And don't be too quick to blame the little chubby killers with the pimples and crew cuts who are shooting up school yards way out in the western part of our nation. The potential is much closer— north of Poughkeepsie and west of the Hudson. It is all so near—and yet so far.

1998

THE KILLING SEASON

The deer season is open in what the Conservation Department calls the Southern Zone, and all day yesterday they came driv-

ing through Westchester—these mighty sportsmen with once lovely and graceful animals slung over cold steel automobile roofs.

Many of our listeners, no doubt, will be offended by our remarks, but we'll give anyone a chance to get on the radio to tell you hunting is a great, worthwhile, manly sport. I have done my level best to try to understand these ancient tribal rites, but these hunters and their trophies of brutality and arrogance hold no magic for us.

Fall is a wonderful and subtle time of year, but its beauty is shattered for three harrowing weeks by the crack of rifle fire. And it's legal because of powerful pressure groups, which represent men who make guns to kill animals. These people come out and tell you that a bullet in the head will save a deer from starving in a cruel winter. And in Albany, the state capital, our great conservationists unleash these morons with orange hats and hunting tags to go into a forest to stalk and kill. They have even found a graceful name for the autumnal killing. It is now known as the annual "harvest."

Men even raise their sons and say, "Son, I want you to learn the proper use of a gun—and go and kill an animal, son, because it's honorable and it's manly." But hunting, in this day and age, may be the least honorable form of war on the weak.

A man named Walter de la Mare wrote about this barbaric pastime that demeans us all and lessens us as a people. We dedicate these words to all hunters sitting at their breakfast table this morning:

> Hi! Handsome hunting man,
> Fire your little gun.
> Bang! Now the animal
> Is dead and dumb and done.
> Nevermore to peep again, creep again,
> Leap again,
> Eat or sleep or drink again.
> Oh, fun.

This all came back to me as I carried the body of my slain dog through the woods last weekend.

December 1, 1988

War = Killing

Vietnam is a nasty little war in a dirty little country and nobody cares about it. But a man like John Brophy cares. He will be there when kids from Westchester get drafted. He will put them on the train, which comes through the early dawn into New Rochelle, and only Brophy—and some parents—shows up to wave goodbye to this train, which goes straight to Vietnam these days.

But nobody else really cares. At night, when a lot of us are having dinner, Walter Cronkite comes on the entire CBS TV network and shows a film of American GIs cutting off the ears of dead Viet Cong guerrilla soldiers. It makes you sick to watch this shocking and barbaric conduct come at you in your living room.

You think you are prepared for anything if you saw President John Kennedy get his brains blown out. But these barbaric acts, which came off the television screen right at you during dinner, reflect on every American. Everyone has a piece of this stinking war. It has made animals of our young. Every high school principal who pushed science and technology instead of history and humanities contributed to what we saw last night. Everybody who ever stood off with their smugness and said, "Why should I vote?"

And if you want a reason to object to this rotten war, think of what it is doing to our young. It wasn't the Japanese or the Nazis last night on Walter Cronkite. It was us.

1970

It was warm for October on the Iona College campus yesterday with these young men. But the sky was gray and mean as

they dedicated a piece of cold, smooth marble to the "sacred memory" of nine Iona students who died in Vietnam.

There were no unwashed hippies yesterday at this suburban college run by the Christian Brothers for the forgotten minorities of the New York area, which is what some sociologists call the Italians and the Irish these days. Nine names were cut in the marble—Iona students who, according to the inscription made by the stonemason's tool, "died for peace" in Vietnam:

W. Tim Dorsey
Anthony O'Neil
William Wagner
Dennis Russo
Charles J. Garity
Daniel J. DeSocio
Joseph Smith
Stephen Parker
Thomas E. Grix

Noting that these nine named took up most of the cold rock in front of Cornelia Hall, you wondered how much smaller the stonecutter would have to write the next time—before somebody gets us the hell out of Vietnam.

An old bishop, which the holy Roman Church calls a military vicar, stood with his staff and miter on the campus and told these young men about getting shot up in two world wars before he retired. And then the bishop called the Vietnam disgrace "half a war."

It may be, as the bishop said, "half a war." But as we stand and look at these names engraved in marble, we know that it took these nine whole lives.

And how many more!

October 20, 1970

Abortion = Killing

THE GREATEST ISSUE

This is not as a broadcaster, but merely as a citizen of Westchester County. I consider myself a "progressive" individual and a liberal, but I'm sorry I have not spoken on this issue.

Just as the evil we call abortion is not new, neither is the outcry against it. Far from it. Back in A.D. 190, in the ancient city of Carthage, writer and scholar Quintus Septimus Tertullian said: "To prevent birth is only a quicker way of committing murder. He is a man who is to be a man. The fruit is always there in the seed."

Tertullian was not alone in expressing his horror. Ishmael Ben Elisha, a rabbi, cried out in the second century against abortion and the slaughter of children yet unborn: "It is a capital crime to destroy an embryo in the womb."

And now in the United States of America, Terence Cooke, a cardinal archbishop, warns: "Once innocent life at any stage is placed at the mercy of others, a vicious principle has been legalized. Thereafter, it may be decided that life is to be denied the defective, the aged, the incorrigible, and granted only to the strong, the beautiful, and the intelligent."

Thus, centuries apart, a Carthaginian, a Jewish rabbi, and an American cardinal were not deceived.

He is a man who is to be a man.

Long after our bond issues are passed or rejected and long after our bridges are built or rejected, our nation may be judged on its reaction to this horror we call abortion.

TO LIFE!

Here are thoughts from the past, but always in season, about unborn children whose fragility hides divine potential from a rejecting world.

Yesterday's *New York Times* ran an extraordinary advertise-
ment in the section known as "The Week in Review." It was a
full-page ad designed to enlist help and money to "check the
population explosion." The ad showed a picture of a child
about six months old—a glorious, fat, healthy, magnificent
baby. At the top of the ad you saw words charging the baby
with being a "threat to peace." The text went on to suggest
that this baby alone was not really a problem, but almost two
million like her who are born into the world every week *are* a
problem—and a threat to peace. The ad then went on to ac-
cuse the baby, and others like her, of being responsible for
famine, rioting, and war.

The ad was signed by Emerson Foote, one of America's
greatest advertising men; Winthrop Aldrich, former Ambassa-
dor to England; Eugene Black, former head of the World
Bank; and several other people who should know better.

We found the ad distasteful and vulgar, to say the least. Reli-
gion really has nothing to do with it, but we'd much sooner
entrust our young planet to babies born in the image and like-
ness of a wise and compassionate God than to the people who
allowed this gross and selfish ad to run over their signature.
It's too bad these men have to use their money and power
and influence to blame their own mistakes as members of the
human race on babies yet unborn.

There are a lot of problems confronting us close to home,
but we cannot overlook this dismal testimonial to our own
decadence and sickness as a people. You can disseminate in-
formation about birth control, but why must it be done in such
a depressing and gross way.

Surely there's a God in heaven who will one day call us to
answer for vulgarities such as this.

July 1, 1968

STATISTICALLY SPEAKING

Let it be recorded that in the year 1971, in the United States
of America, in the great, sovereign Empire State of New York,

262,807—that's 262,807!—abortions were performed. This tidy little figure of life denied was released yesterday from Albany, which is the capital city of our state.

I am reminded that a wise man from Yonkers, who has the number "2" on his automobile license plate—the Lieutenant Governor of New York—once counseled us that it would not be at all fitting or proper to impose our morals or values on others. Well, Malcolm Wilson happens to feel as we do on the subject of killing but, of course, he is right about imposing our own moral beliefs on others.

And so, this morning, we can only congratulate the great Legislature of the State of New York and the executive branch for allowing these "statistics."

Two-hundred-and-sixty-two thousand, eight hundred . . . and seven.

September 1, 1972

PART V: THE FIRST AMENDMENT

Introduction

Not many people know the story of John Peter Zenger. The courageous precedent he set was the forerunner of our First Amendment rights to Free Speech and Freedom of the Press.

The story is not lost on us, however. It all happened in colonial times in WVOX's backyard, what was then called the Town of Eastchester. A colonial journalist by the name of John Peter Zenger printed a story about a rigged election that was held on the village green in front of St. Paul's Church—which now stands as a national historic site and monument to the events that took place there.

Zenger accused the royal governor of rigging the election by announcing the date for the vote, but not the time. When all of the appropriate partisans were assembled at the appropriate time, the election, of course, went to the governor's candidate.

Zenger was charged with treason for printing a story that could be interpreted as critical of the crown. The matter went to trial, and Zenger was acquitted by a jury of his peers—assuredly, not on the facts of the case, but on the principles since embedded in our Bill of Rights.

In the spirit of those days, we have taken up the cudgels on many an occasion to defend this most precious of freedoms. As the "point man" for the National Association of Broadcasters, I have spoken time and again against the onerous requirements of the Fairness Doctrine and the censorship forces that well up in response to the on-air antics of "shock jock" Howard Stern or the sexually explicit—even violent—lyrics sung by our more outrageous rock-and-roll groups.

These are some of the editorials and speeches that I have given on the air, on the road, and in the halls of Congress on the topic of Freedom of Speech and Freedom of the Press. I hope they are valuable pronouncements on some of the great issues of the day.

Free Speech on the Airwaves (Again!)

Some years ago, in Palm Springs, California, the board of the National Association of Broadcasters met in high council to consider a censure motion against Howard Stern. When the debate began, I didn't have the votes to stop it.

Many editorial writers and columnists—among them, Abe Rosenthal of the *New York Times*, Don West, Nat Hentoff, Jerry DelColliano, and Harry Jessell—and many constitutional scholars, including Monroe Price and Lawrence Tribe—believe that recent actions of the Federal Communication Commission represent an intolerable intrusion into program content. And so do I.

That view is also held by many of our colleagues, including my prolific and articulate constituent Jerry Gillman of Woodstock. It is not necessary to mention those specific cases because, indeed, the matter affects all of us. I will merely, for purposes of this discussion, call him the "Unmentionable," the "Wisecracking disc jockey Unmentionable" who, thanks to the commission, now has a career on television as well as radio.

At any rate, the broadcasts for which he stands accused may have been indecent or obscene. We now realize, however, that such a judgment should be left to the broadcaster, and thus to the viewer or listener who should be able, in this republic, to exercise the ultimate and only permissible censorship: by tuning out material that may be offensive to his or her eye or ear or sensibilities. Indeed, as I read the transcripts, the only "crime" of which the "Unmentionable" should perhaps stand accused is grossness or vulgarity. And I would join my many colleagues in this room who find against him on that score.

There is a feeling abroad in the land that community stan-

dards differ by market size or geography. What goes in New York or Berkeley or Denver does not belong in Spirit Lake or Pocatello. But as a result of our "wired nation" and the modern technology of cable, satellites, networks, and super stations, we are all one. It is thus dangerous—as well as impractical—to say: "Crack down on the 'Unmentionable,' but not on the rest of us."

I have acknowledged my belief in the existence of Evil, which is to be fought in every way, on a daily basis, in our own personal lives. But whether we like it or not, as broadcasters, as citizens, and as passionate believers in the Constitution, we have to take our stand with the raucous, the gross, the clumsy, and the sensational.

Earlier this week, I sat in the office of the publisher and president of *Broadcasting*, that singular publication we have called our "bible." It is, at least, the most respected journal of the "fifth estate." Larry Taishoff and I debated and agonized over the grossness and vulgarity of some of those broadcasts to which I've referred, and over the lyrics of some of the popular songs of the day. We were as distressed and as uncomfortable as you are—or, indeed, as uncomfortable as the bureaucrats at the FCC were before they took their disastrous steps of the last few months.

After a few minutes, however, with the likeness of his late father staring down at us from an oil portrait propped up behind his desk, Larry Taishoff said: "We have always had terrible examples to defend." He reminded us of Rev. Carl McIntire, for example, and his hate-filled pronouncements. And I then recalled the days of uncertainty when it was so painful for our stations to carry a harsh, strident program attacking Israel, the Zionist movement, and even my esteemed Westchester neighbors, the Rockefellers.

So, once again, we have terrible examples.

But the issue is monumental and goes far beyond Howard Stern. Our national association, with the encouragement of every one of us, has to be prepared to fund a major legal challenge if the Commission does not back down.

For many good, decent, and God-fearing people in this republic—and for broadcasters and many others in this room—

the connection is a hard one to make. But the songwriters, disc jockeys, rock stars, and musicians struggling to communicate in the vernacular and with the currency of the day—in all their grossness and clumsiness, in all their lack of grace and finesse, for all their lack of style—are, whether we like it or not, the bards and poets and minstrels of the day. Despite their lack of depth and their outrageousness, they deserve to be protected from the prevailing attitudes of federal bureaucrats in every instance. They deserve the opportunity to be rejected only by the broadcaster functioning in our role as fiduciary and trustee and "permittee" or, as I've suggested, ultimately by those people we serve and with whom we reside as citizens and neighbors in the republic, people whose decency, goodness, and perception we must trust.

As a result of the Commission's actions, the whole profession—the whole "industry," if you prefer—is now at risk and at peril forever. For as it now stands, anything can be held to be indecent by three individuals, three bureaucrats sitting on the commission.

I'm glad we moved this away from any discussion of license renewal legislation or "trade-offs" or the economics of the profession. This is infinitely more important, and I hope today we can send a strong, unequivocal, and unanimous signal saying that Free Speech is not negotiable or part of a package.

It's not that we're for or against obscenity. There are, we must acknowledge, laws against obscenity. And there are laws against decency—although a chairman of the FCC was recently unable to cite them. Even the Communications Act, whose provisions enable us to exist, is contradictory. In part, it says that the Commission should stay away from programming, while other provisions suggest that the FCC should be enforcing violations against community standards. This present Commission, quite obviously—with its unique philosophical inclination and under pressure from religious fundamentalists—is holding to that part and ignoring the rest.

The whole, damn, difficult question should go to the Justice Department and thus to the courts. But the Justice Department—even the Justice Department of President Reagan and Ed Meese—didn't want to play with this one. But the

Commission did. And so, the question—with all its implications, in all its dimensions, and with all its danger—should be adjudicated by the branch of government which provides for due process.

In the courts, then, the matter will be debated and argued and exposed and appealed and, we hope, decided fairly and intelligently as the Founders would have it—not by an administrative body, not by three bureaucrats, but by the courts of the land, and probably even by the highest court of all, the Supreme Court of the United States. All the wise scholars, all the students of our Constitution, and our democratic form of government have counseled, always, in every age, that if a nation would seek to enforce social conduct, you go to court for redress.

By our action today we can let one and all know that we stand our ground and are prepared to see it through. And as I've said, the battle is joined for all of us. Paul Hedberg, the "owner" of radio stations, told us this week about a major advertiser—his biggest, in fact—who called him late at night to complain about a certain record. The sponsor said, in effect, "Get the record off—or I walk." And Paul did what any of us would do. He jumped in one of his twelve cars, headed for the station, and broke that record into a thousand pieces!

Every broadcaster should have the right to do that for whatever reason—to say, "Not on my station." And most will exercise their office. Ninety-eight percent will say, "Not on my station," and perhaps a small percentage will not. But that small percentage is just as entitled to exercise their franchise as we are. They are just as entitled to exercise their creativity and judgment as we are. Somebody, some minority, among our fellow citizens wants to hear that.

The danger and threat to all of us which the Commission promises by its stated policy of refusing clear guidelines—and instead threatening "case by case" enforcement of those nonexisting guidelines—dictates that we act now and send an unmistakable message that this issue is beyond tactics and strategy.

We have fallen into familiar patterns during this debate. There stands John Summers, providing us with the tactics and

prudent strategy dictated by the current political "climate." Because Summers is a Washington "insider" and a longtime warrior in the legislative and regulator vineyards, we must weigh his sober, practical, timely advice against the timeless, fragile concept of Free Speech armed only with the repulsive examples we've all read.

That "practical" approach is driven also by the wise and respected counsel of Gene Cowan of Capcities/ABC, who does the bidding of my Westchester neighbors Mr. Murphy and Mr. Burke. He advocates that we not provoke the FCC or drive them into a corner. And, as always, we must pay special attention to Gene, for he is greatly heard and heeded here in the capitol, where he spends his waking hours.

These voices are allied with Chairman Snider, who stands at his podium, armed with righteous indignation, trying mightily to apply his own innate decency and goodness to support his feeling that purveyors of filth should be driven from our ranks at any cost. I admire and respect Mr. Snider, but I'm not willing to pay the price. Our disagreement is on the choice of referee. We believe that the American people should blow the whistle and control the clock by tuning us out. And we believe that the institution established by the people for social policy disputes—the courts—should handle any protests beyond that.

So, while John Summers's position is smarter and more practical, and Ted Snider's view has more appeal, those of us who would try to embolden our profession to action against the Commission are left with only vulgarity, coarseness, and grossness, with those "terrible examples" Larry Taishoff spoke of.

Which words are really obscene? Jerry Gillman of Woodstock, for example, wonders if "fuck" is really worse than "nigger" and "kike." Which, indeed, is ultimately more obscene and indecent?

The fundamentalists, who have relentlessly lobbied recent appointees to the FCC, have probably forgotten that Jesus of Nazareth showed great compassion for prostitutes and other sinners against "the flesh," while reserving his greatest disap-

proval for the self-righteous, the hypocrites, the chief priests, the elders, and the magistrates of the day.

And so we really are left with only vulgarity . . . and grossness . . . and some fragile notions about something called Free Speech . . . and the First Amendment to the Constitution we now celebrate, but sometimes forget.

June 25, 1987

I'm pleased to note that my colleagues bought into my pleadings on the subject. But I also had some powerful and timely help from Mel Karmazin, Howard Stern's boss, who now heads CBS.

The Fairness Doctrine

I am privileged to represent the radio stations of New York and New Jersey on the board of the National Association of Broadcasters in Washington. On occasion the enthusiasm of our trade association for the First Amendment has been somewhat underwhelming. My colleagues were even tempted to accept the imposition of the so-called Fairness Doctrine in exchange for a reduction in regulatory fees.

All of this is not about pawns or bargaining chips. It's about what we are.

As broadcasters, we are about the people's business. We send words and pictures and images and ideas—even the truth, on occasion—into the homes and minds of our listeners and viewers. We are not Ford dealers, as we resembled Saturday night at the luau—standing around the lawn at an island resort with loud shirts on and flowered leis around our necks, stuffing ourselves with poi and roast suckling pig. We are not insurance agents or realtors or holders of a John Deere franchise. We are who we are.

We are broadcasters—and we know who we are and what we are about. We report and comment on the daily lives of our countrymen and those who govern them. We can topple governments and even presidents. We can make the communities from which we've come better, wiser, kinder, more enlightened—even "sweeter" places to live.

We are, thus, more than performers and entertainers. We are more than show-biz types, like the constituents of Jack Valenti. And we are free and over the air. Even in this high tech, speeded-up, electronic day and age, we are still the medium closest to the people—the poor, the lonely, the misunderstood, the disenfranchised. And as the Fairness Doctrine interferes with that relationship, I ask that we strengthen our resolve on this one. If we weaken or wobble or make any cal-

culated trade, or if we try to "finesse" this one, we will have lost credibility for all time to come.

My meager plea, then, is only this: that we not send any uncertain or unclear or unsteady or confusing signals on a bedrock, fundamental issue. The Fairness Doctrine is not a bargaining chip; it is not negotiable. It is about what we are. If we cut and run now on Fairness, and if we jettison our principles and throw them over the side for political expediency (and don't think I'm being even a little grandiloquent or melodramatic), it will be our own Day of Infamy.

January 18, 1988

Porn Rock and the PMRC

This is a great and good profession. I believe, as my Westchester neighbor Julian Goodman (a former chairman of NBC) once observed, that we broadcasters have an "awesome trust." It is a lovely and graceful phrase.

We've come a long way since Mitch Miller telephoned Oscar Brand, the brilliant folk singer who wrote "A Guy Is a Guy" for Doris Day. Mitch Miller told Brand that it was a great song, "but," said Mitch Miller, "they have to get married at the end." And so Oscar Brand was made to add the memorable line: "So I walked down the aisle . . . like a good girl should!"

I want to acknowledge my respect and admiration for Tipper Gore and her colleagues Mrs. Susan Baker, Pam Howar, and Sally Nevius. Instead of buzzing around Washington and submitting to an endless round of polite teas and receptions as the wives of powerful senators and the Secretary of the Treasury, they have decided to climb into the arena and do battle for something in which they deeply believe: the environment in which their children will be raised.

As I have acknowledged, we struggle and churn about this, and we worry with the Parents Music Resource Committee. We are mindful, most of us, of John Kennedy's prophecy: "When the dust of centuries has fallen over our cities, we will be remembered not for the battles we have won (and we would add, not for the numbers or ratings we have achieved or the advertising sales we have made), but rather for our contributions to the human spirit."

We broadcasters are "permittees" and trustees, with a fiduciary relationship to the airwaves, which rightly and properly belong to the people of this country. Many, perhaps even most of us, believe that a radio station achieves its highest calling when it resembles a platform, a soapbox, for the expression of many different viewpoints. We speak out on con-

troversial issues and try to provide leadership in our community. The First Amendment is very important, almost sacred, to us. We will fight anyone who would dare stifle our newscasts or editorial pronouncements.

I am not sure that the popular songs of our day might not deserve the same sensitivity and protection and consideration as our own pronouncements—no matter how gross, no matter how outrageous. A song is like an eyewitness report. The writers of those songs write of the daily life in America, the daily passions of our countrymen, the milieu in which they live. They write in the vernacular and with the currency of the day.

In any society, there is a fine line of taste that constantly changes. The populace redraws it every season—and we can't stop it. People have been making songs to reflect their environment since the beginning of time. The first music was probably a repeated note similar to the insistent rhythm of an Indian tom-tom. (And incidentally, the American Indian has a marvelous trove of bawdy songs.) As for me, I make a living playing the songs of Fred Astaire and Mabel Mercer and Bobby Short. I don't even understand most of the songs on today's hit parade. But I'm convinced they deserve respect and sensitivity from us.

The immortal Cole Porter was a genius at detecting shifts in social behavior and standards. What would Cole Porter write today? Would he write of the chic, sophisticated world of high society, which has expired? Would he write for the approval and edification of his classmates at Yale?

And there are lovely songs being written by Murray Grand and Dave Frishberg and Rupert Holmes and Stephen Sondheim. But they are heard only on the lips of lonely, often obscure saloon and cabaret singers, the minstrels of the night.

For many years, Puritan America would not let us use the word "hell" on radio. Indeed, and somewhat ironically, the word "virgin" was considered unacceptable for a good, long time as well. But to assume that popular songs could be apart from the vernacular itself is a mistake.

What is the difference between a suggestive lyric and a dirty lyric? What is the difference between prurient and risqué? I'm afraid that the scraggly haired, unshaven songwriter of gross,

clumsy, prurient—even vulgar—lyrics has to be treated with the same protection and sensitivity we now give, in retrospect and with great affection, to Cole Porter or Johnny Mercer or Johnny Burke.

Today's songwriter, record producer, and artist has been accused of "doing it for money." And yet Cole Porter, we know, considered his songs as "goods, merchandise." And as the introduction to that stunning collection of his lyrics published just last year pointed out, "The primary aim of popular music's songwriters and publishers then (in the pure and pristine 20s) was unabashedly commercial."

Few people then, including the creators of songs, thought of songwriting as one of the higher arts. Just as today, the great, classic American songs, the playing of which on WRTN provides me with a handsome income, began as "product" and was meant to become as automatically obsolescent as last year's fashions. But it's too easy, and perhaps risky, to say that the music of today will never emerge as enduring work. Are the songs of Cyndi Lauper or Venom or Def Leppard or Prince, for example, any worse than those of some of the icons of the musical stage? Listen again to Noel Coward's "Don't Put Your Daughter on the Stage, Mrs. Worthington." Listen again to the great Cole Porter: "Some get a kick from cocaine"—and listen to the orgasmic suggestion and pulsating rhythm as the airplane goes higher and higher. Or the girl in "Kiss Me Kate" who is "always true to you darling, in my fashion." Or "Love for Sale." Or "Let's Do It." And that lovely song: "Bewitched, Bothered, and Bewildered." "He's a joke, but I love him . . . because the joke's on me."

The so-called great songwriters wrote of sugar daddies and mistresses with such anthems as "My Heart Belongs to Daddy." Listen carefully to that classic of Abe Burrows called "Adelaide's Lament" from *Guys and Dolls*, and Frank Loesser's lyrics about the travails of a single girl getting "a kind of a name for herself." Or Eddie Cantor's "Making Whoopee": "What they do for . . . is all for . . . making whoopee! . . . They had a child . . . Where did it come from? . . . Making whoopee!" Making whoopee was doing "you know what" in the vernacular of the day. Scandalous and shocking, indeed!

I come from a place in the East where the printer John Peter Zenger risked all to be able to rage against the despotic governor of the day. He lived and worked with his pen and with a printing press. But what of the songwriter, the bard, the poet, or the minstrel of the night who talks of his demons and the things that oppress him, whether that song is a polemic, a political statement, or just a lonely cry for understanding?

A Justice of the United States Supreme Court wrote pornography. Look up "Humoresque": "Passengers will please refrain from flushing toilets while the train is in the station." "We go strolling through the park, goosing statues in the dark." "If Sherman's horse can take it, why can't you?" His Honor Mr. Justice William O. Douglas wrote that!

And Rudyard Kipling wrote "The Bastard King of England" and a somewhat lesser known work titled: "The Great Farting Contest."

We're talking about lyrics and words.

William Shakespeare, the Bard of Stratford-on-Avon, called someone "A hoarsome-bitch." Benjamin Franklin wrote songs that would shock some of those senators who will consider this subject next week.

And so did Ogden Nash.

And "The Ballad of the Joking Jesus" was not written by Michael Jackson or Prince. The writer was James Joyce.

Nothing "encourages" people to sin or change history—such as an anthem like "La Marseillaise" or "Lili Burlero," which is often incorrectly accused of encouraging the British to destroy the Irish. No, songs are signs, banners; they do not make history.

In Elizabethan times, the language was much broader. The vernacular included words we would not accept in daily usage or in the media. Restricting language is only possible in a totalitarian atmosphere. It was possible in Germany, in Bulgaria, in Cuba. It is possible where only one mode of communication predominates. So, no, you can't sing an off-color song in Bulgaria, and yet, even without such songs, they have drunkenness, adultery, and suicide—but not on the radio.

Mrs. Gore and her colleagues, about whom I have already

expressed my considerable admiration, want the atmosphere
and the milieu of their homes to prevail in society at large.
They are of good heart and motive. We all want our ideas to
predominate, to be the ideas of the marketplace. But that won-
derful, warm, stable, secure atmosphere in the Gore home or
the Baker home is not the same as the atmosphere or milieu
that confronts a ghetto kid in Harlem or the farm boy in Bis-
marck or a beach boy in Berkeley—or even an oil rig worker
in Houston or Dallas.

It is all different.

So, perhaps there is a larger question here than an X rating
for a specific song. Perhaps we're considering what the great,
thoughtful editor Don West calls the more "cosmic" issue:
"Who owns America?"

And, is it possible to restrict language in a democratic
world?

The Parents Music Resource Center wants a world that is
uncomplicated, without pain for their children, not obscene,
not profane. But, the hard, real truth is that their children, our
children, in their private lives, are meeting the very influences
we are trying to restrict. Indeed, if you've ever debriefed a
child on returning from summer camp, you will realize that
children make up their own songs—songs that are a lot worse
than those on the radio!

I'm afraid we have a great fear of what we already know.

Those who fight pornography know the meanings of the
words. They have used and lived them. But nothing has hap-
pened to them. They are upstanding and respectable people,
because nothing takes the place of an honest home.

We are concerned about children, our most precious re-
source. After all, they are of us; they are ours. But the only
thing we can hope for is that what we give them at home will
prevail and carry them through life. If parents give their chil-
dren the right kind of vehicle, their kids will float on any kind
of debris. The censors and the bluenoses can't, however, get
rid of the debris. It's always been there. It's part of the land-
scape. It's called *Life*.

A song is a banner, but even without the banner, the parade
will go on.

John Updike writes that "popular" composers, from generation to generation, "if they do not teach us how to love, do lend our romances a certain accent and give our courting rites and their milieu . . . a tribal background, a background of communal experience."

I'm afraid we parents simply have to hold on . . . until that happy day when our youngster walks in to say, as he will: "You know, Mom . . . that Frank Sinatra really knows how to sing!" Or "Dad . . . that fellow, Fred Astaire . . . what's the story on him?"

But even that great occasion should be observed with a bit of caution and perhaps some skepticism. The fear, of course, is that as sophistication sets in—like rigor mortis—there is always, in society, a tendency to restrict the language. It was not too long ago in this nation that Richard Nixon established a "Presidential Commission on Pornography." And when the report came back with the finding that pornography was an outlet for passions that might otherwise have been expressed in violence, the president—the story is told—used some unprintable words himself. Well, we survived Richard Nixon's colorful language—and we will survive porn rock.

I do, indeed, believe that there is such a thing as Evil in the world. My remarks should not be interpreted as a denial of its existence. I also believe we should resist Evil on whatever battlefield or with whatever franchise is provided us—but *first* in our personal lives and in our own families.

And then, as we go forth to do battle in society at large, we should do it with a careful, generous attitude and with a loving heart that is armed with the knowledge that we could be wrong sometimes. We could make some mistakes along the way. We could . . . strike at ourselves.

October 16, 1985

Eldridge Cleaver Must Speak

When Eldridge Cleaver died last year, my mind drifted back to his appearance on the campus of Iona College.

Many people are suggesting that Eldridge Cleaver, the Black militant, not be allowed to speak on the Iona campus this afternoon. We can tell you, in fact, that the situation is such at this great college that economic threats have been made against the wise and gentle man who is Iona's president. Brother McKenna and his colleagues have been beset by filthy and obscene calls from Westchester residents with small minds and meager brains—but colossal fears. Our distinguished neighbors have been calling the Brothers to say bad things about them—and awful things about Eldridge Cleaver.

As you know, we've been devoting recent days and nights to our analysis of the current political campaigns, but we must pause this morning, in the face of this madness, to speak in favor of Eldridge Cleaver's right to speak in our city.

True, the man may be an unattractive individual. True, he may have advised that the best way to receive justice in a courtroom is to shoot the judge. True, he may be an ill-bred, uncouth boor. True, you may see in him a rabble-rouser or an anarchist or a revolutionary.

But Eldridge Cleaver must speak in our city today.

The administration of Iona has, we believe, prevented the kind of riots Mr. Cleaver might desire to provoke. The college has prevented this horror by not withdrawing his invitation, despite incredible pressure from trustees and students.

Over one hundred years ago, John Stuart Mill said: "If all mankind, minus one, were of one opinion, and only one person were of the contrary opinion, mankind would be no more justified in silencing that one person, than he, if he had the power, would be justified in silencing mankind." Mill also said: "We can never be sure that the opinion we are endeavor-

ing to stifle is a false opinion; and if we were sure, stifling it would be an evil still."

That's why Eldridge Cleaver must speak. That's why WVOX must insist he be given a hearing. We hope the calls and threats against Iona will stop immediately, and we call on Chief McCaffrey, in Commissioner Carey's absence, to provide adequate protection for the occasion. Our police will not be defending a demagogue named Eldridge Cleaver. Rather, they'll be defending Freedom of Speech.

Cleaver must be heard in our city just in case Voltaire was right when he said: "There are truths which are not for all men, nor for all times."

Just in case.

November 1969

Freedom of Expression at Iona College

John Hagan and His School Newspaper

Peter Cooper said: "Neither piety, virtue, nor liberty can long flourish in a community where the education of youth is long neglected." This is another way of saying that Iona College should be more important to our community than malls for commerce, more important than factories of industry, more important than anything except our churches, which are also struggling in this peculiar and confusing age.

Iona College of Westchester, we can report, was dealt a serious blow by the resignation over the weekend of John Hagan, the chairman of its Board of Lay Trustees. This John Hagan is a self-made man who fought his way up and who is now a millionaire and the most important and dynamic trustee Iona has ever had. He is reported to make his money from a device that grinds up garbage on the back of sanitation trucks.

And now John Hagan has severed his connection with Iona College, because of some strong writing in the student newspaper. Yesterday, over coffee in his office, the gentle and wise man who is president of Iona, Brother Joseph McKenna, said that Iona College is a five-million-dollar proposition, and that he could run it on current revenue. But this Christian Brother wrung his hands in his big office on North Avenue yesterday. And Brother President, as he is called by the other Christian Brothers, sat and talked about this student newspaper thing which took away his best trustee. He sat and he thought about the three hundred thousand dollars that the college gets in gifts every year from wealthy men like John Hagan, and he thought about the one hundred and fifty thousand dollars that the trustees come up with—and much of that is in jeopardy. The tall, strong Christian Brother was thinking he could have

saved this money by closing down the school newspaper before John Hagan withdrew his patronage.

But this educator also talked about the Italian and Irish kids who come to Iona. He said that they are not different from the kids at Berkeley or Columbia. "They were all," Brother McKenna said, "born in 1950. Oh, I may have more confidence in these Iona kids, but they are all alike," said the college president. "This newspaper is their only outlet, their only release."

And as neighbors of the college, we can thank a man like this that we have not had network television cameras on the campus of this college. The controversy has not gone sky high because of the wisdom and brilliance of this man. But yesterday, he was clearly in trouble and thinking about a meeting of the trustees scheduled for 8:00 last night. He knew that several other trustees might go with John Hagan. As the God-Christ hung on the wall over artificial flowers yesterday in an educator's office in our city, the true meaning of Freedom of Speech and Freedom of the Press was discussed on the campus.

The Indian Nehru said something once about education not being something in the air, cut off from the daily life of the student or from his future work as a citizen. "Real education," Nehru said, "must be based on the actual environment and experiences of the child, and it must fit him for the work he will have to do after he goes out into the world."

At his conference, John Hagan delivered a withering broadside at the students of Iona for what he considered indelicate remarks about a trustee and about the college's choice of a commencement speaker. But Brother McKenna knew yesterday that John Hagan, the millionaire, was really saying to him: "How could you allow it? Why didn't you close down the paper? Why did you let Eldridge Cleaver speak last year? Why did you let him be heard? Why give the students their say? Why not crack down?"

And yesterday, the secretaries at this college in our midst spoke in hushed tones while students changed classes—students carrying history books that quoted the words of John Stuart Mill and Voltaire. It was not good—this thing about

John Hagan and the student newspaper and the trustees. And then the word spread—and it is true—that another trustee had promised, at the annual dinner a few months ago, to give one million dollars. And John Hagan, who is gone now, had come up with a plan to match the one million, and had even promised fifty thousand dollars of his own—an offer he withdrew over the weekend.

Maybe it is time to stand up to the hippies and the yippies, John Hagan! And in our city, maybe they have gone too far with drugs at the high school. And maybe those people in Chicago should not have said those things to a judge. But you don't get respect from an alienated generation by stilling their voices—by closing down their newspaper. And so, the college president held on to some basic principles yesterday on the Iona campus, and everyone in our city is wondering if they were right to keep the newspaper going and lose John Hagan—and any other trustee who does not understand the times in which we live.

Maybe things were bad all right, but we'll cast our lot with the patient man who sits in the president's office. You may not know it yet, Brother McKenna, but it was not only the college's finest hour—it was yours as well.

February 26, 1970

THE PURGING OF OFFENSIVE MATERIAL

Three decades later another president of Iona College faced a similar dilemma.

Our neighbor, Iona College, is a tremendously valuable presence in our community and an endearing and enduring resource for all of Westchester. It has grown in wisdom, age, and stature under the enlightened leadership of Brother President Jim Liguori.

Because of Iona's history and lineage, as well as its great value and importance today, one is reluctant to criticize or second-guess in the contretemps over the confiscation of a stu-

dent literary publication and the purging of the "offensive material."

Brother Liguori is a great educator, a shrewd, tough, and dynamic administrator, and a man of keen intelligence. In recent years, Brother Liguori has moved with great vision and dispatch to shore up Iona's standing in the community, in its own backyard. WVOX values our unofficial "official" designation as Iona's "radio voice."

Even so, it's difficult to understand the thinking or the campus dynamics that led to the seizure of the offending journal. Nor have we seen the poem that so shocked Iona's elders. But we respectfully hope that Brother Liguori and his administrators and educators will quickly rethink their decision to crack down on Free Expression.

In years gone by, another Iona president faced a similar dilemma in trying to create a safe, sanitized milieu for his students. In 1970, Brother Joseph McKenna bravely stood up to a holier-than-thou trustee who tried to persuade the Christian Brothers to shutter the student newspaper. Brother McKenna stood firm, while losing the trustee and several million dollars—in the same way he had the previous year, when he insisted that the militant Eldridge Cleaver be allowed to speak on campus.

At the time—almost thirty years ago—we approached this same microphone and quoted John Stuart Mill: "If all mankind minus one, were of one opinion, and only one person were of the contrary opinion, mankind would be no more justified in silencing that one person, than he, if he had the power, would be justified in silencing mankind." Mill also said: "We can never be sure that the opinion we are endeavoring to stifle is a false opinion, and if we were sure, stifling it would be an evil still."

It still sounds pretty good today—some thirty years later.

So, no matter how gross, offensive, risqué, prurient, vulgar—or just awkward and clumsy—that poem was, it was essentially, we may assume, an authentic and truthful expression of a young woman—a student struggling to be heard and writing in the vernacular for the Iona community.

Should there be different rules for campus publications? We think not.

No one should question Brother Liguori's good intentions or his motives in this matter. But as a healthy respect for Freedom of Speech and Expression is one of the greatest lessons Iona can bestow (in addition to things like values and ethics), we hope the college will trust its students to be their own censors. After all, there are a lot of trash cans in those dorms!

No one was ever injured by a thought—or a poem—on the campus or out there in the real world beyond the campus walls, where the students will one day go to test what they have learned.

September 30, 1998

Mr. Justice "Whizzer" White Fumbles

The *New York Times* is the only newspaper that counts in this country. They make movies about the *Washington Post*, and its editor, Ben Bradlee, may be a more glamorous figure than Arthur O. Sulzberger. But the *Times* has New York in its name, and that says it all. Everything else is the *Bridgeport Bugle*.

The *Times* is a newspaper operated, written, and edited by human beings. Thus, the *Times* is not perfect. But it is as bright and progressive and compassionate as any newspaper in America. And now, for all its reputation, its majesty, its influence, the *New York Times* is in trouble with those who administer justice and interpret the laws of our land. It is in big trouble, even for the *Times*. But the battle is not theirs alone.

You expected this of Southerners and the country club lawyers appointed by Richard Nixon. It would be one thing for them to find in favor of the New Jersey judges who have forgotten about Madison and Monroe and John Adams and Thomas Jefferson, and about an itinerant printer named John Peter Zenger. But not Byron "Whizzer" White, who was appointed by John Fitzgerald Kennedy.

The average man in this country, pursuing his salvation and raising his family, is too busy to follow such things as "the ideological drift" of the Supreme Court of the United States. But the one named Whizzer White they thought they knew. He was one of the Kennedy people.

But Mr. Justice Byron R. White, in the cold, formal language of the lawyers, said that New Jersey judges who came out of political club houses in Hudson County or Union County can insist that a reporter turn over his notes for an "in camera" reading. "In camera" is the way a Supreme Court

justice says "a little pregnant." Let the judges see your notes in his chambers. Give him just a little peek at your sources. All will be well.

This battle for a free press is being fought by a reporter named M. A. Farber—the M. stands for Myron—and by his newspaper, *the* newspaper, the *New York Times*. It is being waged by good, gray, serious retainers for the premier paper of America—and that is the real danger.

The *Times* has championed every brave and unpopular cause in this country. It is a great newspaper, if a liberal one. But it has no one who writes emotionally and with the fire and passion of Jimmy Breslin or Pete Hamill—both of whom toil for the *News*. If every Joe Six-Pack in Queens or the Bronx could imagine James Breslin, journalist, instead of Myron Farber, reporter, being "remanded" to the local hoosegow, you would have an uproar that would shake this country.

But that really is the issue. If Farber's notes and confidential sources fall to the will of a New Jersey judge, it will happen in Westchester. It won't happen in Joe Gagliardi's court—or Alvin Ruskin's or Tony Ceratto's—or even Irv Kendall's in Mount Vernon, or Ben Mermelstein's. But it will happen, and it won't happen to Myron Farber. But imagine the Sheriff of Westchester moving with a pair of handcuffs toward Guido Cribari or Milt Hoffman or Eileen Campion or Elaine Bissell or Susan Garvey or June Shetterer—or against our own Sandy Arnn and Fred Hirsch. In their case, the judge will be demanding tapes.

There is money involved in this, too, of course: five thousand dollars a day. Punch Sulzberger's empire can afford that and, as he himself has said: "If that be the price of Freedom of the Press, so be it." That's brave talk for a mighty newspaper, but even our local, Westchester papers, with the immense Gannett resources behind them, could afford that fine.

But what of the *Pelham Sun* or the *Yonker's Record* or the *Harrison Independent* or the *Rye Chronicle*? And what of the Mount Kisco radio station or the Brewster station? The money is important to be sure. But if a reporter for any of these publications or broadcasting stations is called before a magistrate and forced to divulge confidential sources and turn over his

or her notes to the state—and that means to any judge—then we all lose. And we lose a lot more than five thousand dollars.

Whizzer White fumbled a chance to play in the same league with Madison and Monroe and Jefferson and John Peter Zenger.

August 3, 1978

Issue Advertising Is the Issue

The Mobil Oil Corporation and its brilliant public affairs chief Herb Schmertz advanced the notion that even big corporations have a right and obligation to speak out on the great issues. The battle is being fought, even to this day, by enlightened advocates such as Arthur Shapiro of Seagrams.

I want to share with you some thoughts—which are my own—about idea advertising. Some have called it "issue advertising," while others refer to it as "advocacy advertising" or "editorial advertising."

I believe a corporation or an individual should have the opportunity to purchase airtime to espouse thoughts or views that may be favorable to the corporation or the individual—or at least in their best interests. Thus, I'm greatly concerned about the reluctance—or outright refusal—of many broadcasters, and especially the networks and many large stations, to accept idea advertising. Advocacy advertising needs some advocacy from the broadcasting industry.

For too long now, many of my fellow broadcasters have been working both sides of the street on free speech matters. Although broadcasters, for the most part, wax eloquent about the glories of the First Amendment, and most of us are instantly capable of a brilliant defense of the genius of the free enterprise system, some of us hesitate to extend those benefits and protections to corporations (or individuals) trying to express and expose ideas. As Mr. Justice Oliver Wendell Holmes put it: "The ultimate good desired is better reached by free trade in ideas—that the best test of truth is the power of the thought to get itself accepted in the competition of the market. . . . That, at any rate, is the theory of our Constitution." And it has always been a cardinal principle that this marketplace of ideas will function best if it is left unencumbered with restraints on expression.

In the Red Lion Case, the United States Supreme Court reiterated that: "It is the purpose of the First Amendment to preserve an uninhibited marketplace of ideas in which truth can ultimately prevail." And again last April, the Supreme Court, in *First National Bank of Boston vs. Bellotti*, ruled that "free discussion of governmental affairs is the type of speech indispensable to decision making in a democrary." Wrote one justice, "This is not less true because the speech comes from a corporation rather than an individual."

The history of broadcast editorializing is shot through chronologically with contradictions. First the FCC forbade such practices, saying that "the broadcaster may not be an advocate" for an idea or person with his federally granted franchise of the airwaves. Then the commission reversed itself and even demanded that broadcasters do some editorializing. When we finally did get the right, many of us gradually let it erode by limp, irrelevant, innocuous statements of general piety—with some notable exceptions.

So, a gut question in all this revolves around our own sense of seriousness, of integrity, of courage, and of conviction about free press/free speech and truly free airwaves. If generally listless, "safe," predictable airborne editorials (contrasted with newspaper editorials) reflect our current industry mentality, then I suspect broadcasters will be even more timorous in this matter of issue advertising.

Clearly, our pluralistic society works best when all points of view are heard and seen. We must take a strong stand in support of Freedom of Speech in all areas of public life.

January 16, 1979

CBS vs. Harley O. Staggers

"Freedom of the Press," said Benjamin Disraeli, "sprung from the people, and with its immortal instinct, it has always worked for the people."

We hope that sequence and that "immortal instinct" don't get trampled as a result of the confrontation between CBS and the Congress. As you know, CBS has refused to turn over un-aired portions of the controversial television program *The Selling of the Pentagon*. As a result, the Honorable Harley Orrin Staggers of Keyser, West Virginia, will ask his distinguished fellows and colleagues in the Congress to find Dr. Frank Stanton, the scholarly president of a television network, "in contempt" against the Congress of the United States of America.

"In contempt" is a nasty little phrase our forefathers reserved for gangsters and rum-runners who might plead the Fifth Amendment. It was not in the minds of our Founding Fathers, however, that Frank Stanton should be called contemptible.

This man Harley O. Staggers, chairman of the powerful Committee on Interstate and Foreign Commerce, is hell-bent to exercise his "personal privilege" as chairman of these important committees, to show the world that he and twenty-five committee members who voted with him are now the twenty-six human beings most capable of detecting pure truth. He is doing this, we're afraid, with an evangelistic fervor that would surely do credit to his former calling—that of head football coach at Potomac State College. Mr. Staggers's tenacity might also come from the fact that he served as Sheriff of Mineral County, West Virginia, and as right-of-way agent for the West Virginia Road Commission.

Mr. Staggers is certainly an honorable man and, as such, he is now sure that he is called, as surrogate of all the people of the United States of America, to go deep inside the news and

program department of a major network to look at tapes and recordings that were never used and that are to electronic journalism what a reporter's notebook is to a newspaper journalist.

This issue has to do not only with mighty CBS and with a big corporate executive like Frank Stanton. It also has to do with radio stations in Walton, New York, the local station in Greenwich, Connecticut, and with any station that considers itself to be more than a jukebox. There are almost seven thousand radio stations in America, and a thousand television stations. Not all are imaginative. Not all are sensitive and courageous or committed to good, solid journalism. But some are. And while they are licensed by the government, is it not in the best interests of our nation to have these voices completely free of government control and—once the franchise is granted—to give broadcasters the protection of the First Amendment of the Constitution?

Jack Gould of Old Greenwich, the great writer on these matters for the *New York Times*, said: "Every independent voice is a national asset."

We agree.

Jack Gould has also said that not many broadcasters are courageous—and we agree with that, too. But when a broadcaster *is* courageous, however clumsy—and CBS may have been clumsy in editing the program—he deserves to be encouraged instead of being found "in contempt." And yet, we are going to see this Congress treat Frank Stanton like a rumrunner next week, because the House has never refused a request for a contempt citation from one of its committees.

The great men of our state and our nation are rallying on this issue. Senator Jacob Javits, the patron of many brave and unpopular causes, is trying to get his colleagues to have more respect for the First Amendment than they have for the customs and traditions of the Senate. Javits is always there when it counts. He and others, like our dynamic and courageous Ogden Reid, and John Moss of California, are picking up the tattered and misunderstood banner of the electronic press. So, too, are twenty-one liberals who rallied behind Congressman Parren J. Mitchell, a Black man from Baltimore.

If Dr. Stanton and CBS are found in contempt, it will not only be a defeat for Freedom of the Press and the First Amendment, it will be, without question, harmful to small broadcasting stations and to the people who listen to those stations. If Congressman Staggers can persuade the Congress to impose its will on every local station in America, and thus on the audiences of those stations, then not only local stations, but every regional station, every rural station, every community station, and every hometown radio station runs the risk of similar censure.

CBS believes broadcasters should be accountable to the people. Congressman Staggers believes we should be accountable to his committee. We'll choose the people and stand with CBS.

Mr. Staggers has produced an eighty-page brief to support his position.

CBS has produced the First Amendment.

It gets a little confusing when the two sides square off, but if we want to make it easier for all of us to understand the issue, we should not worry about any of that. We should forget about Disraeli and highbrow stuff like John Milton and his "Areopagitica," which in the seventeenth century cried out against government censorship. We just might focus, not on corporate executive Frank Stanton, a scholar with a Ph.D, but on Walter Cronkite being thrown into jail and fined. Or think about our own reporter, Steve Osborne, being called contemptible by Harley O. Staggers.

July 7, 1971

After a lengthy debate in the House of Representatives, the move to censure CBS was defeated.

Part VI: Broadcasting and the Press

William B. Williams

*The National Association of Broadcasters presented a special
tribute to William B. Williams, one of America's best-known
radio personalities, who set a high standard for more than forty
years. William B. was a colleague at radio station WNEW. I
remember him especially for his early kindness to a young Irish-
man. I hung around his studio twenty-five years earlier, much
to the consternation of another legend, John Van Buren Sulli-
van, the general manager. No matter. William B. was my friend
as long as he lived.*

THE DISC JOCKEY

There are 37,542 persons who make a living in this country by
sitting in radio studios playing records, between which they
are called on to talk into a microphone. They are known as
disc jockeys, though most of them prefer to be called "air per-
sonalities." Few of them deserve the title. One who does, how-
ever, is William Breitbard. You know him as William B.
Williams. He is the preeminent disc jockey in this entire na-
tion. There is no one like him.

Every town and city once had a famous radio personality.
New York still has William B. Williams. It is right and proper
that he does his work in New York, where there are ninety-six
radio signals, including the one at 1130 on the AM dial that
carries his programs.

There is a lot of what we call "diversity" in this radio mar-
ket. It means there is classical music and rock 'n' roll, lots of
it. There are two all-news stations. There are countless hippy-
dippy, finger-snapping deejays. Most have little depth or intel-
ligence beyond an intimate knowledge of the Top 10 songs.
The great issues of the day are remote and alien to them. They
introduce records that have no meaning or sweetness, only a

dull, relentless, uncomplicated beat. They go to work to preside over a jukebox. They are like the wind that carries their voices—without substance or depth. Their words and meaningless chatter drift off into the ionosphere.

Then there are those among us who peddle schlock nostalgia—old music that wasn't great the first time around. They operate from the unshakable belief that old means good. It is a sad deception. It is no wonder then that disc jockeys are being banned from such refined places as Jones Beach and Playland and Orchard Beach and Central Park. It is an act of mercy by the parks' administrators.

For the past two months, it was especially bleak around New York while William B. Williams recovered from a painful, serious operation, and we had to contemplate being part of an industry that might not include this classy, bright man who each day for the last forty years has opened his program: "Hello, World . . ."

And a man from Larchmont named John Van Buren Sullivan, the eminence grise of the radio industry in these parts, was on the phone for weeks, telling people Williams really would be back in front of the microphone.

He did indeed go back to work as Jack Sullivan said he would. On Monday. On the Radio. On WNEW. On the "Make Believe Ballroom." The program is, once again, an oasis of style and taste, and Williams is an icon properly restored to where he belongs.

And so while other disc jockeys are chattering endlessly these summer days about Prince and Cindy Lauper and Menudo, William B. Williams is talking again of Frank Sinatra and Mabel Mercer, Susannah McCorkle and Mel Torme, Rosemary Clooney and Murray Grand, Cy Coleman and Bobby Short. The records on his turntables are by Ronny Whyte and Daryll Sherman and David Allyn and Sylvia Syms. He is a teacher as well as a performer or entertainer, having taught us about Johnny Mercer and Lee Wiley and Matt Dennis and Ted Straeter. He is to radio what Jimmy Cannon was to sports writing. He is the Mother Lode.

You can also expect him to rage, as he always has, against injustice and unfairness and about the times we are cruel and

brutal and mean to one another. He was there on the radio talking about Martin Luther King long before his martyrdom, and William B. even went down to Selma, Alabama, in 1963 to walk with a Black man along a dusty country road into the history of this country. And he talked about the indignities we heaped on Black artists long before it became fashionable to care. He proved that a radio station could be more than a jukebox.

As a young man, I sat often with Williams in the late fifties and sixties in places like the Stage Delicatessen and Rocky Lee's and the Friars Club. The radio entertainer talked the same sensitive, caring, thoughtful game at all those places when he was off the air with a drink in his hand. There is a big, broad range to his life, and he is now the most famous disc jockey of our day and age. Martin Block and Art Ford are gone. So, too, is Jerry Marshall and Stan Shaw, the Original Milkman. But Williams has survived, and he is still on the radio. He prevailed even against that man who was installed as his boss ten years ago—the one who tried to get William B. Williams to play Wilson Pickett records. And he outlasted the food broker from Washington with the sapphire pinky ring who thought Jerry Vale was better than Sinatra.

Indeed, it was the success of our own WRTN that emboldened a man named Jack Thayer to abandon WNEW's flirtation with mediocrity and return to the music that caused *Variety* to call it "the best sound coming out of radio in America today."

I had a different kind of piece all ready to go if Williams had not survived the surgeon's knife. It quoted Red Smith, who in one of his final columns tried to console himself that he had paid too much attention and showered too much praise on athletes who were less than great. "But not to worry," wrote Red Smith, "I kept telling myself that some day there would be another Joe DiMaggio."

There won't be another William B. Williams. He is *sui generis*. And I'm so glad he's back. On the radio. Where he belongs.

I hope he plays "You Are Too Beautiful."

July 19, 1985

He Respected His Audience

William B. Williams died a year later. I delivered this tribute to 31,000 broadcasters in the city of New Orleans. He was the best of what we are.

William B. Williams was truly *sui generis* . . . unique and able to be defined only on his own terms, a radio legend. In New York, we've had our share of these: Art Ford, Jerry Marshall, Cousin Brucie, Alan Freed, Klavan and Finch, the father of them all Martin Block, the Gamblings, Ted Brown, Jim Lowe, Jonathan Schwartz, Bob Jones, my Irish friend Scott Shannon, and Don Imus. But William B. Williams was unique; he stood out even against this stellar field of New York radio performers.

When William B. died, in August 1986, we found out just how special he was. For on that summer night, the lead story on every New York television station was of the death of a man who played records for a living.

I recall how most of us felt when we first heard the sad news earlier that evening on the radio—on the very medium in which he had distinguished himself for so long. As New Yorkers made their way home from the shore and the mountains, the radio stations began interrupting their evening broadcasts with the stark, sad announcement that the host of the "Make Believe Ballroom" on WNEW had died of leukemia earlier that day. Try, if you will, to imagine a million and a half New Yorkers in their cars, stuck in traffic on the Long Island Expressway and on the interstate highways, many with tears streaming down their tanned faces.

On the following Tuesday, the day of the memorial service at Riverside Chapel, we saw just how special this one disc jockey was. The city stopped. It just stopped moving, while the people of the Big Apple said farewell to the man who had greeted them each morning at ten o'clock with the words: "Hello, World. This is William B."

Taxi drivers, cops, bookies, waitresses, songwriters, musicians, politicians, firemen, sanitation workers, Rockettes from Radio City, and housewives young and old: they came by the

thousands, in a spontaneous and unforgettable tribute to someone who made his living as a broadcaster.

It happened, I suggest, because William B. Williams always trusted and respected his audience. He never cut his conscience to fit the fashion of the day. He never diluted that innate, exquisite good taste and style to accommodate the passing fancy or the mood of the moment. Over the course of four decades, he became the poet and bard and the preeminent spokesman for the charms and attributes of what Alec Wilder called: "American Popular Song."

The records William B. Williams played were filled with sweetness and gentleness and love. The words and music he broadcast were the exquisite product of the creative minds and hearts of Cole Porter, Jimmy Van Heusen, Jerome Kern, Richard Rodgers and Larry Hart, Murray Grand, the great Johnny Mercer, Arthur Schwartz, and the Gershwins. They were always interpreted with consummate style by the likes of Vic Damone, Peggy Lee, Tony Bennett, Rosemary Clooney, Margaret Whiting, Jo Stafford, and Fred Astaire. And often on the turntables of his studio were the tasteful works of obscure but worthy saloon singers, the minstrels of the night: Matt Dennis and Bobby Short and Richard Rodney Bennett and the late Hugh Shannon and Sylvia Syms and David Allyn and Blossom Dearie. And, of course, Sinatra.

William B. Williams championed this kind of music for forty years, giving testimony each day to the proposition that good taste knows no age or season. And always, you could understand the words to his songs—and always, you could hear the sweetness in them. For forty years on the radio—in thousands of broadcasts, and in the way he lived life itself—the music of the man was true and lyrical, with an enormous integrity to it all.

The accompaniment for all this was provided by the likes of the Basie Band, led by William Basie, whom he called the "Count of Basie." And by Edward Kennedy Ellington, who, of course, became the "Duke" Ellington.

William B. Williams provided a platform for Billie Holiday—Lady Day—and Ella, whom he called the "first lady of song," and Sarah Vaughan and Billy Eckstein and Lena

Horne and that great, joyful son of New Orleans, the incomparable Sachmo—Louis Armstrong, a/k/a "Pops."

Other DJs referred to Nat King Cole as Nat *"King"* Cole. Billy called him simply "Nathaniel." And as all the world knows by now, in William B.'s special lexicon, Sinatra was "Francis Albert," or that famous appellation Billy gave Frank so many years ago and which is now used wherever Sinatra goes: the "Chairman of the Board."

To everything he did, William B. brought a quiet dignity and grace—the same quiet dignity and grace with which he confronted the terrible illness that finally claimed him. George Maksian of the New York *Daily News*, who chronicles and writes so thoughtfully of the things we do on the radio in New York, said: "William B. was a class act in everything he did—and in the way he lived."

He was a shy man, and yet William B. was as comfortable with show-business types like Buddy Hackett, Don Rickles, and Steve and Eydie as he was with cab drivers and waiters and priests. And he was unfailingly generous with advice and counsel to young people who aspired to our profession.

He squandered his name and talent and reputation across a thousand nights as the master of ceremonies of countless banquets and charity events. Frank Sinatra said: "You are simply the most generous man I know."

In a front-page story, the *New York Times* pointed out that William B. was a familiar figure on Broadway at opening nights and at the Stage Delicatessen and—always—at his beloved Friars club, where he serves as Abbott. He was a performer and entertainer who could not resist involving himself in the world around him. There was a big, broad range to his life that went way beyond the fabled walls of his "Make Believe Ballroom." When Martin Luther King, Jr., walked those desperate, dusty roads at Selma in the early sixties, for example, William B. was at his side, a white broadcaster from Babylon, Long Island.

On the air, William B. Williams rarely preached—and he never pontificated. But he would often speak movingly about injustice or those occasions when we were less than kind and loving to one another. He was a quiet man. And it was the

things he left unsaid that were the most eloquent. He was not ever given to the idle or meaningless chatter we've sometimes allowed on our airwaves in recent years. He respected his audience.

We remember William B. for the quiet grace, dignity, and style he brought to our profession.

August 1986

John Van Buren Sullivan: The Sounds of Paris at WNEW

Sullivan: Saying Good-bye

Variety *once called WNEW "the greatest sound coming out of a radio in America."*

He sat there in the big corner office at 565 Fifth Avenue. It was New Year's Eve in New York City, but John Van Buren Sullivan guided the conversation back to other times in another town. The phonograph reminded him of happier days in the springtime in Paris.

The same people who gathered around the broadcaster's desk yesterday had hung around the big corner office of this New York radio station hundreds of times over the years. During those sessions, the talk drifted to radio. You heard names of radio legends like Bernice Judis, Ted Cott, Richard "Dimes" Buckley, Art Ford, Jerry Marshall—but that was all gone now, and Jack Sullivan just sat there drinking champagne and listening to sounds of Paris.

He is famous in the industry for encouraging disc jockeys, and now the man who had created thousands of hours of wonderful radio programming was hosting his own show by playing Count Basie on the office stereo. Those in his office on this New Year's Eve thought he deserved to do this.

Every once in a while, Joe Williams and the Basie band or a Sy Zenter record lifted the mood. But that was only temporary, and then some vocal group would sing about Paris while people who love this man drifted in and out that long afternoon before the new year. The vintage French champagne flowed good for hours—and eventually ran out—and Jack Sul-

livan, who should be drinking vintage French champagne, could only offer his guests bottles of domestic grape. No one really noticed, though, except the host in the big corner office who did not want this moment to end.

Jack Sullivan has been toasted more than any broadcaster in America during the previous month. On December 16, the people who work for him at WNEW said good-bye at a swinging bash at Basin Street East. A lot of people joined his wife, his daughters, and his son. They all smiled for the photographer—the way you do at farewell parties. Jack Sullivan stood in the bright spotlight that night and said his good-byes—and the tears came. He was his usual eloquent self, standing there clutching a WNEW microphone.

And then, two weeks later, on New Year's Eve, in the big corner office, Jack Sullivan was still clutching the past, drinking champagne, and listening to records about Paris. Those people who drifted in and out on New Year's Eve told him that they came to the big corner office because of the champagne—a lovely deception. They came just to be with this man, because he set a style and a tone for a radio station, which has never been equaled. Some of them know Jack Sullivan as a friend, some as "Big Papa," some as a banker. It didn't matter that he was the softest touch in town for these guys. They were just there because they knew him and they knew how hard it was for him to let go.

John Van Buren Sullivan has a bigger job now as president of Metromedia Radio. On Monday morning, someone else will sit in the big corner office, and Jack Sullivan will breeze down the hall with a confident walk that can only be called a strut. He will see old friends and say, "See ya later," and he will walk out the front door and hop a cab. And as all the young staffers and the famous ones like William B. Williams look out the window, they will see this elegant man down on 46th Street getting into a cab. They will notice two things. He will have on that winter coat with the fur collar—it's the one he wore to Paris. And he will brush away a tear. And then the cab will pull away, and he'll be gone.

An era in New York radio is over. Already Elmore Jones of the WNEW mailroom is dragging Sullivan's brown Kennedy

rocking chair down the hall. All this on a Monday morning after New Year's Eve.

Unless you happen to know Jack Sullivan or work at WNEW or owe him money or just love the man, you must figure I should find other things to do on a Monday morning. In its halcyon days, the station had a slogan: "WNEW is an elegant radio station . . . with just a touch of ragtime in its soul." This—and practically everything you can say about WNEW—fits Jack Sullivan. I can think of no tribute he would like more.

<div align="right">January 2, 1966</div>

JVBS: A MAN OF GREAT STYLE

John Van Buren Sullivan! What a unique, singular, vivid, colorful man he was. What great style he brought to all of it! What great love he brought to all of us!

Before I came over here, I had the station provide me with an important statistic—"the station" being Jack Sullivan's hometown station, the one he "used" for mundane things like the weather. I am informed, and you will be pleased, I think, to know that it is seventy-seven degrees and sunny—in Paris.

If you're paying tribute to John Van Buren Sullivan, it ought to be done in a saloon, a high-class saloon. I was thinking "21" would be just fine. It should come with music and jazz and Sinatra, Steve and Eydie, Basie cranked up to the rafters, to heaven itself. This is Jack Sullivan you're talking about. He was a man of great style—vivid and joyful and loving. Joan, his wife, called him "Jack" or "Himself." Adrianne and Evelyn called him JVBS. A lot of us knew him as "Mr. Sullivan." Nat Asch and Buddy Hackett called him "Mr. Solomon."

Jack was a broadcaster. He was the best at his calling. Here's what he did. He went to advertisers and advertising agencies and got them to put up money so he could hire disc jockeys to play music. The music they played was by Frank Sinatra, William "Count" Basie, Edward Kennedy "Duke" Ellington, Rosemary Clooney, David Allyn, Jackie and Roy,

Dinah Shore, Bobby Short, Sylvia Syms, Les Brown, Peggy Lee, Margaret Whiting, Tony Bennett, Michael Carney, Al Hibbler, the Four Freshmen, Daryl Sherman, Jack Jones, Vic Damone, Blossom Dearie, June Christy, Stan Kenton, Steve Lawrence, Eydie Gorme, Johnny Mercer, Joe Williams, Mel Torme, George Shearing, Julius LaRosa, Jonathan Schwartz, Susannah McCorkle, Mabel Mercer, Marian McPartland, Glenn Miller, Hal Kemp, Skinnay Ennis, Ted Straeter, Peter Duchin, Marlene VerPlanck, Richard Rodney Bennett, Teddi King, Anita Ellis, Dick Haymes, Bing Crosby, Louis Armstrong, and the incomparable Fred Astaire.

They performed songs by Cole Porter, Richard Rodgers, Lorenz Hart, Alec Wilder, Bart Howard, Vernon Duke, Harold Arlen, Jerome Kern, Irving Berlin, Sammy Cahn, Jimmy Van Heusen, Burt Bacharach, Vincent Youmans, and Hoagy Carmichael.

And Jack Sullivan put all of this on a radio station in America known as WNEW. That's what he did for a living.

He was "the last, great philosopher-statesman of the radio profession," according to our neighbor Les Brown. "Most radio and TV executives are always telling me something sells—but never what it stands for. Jack, and very few others, are able to articulate the loftier goals and objectives of the medium." He was to radio what John F. Kennedy was to Democrats—with a little Adlai Stevenson thrown in—and what Nelson Rockefeller was to Republicans. He was a man of Moët champagne and double-breasted suits from John Reyle with pick stitching on peak lapels.

It is 1992, and Jack Sullivan died a few days ago. On Fifth Avenue now, there are peddlers and beggars where once he came down the street in a camel's hair coat with a Dunhill cigar in his pocket, a WNEW lighter, and a flower on his lapel. Sullivan was about elegant saloons, good red wine, and beautiful daughters, a handsome son, fresh, beamish grandchildren, and a wife beloved above all others. He was of Basin Street East, turkey hash at "21," the Friars Club, the old Miramar, napoleons at Christ Cella—and napoleons delivered direct to the office from Christ Cella. He had, always and at all times, a boutonniere. And how he loved the New York Giants.

Jack Sullivan moved around New York. He knew the haze of an evening in establishments run by Jerry Berns, Pete Kreindler, Thomas Margitai, Paul Kovi, Sirio Maccioni, Jimmy Neary, Jimmy Weston, Danny Lavezzo, Jilly Rizzo, and Mr. Bernard Shor himself. He faded maitre d's all over town, and the newsboys hawking the *Journal-American* on Vanderbilt Avenue were always glad to see him heading for the express to Larchmont. Jack once called Ambassador John Hay Whitney "kiddo," which is what he also called Arthur Ochs Sulzberger of the *New York Times*.

Jack was a man of words, a teacher. He taught us grammar and precision and how to make our living with words. He taught us how to love with words, and with music. He read Jimmy Cannon and the strong, muscular sentences of Pete Hamill and Breslin and James Brady, and he knew about Mario Cuomo ten years before the rest of us. Jack was probably not a member of the parish council, but Father Raymond Rigney told me that he fed a lot of priests in his day, and he knew about the Franciscans on 31st Street—three Hail Marys for a homicide! Jack would stride right by St. Patrick's, but I once saw him on his knees at St. Agnes.

Jack Sullivan did a lot of things we know about: educator—vice-chancellor, in fact, at City University. He stepped in and ran the New York State Broadcasters in Albany during a difficult period of transition. He presided over WHN, but Mickey Gilley was not his kind of singer. JVBS then supervised all the Metromedia radio stations when they made him take that title: president of Metromedia Radio. He also had some fun as president of *Playbill*, which was all about Broadway and the theater.

But most of us here tonight remember Jack in the big corner office at 46th and Fifth, at his beloved WNEW. Jack helped make the station. Jack and WNEW were made for each other.

Those were the glory days—and our minds, blurred by the sadness of this night, drift back to the radio station that *Variety* called "the greatest sound coming out of radio in America." There was Klavan and Finch and Gene Rayburn, who is here tonight. And Jack Lazare and the "Milkman's Matinee." We remember Lonny Starr, Bob Landers, Bob Howard, Dick

Shepard, Big Wilson, Jim Lowe, John Dale—whose real name was John Flora—Mike Rich, Joe Hasel, Marty Glickman, the late Pete Myers, gentle, kindly Kyle Rote, Jim Van Sickle—who wrote for radio better than anyone except Charles Osgood—Bob Fitzsimmons, Ted Brown, Rudy Ruderman, Steve Osborne, Martin Weldon, Lee Hanna—who never smiled—Ike Pappas, Jim Gash, Mike Eisgrau, Wally King, Bob Jones, Bobby Hodges, Elmore Jones and Chuck Robinson in the mailroom, Dave Pound, Mary Toritto, Jack Pluntze, and Millie, the switchboard operator who wore tight blouses.

Sullivan presided over a stable filled with talented souls on and off the air: Bill Persky, Sam Denoff, in Hollywood this night surrounded by their Oscars, were there. And Mark Olds, Nat Asch, the Admiral, Frank Young, David Schoenbrun, Varner Paulsen, Earl Ubell, Martin Caidin—America's first space correspondent—Alex Webster, and handsome Frank Gifford—who spent Christmas Eve with Joan and Jack back then—and Well Mara—and how nice to see Mrs. Mara here tonight. And there was also, in those days, the greatest of them all: William Bernard Breitbard. Everyone called him William B. Williams—Jack called him "Billy." Our tribe also included Jonathan Schwartz, Adrianne Gluckman and Evelyn, and Tom Tracy, Kay Reed and Billy Reilly. Skitch Henderson was around then, and Art Ford would come by—and I once saw Martin Block and Ray Ross. There was Al DeRogatis and Bobby Goldsholl. I remember Bud Neuwirth came to town during a taxi strike, and Jack allowed me the unique privilege of carrying Neuwirth's luggage and his golf clubs, thirty blocks north to the Carlyle! Jack Beaton was the best salesman then, after Jack himself. Beaton drove a Rolls Royce that had gold fixtures. He parked it on 46th Street near our fleet of five Chrysler station wagons. Kermit Moss, another power hitter from the advertising department, once let me go with him on a sales call to see the legendary Eve Nelson, who handled the E. J. Korvette account. She was mad at Kermit about something, and I heard words I had never learned in Westchester or heard since! Dick Barry was there and Dick Kelliher and George Duncan and Kevin Cox and Reid Collins, who is now on television. Carl Ally did our ads, and I used to

keep him waiting in the lobby while Jack and John Reyle were "in conference" discussing an important, new, blue blazer. Carl has since made millions and is a great icon of Madison Avenue. He is here tonight, and I hope his memory is not as good as mine. WNEW had all the best radio personalities. But Jack—who was their champion and advocate, their definer, protector, and promoter—was the one everyone wanted to see. The record pluggers, the singers, and the musicians who came calling on the jocks always wanted a word with the man in the corner.

And allow me this personal observation. I mean or intend no disrespect for anyone here present, but I have always been of the opinion that WNEW's slow, sad, inexorable decline into mediocrity began the day Jack left and Elmore Jones carried his Kennedy rocker down the hall for the last time.

I remember another day of tears in that place. It was November 22, 1963. I was a private in the U.S. Army, and I had an appointment with Jack to discuss getting my job back after a stint as newspaper editor at Fort Wadsworth. As no one quite knew what the hell I ever did there anyway, it was to be a fairly easy meeting. I wore my uniform anyway. As Adrianne led me down the hall, we heard a commotion in the newsroom. And I remember John Van Buren Sullivan almost bodily throwing everybody out of there, and I saw him standing alone over the wire machines—we had AP, UPI, and Reuters. Almost thirty years later, I can still see the tears streaming down Jack's face as the terrible bulletins came from Dallas. "Son of a bitch," said this elegant man as tears ran down his cheeks. "Son . . . of . . . a . . . bitch!" He went into his office and closed the door—and I went to the Miramar to drink.

Jack Sullivan loved politics, and he loved Jack Kennedy. And few will recall, but JVBS actually ventured into politics himself. It happened right here in Westchester. The local Democrats, desperate to drive the Republicans from office on the high council of the Village of Larchmont, came up with a brilliant scheme. They would take Jack Sullivan, great titan of broadcasting, and team him up with Phil Gilbert, Jr., who was president of Rolls Royce/America. And Jack and Phil would

run with a man named Ben Ginsberg—Ginsberg, of course, had the money. And the "dream ticket" would thus be known as "Gilbert and Sullivan . . . and Ginsberg, too." Need I tell you, they lost? But Ginsberg ran ahead of the ticket. They're still looking for all those absentee ballots for Gilbert and Sullivan. Phil Gilbert, who knew and loved Jack too, is here tonight. He will confirm this glorious chapter in the political history of our nation.

So much then for Jack's professional life in New York and in politics. There was another Jack Sullivan, here in this neighborhood, at the Corner Store, where he would pick up the *Times* and *Paris Match* and *International Herald Tribune*. He had a life here, too, with the greengrocer, the cobbler, at the gas station, over at that restaurant near the train station when it had a French menu. Not all these people—the shopkeepers—knew what Jack did for a living. But they knew he was special. They knew from his walk, from his clothes, from the smile on his face. They knew about him. And over at our local station, where we have a studio named for him—the "John Van Buren Sullivan" studio—we recall the day he drove up and summoned the office boy to help carry hundreds of records—Jack's "private" collection—into our library. "You'll know what to do with these," he said. In recent years, if he heard a fledgling announcer who was wobbly on our airwaves, Jack would call and merely say, "Tell him I'm coming over." And he would sit with the youngster and go over pacing and breathing and delivery. And on the way out, he would give me a few messages and some none too subtle advice to be delivered directly to the Governor of New York at the very earliest opportunity.

We should do this again—with music, with Chauncey Olcott, and with Mabel Mercer. Hugh Shannon should sit at a piano with velvet slippers; Tony Bennett should sing; Julie LaRosa and Ella. You can forget Ellington or Dorsey. Just get the Basie Band to crank up "Cool as a Moose"—or "April in Paris."

Now, though, I want to leave you with Jack's own words. They were written so long ago, on a day in May, during another springtime. He typed these words on WNEW stationery

to a young man who I think was counting the days until he was out of the Army and back in Jack's care and keeping at WNEW.

"I've just written a promo spot for our INDY 500 contest, a rewrite on Jim Lowe's blurb in the personality sheets used by the salesmen, and a very cute note—if I do say so—to Val Adams of the *Daily News*. I think if I could do half as good a job writing you a cheerful note, I'd feel a lot better—but at least I wanted to reach out with a little courage and warmth.

"So be of good cheer and stiff upper lip. Besides, today in Paris the city is alive with fleur-de-lis and the frothy whiteness blooms in stalls and in flower sellers' carts, and school children offer a franc's worth for a good cause. And everyone feels better on the first of May, because more people than usual are thinking of others. And maybe that can help you, too. Toujours. JVBS."

I treasure that note. And his friendship.

So go now to your homes and be of good cheer.

It's seventy-seven degrees and sunny in Paris.

And this planet, this place, this profession, this village, this family—all of us—had Jack Sullivan for seventy-eight years.

All those songs. All the music. All the love.

Toujours, Jack—and, bravo!

May 20, 1992

American Popular Song: Is There a Place on the Dial for It?

The radio station WQEW, 1560 on the AM dial, gave up the ghost at the end of 1998. But did it ever really stand a ghost of a chance?

WQEW was a pale imitation of the once glorious WNEW, with its disc jockeys who were authentic personalities. They had something to say beyond the obvious, the trivial, the mundane. They understood the poetry of American popular songs.

There was William B. Williams, for example, who walked the walk with Dr. Martin Luther King, Jr. And Jack Lazare of "Milkman's Matinee," who owned the night. And Klavan and Finch, who got us up in the morning with hip, savvy, social commentary and hilarious one-liners.

But when WNEW faded, the *New York Times* split off the AM side of WQXR and created WQEW at 1560. The *Times* was more comfortable with classical WQXR and never quite knew what to do with WQEW.

To succeed with a nostalgia format of American popular music, you have to take it "up market," play music for the folks who live on the hill.

John Van Buren Sullivan, the majordomo of WNEW during its glory days, understood this. He was a colorful, vivid, beguiling figure with great dynamism and class. His parties were legendary. He insisted that everything you do should have style.

But when WQEW hosted a retirement party for its station president, Warren Bodow, WQEW hired an upper room in a restaurant, had an emcee acting like a carnival barker, and offered as refreshments exactly one tray of red wine, one tray of white wine, and one tray of cheese.

Sullivan would have taken over "21" or Le Cirque.

He defined WNEW the same way—with style. The disc jockeys were extensions of that.

With a few exceptions, WQEW employed journeymen announcers. It fulfilled the observation that *Herald Tribune* critic John Crosby once made: "Radio's great failing is that it ignores and demeans the preferences and tastes of the elite. It is making the same mistake as television."

WQEW tried to attract a mass audience with pop nostalgia.

But as the *Times*'s own highly regarded music critic Stephen Holden observed, "What will be absent from the airwaves is an ideal of civility exemplified by popular singers conveying the deepest personal emotions in intimate voices. WQEW played it safe by acting most of the time like a Top 40 radio station. Instead of insisting on quality, it relied on the pop charts of the 1940s and 50s . . . clogged with silly novelties and saccharine ballads." Holden also pointed out that "many of the pop songs we now call standards never hit the upper reaches of the charts in their day."

We need a radio station to play the great popular standards. Whitney Balliett, America's foremost jazz critic and one of the most graceful essayists in the English language on *any* subject, has compared American classic songs to the sonnets of Shakespeare: "The songs will always be there. It will simply be a question—as it is even now—of where and how and when they will be performed." My suggestion to save the format: dress it up in black tie. Class it up. Let musicians and social arbiters program it, not hack DJs. Let people with style run it. An Alec Wilder would have been perfect. Or Wilfrid Sheed. And certainly Whitney Balliett himself.

New York deserves better than schlock nostalgia.

January 1999

The *Herald Tribune*: Death on the Ninth Floor

The New York City newspaper world had been shrinking steadily in the twentieth century, from fifteen daily papers in 1900 to seven in 1950. It came about in large part because of the great exodus to the suburbs at the end of World War II. When the middle class moved out of the city, it subscribed to the local suburban paper and began watching TV instead of buying and reading two or three city dailies.

The newspaper unions then began to demand a bigger share of the shrinking pie and went on strike to make their point. They shut down the papers for short periods in 1953 and 1958. In 1962–63, however, the strike lasted one hundred and fourteen days and killed Hearst's Daily Mirror, *even though the paper sold a million copies every day.*

Just two years later, in 1965, a twenty-five-day strike led three dailies, the morning Herald Tribune, *the afternoon* World-Telegram & Sun, *and the* Journal-American, *to combine into one twenty-four-hour operation. But before even one edition came out in April 1966, the unions struck again.*

When the strike dragged into the summer, the owner of the Herald Tribune *folded his newspaper, one of the best in the country. It happened on August 15, 1966. Here are some thoughts from the morning after.*

There was a funeral yesterday on West 41ˢᵗ Street in New York City.

It is 1966, and we are now an entire nation sitting in front of a television set, which is an electronic instrument that does not impose on us any serious burden such as having to use our minds to think about anything more difficult than a headline or a baseball score.

The story out of the afternoon was to be the death of the

New York *Herald Tribune*, which was founded by Horace Greeley. It was a civilized newspaper written by men and women who sat at typewriters to string words together. That meant you had to think a little bit when those words appeared before you in print.

It happened on the ninth floor. The television crews and the few radio reporters who are still out on the streets came to tape this funeral for their six o'clock news. The cameramen from NBC were there first to wire up the room, which responded to the bright lights set high on their tripods—no dark funeral parlor on Queens Boulevard for this victim. The *Herald Tribune* would go out in bright lights as a media event, because it is 1966, and the electronic age, the wired nation, is here.

A tall, shy man named John Hay Whitney came riding down 41st Street in a vintage dark green Cadillac, known around here as "the green hornet." Minutes later, up on the ninth floor, this well-bred patrician, a former Ambassador to the Court of Saint James, read some graceful words over the fallen newspaper. Jock Whitney, as he is known in London, Saratoga, Manhasset, and Thomasville, Georgia, received the largest inheritance ever probated in this country, which means no father ever left his son more cash. He stood there in the bright lights in a rich woolen suit made by Davies and Son of London—Saville Row's best bespoke tailor. John S. "Shipwreck" Kelly, his friend and court jester, calls Whitney the "Aga John." Yet, it was this fine, bright man who left the rarefied atmosphere of London eight years ago to try to save the *Herald Tribune*.

A lot of him went into the paper. He squandered his reputation and his money—forty million dollars of it—trying to keep the paper afloat.

"The function of the press in society," said A. J. Liebling, "is to inform, but its role is to make money." Even a Whitney could understand that. So he stood there yesterday with Walter Nelson Thayer, the president of the *Trib*. The Gallagher Report newsletter calls Thayer "Wily Walter." Richard Nixon says he is the toughest, shrewdest individual in the country, which is rather like praise from the Master. But the *Tribune*

was hemorrhaging badly, at a rate beyond Whitney's cash or Thayer's genius and toughness. "It is a bitter blow to finally have to abandon the *Herald Tribune*," Whitney told the newspaper reporters in the big room on the ninth floor.

You stood and watched all this, and your mind drifted back to Sunday, October 4, 1964, when this quintessential Republican newspaper stunned the nation by endorsing Lyndon Johnson over Barry Goldwater. It did many things that surprised people.

The *Trib* provided a forum for strong writers such as Tom Wolfe, Dick Schaap, Pete Hamill, John Crosby, Eugenia Sheppard, and Walter Kerr. Not many of them were around to hear Whitney's eulogy, but Tom O'Hara, the old reporter, was there. And Jimmy Breslin—who, in this decade, is the finest, strongest writer for any newspaper—was there cursing and muttering that "the newspaper game will never be the same, because Whitney and Thayer were owners who happened to be Big Republicans." "But," Breslin said, "I could write a column and murder one of their friends, and they would just smile. Whitney ran the paper with great class and grace. Jock Whitney was the only millionaire I ever rooted for."

And the great sports writer Red Smith was there—an icon of this calling. His hands shook as he dragged on a cigarette and watched this all happen. Red writes about the games men play, but he told us that this day he was going to damn well write an obituary about the newspaper. He sighed and said that he was sick of writing obits about his friends. But as you'd expect, this was heart tugging. "What it means here," Walter "Red" Smith wrote, "is that my best girl is dead."

The whole funeral took twenty minutes. When Whitney finished his statement, the room emptied out fast, and he and Thayer did not look back as they walked past Archie's newsstand in the lobby. The proprietor, Archie, had run the place for the *Trib* people for twenty-five years. He refused to close down, even during the newspaper strike. But late yesterday afternoon, when the *Herald Tribune* folded, Archie was gone, too. It was the first time he closed early in twenty-five years.

Next door at Jack Bleeck's saloon, known on the sign over the door as the Artists and Writers Restaurant, the newspaper

people came in for a drink. The pub owner has been sitting on more than six thousand dollars in bar tabs for the liquor consumed by the *Trib* people on their bar bills as a "show of good faith." And now they would drink again and talk about newspapers.

John O'Hara, the author, wrote some lines that fit this strange, bittersweet afternoon in New York: "When a journalistic institution is allowed to die . . . every man and woman who has ever read a single word in that publication—in agreement or disagreement—is the loser. The loss to non-readers is incalculable, and the loss to freedom is absolute."

Jack Gould put it better in the *Times*: "Every independent voice is a national asset."

Our piece on all this ends with the writers and editors, the rewrite men and proofreaders, some messengers, secretaries, and the switchboard operators sitting in Bleeck's. They had all just come from a funeral. The deceased was one hundred and twenty-five years old.

<div align="right">August 16, 1966</div>

The First Lady of Little Italy in the Bronx, Mama Rose of Mario's Restaurant, with Nancy O'Shaughnessy. The author and his wife frequently visit the landmark restaurant on Arthur Avenue for soulful talks with Mama Rose.

Shaking the money tree. The author pitches in to help raise funds for the Heart Association. WVOX and WRTN have done hundreds of on-air fund-raisers over the years. *(Ken Lauben)*

John Cardinal O'Connor with the author and Nancy. His Eminence is a great wordsmith. The author emcees many of the dinners at which the cardinal presides.

The author with His Excellency Garret Fitzgerald, Prime Minister of the Republic of Ireland (left), and "Tip" O'Neil, Speaker, U.S. House of Representatives (center), after a memorable session at "21."

Pulitzer Prize-winning author William Kennedy, attorney Peter Johnson, Governor Mario Cuomo, and the author at the Executive Mansion in Albany. The inscription, by the governor, pokes fun at the author's crest ring.

The author with John F. Kennedy, Jr. (left) and Andrew Cuomo (right). The three were plotting strategy to outflank the NIMBYs ("not in my backyard") in the heart of the Eastern Establishment and gain approval for local housing for the homeless.

The author interviewing Westchester County Executive Andy O'Rourke. Now a federal judge, O'Rourke ran for governor against Mario Cuomo and later teamed up with Cuomo's son Andrew to build housing for the homeless in the Golden Apple.

(l to r) The author, Governor Malcolm Wilson, GOP leader Tony Colavita, and Jack Kemp. "Sometimes I think I've squandered half my life at political dinners . . . but there's usually a good story to be had of an evening."

The three Marios: (l to r) Cuomo, Biaggi, and Migliucci—the governor, the hero cop-congressman, and the fabled restaurateur from Little Italy. This photo was taken at a WVOX Christmas party.

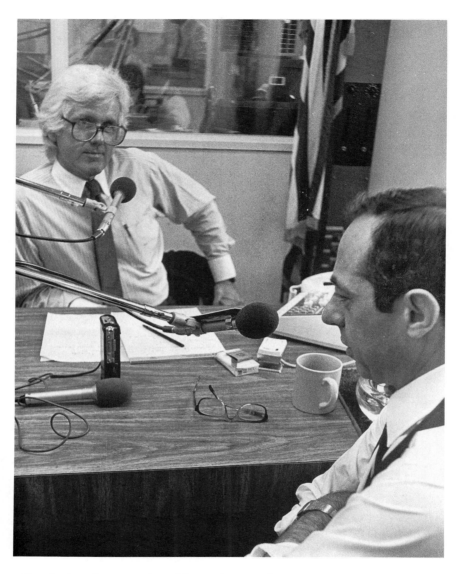

Pondering the question. The author and Mario Cuomo go head-to-head in the studio. "The first time I interviewed him, I knew there was something very special about this fellow." *(Camera's Eye)*

WVIP: When a Station Dies

I learned about local radio at WVIP, one of America's first community radio stations. It went on the air in northern Westchester in 1957 and broadcast every day for nearly forty years until fire destroyed the station.

It is sad that WVIP has had to suspend operations. When a radio station dies or goes off the air, we have a phrase for it. In the jargon of our craft, it "goes dark."

It is a tremendous loss for the people of Westchester. I am sorry for them. I am especially sorry for Martin Stone. Having known and admired him for forty years, I am well aware just how much WVIP meant to him. I'm sure the decision to shut it down was wrenching and difficult. It was, I assume, a business decision.

We can only congratulate the dedicated and courageous young broadcasters who tried to restore WVIP to the airwaves over northern Westchester and thus to the service of all those thousands of families who look to WVIP as their local "hometown" station.

This pristine jewel of a radio station, right in the heart of the Eastern Establishment, has *always* attracted extraordinary young broadcasters who came, over the years, not merely to speak into microphones and spin records, but to learn from Martin Stone that a radio station achieves its highest calling when it resembles a community soapbox or forum for the expression of many different viewpoints.

The historic Edward Larrabee Barnes "Studio in the Round" building, in the form of a seashell—which produces an echo—so unique and daring in concept and function, fell before the flames of this tragic fire. But the unique *spirit* of WVIP remained for a time in the aftermath of the blaze. It was the spirit of Martin Stone who, even at eighty-two, continues to attract creative and remarkable young men and women to his side.

Every independent voice is a national asset, and among those who rushed to sustain this valuable voice were other broadcasters. Pete Partenio, a former WVIP engineer, was there in the early morning hours with scotch tape, chewing gum, bailing wire—and a lot of marvelous ingenuity—to activate the station's transmitter in a separate building, which escaped the flames.

Dennis Jackson, a keen, respected student of broadcasting who owns several stations in New England, drove over from his home in Connecticut, bringing with him mixers, microphones, and a console. He had been alerted by John Harper, the host of a morning show in New Haven. Charles Naftalin, a brilliant, young communications lawyer in Washington, was on the phone with technical and legal advice.

And Matthew O'Shaughnessy and Matthew Deutsch of WVOX and WRTN arrived with a collection of batteries, paper clips, pencils, cleaning supplies, trash bags, wires, plugs—and even a few chairs. The two young broadcasters then raced up and down the aisles of the local Grand Union to stock up on bottled water, apples, peanut butter, plastic cups, and Oreo cookies—provisions for their colleagues for the difficult days and nights ahead.

Not everyone who responded was from the broadcasting fraternity, however. Richard Dwyer, a retired police officer, was everywhere apparent as the radio station struggled for life. Dwyer worked cellular phones to request help from NYNEX (the local telephone company), village officials, and insurance agents. He also remembered to order up a "porta-potty."

And even a station *sponsor* appeared to pitch in. Jodi Ettinger, who runs a shopping center, tried to organize paperwork and reconstruct commercial commitments. And, with Don Stevens and Richard Dwyer, she also handled fire inspectors and insurance adjusters who swarmed around the still smoldering main building. Someone even found a FAX machine as NYNEX added more phone lines.

I was WVIP's advertising rep when it first flung its singular voice out over the hills of Northern Westchester on October 27, 1957. I remember the day it was born.

And I will never forget the day—forty years later—when it died.

But perhaps its finest moment occurred in the desperate hours after the fire, when it was brought back to life, however briefly, by those few dedicated, young broadcasters who remembered they were involved in a profession and not just a business.

September 15, 1997

Charles F. McCarthy: A Legend

Charles F. McCarthy was a famous network announcer who joined us late in his career. Mr. McCarthy came to us recommended by Floyd Hall, who ran Eastern Airlines, and also by the president of the bank who held our mortgage. I'm not stupid, so we brought him on board for the last years of his life.

Charles F. McCarthy came off the mean streets of Brooklyn, where his father was a fireman. He came up and made his way and he had great dignity.

When he went on the radio, Charles F. McCarthy came right at you. My friend Jeffrey Sprung, who loved him, too, used to say that Charles F. McCarthy shined his cuff links before each newscast, which is another way of saying he had great dignity.

And as the Irishman who meant so much to our industry lay dying in Alex Norton's Sound Shore Hospital, his relatives were saying that he did not look too good, but I thought he looked great. He went into the hospital the night before with a cerebral hemorrhage that would take him twenty-one hours later. And Charles, who was sixty-three, was saying he was fifty-two years old. That lovely deception had so much class.

They worked over our friend Charles. When Alex Norton heard about it, he put three doctors around him. And when you are really in trouble, I'll spot you fifteen years and give you all the better known and more famous medical centers in the world and take Alex Norton on my side. But Charles F. McCarthy had sixty-three years, and he sent three generations off to school in the morning—and even Alex Norton and his doctors and all the fancy machines in the intensive care unit couldn't save him.

So when Charles died at three o'clock Saturday morning, his widow said, "I don't care about the newspapers, but call the radio stations, will you, and let them know."

At the ABC radio network, a young man answered the

phone and bellowed, "Hey, anybody ever hear of Charles F. McCarthy!" An old announcer named Don Gardner grabbed the phone and apologized, and said something to the young man that radio announcers never say on the air.

On Wednesday, Monsignor Timothy Flynn will say a Mass in New York for Charles F. McCarthy. A lot of monsignors and bishops will be there because Charles, who had great dignity, traveled in those circles. The old St. John's crowd and some from Fordham University will show up, as well as a lot of radio people who knew about his dignity.

And, of course, Hughie Doyle will be there—as he always is when you need him. They will reminisce about the great broadcasts, like the time he came on and said: "This is Charles F. McCarthy aboard the USS *Missouri* . . ." while some skinny men with top hats and beat-up swords were surrendering to Douglas MacArthur.

They'll talk about the old days, but we'll remember how Charles came up from New York and walked right in the front door of WVOX and said, "My name is Charles F. McCarthy. My friends in New York tell me this is a damn good radio station. I believe I'd like to join up with you because suburban radio is the wave of the future."

At sixty-three, Charles wanted to hop aboard the wave of the future and send another generation off to school. And that's why he was a beautiful man. The first week he came to work for us, the Westchester Golf Classic was in residence at the Westchester Country Club, and as you sat in the clubhouse with Fred Sunderman and Fred Powers and all the big people, Charles sipped a glass of sherry and then walked out with you to the WVOX broadcast booth, which was perched about forty-five feet over the eighteenth green. It was built that way so that WVOX would be higher than any other radio station. And in deference to his "age," you suggested that Charles wait for you, but he would have none of it. And all two hundred pounds of Charles F. McCarthy went up this shaky ladder. You see, there was a microphone at the top, and people out there listening, at radios, the way you are this morning.

He was among the best of what we are. And if they have a radio station in heaven—and I don't know why they wouldn't

have—I can just see guys like Gabriel and Michael and some of those other fellows sitting around listening for the news, and on comes Charles. It just has to happen that way.

January 16, 1968

The Eagle Has Landed: What Does It Mean?

America rejoiced at the success of Apollo 11. But I had some questions about our space endeavors.

You sit next to Walter Cronkite at a dinner party, and he talks about deep sea diving and sports cars with high compression engines. And last night—and all through the weekend on the entire CBS Television Network—he talked about the "epic flight of Apollo 11." Cronkite is clearly a nice man, but what does it all mean this morning? One nation has spent billions of dollars to land human beings on a distant and romantic place called the moon.

July 20, 1969, will go down in our history books. Our grand-children, yet unborn, will ask us what it was like when the United States of America landed two men on the moon. As for us, I think we shall have to say that as we sat at home and watched this awesome and fantastic feat on television, a few more children died of malnutrition in a far off country called Biafra. And a few more Chinese and Indian children died in infancy because their mothers were too poor and too illiterate to care for them.

It was wonderful and courageous, this flight of Apollo 11. And it was good that we should watch it on the same television screens that showed us what a nice sunny afternoon it was near an underpass in Dallas. We would rather watch two brave astronauts than watch the life ooze out of Martin Luther King, Jr., or Robert Kennedy. But think about all that money!

We don't have President Richard M. Nixon's "overview," which is a hip word, but I would rather have had us spend those millions to purge assassins and murderers from our midst before we set off to colonize other worlds. I know it sounds like the textbook liberals and the do-gooders to suggest

we should eradicate sickness and disease, but I think I might have gone and diverted a few million from our space efforts to remove words from our language—words like "nigger" or "kike" and "harp" and "wop." And I think I would have been tempted to spend all that money just to get one Westchester teenage boy or girl off dope.

We walk in the craters of the moon, but not in the streets of Harlem, just minutes south of here. And we are still a nation of Larchmont Irish and Bronxville WASPs and Mount Vernon Italians. Kids are hanging around street corners in Mount Vernon and Yonkers and on Lincoln Avenue in New Rochelle, asking what the hell this all means—this moon business. We are still obsessed with our cars, our antiques, our little half acres. Our pressures and our anxieties remain.

I'll let our clergymen tell us what it is we're hoping to find on the moon. If today is a nice day, and everyone heads for the beach on a national day of rejoicing, then you'll know it's only a matter of time until those starving children in China come roaring across the earth while we play on the moon. Spiro Agnew speaks now of Mars. But what does it all mean, Walter Cronkite? The Eagle has landed—but here in our world, here on earth, pigeons still rule the skies.

July 20, 1969

PART VII: ASSASSINATIONS

I've sat in front of the WVOX microphone too many times to tell my listeners about great leaders and statesmen cut down by bullets. Here are several pieces, most of them done the morning after the shootings.

Martin Luther King, Jr.

So now we've shot and murdered Martin Luther King, Jr., and each of us owns a piece of this latest outrage, whether we live in New Rochelle or Scarsdale or Rye or Mount Vernon—or Bronxville, where Negroes aren't allowed to own property.

I'm not sure what Martin Luther King will mean against the broad canvas of history. We met him only once—last October. He was in Nassau in the Bahamas, traveling with us on a tiny sightseeing bus—wearing Bermuda shorts and a camera slung around his neck. And I only know that he was courteous and gentle and polite, and seemed like the rest of us—who murdered him.

Ask not for whom the bell tolls in Memphis. Any man's death diminishes me. Can't we ever get that through our damn, thick heads? But let's hope we all get ahead in business today. And let's hope the Pelham Junior League can find out what's wrong in New Rochelle. And let's pray the wonderful Bronxville Junior League can straighten out Mount Vernon.

And meanwhile, we'll keep killing because we won't look at our own marvelous selves.

August 5, 1968

AFTER THE SHOOTING

Reaction to the murder of Martin Luther King, Jr., started to come at us yesterday. All the politicians raced for the nearest microphone to try to make some sense out of this latest outrage, which demeans us as a people.

Lyndon Johnson sent the Attorney General of the United States down to Tennessee and canceled a trip to talk about the Vietnam War. Finally, someone has shown that anarchy here

at home is more dangerous and destructive than the situation in Asia. Johnson thus showed it was more important to keep the American flag flying over Memphis, Tennessee, than it is to keep it propped up over Hue or Saigon. This would have made Martin Luther King happy, because that's what he tried to tell us. All the while this nation was concentrating on being a global power, Dr. King was saying that we should concentrate on places like New Rochelle, Memphis, Mount Vernon, Atlanta, Yonkers, and Chicago.

But now he's dead, and Billy Graham, the North Carolina evangelist, cried out from halfway across the world that "America is sick." Graham said there are tens of thousands of sick and mentally deranged people in our own country. We certainly didn't need Graham for this revelation: it's right there in front of us. We are a nation of opportunists, and nothing Lyndon Johnson or Roy Wilkins or Whitney Young can say will make it any easier for us to look a Negro in the eye today.

This must not be ours alone, this thing about Martin Luther King, because Stokely Carmichael and Rap Brown and the rest of the loudmouth naysayers own a piece of this murder. Any Westchester civil rights leader who ever denounced King or Wilkins is to blame, too. And plenty of them did. A Negro minister from New Rochelle got right on this radio station recently to abuse King and Wilkins and their solid, nonviolent, and reasonable approach. But this is all a reaction to social evils we live with and do nothing about.

In Westchester, we are up to here with do-gooder organizations. The Junior League from Pelham, for example, is doing a case study on what's wrong with New Rochelle. And last year, the Bronxville Junior League tried to tell us what was wrong in Mount Vernon.

Because we are smug and secure, the murder of Dr. King won't mean much to us. As long as the railroad runs for us today, and as long as we can get ahead in business and compete and worry about ourselves, the latest killings won't jar us or make us break into a cold sweat.

We've killed four presidents, and we've shot demagogues like George Lincoln Rockwell. And when someone at your breakfast table asks you what that murder in Memphis means,

if you say, as many will, that it's his own damn fault, that he got what he deserved trying to stir people up like that—if you say that in your home, God help you! And God help your children who look to you for balance, leadership, and guidance in this world filled with hate and insanity.

Each of us has a share in this murder, every one of us who ever stood off in our smugness and called somebody a Nigger or a Jew. I'm afraid that people like us who stand back and duck the tough moral issues of our day breed the ones who pull the trigger.

The man who killed Martin Luther King is a product of us.

April 6, 1968

Pope John Paul II:
I Wonder What He'll Say

And now the Bishop of Rome, the Pope of the Holy Roman Church.

We are running out of ways to tell you this story. It's all too familiar. We are becoming too savvy, too well rehearsed, too practiced in our response. Too accustomed.

When the Associated Press wire sends the first stark bulletins into the radio station, you gather in the newsroom to monitor the network. In the executive offices, the television sets go on and you curse the damn daytime soap operas as you wait once more to hear how well the assassin did his job this time.

It comes naturally. We have been here before. Only the datelines are different: Dallas. Memphis. Los Angeles. Washington. And now St. Peter's Square in Rome, the City of Martyrs, the Eternal City, the Holy City.

It is becoming too predictable: a gun; shots; a race to a hospital; grief-stricken people; medical bulletins; doctors; prayers; statements by world leaders; television cameras in St. Patrick's Cathedral. Another media event and, again, the ancient prayers.

Because we have heard it all before, the radio stations play music and commercials sooner than they used to, and the business of America, which is business, goes on. We are a street-smart people about all this.

And right now, in a hospital in Rome, the successor to St. Peter, a man who preaches a message he got from a carpenter's son that we should "forgive those who trespass against us," fights for his life as they try to take bullets out of his mortal body. I wonder what this man they call Holy Father will say. I wonder what that carpenter's son would say about all this. I wonder, more than anything, why it doesn't shock us much any more. I wonder why we have grown accustomed.

May 14, 1981

Judge Richard Daronco: One of the Neighbors' Children

Richard Daronco was a U.S. Federal Judge who was murdered in his backyard in Pelham, New York.

The television networks, all of them, had it on, and Louis Boccardi's Associated Press satellites moved the terrible bulletin across the skies to damn near every newspaper and radio station all over the face of the earth. "United States Federal District Judge Richard Daronco has been assassinated in the Village of Pelham, in Westchester County, New York."

But here it was quite different. Some son of a bitch had shot Dick Daronco, who was one of the neighborhood. We saw him in the drugstore and on the golf course. We saw him on his knees at St. Catharine's on Second Street, and we heard him play his horn in a Dixieland band.

Daronco once had a weekly radio show on WVOX. Someone from this radio station introduced him to Senator Alfonse D'Amato, who recommended him for the federal bench. We watched him stand among the great, gray eminences of the federal judiciary to raise his hand and take an oath in a packed federal courthouse in Foley Square after Ronald Reagan had called him to say he wanted him on the bench—for life.

I feel dreadful telling you about what happened to Dick Daronco, how some poor, tortured man with a scrambled-egg mind, a gun, and a heart filled with hate came all the way up from Pennsylvania to find Corona Avenue so he could walk through the bushes at number 207 and go right into the backyard to empty a gun into Dick Daronco as he tended his garden. The man, Koster, didn't just murder a federal judge; he took one of the neighbors' children, one of great gifts and charm and brightness.

I will only tell you a few of the many things I know about Daronco. He laughed a lot. A man of great, spontaneous wit, Daronco would kid the other judges in the courthouse in White Plains, reserving his best lines for Justice Alvin Richard Ruskin, who came to work with a tuna fish sandwich in a brown bag and who called here on Saturday with an awful sadness in his voice to find out if Dick Daronco was going to make it.

I liked this man. He always found discreet ways to inquire of Samuel Fredman, Esquire, and of me, when I was going through a divorce up in the 9th Judicial District courthouse. I made Daronco miss a flight to sit down for coffee one day at Le Cirque restaurant so that a United States Senator could meet him. I told Senator D'Amato that Daronco was one of our very brightest and would surely make a splendid candidate for a federal judgeship.

I made speeches for Daronco back in the 70s, when everyone around here thought he could go all the way in this state, maybe even to the governor's mansion. Daronco was much more than the "able, gifted" judge they had been calling him. And I was not alone. He was like a son to Joseph Gagliardi, the former chief judge in Westchester, who wanted Daronco to succeed him. But on the streets of Westchester and in the neighborhood, he never carried himself like a judge. Rather, he was friendly, outgoing, laughed a lot, and told wonderful stories.

There is thus a terrible heaviness here in the neighborhood after the events of this weekend and what happened in the backyard of 207 Corona Avenue. There is shock and grief. There is no laughter.

As I sit here in front of the microphone at his hometown radio station, my mind drifts back to a story I once heard from Judge Daronco. It is a small story, a personal one.

It seems Joan and Dick Daronco were out in the Hamptons for a family holiday just a few summers ago. In the weeks before starting his vacation, the judge had quietly visited a doctor, a cancer specialist, who had called him back several times with those dreadful words: "Let's take more tests."

The Daroncos had rented a modest house from a very reli-

gious woman and when they arrived, Dick and Joan Daronco stayed away from the beach and close to the telephone, waiting for the verdict from the cancer doctor. For several days, nothing—no word came. And then, as Dick told it, one morning as the sun was burning through the clouds, he went out to inspect the owner's backyard. In a corner of the garden, he noticed a statue of the Virgin with gentle flowers growing up around it. After looking around to make sure his fashionable Hamptons neighbors couldn't observe him, the young judge knelt down and said a prayer to the Blessed Mother. At the precise moment he said the words: "Holy Mary, Mother of God, pray for us sinners, now, and at the hour of our death," the phone rang in the cottage. It was his law clerk relaying a message from the cancer specialist: "All clear. Everything negative." And Joan and Dick Daronco went off to the beach to sit in the summer sun.

That is just one story I know about the federal judge who was murdered in his own garden over the weekend. All I can really tell you is that Dick Daronco was a bright star in the neighborhood—and he laughed a lot.

May 24, 1988

Yitzhak Rabin: A Tribe Cries

This was a bad week for all those who hate the Jews.

The very worst moment, of course, occurred in that parking lot in Israel when Yitzhak Rabin slumped to the pavement with two dum-dum bullets exploding inside his chest.

Here in America, our leaders are taken down in open, moving convertibles with their brains flying all over Dealey Plaza. Or they collapse on motel balconies in Memphis, or under the glare of the neon on greasy kitchen floors in Los Angeles. Sometimes, it even happens in a theater in the capital city of our nation.

Always there is a gun and a human being with a scrambled-egg mind. And then a widow who must endure the talk of martyrdom for a husband who will not wake up next to her in the morning.

But Mario Cuomo pointed out yesterday, it has not happened in four thousand years that a Jewish leader was cut down by one of his own. So their record is somewhat better than ours. But as Yitzhak Rabin becomes the first great statue of modern Israel, his assassination also does great violence to the notion of the Invincible Jew, the Survivor with all that security on his El Al airplanes and the commando teams that always win against the Arabs. You can also forget the helicopters and the gunships with the Star of David that don't crash in the desert.

All of a sudden, in one, swift, sad weekend, the world had to notice that the Jew actually bleeds—and even dies—just like the rest of us when we are murdered by our own. He is mourned by grandchildren and buried with tears in cold ground, while his enemies rejoice—although dying is something you have to do all by yourself.

It is a familiar story to all of us. And now, even the gutsy, tough people of the modern State of Israel hear its awful music. The tribe that made a desert bloom and survived a Ho-

locaust now cry as we have, and their tears fall on the same cold earth.

The Jew, it seems, is just like us.

November 10, 1995

George Lincoln Rockwell: "Any Man's Death Diminishes Me"

A man who had the middle name of Lincoln was shot dead last week in Arlington, Virginia, and once again each one of us owns a piece of a murder.

George Lincoln Rockwell was the worst of what we are as a people. This self-professed superman and *Führer* was less than a creep or a jerk. He was, in fact, a sickness, an aberration of America. He wanted to be like Adolph Hitler, who was an apostle of hate and evil. But George Lincoln Rockwell never made it as big as the nasty, arrogant Nazi *Führer*. He resembled Hitler only in the grimness of the way he died.

Rockwell looked small and pathetic as he lay on the mean, cold concrete outside a laundromat. And the only thing you hear about our cult of violence in America is how bad all this must make us look to the rest of the world. That's so typical of a nation concerned with images and toys.

So the murder of this little man, who had the middle name of Lincoln, meant something. Although the world will little note nor long remember what he said about Negroes and Jews, the world will remember the cult of violence that consumed America in the 1960s. Even though it's hard to swallow the words of John Donne's lovely "devotions" along with a dose of the hatred and arrogance that was George Lincoln Rockwell, recall them: "Any man's death diminishes me, because I am involved in mankind; and therefore never send to know for whom the bell tolls; it tolls for thee." In other words, weep not for a minor demagogue, but shed your tears for America and for our cult of violence. America—where we shoot the bad as well as the good.

August 28, 1967

George Wallace:
Blame This One on Us

How the hell do you put this all together? Do you alphabetize the names of the people we have shot, or do you just let them come at you? Medgar Evers, Abraham Lincoln, John Kennedy, William McKinley, Robert Kennedy, Malcolm X, George Lincoln Rockwell, Martin Luther King—and now George Wallace. These awful things always happen when we least expect them. They happen in the springtime and in the fall of the year. They happen in Dallas, Los Angeles, Memphis—and now in Laurel, Maryland.

President Richard Nixon is appointing men to serve on blue ribbon committees to commemorate the Bicentennial of the American nation. But there again, last night, was Walter Cronkite shaking his head at us as they rolled the opening billboard and credits on the entire CBS Television Network.

Men came home to Westchester last night and tore open a six-pack or knocked down a Canadian Club, looked at their wives, told their kids to shut up, and sent them out of the room. They saw George Wallace's wife leaping on him in a parking lot in Laurel, Maryland—and then looked at old steady Cronkite. But even he looked shaken this time.

One thing, thank God, is that we tape all these things with our television cameras. We will always be able to recall how it was when George Wallace went down in a parking lot in Maryland, while our wives were starting to get our dinners ready. We've got pictures of John Kennedy's brains being blown out, of Robert Kennedy squirming on a kitchen floor, and of Martin Luther King slumped outside the Lorraine Motel in Memphis.

We do not know the man who shot George Wallace, just as we did not know James Earl Ray or Lee Harvey Oswald or Sirhan Sirhan. Yet, they come out of us. They spring from us

as a people. We can blame what happened yesterday in the Maryland parking lot on one poor, twisted, scrambled-egg mind. But that would be unfair.

We pass legislation that makes it possible to kill children yet unborn at "clinics" in Pelham. We hoist the flag promptly whenever someone tries to get us out of Vietnam. We hear a public official like Diane Collins talk about gun control, but we don't hear her. We call our young dirty, evil, and sinful when they try to tell us about the war—as they did last week in front of our high school. We have tampered with our bodies and drugged our minds. We have fought useless wars. And we have sent our young, the fruit of our nation, to drop napalm on human beings, and we have seen the pictures in *Newsweek* and *Time* week after week.

Our admirals and generals send young men to war in Vietnam. Right here in Westchester, fathers raise sons to hunt deer, to stalk and to kill. And these "isolated instances," as we used to call assassinations, are starting to run together, and we are shooting people down every time the spring or the fall of the year comes around.

It is not enough this morning to blame this latest outrage on George Wallace's hot rhetoric or the lunatic fringe. We can blame this one on us. Every time we beat someone for a seat on the train or the subway; every time we abuse our horn; every time we go hell bent for home at night, never caring about the other fellow: all of these selfish things and our shabby priorities breed the morons who pull the trigger. George Wallace may not deserve this latest shooting or martyrdom—but we do.

May 16, 1972

PART VIII: O'SHAUGHNESSY AT THE PODIUM

William Mac O'Shaughnessy: 1904–1974

Saint Joseph's New Cathedral
Buffalo, New York

Friends of my father . . . my father's friends . . .

We few from among his many friends are here in this great cathedral during the springtime of the year as surrogates for his entire family, and for all those people who knew and loved my father during the sixty-nine years he spent on this earth. It is, therefore, quite appropriate that we consider for just a moment the life of this splendid individual.

He was not a great industrialist. He was not a millionaire. Yet, he leaves a great deal for all of us, and to all the members of the O'Shaughnessy and McLaughlin families. He leaves us the memory of a rare and wonderful individual.

And memories, said Jimmy Cannon, are the trophies of life. Although my father is gone from this earth, our memories of him—the memories he gave us—are rich and clear and constant and fine. And everlasting.

Because of the kind of man he was, it is not necessary that we bombard heaven on high to protect William Mac O'Shaughnessy. My father was bright. He was kind. He was a decent man. He was all of these things. And he was more.

I recall that his great heroes in the political arena were Alfred E. Smith and Jimmy Walker and Jim Farley. He was of their time, and he brought their style and their dash and their wit and their humor into his own way of conducting himself. And most significant and more than anything, he shared their love of people.

"Look a man in the eye," my father would tell his sons. "Look right at him and give him not only a firm handshake,

but give him some kindness and give him some gentleness and give him your friendship."

He gave me, his son, the gift of years I've never lived.

He would appoint himself the champion and advocate and propagandist for his two sons.

He could inspire the love of a wonderful and dedicated and selfless woman who, through her own constant devotion, earned her own right to a very high place in heaven. She was with him for over a quarter of a century—and he is with her now: Marguerite Lascola.

We all saw my father's toughness and courage during the recent debilitating illness. He dedicated it to Almighty God, and his courage was in imitation of Christ himself. We saw this and we felt it and we drew from his strength.

But my father was also gentle. His priorities remind us of the words of a song inspired by José Martí, the great Cuban liberator: "The colors of his brush as he walked this earth were not of flaming crimson. They were soft green. The streams of the mountains pleased him more than the sea. His poetry and his music were for the little people of this earth."

How symbolic and how wonderfully appropriate is the name of the lovely, pristine village my father so loved and where we will now lay him to rest: Friendship. Friendship, New York. When we think of this lovely, serene village, let us think of my father and the friendship he gave to so many of us.

And, finally, we should like to observe that my father's life, as he battled sickness, should have a special meaning to you if you are Irish. In the face of adversity, my father was what our forefathers and our poets told us a man should be. He was a gentleman—and he was a gentle man.

Say a prayer for my father when you can, and protect and preserve those trophies, the memories he has left us.

May 22, 1973

Catherine Tucker O'Shaughnessy: 1906–1991

St. Francis Church
Mount Kisco, New York

May it please you, reverend fathers, and also your excellency, Governor Cuomo, whose presence here today so enhances this bittersweet occasion. I won't intrude for very long. But I want to tell you what I think we are all about this morning.

My mother knew the loneliness and suffering and pain of Damien. She knew how to bombard heaven on high with prayers for her sons and grandchildren. But she had some fun, too.

She was a vibrant, vital, vivid figure, a woman of great zest and derring-do. She came at everything with a marvelous, relentless energy. She had a dynamism and charisma about her, and she kept up the music for eighty-five years—all the days of her life.

Let me explain. This is not easy for me. Although I make my living, sometimes clumsily and "inartfully," with words, I have a difficult time getting up and referring to this particular woman I loved in the past tense. Eulogists usually try, in these circumstances, to evoke images of peacefulness, tranquility, quietude, and repose beside gentle streams. But when I think of this one, unique, absolutely indestructible lady, I hear the sounds of loud night music, of jazz and ragtime. And although she is gone from our midst, that unmistakable beat of hers, that unique, special rhythm, will echo and play in our minds and hearts for years to come. Her music will go on in her grandchildren, because that, essentially and ultimately, is what she was all about. She was all about generations.

My mother's part in the scheme of it all started in 1906, in Waverly, New York, the tiny, upstate village near the Pennsyl-

vania border that she talked about so often—the home of her father, Frederick Fremont Tucker, and of her beloved grandfather, Dr. John Thomas Tucker, whose name Jack and Johnny carry so proudly.

Her own, actual name was Catherine Pauline Tucker O'Shaughnessy. But she answered to lots of other, less formal appellations. In college, at Marywood, they called her "Kitsy." Her grandpa and father—she was an only child, who would ever have guessed—dubbed her "Kitty." My dad called her "Kay." Johnny and Laura and Matthew, David and Kate and Michael called her "Baga." Up at Westfield, where she had a splendid career in education, she was "CTO"—and don't you forget it, Buster! At Sam Rogers's place and Joe Angi's, and at the Kittle House, she was "Mrs. O'" among the cooks, waiters, and busboys. Chet, of course, always referred to her as the "Dutchess." And up at the Shepard Hills Club in Waverly, where they still have fish fries every Friday for $6.95, plus salad bar, they still know her, with some awe and considerable respect, as "Catherine Tucker." Jack and I, of course, are the only ones entitled to call her "Mom."

Now, in the moments of your lives that are given to me this morning, I want to say only a few more things. I think I have to make the case that my mother was a marvelous character— and there is no other word I know that fits. She was a *character*. This was everywhere apparent as we sorted through her effects and archives yesterday—not an easy task, but enlightening. As we inventoried her collection of keepsakes and mementos, we could see the big, broad range to her life. There were 342 pictures of Sam Rogers, for example, and only 126 of Dick Crabtree! But we also encountered a teapot from the "21" Club; ashtrays from Le Cirque, Lyford Cay, and Nino's; the Commodore's burgee from the American Yacht Club—I have no idea how she acquired that—and an entire twenty-four-piece place setting from the Kittle House!

And in the larder, the kitchen, of this eighty-five-year-old woman who was always being ordered to a strict diet by her devoted Doctor Luderman, one finds capers, shallots, macadamias, sweetbreads, pâté, rum cakes from Neiman-Marcus, candy bars, champagne, and not a few bottles of Dewar's, sit-

ting cheek by jowl in the cabinet with row after row, bottle after bottle of her famous Schweppes "peppy" soda, which has grown into legend! And speaking of food, a young nurse named Karen told me last night how she was dispatched from the hospital every afternoon at three o'clock and told not to return without some Saga cheese and beer.

In a world of dullness and ordinary people, my mother was a bright star. She loved children. She knew about horses and dogs and how to care for them. She could hit a golf ball out of sight in her day.

She knew about Cole Porter, Rodgers and Hart, Harold Arlen, and Hoagy Carmichael. She taught me about all this, and about Ted Straeter and Skinnay Ennis and the Hal Kemp Band. And last month, a guy of about ninety years, named Nick Peckally, came up to me in the paper store in Waverly and said: "No offense, young man, but your mother had the best pair of legs I ever saw on a girl!" When I reported this to her, she said: "Nick is an old fool." Then, after awhile, she called me back and inquired: "Did he really say that?"

My mother was a lady. She knew about country clubs, dances at Cornell—when Franchot Tone was there—and fast roadsters with rumble seats heading up to Elmira or careening around Wurtsboro Mountain. She could not abide rudeness or a lack of grace in those she encountered. Breeding she called it—and manners. She would enforce her views among the grandchildren by telling them she had a gun that "shoots around corners!" To this day, the kids are not quite sure she was kidding about this.

So, it was a great life, lived strictly on her own terms. She was *sui generis*, altogether unique, and able to be defined only on her own terms.

Nancy also asked me to point out that Baga was a woman well before her time—a single woman who raised her children alone in an often hostile and unforgiving world. They write about this in the magazines of the day of women who balance careers and raising children. She did it all fifty years ago.

Finally, I want to share with you a conversation I overheard just a few months ago. The phone rang at our house early one morning. The trooper at the governor's mansion came on the

line and said: "Please hold for a call from Mario Cuomo for Mrs. O'Shaughnessy." They talked, the governor and Mom, for a good, long time that morning earlier this summer. They talked about children, grandchildren, and, predictably, generations. And I remember Mom said: "Mario, I've had a good life for eighty-six years"—she was always, as you know, adding or subtracting a year or two! And feeling I might be eavesdropping, I left the room, but not before I heard her tell the Governor of New York: "Mario, I never knew so many people loved me."

Tomorrow, at precisely one o'clock in the afternoon, in the historic Penn-York Valley, my mother returns to her beloved Waverly, to a spot right next to her grandfather, Doctor Tucker, and her adored grandmother, Stella Lounsberry.

I hope they have a jazz band playing—or a little night music—when Baga hits town.

After eighty-five years out on the road, she returns triumphant.

August 1991

John Thomas O'Shaughnessy: 1940–1998

St. Patrick's Old Stone Church
Yorktown, New York

He fancied liters of Pepsi, tuna fish sandwiches—hold the to-mato and forget the lettuce—Heinz Ketchup, Hellmann's Mayonnaise, Carvel milk shakes, and the worst jokes! He also loved all of you—and we thank you for coming this morning.

This is a task I'd gladly leave to someone else. For you see, I've delivered formal eulogies in other churches, even in ca-thedrals, for all kinds of unsavory characters: disc jockeys, politicians, merchant princes, saloon singers, broadcasters—and some of them, I'm afraid, were really quite disreputable! They were acquaintances, friends, colleagues, associates. But they were not of me and mine. Or of us—as Jack was.

When you stand up like this for an acquaintance or col-league, you summon up all the sincerity you can muster. You try to be glib. You struggle to be articulate and reassuring. You remind people that the ancient wisdom of our Church dictates that rites and proceedings like this and the one last night are ultimately joyful, not sad. And then it's over. Your remarks end, and you go home to your own—unscathed, undiminished by their sorrow. That's usually what it's like in my business.

But this is for Jack—and he meant a lot to all of us. But he was my only brother. We thought he would always be there, because he was always there.

Jack was a rock-solid citizen all of his days. He was a wise counselor and the quintessential townie with a fierce devotion to his family, his friends, his community. He was everything I'm not.

Jack was always punctual to a fault—always on time. I can remember so many parties, functions, and events—some of

them at our house. The appointed hour would arrive, and Nancy and I would usually be in the shower or on the phone with towels around us. And up the walk would come Jack, five minutes early, as we scrambled to answer the door. He could find no magic in being "fashionably late"—and he never was.

And while we find lessons in his life, we can find no understanding of his leaving us. The suddenness of his passing—the untimeliness of it all—is so out of character for Jack. I should tell you only that he was everything I aspire to be. "How different you boys are," everyone would say over the years. Bill is the one who always seems to need a haircut, while Jack looks like he just got one!

I make my living with words—usually "inartfully," awkwardly, imprecisely, and clumsily, as you have already observed. I thus try to make my way in life with concepts, notions, and suggestions. Jack made his with sureness, clarity, focus, determination, example. And what an example he set with his fierce devotion to his family and his community. And speaking of haircuts and loyalty, Jack had the same barber in Yonkers for forty years!

Jack was a Hallmark Hall of Fame kind of guy. He loved "occasions" and holidays: Mother's Day, Father's Day, Valentine's Day, birthdays. He would send sentimental cards for all of them, inscribed with soaring passages of tribute and love. But no verse, plaintive or sorrowful, could capture the sadness and emptiness we feel in this little country church on this morning in May.

We are often—at least I am—"selective" in my enthusiasms. Jack, however, never discriminated. He always had a good word and found time for everyone. At the market, at the greengrocer with the clerks, the mechanics at the gas stations, the shopkeepers, in restaurants with the busboys and the waiters. And the lovely couple who runs his favorite pizza restaurant are here this morning for Jack.

He was always a gentleman. And although he never smoke or drank—I told you we were different—he had a marvelous sense of humor that he visited on us often—and which was delightful to experience and behold.

Jack was the family historian. Julie and Nancy and I re-

member supper at Winged Foot a few months ago, when Jack took us on a tour of his boyhood—our boyhood—with marvelous, heroic, funny stories of childhood dreams and great aspirations.

My brother was a townie. That's a term of great respect from me. He had a strong sense of his roots. He traveled a bit. He and Julie saw a good part of this world. He never slept on those transatlantic flights, though, in case he was needed! But Jack returned always to these hills: Somers, Katonah, Bedford Hills, and, finally this morning, Peekskill, within a mile of where he and Julie were married.

Jack was always devoted to the 3M Company, and we thank the high officials of 3M for coming. We also thank his present and former colleagues. We're also grateful to his fellow Marines. I sat on a dais once with General Gray, the commandant, a four-star general. I told the commandant that my brother was a Marine, and when he got up in front of a thousand people, he reminded—actually reprimanded—me. "Your brother *is* a Marine," he said. "There are no *former* Marines."

Finally, I want to observe that if Jack was your friend, he was your friend for life. John Brick, George Becker, Bob Burlenson, and Bob Hyland, our All-American Friend, know well of what I speak. Some of us "trade up" and "move on" in our friendships, but not Jack. He stayed with you forever. As do so many of you who also enjoyed his friendship.

But in all his fifty-eight years, Jack had no greater enthusiasms than his love for his family. He married a beautiful Westchester girl, who was devoted to him for three decades—and he to her. The thirty-third anniversary of their wonderful marriage is next week. Their children, John and Laura, meant everything to Jack. And as I ask Johnny to come up, I just want to share a final observation with you.

It has to do with one war story Jack forgot to tell that night at Winged Foot. That the O'Shaughnessy Boys were once the two greatest caddies in the history of the Bedford Golf and Tennis Club. I will tell you, for the first time ever, how we achieved that reputation.

It was known that the moguls, bankers, and financial titans of the day, who belonged to Bedford, would always ask for

"one of the O'Shaughnessy boys" to accompany them on their rounds—because we never lost a ball—*ever!* However, I'm afraid I achieved my reputation, I have to confess, by sheer guile, cunning, and subterfuge. I used to carry an extra Titleist in my pocket. "Just get it over the hill, sir, and out of sight. I'll do the rest." I was also known for producing remarkable lies and helping them avoid sand traps! Jack, on the other hand, didn't need to resort to this kind of deception—and I'll tell you why. He never took his eye off the ball!

And you know, as I mercifully yield—ultimately and essentially—that is really the only observation I can leave with you about Jack. And, I think the highest, most accurate tribute. He *never* took his eye off the ball. That's why we loved him, and that's why we will miss him so much.

As Father Emil has assured us, Jack has gone on from us to eternal life with no time to constrain him—no height, no breadth, no length to contain him. With no sorrow, sadness, or loneliness to diminish him. When we reflect on Jack, we can see something in the lesson of death. We are confined by clocks and watches and specific locations and places—and aloneness. But now, Jack is unlimited, you see, totally joyful, satiated, saturated—knowing no start, sensing no end.

At some funerals—we've all been to them—the priest has to stretch a bit, assuring us that someone is, in fact, "with God." And sometimes we have to cross our fingers and hope he is right. With Jack, and the way he lived for those fifty-eight few but full years, we are sure, beyond a certainty. He was a good man, a great brother, a wonderful husband, a terrific father and uncle—and a superb friend. He was always "there."

May 9, 1998

Martin Stone: 1915–1998

Memorial Service
Northern Westchester Center for the Arts
Mount Kisco, New York

The last time many of us were together like this was about a
year ago, when Martin Stone received the Raoul Wallenberg
Award from the B'nai B'rith. And Marty, with his usual, exqui-
site instinct for high drama, picked an Irishman named
O'Shaughnessy to be the keynote speaker.

Marty was a visionary and a pioneer, who had a big, broad
range to his life: adviser to Franklin D. Roosevelt, Harry S.
Truman, and the incomparable Jack Roosevelt Robinson,
whose beautiful Rachel is here with us to honor, remember,
and pray for Marty. He was an entertainment lawyer, pro-
ducer, founder of a radio network, showman, broadcaster,
public servant. He was a lot of things in those eighty-three full
years. But the appellation that draws so many of us together
is *mentor*. That's how we saw him. That's what he was—our
mentor, trusted adviser, counselor. It is so appropriate that
we do this on Father's Day, because he was such a *father figure*
to so many of us.

And while we are sad today, we should take heart and feel
blessed that Marty chose *us* as recipients of his friendship. He
was drawn to us as we were drawn to him. We were exposed
to his restless genius and relentless creativity, because he
found something in each of us that was perhaps a reflection of
himself. And we should feel very good about that, hold on to
it, and never forget it.

Marty was also a teacher. When we recall the lessons of
his bright, fine mind, I'm reminded of an encounter with the
glorious Mabel Mercer one night long ago at the Algonquin
Hotel in Manhattan. Miss Mercer, who was a lady of a certain
age, and the greatest interpreter of Cole Porter, had just fin-

ished singing in her trademark wing back chair under the hot cabaret lights. She requested that I "escort" her to the elevator and, as we stood waiting for the slow, ancient lift in the Algonquin, Mabel reached in her purse and produced a telegram she had received on the occasion of her seventy-fifth birthday. It said, simply: "I learned more than most. Love, Frank." Sinatra! Who, alone, was almost her equal when it came to phrasing and musicianship. I was thinking of that lovely gesture by Sinatra while we were driving up to northern Westchester this morning, and how much I learned, how much we all learned from Marty over the years.

He would take a bank trainee from Mount Kisco and a young man from Fall River, and install Bill O'Shaughnessy and Morton Dean before the microphones of WVIP, as it flung its singular voice out among the hills of northern Westchester that October day in 1957. For forty years, he nurtured and sustained that pristine jewel of a radio station, as he nurtured and sustained our friendship. But WVIP was brick and mortar, tubes, wires, microphones, turntables, and tape. Marty's legacy was more enduring and endearing. It is the inspiration he provided to all of us in whose memory he still lives.

A lot has been written about the marvelous building in which WVIP was housed. Designed by the legendary Edward Larrabee Barnes, an architect of international reputation, it is bold in concept, unique for its day, shaped like a seashell—a "reflection" of the community. All the architectural journals and critics praised the "worthiness" of its brilliant design and form: "stunning," "very cutting edge."

But, in the intimacy of this room, they missed the greatest feature of the Studio-in-the-Round. They missed the *ladder* that led up to the roof! For it was to that roof we often invited the Mount Kisco girls—to get them closer to the stars, to study the planetary system and intergalactic developments! In fact, so much activity did the roof receive that the engineers actually recommended that Marty study it to determine its "load-bearing factor." "No," said Mr. Stone. "I'm quite sure Ed Barnes designed it for every possible kind of use, conforming or nonconforming!"

I remember going over to New Caanan on my first sales

call. Marty said: "That's where the money is." I was making sixty-five glorious bucks a week at the time. On my very first day, walking down the main street, I spied a handsome leather briefcase in a store window. It was just like Marty's! Beautiful! Rich! Classy! Only $165! That would be twelve hundred dollars in today's market. So I bought it "on time"—and started my career "in the hole." When I raced back to the station to show Mr. Stone, he never noticed. He only inquired if it had some orders inside it. It usually did.

I remember driving Marty's big, white Chrysler Imperial. Whenever he would dispatch something of importance to White Plains, he would "suggest" I take his car. En route to the county seat, I would always stop in at the old Log Cabin in Armonk, early home of the big band remotes, just so they would see me drive up in that boomer car!

Marty did everything with great style.

Now if Marty had driven through town, they'd have taken notice! Nancy will confirm that at our wedding in 1990, at Manursing Island Club, we had two governors, five supreme court justices, an assortment of bank and college presidents, a network president, Ossie Davis, and Ruby Dee. But all anyone inquired about the next day, when they called to thank us for the party, was Marty: "Tell me more about that Martin Stone. What an amazing, fascinating man!"

As I said, it was always like that for him, even walking into the market in Pound Ridge or the greengrocer. He was very special and everyone knew it.

His brother, Allan, mentioned a sighting of Marty in the company of Brandeis, Cardozo, and Einstein, and so I thought I might leave you only with a passage from the great Benjamin Cardozo, who served early in his career on our highest tribunal, the New York Court of Appeals, and, later, with stunning brilliance and great distinction, on the Supreme Court of the United States. Justice Cardozo said: "Three great mysteries there are in the lives of mortal beings: the mystery of *birth*, at the beginning; the mystery of *death*, at the end; and greater than either, the mystery of *love*. For you see, everything that is most precious is a form of *love*. *Art* is a form of love, if it be

noble. Labor is a form of love, if it be *worthy. Thought* is a form of love, if it be *inspired.''*

In the forty years we knew him, Marty made the things we did together *noble, worthy,* and *inspired.* It was *all* about love.

June 21, 1998

Mario "Pop" Migliucci: 1914–1998

Our Lady of Mount Carmel Church
Little Italy, Bronx, New York

This is what I know about Mario Migliucci, about "Pop," a Bronx legend.

I will begin in Montauk, where he would revive and restore himself by the sea on weekends alone, with the wind and the light and his beloved Rose. Then, each Tuesday morning, he would return to what he was and where he had to be, always to these streets, to this neighborhood, and to the landmark restaurant that bears his name.

Pop's goodness and charm brought them to this neighborhood. Judges, magistrates, food critics, journalists, merchant princes, civic leaders, the people of the neighborhood who loved him, even a few competitors—other restaurateurs. The rich and privileged came from Westchester and Connecticut and even from New Jersey. They came down from their country clubs in Bronxville and their yacht clubs in Rye, because Pop gave them something they couldn't get in those rarefied precincts. He gave them realness.

Pop provided an agreeable venue, a warm, beckoning place, where they could sit at table with their families and eat and drink and talk—and laugh—through the night. "Vera real," he called it. Authentic! Everything about Pop was authentic.

What an attractive man he was! What a handsome man! He would move through the dining room with that lean, lithe, taut body like Fred Astaire. He was always imperially slim, while the rest of us put on too many pounds as a result of the abundance of his hearty, earthy Neapolitan food! He moved with a grace not found in men of his years.

And his hands were beautiful, graceful, and elegant—the

hands of a craftsman, an artisan. Especially when he would send the pizzas swirling skyward, borne aloft by those beautiful hands. He let me try it once. The pizza is still on the ceiling!

You saw him across eighty-four years. You have your own stories, and you will go off to share them with one another. You know he was a man of great subtlety, great warmth. Mario's Restaurant, during his time, was the quintessential family restaurant—and it still is. There were always children, in-laws, and out-laws! And, always, someone who was related to Rose. It was always about family.

If you didn't have one, or if your own was falling apart, you could come and appropriate his family—and make it your own. You could throw your arms around Rose and have Joseph, who is his father's son, call you "brother" and give you a big, wet kiss on both cheeks.

And Momma—you cannot tell the story of Mario Migliucci without Momma. They were always together, for more than fifty years. Since that day he saw a young Rose Bocchino looking out the window across the street, a few blocks away. It happened on Arthur Avenue, most of this story. She was with him in all the good times—for all the weddings, for all the children, for all the grandchildren. She saw it all. She felt it all.

But all those times in Montauk, on Arthur Avenue, were just a prelude to their last year together. Momma was there every day; so were her children, Joseph and Diane. But the love of Rose for Mario, and Mario for Rose, in those hospitals, every day, was something never witnessed by the attending physicians or nurses at Stony Brook or at Our Lady of Mercy across the parkway. The good and gifted Cardinal Archbishop John J. O'Connor talks often and eloquently of couples who remain together for fifty years or more. He even gives them prizes and bestows medals. But if Cardinal O'Connor sent to central casting for vivid, contemporary, perfect examples of fidelity and commitment and devotion, central casting would send you a profile of Rose Bocchino and Mario Migliucci: Mom and Pop. We, who look through a glass darkly, can't see it yet. We can't yet realize or understand it. But the last, not yet final,

chapter of their love was absolutely their best, most memorable work together.

Mario lived his life in these streets, with the butchers, the fishmongers, the greengrocers, the bakers, the old women of the neighborhood in their dark shawls, the priests, and the students from Fordham University.

Our religion, when we listen and when we are still, tells us to try and see the goodness in every face we encounter. It's not always easy. But every once in a while, we do come upon a face that radiates the goodness and sweetness within that person. Mario—Pop—had such a countenance. Rose has it. When they entered a room together, you knew there was something special coming at you. And that something good and very sweet was going to happen.

I asked one of the merchant princes of Little Italy to tell me something about Mario. "He was there for about seventy-five years!" the merchant said. But we loved him, and we mourn him—not because of his longevity. Mario's life, however enduring, instructs us in the old-fashioned, eternal values. They are the lessons of a man who stayed at his task.

Another man named Mario—who wrote to Pop in the hospital—once reminded us: "Don't let us forget who we are and where we've come from. We are the sons and daughters of giants," said Mario Cuomo. The governor spoke not of physical stature or the magnitude of our purse or the resonance of our voice and reputation or of our high estate and standing in the community. Rather, he spoke of other strengths, other attributes, other qualities, and sweeter truths—harder, more difficult to define, but none the less real. He was identifying for us, and leading us toward, those men and women who live their lives out of the glare of celebrity, but not removed from the rest of us. He was leading us to Mario Migliucci, to the kind of man he was, to the way he lived his life, even to the way he died.

So it is a remarkable story! A story of generations. A story of a unique Bronx institution as endearing as he was enduring. And, finally, a story of a marriage as strong and remarkable and resilient as any of us have ever seen.

And it is a story about the unique goodness of Pop. Some of

us move toward things, things we can control and maneuver like instruments. Others move toward people, people who breathe and think and feel—and love. The restaurant business, where Mario chose to spend all his years, is about people—about feeding them, giving them sustenance and drink. Like the reading this morning: "You spread the table before me. . . ." Some see it as a business. Others, like Mario, view it as a calling, a way to bring people together, and love them—and to be loved in return. So how could he have chosen any other venue for his genius, for his love, than the restaurant? It was his podium, his forum, his theater. He was its interpreter, its impresario, its steward. It was his calling. But it was merely an entity to bring him closer to people.

Pop fed everybody: rabbis, baseball players, failed priests, Steinbrenner, Fugazy, Biaggi, DiMaggio, Rockefeller, and the great Cuomo himself. Neal Travis, in the *New York Post*, recalled when Lee Iacocca would dispatch his jet to New York to pick up an armload of Pop's pizzas! Mario's hospitality was natural and unforced, a product of a good heart and a generous soul. He was a good man. He was always there. He stayed.

And he is glad you came today.

<div align="right">January 27, 1998</div>

Hugh Shannon: 1921–1982

St. Monica's Church
New York City

In the few moments of your lives that are given to me this morning, I want to talk about and remember Hugh Shannon, a joyful, elegant man with a touch of ragtime in his soul.

It should be night when we talk about the man we have just prayed for. He deserves more from us, I think, than a Saturday morning by daylight.

His name was Hugh Shannon, but those who knew him best called him Hugo. And Helen Tubs, who is not even a countess or a princess, sometimes called him Erwit, which goes way back to DeSoto in eastern Missouri.

Hugh needs no defining. His life of sixty-one years requires no explanation in its telling. It is not necessary to position or fix him against the canvas of his own calling—or in our own lives or in our hearts. He was joyful and, as Mabel Mercer told me yesterday: "He was warm." Hugh was an entertainer, a singer of songs, a minstrel of the night. The words and the tunes were those of Cole Porter, Noel Coward, Cy Coleman, Johnny Mercer, Hoagy Carmichael, and Rodgers and Hart—and, occasionally, of Billy Joel, Stevie Wonder, and Stephen Sondheim.

Hugh was not the greatest singer or even the most terrific piano player. He did, however, have the greatest left foot in the history of show business. He wore out more Lefcourt velvet slippers and Belgian shoes than any other piano man.

John S. Wilson of the *New York Times* wrote that Hugh's voice was "aged in saloon smoke and warmed to a glowing hoarseness." He called him the "last of the breed, the last, great saloon singer, and the progenitor of a whole new generation of cocktail piano players." And Whitney Balliett, who wrote so lovingly of Hugh in his *New Yorker* profile, observed

that "there are really only four great saloon singers: Mabel
Mercer, of course, inimitable Bobby Short, Blossom Dearie—
and Hugh Shannon."

Hugh touched chords in our hearts that no one ever touched
before. Mabel said: "You sing to everybody, because every-
body has feelings. They react inwardly; they react inside. You
just get up and sing." And you give; night after night after
night, you give. That's what Hugh did for a living, and that's
how most of us came to know him. *"W"* magazine, said: "He
extracted from life all the emotions and put them into songs.
He articulated our feelings He was witty and we laughed.
He was sad and we cried."

"You sing to everybody," said Mabel. But, and perhaps you
had the same reaction when listening to Hugh, he always
seemed to be singing just for me and mine. And *that* was his
genius. Others who worked at his calling "performed," "ap-
peared," "sang," "played," or "danced"—and the songs were
technically perfect and skillfully done. But they were for the
artist in his own private world—not for us or ours.

Hugh, on the other hand, beamed! He reached out—beyond
the microphone, beyond the pencil spotlight and beyond the
piano. He made people happy with his music. He loved! Hugh
Shannon's songs were an expression of that love and, as he
squandered his talent across more than ten thousand nights
over forty years, he became the greatest saloon singer of them
all—and it was all because of the love he had for everyone and
everything.

Capri, London, Rome, Cape Cod, the Riviera, St. Thomas,
Nassau, the Hamptons, Palm Beach, and, finally, New York.
So many swell places. So many elegant nights. So many sweet
songs. So much love. Other singers had fans who were "cus-
tomers" or "patrons" of all those joints in which they dis-
played their well-hewn talents. But the ones who came night
after night to hear Hugh came as friends. They came to be
with him. They came to love him back. Like I said, he was
different and unique. He loved!

There was a big, broad range to the life of this itinerant min-
strel. From the 22 Club in Woodside, Queens, and the Blue
Haven in Jackson Heights, where his first admirer was that

bus driver who would double park outside in order to hear Hugh sing a few tunes which always had to include the driver's favorite anthem: "It's a Big, Wide, Wonderful World," to the titled, the privileged, the well-founded, who came in season to Numero Due in Capri, to Bricktop's in Paris, to Francis Carpenter's Bull's Head Inn, to Grace and Rainier's Café du Paris in Monte Carlo, to Carol's, to David Keh's, to the International Club in London, and, finally, to his last stand, the final booking of his life—to Peter Sharp's Café Carlyle.

They will miss Hugh, too, all those elegant, sophisticated ladies and gentlemen of high estate who adopted him and took him into their rarefied world and made him theirs. They had names like Cordelia and Bibi and Doris and Ruby and M'liss and Rebecca and Peggy and Diana. And there were Biddles, Dukes, Cushings, and Whitneys—and even a "Bang Bang" Rutherford, who, I understand, was "persistent," if nothing else, in her fabled attempt to have Hugh all to herself.

Some of them are here today in St. Monica's, and I hope they won't take offense, but Hugh had another life, too. It was here, in this neighborhood, in these streets, in the shops with the cobbler and the greengrocer. It was in the park with the children, and with the construction workers in their hard hats. It was with the nurses at Lenox Hill and in Dressner's bar telling tall tales. And here, with his God, in St. Monica's. Just as he lit up our nights, so, too, he illuminated their days. Thus, it is fitting that so many of Hugh's neighbors are here today as well.

There really was a lot to his life. There was Betty and there was Gus and the Osmunds—Joanne and Jerry. And Bob and Patrice and Helen and Sheila and Kathleen. And you, Father Leone. There was Dick Gelb's mother and the Conroys and the Savitts and the Millers, who took him in. And the Erteguns and Millie and Sheldon and Bricktop—he called her "Brickie." And there were so many others who gave him their friendship and shelter—and always love.

Hugh gave us a lot: the songs, his love, his friendship. And now, the two nice men who run Audiophile Records in Atlanta told us this week that a two-record album will be in the record stores "in the early weeks of November." It was lovingly and

carefully recorded by Wendell Echols and George H. Buck, Jr., last fall when Hugh was at the Carlyle. There was some uncertainty about a fitting and appropriate name for the new album. Many suggested: *Hugh Shannon at the Carlyle.* But I'm pleased to tell you that it will be titled, simply, as he would have it: *Saloon Singer.* So his music will live on after him.

But Hugh is gone. He died, as he lived—with style and grace.

October 30, 1982

Bob Cammann: 1925–1999

Blessed Sacrament Church
New Rochelle, New York

*Robert J. Cammann was executive director of the New Rochelle
Chamber of Commerce for thirty-seven years. During that time,
he organized downtown festivals, farmers' markets, and, most
notable, the city's Thanksgiving parade. When he died in Febru-
ary 1999 at age seventy-four, a member of the City Council said
others could have done the job, but no one could put his "heart
into it in the same way."*

They speak of Bob Cammann's accomplishments in the shops
along Main Street, which he knew for four decades. And they
knew him . . . as their advocate, their drumbeater, their cham-
pion.

It was never just about money or shopping or sales-tax reve-
nue. It was not just about commerce—Bob's love affair with
our city. Nor was it just about the merchant princes whose
herald he was.

Bob was our connection to the days when the carriage trade
from Pelham, Larchmont, Scarsdale, and Rye shopped in our
downtown streets at Arnold Constable and Bloomingdale's,
which prospered without even so much as a sign on its front
door.

Bob made a lot of the bankers and merchant princes rich,
but he was always connected to the "townies"—the people
with roots in our community. And he became one of them.

The *Journal News* reported that he died after becoming ill
while "vacationing in Dutchess County." Who would ever va-
cation in Dutchess County? You go through it on your way to
Albany, the Adirondacks, or the Berkshires! But Bob vaca-
tioned there. And you know why, of course? Because it was
only an hour away from his beloved New Rochelle!

We speak of "fair weather" friends. Bob was a "foul weather" friend, who saw our city through all the lean years and less than stellar times. He never gave up on New Rochelle, its potential or its people. He knew that a community is not defined by tax rolls, revenue receipts, or skyline, but by the strength of its people.

Even when this extraordinary city, so richly endowed by its Creator, was rejected by developers, abandoned by Bloomingdale's, and left at the altar by Lord & Taylor and UNICEF, Bob's enthusiasm never faltered, his confidence never waned.

He was the first to greet and encourage the *new* Americans: the Mexicans, the Portuguese, the West Indians, the Koreans, the Hispanics, the African Americans. Not all of us were so sure about this, or willing to accommodate the change brought on us by shifting demographics. Not all were hospitable. But Bob was.

And his beloved Thanksgiving parade, which he nurtured and protected for so long, raising up support to keep it going for thirty-seven years, but one. Bob saw it not as a marketing device to enrich the purses of the shopkeepers or captains of commerce in the central city. He envisioned the parade as a link to the past and as a way to bring us together in the here and now, every fall, before the winter set in. Rich and poor. North End. South End. It was an instrument, a manifestation of his love. People marching together, singing, making music together. Grandfathers like him holding their grandchildren aloft on their shoulders to see the floats and marching bands, watching the parade passing by.

I want to leave you with a respectful suggestion. They say the good that men do lives after them. We have a Hughie Doyle Senior Citizen Center and a Rocco Bellantoni Chapel in our magnificent Sound Shore Medical Center. But I'm not suggesting that New Rochelle designate anything of brick and mortar in Bob's memory. Rather, let me presume to suggest that we begin to call our parade "The Bob Cammann Thanksgiving Parade."

Murray Mendelsohn of SCORE, the retired executives volunteer corps, which works out of the Chamber of Commerce

office, said, "How do you replace him with all the energy, the devotion—all the love!"

The answer is, of course, you don't.

I once called Bob "a warrior" in a radio broadcast. I'd like to amend that.

Bob Cammann was, ultimately and essentially, a lover. This town—and all of us—are the beneficiaries of that extraordinary love.

Now that New Rochelle is shaking off its long somnolence and is starting to show signs of a pulse once more, maybe Bob just thought his work was done.

But the parade goes on.

<div align="right">February 11, 1999</div>

Judge Irving Kendall: A Retirement Tribute

Briar Hall Country Club
Briarcliff Manor, New York

We have come here on this chill night to honor a man who is of us and who is ours, Judge Irving Kendall. We, his neighbors, his boss Mr. Justice Joseph Gagliardi, his colleagues, Judge Adrienne Hoffman Scancarelli, Judge Sam Eisenberg, Judge Anthony Scarpino, and the leaders of the city have gathered here to try to compensate Irv Kendall for a splendid life of dedication and service to Mount Vernon.

Mount Vernon has suffered and bled for more than a decade. But along with its litany of urban woes and problems, the city and its people have you.

I will tell you why that is so important. Malcolm Wilson, the former governor and the great Fordham University orator, loves to remind us that on the façade of the federal courthouse at Foley Square in Manhattan is the inscription "The True Administration of Justice Is the Firmest Pillar of Good Government." It means, I think, that any government of people, and any city like Mount Vernon, can survive a less-than-enlightened executive branch. It can also survive shortfalls in its legislative branch. But a government or a city will not prevail if you have a less-than-enlightened judiciary.

As the city judge of Mount Vernon, Irving Kendall indeed has caused an "enlightened judiciary." The courtroom where he presided daily, where he sat in judgment is—lawyers will tell you—the court of first resort. It is the place to which the poor, the underprivileged, the people at the edges repair.

Most of them could not afford the price of a ticket to come here tonight. And yet each day—to settle their grievances against each other or to get an interpretation of the fundamen-

tal laws of the land and the statutes of the city—these people came.

They found a man of great sensitivity, often of brilliance, and always of compassion, a man who has demonstrated an innovative and imaginative approach to the administration of justice.

There's a difference between justice for which a judge strives and the law, which you have designated him to administer and interpret.

Many years ago, when Irving Kendall was still in law school, Learned Hand, the distinguished New York appellate judge, was arguing a point of law with the great Justice Oliver Wendell Holmes. "But," said Judge Hand, "we are talking about a court of justice."

"No," said Justice Holmes, "it is only a court of law." Holmes meant that the courts and the courtroom itself are only instruments, but that Justice is an infinite ideal, like Truth.

And to wrestle with these difficult things, the city of Mount Vernon had Judge Kendall. He has been innovative and creative.

He fought for the adoption of the state probation law, which permits judges to combine jail sentences with probation— leading more surely to the rehabilitation of those who really do deserve another chance.

His "honor court" for alcoholics has been profiled in all the law journals as well as his Night Small Claims Court, his teenage referral program, and his parent-education program. But his greatest contribution, I believe, and his greatest responsibility, occurred in judgment on young people.

He has bravely called for the realistic and compassionate sentencing of juvenile, youthful, and first-time offenders. He was tough when he had to be. A lawyer, Joe Goubeaud, said that he was always tough on drug cases because, he said, "They are slowly killing people. Drugs can kill a city, and as Irv Kendall knew this, his views have been sought by other city judges throughout the state on the need to revise juvenile justice standards."

As a public man he has been active almost everywhere in

the community. Even with the burdens of his official duties, he finds time to be active in many organizations and civic groups that benefit his neighbors.

John Vliet Lindsay, the former mayor of New York, said something we already know. When he heard you were being honored, Mayor Lindsay said, in his wonderful, patrician way, "He's a lovely man, one of the very best. This is the kind of fellow you don't want to lose."

The presiding justice himself says this behind Judge Kendall's back: "The guy was good. He had a wealth of ideas. He was really a hard worker and had a total commitment." And as we spoke, Judge Gagliardi summoned a deputy in his office to look up Judge Kendall's salary. And it comes as no surprise, but practically every lawyer and everyone in the room tonight who appeared before him earned more than he did!

He did what he did, not for money, but because it was his calling. It was what he felt God wanted him to do. And he did it so well.

He is a living example of the words of Thomas Paine, who lived about a mile from where we sit. In his *Age of Reason* Paine wrote, "I believe in one God and no more, and I hope for happiness beyond this life. I believe in the equality of man; and I believe that religious duties consist in doing justice, loving mercy, and endeavoring to make our fellow-creatures happy."

I will close now with a lovely observation from the Book of the Prophet Daniel that applies to him: "Those who lead others to justice are like the stars of Heaven."

1982

The Bedford Golf Club: The 100th Anniversary

A Caddy Remembers
Bedford, Westchester County, New York

I was surprised, but also very pleased, to receive an invitation from my old boss, Stan Feret, to contribute some recollections for the 100th Anniversary. I caddied at the Bedford Golf Club in the late 1950s and into the 60s, and I have strong and fond memories of my trips down your gentle fairways. I can still recall early mornings in the caddy yard waiting for the call from Stan, Kuppie, and, later, from Buck Adams: "O.K., O'Shaughnessy, you're up!"

It has been almost thirty-five years, and I am glad for this opportunity to acknowledge my gratitude for the things I learned while carrying those golf bags—including the mercifully light, tan canvas ones—over Bedford's rolling hills during those summer afternoons so long ago. I mean or intend no disrespect to anyone living or past. This is what I remember:

Loudon Wainright talked to me of books and writing and the great issues of the day, as he developed themes for his graceful essays in *Life* magazine. James O. Parsons tried to show me how to hit a golf ball and made me look forward to those Mondays when Stan let the caddies go out and try it on their own. Jack Shaw was there in those days, and I always yearned to play an iron off the right foot like Bill Durcan. I never did learn to hit a booming wood shot like his son, Billy. But Monday was my day, and I was always out there at "my" club.

I was also there the day Richard Nixon came to play, and when Mickey Mantle and the great Joe DiMaggio himself teed off for a local charity. I often shagged balls for Kuppie and Buck Adams late in the day, as the sun fell over the back 9 into

the western sky. One day, Stan even let me watch the pro shop and pronounced himself well pleased that I had sold an expensive putter and five boxes of Titleist balls to a high rolling "visitor" from a strange-sounding place called Winged Foot.

Chico was the legendary caddy when I started. He knew a lot about a lot of things, and he told us about girls and how to swear in several languages. And on slow days, my brother, Jack, and I learned how to fight from a tough kid called Champdelain, whose father was a world champion by the name of Delaney.

But I learned the most from the members. What classy men and women they were in those days. I've since played at golfing clubs like Burlingame on the West Coast, Lyford Cay in the Bahamas, and good, gray Blind Brook, right here in Westchester. But I've never seen or met any finer sportsmen than those I encountered at Bedford. My favorites were Gavin MacBain and old Bill Fitzgibbon, a man of great style who looked and moved like Fred Astaire and always had a Coca-Cola or some marvelous summer drink waiting for the caddies as we approached his house off the 7th green. We drank from the same rich crystal glasses he proffered to the members of his foursome. I remember Peter Phillip, his thoughtful son-in-law, who, Stan tells me, is now an elder of the club. But I still see Mr. Fitzgibbon handing us those cold, good drinks on hot afternoons. Chico, of course, always opted for a beer—and another one for the back 9.

Walter Wood Hitesman had the most beautiful bag—and the heaviest—with tooled leather and the latest set of matched clubs. I think he made pretty good use of them, too.

I lost plenty of head covers in my day, and I once left a putter on the 16th green. But I never lost a ball on Phil Milner, who was a special loop we all vied for. A round with him made the caddies feel we were taking part in a great adventure, as he led us up and down the hills like a man possessed. And when I was three payments down to GMAC and needed to float a loan on an important and most impressive new 1960 MG roadster, Mr. Milner never forgot I always got him out of the rough in pretty good shape, although his golfing compan-

ions (read: opponents) were often astonished at the luck of his lie.

The names and the memories come drifting back through the years and the mist of time: The McCances, the McKowns, the Darlingtons, the Kilbornes; women with names like Sabina and Sis and Patsy and Meg and Letitia and Maggie. There was Lew Preston, who became head of the World Bank, and his predecessor at the Morgan Bank, the legendary Henry Alexander. And kindly, courtly John Young and a man named Gilbert Bell, who had a "special" putter. We called him "Mister" Bell. I was only eighteen years old, but I knew there was something special about Walter Curley, who carried himself like an ambassador even then, and who was a generous, nice man. So, too, was William Van Duzer Lawrence. And the caddies always rejoiced when Cass Canfield came around. The same was true with the Appletons, Ned Sullivan, the country squire publisher Carll Tucker, and Helen Kennedy, who could hit the ball. And every Sunday afternoon, there was Mr. Righter, whom they called "Turkey." He was anything but on the golf course.

The Bedford Club was a wonderful place for a youngster to learn and grow, all the while getting paid for it. And it was a grand day, that one Sunday in July, when I did two double 18s and a double 9. I've made some money since then, but none of it was ever sweeter than the forty-five dollars I took home that night with aching but proud shoulders. Like I said, there were a lot of marvelous, vivid figures who contributed to my upbringing and education at Bedford. Many, like Bill Durcan and Johnny Renwick and Bill Fitzgibbon, took a keen interest in the inhabitants of the caddyshack. But my best loop was always Gavin MacBain. Years later, I sat next to him at "21," and we shared stories about our days as golfing "buddies" at Bedford. I never told him, but I would have carried his bags for nothing.

So, on this great anniversary of a splendid golf club, which is truly *sui generis* and unique in all the land, I can only express one caddy's debt to all those Bedford members who not only entrusted their woods and irons and putters to my care and keeping but also provided the opportunity for a kid from

Mount Kisco to learn some great lessons from so many grace-
ful and attractive men and women.

A few years ago, I attended a memorial service for a colorful
fellow named John S. "Shipwreck" Kelly, who was a golfing
pal of John Hay Whitney and Walter Thayer and Bill Paley.
During the recitation of Shipwreck Kelly's exploits and ac-
complishments, an Irish priest recalled that "he always
smiled at the caddy." It's a lovely line, which reminds me of
so many golfers I once accompanied down the fairways at
Bedford. I still remember the ones who smiled at the caddy.
And the big tippers. But I took a lot more than tips.

1992

Landmark Designation for the Four Seasons Restaurant

New York City Board of Estimate

Honorable members of the Board of Estimate, you've endured, of late, a lot of criticism from my colleagues in the public press—many of whom have presumed even to question the importance and worth of your deliberations. I'm here today to urge your confirmation, adoption, and approval of the enlightened—and even quite brave—finding of the Landmarks Preservation Commission, which would protect and save the splendid interior of the Four Seasons, a space that is unique in all the land, and in our city.

So, I know the power you have, as well as the importance and timely nature of your work—which, in this case, can have impact even on future generations. The architectural scholars, experts, and historians who will present themselves in support of a designation can make the esthetic, creative, and technical case far better than I am able.

You also have, arrayed against the advocates' knowledge and expertise, the awesome and considerable resources of the Teachers Insurance and Annuity Association. That's a big holding, with a fiduciary responsibility to its investors—a multibillion-dollar responsibility, as I understand it. They also have the considerable good fortune of having Chancellor Cliff Wharton as their guide and mentor.

However, with great respect for Cliff Wharton, I don't believe for a minute that this designation threatens or impedes, in any way, the current—or future—owners of the Seagram Building. The Landmarks Commission would have you merely protect the brilliant Miesian space and Philip Johnson architecture of the restaurant interior itself: the soaring ceilings, the legendary central pool, the interior structure, which, in every scholarly and knowledgeable eye, is *sui generis* as it captures twentieth-century design perhaps like no other space in Manhattan.

I don't come before you to plead for a watering spot for tycoons and titans. There are many of those abroad in the land—thousands of restaurants and hundreds of private clubs for them to do their deals and commerce. I'm here for Tom Margittai and Paul Kovi, who have lovingly and relentlessly held this serene and special place in their enlightened care and keeping for thirty years. Margittai and Kovi fled from the oppression of Hungary and Transylvania—one of them from the horrors of the concentration camp. They came to our country as young men, carrying with them only the integrity of their artistic souls, which contributed so much to their stewardship of the Four Seasons. They started as apprentices, waiters—and now, they are the permittees. The owners. But they know who they are and where they came from. They want only to preserve that beauty, that great design, that art, that was given to them. So, I'm here for them—and for what they would have you do . . .

Looking beyond their own purse, Mr. Margittai, Mr. Kovi, and their attractive young associates—Alex Von Bidder and Julian Niccolini—have created the quintessential New York restaurant. And with the sensitivity, Old World grace, and innate sense of hospitality they bring to everything they do, Margittai and Kovi have made it accessible and beckoning to hundreds of thousands of ordinary people—not alone to those tycoons and corporate chieftains who favor the place.

Nina and Tim Zagat's very popular—and populist—*Restaurant Review* found the Four Seasons beloved not alone of publishers and Wall Street types—or of elite restaurant reviewers—but, indeed, the "favorite" restaurant of the people, people who come, most of them, to celebrate the great occasions of their lives. They come—with apologies to the brilliant chefs who have presided over the Four Seasons kitchen—to sit with their loved ones in one of the most worthy and spectacular interiors ever created. They come for the exciting architecture—and for the space of it all.

Thank you, honorable ladies and gentlemen, for hearing my thoughts on all this. Obviously, I pray for your approval of the commission's designation.

January 25, 1990

The Landmark Designation was approved.

EPILOGUE

The "Golden Apple": Westchester in the New Millennium

In every endeavor and profession, there are those who merely "take" and put nothing back. I've addressed this in many different forums, most recently at the Advertising Club of Westchester.

It is wonderful to be back with so many old friends. The Advertising Club of Westchester, which has grown in wisdom, age, and influence, was my first love and, as such, perhaps my best love. As we begin our thirty-first year, my mind drifts back to those heady, early days of our founding, and those incredible six-hour board meetings on my back porch over pizza and beer. What the hell did we ever talk about for *six* hours?

I *do* recall we thought it quite important to have a forum, a meeting place, a reference point, an entity where communications, advertising, and marketing professionals could assemble to define and reinforce our contributions to our craft—and even to try to elevate it, our profession, to an art. Occasionally, we also engaged in the great issues of the day in a collegial way, which obtains even to this day, three decades later.

I was there at the launch of this influential fraternity, this club. But I have not been as faithful as many of you. That's why when Hal and wonderful Norm Liss called me, the first thing I did was rejoin. I'm glad I was accepted back in your high councils, because I could not presume on your generosity by attempting the keynote address as an outsider.

Your presence today confirms and extends the vision of Norm Liss, Ruthe Berman, Ralph Gottlob, John Kline, Mark Dorian, Art Lewis, Mark Arnold, Connie Kaiser, Roger Fawcett, Bob Pugliese, and Ernie Hickman—that altogether unique, endearing, and vivid character who sold furniture but

loved to hang around with advertising people! I also recall, with sadness, the night I had to get up before you, on January 20, 1977, to announce the passing of Bob Heyda, one of the real advertising pioneers of Westchester and our sixth president.

And while I have been out trying to run failed baseball players for president, you've raised up a whole new generation of leaders and contributors: Barbara Gallois, Dick DePaso, Adam Handler, Rocky Cipriano, Shelly Lyons, brilliant Michael Kane, Nancy Gold, Barbara Hanlon, John Zanzarella, Tim Malsbury, Liz Bracken, and Geoff Thompson—all of them determined to get this unique organization on the right course for the next century.

And so to the topic urged on us, wisely and appropriately, by Norm Liss, for whose recovery we will all pray tonight when we address our Creator: the new millennium. It seems that every speaker these days, in every forum, is expected to offer or display some prescient wisdom about the future. What's to become of us, our nation, our world, our richly endowed county, our profession? And for all of this, I have only *twenty* minutes!

Even my friends at "21"—where I have occasionally known the "haze of an evening" at its fabled bar—are having a Millennium Breakfast series, even though most of the characters who frequent the bar can't get out of bed that early! But they, the "21" elders, presented the genius of Mario Cuomo and some other seers, like Tim Zagat of the Zagat restaurant guides, who made the stunning prediction that we're going to eat out more often. Now, Nancy and I eat out six nights a week! Does this mean I'll *never* eat at home, in our dazzling, new fifty-thousand-dollar kitchen, by the year 2000?

I'm a little nervous about all these prognosticators and their predictions. And I'm wary of their *sureness*. They even had a panel on "Baseball in the Millennium." Tim McCarver and Keith Hernandez predicted—with great *sureness* and solemnity—that there would be *no more umpires!* In the future, all balls and strikes will be called—instantly, immediately, and without hesitation or error—by a *machine*, a combination radar detector and computer, much like they now clock fast

balls. "He's down to ninety-seven miles an hour . . . there's action in the bullpen . . . here comes Joe Torre!" But, thank God, another fellow on that panel—Jim Bouton, a marvelous guy of great wit, and the author of *Ball Four*—shouted, "You can't take away the damn *umpire*! How the hell can you boo a *machine*? How can you throw a beer can at a computer?"

Anyway, as we engage the topic before us and confront the new millennium, in this, as in all things, I pray for *sureness*.

I once asked the great Cuomo: "What do you mean by *sureness?*" The governor said: "It's very simple, O'Shaughnessy. Even *you*, a Republican, can understand it. You're on the road to Damascus. Suddenly, there's a tremendous bolt of lightning in the sky. You're knocked off your horse, and as you look up, wondering what in the world happened to you, the Lord appears, in all his or her refinements, and says, 'Get up and get back on that horse. And, incidentally, your name is no longer *Saul*. It's now *Paul*. And just one other thing: You're now a *saint!*'" So I *pray* for sureness . . . without the lightning bolt in my backside!

Today, on this beautiful Indian summer afternoon, we are gathered by the banks of the Hudson River in the Land of Sleepy Hollow—the *Golden* Apple—home to almost a million well-founded people, including the Rockefellers, just up the road a piece. Home also to our families and our businesses. I'm afraid I'm going to beg the obvious and suggest that *Westchester*, in all its diversity and dimension, must do well if *we* are to do well and prosper. The future is very bright, from a business standpoint, an economic perspective. And some of us are taking wise, prudent steps to prepare.

Gannett will soon launch, as you have seen and heard, a county-wide publication: *The Journal News*. It will be a blockbuster, a constant in our lives, much as their ten separate dailies are now, and much as *Newsday* is in Long Island. Instead of ten different brands, logos, mastheads, there will be *one*. Some say it's a smart, overdue decision—and we wish them well.

Gannett's strategy is kith and kin to what's happening in cable. The "wired nation" has come to Westchester via the good and capable hands of Chuck Dolan and his sons. They've

taken over TCI, a move which, like the *Journal News*, will help pull us together and remind us that we are all one. I should point out another example of just how wise Mr. Dolan and his Cablevision colleagues are: my TCI cable "Interview" show is now carried on the *entire* Westchester Cablevision system— and we've even moved "uptown" to channel 28!

At the same time all this consolidation is going on, other publications and voices will emerge with a narrower and more specific focus in the form of weeklies. An example is the Bedford–Pound Ridge *Record Review*. It's a literate, often brilliant, weekly owned by the Scarsdale *Enquirer*. And it's as good as Helen Ratay's East Hampton *Star*, now owned by Arthur Carter of *The Observer*, my favorite weekly. So there will be more community publications, for sure, finding an eager audience among the "townies"—those people with roots in their communities. And there will be more multicultural and ethnic journals here in the county, celebrating the ethnic diversity that is now all around us and everywhere apparent.

Dee DelBello's *Westchester Business Journal* will continue to be an invaluable resource—so will Susan Meadow's Spotlight and shy and retiring Merna's *Women's News*. Also Ralph Martinelli and Louise Montclare's provocative, irreverent journals; and Herb Solomon's *Pennysaver*. In the north country, Carll Tucker's powerful *Patent Trader* will get even stronger, and there will be more hometown monthlies like Phil Wanderman's successful *Tomorrow* in New Rochelle. And keep your eye on *Westchester WAG*, a stylish new entry from Mary Ann Liebert and Diane Straus Tucker.

It will happen in radio, too. We already have over thirty hours of West Indian and Caribbean programming, and we're working to encourage Mexican, Portuguese, Japanese, and Korean program hosts to join our already established German, Italian, Irish, and Haitian offerings on WVOX. It's all my son's doing, but I've told Matthew that we're still going to play a hell of a lot of Cole Porter and Bobby Short at 93.5 and 1460!

It's all about *focus*. I believe that salvation is often in our backyard. A few quick examples: Lou Gerstner, the savior of IBM—and a lot of pension funds—moved first to shore up his

home heath, Westchester, for Big Blue. And watch Tom Ryder of *Reader's Digest*. The first folks to whom he turned to unveil and discuss his plans to save the old Lorelei in Chappaqua were the *Digest's* Westchester neighbors. We've had more communications, briefings, and personal letters from Ryder in the last month than we received in the previous forty years. I would buy the *Digest's* depressed stock, quickly!

Look at Iona College. They were trying to expand across the mighty Tappan Zee into Rockland and Yonkers, "where true love conquers!" Brother Jim Liguori pulled it back and refocused this great college in its own backyard. Today, Iona is booming—with a great basketball team as well!

Then there's the example of Richard Berman, Manhattanville's dynamic and shrewd president—who is much more than the politician he once was. Berman took a faded finishing school for Kennedy girls and turned it toward the community. Which reminds me of a prediction I *can* make with great certainty: The most popular course at Manhattanville will be the one given by Nancy Q. Keefe, writer-in-residence, and not just because she's editing my book!

What does all this mean for *us?* I sat at the American Yacht Club one month ago with a brilliant, young advertising and marketing genius—a typical central casting guy who left Madison Avenue, moved to northern Westchester, wears his glasses atop his hair like James Brady, bought a Range Rover and a house on the Vineyard, and started making babies. Then he hung out his shingle and waited to be discovered by IBM or PepsiCo! And he is astonished that it hasn't happened! He told Larry Dwyer, the gifted, young president of the Westchester County Association, "I do great advertising, but nobody *knows* it." As I listened to all this, I noticed that he's not active in the community. He's not active in *anything*. He hasn't "adopted" any charity. His children are here. His business is here. But *he* is not here.

So I could only tell him what you already know: To do well in Westchester, in the new millennium, or right now even, you've got to get out and *do* something!

I'll give you an example from "on high": Graymoor. Everybody knows Graymoor—the Franciscan Friars of the Atone-

ment, celebrating the one-hundredth anniversary of their founding on Sunday. The Franciscans are terrific! They run St. Christopher's Inn for the Homeless. And to this day you can get on the midnight train up the Hudson Line, in the last car, and tell the conductor that you're going to the "holy mountain" to dry out and get your life together, and he will finesse your ticket! The Friars, this particular order, are also famed for their ecumenical work—bringing people together. But they owned real property all over the globe, and their mother ship, the headquarters up there on the holy mountain, was crumbling, endowments were dwindling. Enter a new minister general, a reluctant, gentle friar with a beard —Father Emil. He changed their focus. Salvation *is* in my backyard! So they concentrated on their homeless shelter, St. Christopher's, and their AIDS ministry and on people suffering from substance abuse. They became *priests* again, and sold off their far-flung properties. Graymoor is once again flourishing, as two thousand people will attest to John Cardinal O'Connor at St. Patrick's Cathedral on Sunday.

Consolidation, everywhere, will continue. And it's not all bad, for with it comes opportunity. Whether you own an ad agency, a graphics company, a printing press, a PR firm—or a radio station. As so many in my tribe have sold out to speculators and absentee owners, the temptation is great to go up in the sky and pull something off a satellite. But there will always be opportunities for hometown, community broadcasters who home brew their programs and realize that a radio station like WVOX—or a newspaper or cable system—still achieves its highest calling when it resembles a platform or forum for many different viewpoints.

Another prediction—and this will surprise you: The greatest growth in the millennium will occur in the southern tier of the county—below 287, where the people are, where the population is, where the energy is. In Mount Vernon. In New Rochelle. In Yonkers.

My Nancy observed, almost five years ago, that cities have to "bottom out" and slide all the way down before they can come back again. These three great cities of the southern tier have bottomed out—and *they're on the way back*. It's the work,

I think, of three great mayors: Ernie Davis in Mount Vernon, Tim Idoni in my home heath of New Rochelle, and John Spencer in Yonkers. I don't care what your marketing people tell you. That's where the action will be—for local and regional ad agencies, for marketers of every kind, for everyone. And they will find their opportunity among the smaller, entrepreneurial start-up firms that nobody knows about. But they are there. And more are coming. *Below 287!*

But as I again respectfully suggest: It's not enough to sit in a room in front of a word processor and create great advertising or wonderful campaigns with splendid graphics, dazzling layouts, and brilliant copy. Incidentally, you know how I define brilliant copy—it's copy that doesn't use—*ever*—that phrase "a win-win situation!" It never utters, "Whatever it takes!" or "Getting it done!"And it never, but *ever*, tolerates or accommodates the word "pro-active!" If we are to survive and prosper somehow, then I intuit that we have to abandon our word processors, computers, and cell phones, and focus not on ourselves and what we do. We have to go out and build up the extraordinary community in which we have chosen to live, work, and practice our art. I guess I'm trying to peddle the notion—"inartfully" as always—that we've *got* to involve and immerse ourselves in something other than what we are as working professionals. In something bigger, better, and sweeter than ourselves.

The late Walter Nelson Thayer—Matthew's grandfather—when he was president of the *Herald Tribune*, once said to a reporter for another newspaper—my beloved *New York Times*—that "New York (and, I would add, Westchester) is littered with guys whose only goal was to make money—they almost never do." It's a telling observation. There's got to be *something* besides our marketing, tactics, business plans, slogans, symbols, and goal-driven lives.

Many of you already volunteer and dispense your genius, talent, and services pro bono—for free—to so many worthy organizations. You do it not for the "contacts," "exposure," or the "PR," and you don't view these things as opportunities to "network." You do it because it is *right*. You are drawn, relentlessly and irresistibly, to share with others. Incidentally,

the young man from the Yacht Club is not here today. He's still creating brilliant advertising—that no one will see or care about. So, what you're doing with your support for the Ad Club, and so many other entities, is good citizenship *and* good business.

Now, as I mercifully yield a word about technology and computers. In yesterday's Gannett papers—so it must be true—Ann Landers tried to counsel and console a woman whose sex life has become almost nonexistent since her husband brought home a computer! We hear our politicians scream that the future is education—education *and computers*. You've recognized the education part by your generous endowment and support of the Bob Pugliese and Connie Kaiser Awards. And you're strong for computers and technology, too. I notice in our excellent membership directory that there is an entire section—fourteen pages—with hundreds of examples.

So, please consider only this question: Will our computers become our soul mates, withering and obliterating our relationships with humans—person to person, people to people, community to community? Will we fall in love with our computers? Will we become too introverted, or will chat rooms, which make us disembodied conversational companions to people all over the world, draw us closer together? Because now you can talk to anybody—but you can't *feel* them. You can't *touch* them. You can't *smell* their breath. You can't *kiss* them. You can't *hug* them. But you *can* talk to them. Will that make you closer? Will we be better people for that? We'll certainly be stronger and smarter in a lot of ways, but will we be *better*? Ever since Adam wondered why the fruit was forbidden and Einstein struggled with the meaning of energy, thinkers have been forced to admit that there are more questions than answers. But because it's true that where there is no vision the people perish, we have to continue asking ourselves these questions. We should have asked them about the millennium a long time ago—but it's not too late.

And we should be practical and constructive about preparing for this future, or we risk a world run by computers—

which would be a grotesque immensification of the Frankenstein fable. The cute computers would be running us.

We should start the process of planning for the future by reminding ourselves where we are right at this moment. Very quickly, where are we? Both America and Westchester are stronger economically than they have been in a long time. Unemployment is down, inflation is down, interest rates are down—all good economic signs. Budgets are virtually balanced, thanks to a flood of revenues from a persistently strong financial sector. One can confidently predict a bright future for our region.

But one last thing—more important than anything else, and something that I don't think we can learn from our computers or marketing people. We have to remember that no matter how much cloning and innovating we do and how fast we do it, we're never all going to look alike in Westchester or in America. Thank God there'll always be tremendous diversity of race, color, gender, sexual orientation, national origin, economic class. There'll always be great differences. That's *what we are*. We're made up of differences.

And we continue to be nurtured by those differences. We're not endemic. We virtually destroyed the people who lived here first: the Native Americans. Them we killed, brutalized. All the rest of us *came* from somewhere else—and that's continuing. One of the great strengths of Westchester is the in-migration of people from Asia, and the Caribbean—Matthew devotes thirty hours a week to those new residents. These people bring strength, spirit, values, families—and that's going to continue.

And no matter how we try to widen the distribution of opportunity and success, there'll always be winners and losers, the well-to-do and the strugglers, the people who can afford to *give* and the people who desperately *need*. You're going to have a lot of that. And how will we deal with that as a society? as a profession? as communicators?

That's the question for the new millennium. For the first part of it, for the middle of it, for the end of it—and for the next one. And I think that above all, we should be sure that our Westchester neighbors remain fully human. We should make ourselves masters of the technical universe without ever for-

getting a truth thousands of years older than our computers and infinitely more powerful: that we will find our greatest good as individuals in the good of the whole community. That's what the Hebrews meant when they said, "What do I do with my life, Lord?" and some Hebrew God said, "Repair the universe!" *Tikun Olam!* They said, "But Lord, I can hardly take care of my child." He said, "Take care of your child, take care of your wife, take care of your village, and then do what you can for the universe."

And then they asked the Christians, who borrowed it whole from the Jews. And some smart aleck asked the carpenter's son, who started the religion, "Sum it all up for me, Rabbi, in a fifteen-second commercial." And he knew that this wise-guy lawyer was testing him, and so he said: "I'll do it for you: Love one another as you love yourself with the love of me because *I am Truth*. And by Truth I mean forget about sin, morality— that's for the weekends!"

The truth of this place is unless you're interconnected and interdependent, you're not going to make it. Unless the people in Bedford and Pound Ridge and Bronxville understand that the people in Mount Vernon and Peekskill and Yonkers are just like them and that you should work together for a better county, with the people in the river towns and the people down the block and those in the great estates of Westchester and the people you're married to—unless you understand you're *interdependent* and you're *interconnected*, and that your mission is to make the whole place better *together*, somehow, to the extent that you can . . . there's no point in being here. Because then, it's just the computer's world. And that would be a terrible, drodsome place to live.

Thank you for listening, and thank you for letting a prodigal son come home. This club means a great deal to me.

September 18, 1998

Afterword . . .

As I review this collection my mind drifts back over the years, and I am reminded again of the tremendous debt of gratitude I owe the people of Westchester County, New York, who have indulged—or a least tolerated—my enthusiasms and pronouncements for almost forty years.

I have tried to include my take on some of the great souls I've encountered as a broadcaster over the years. But I also realize some glaring omissions.

I have raged often and in many forums that so few men and women of quality and talent are persuaded to enter public service. And that immediately brings to mind several of the great ones who answered the call. Edwin Gilbert Michaelian was county executive back in the seventies and in that role was the father of modern Westchester, the Golden Apple that casts its own special glow right outside the Big Apple.

And I remember Howard Samuels, the brilliant, affable upstate industrialist, who aspired to be governor of New York but never made it. His odyssey deserves a chapter. The same is true of Ogden Reid and John Lindsay, who are still with us. Also, a dear man named Max Berking, who was a Democrat leader in Westchester.

I've found other remarkable individuals during my time on this beat. Some have been celebrated elsewhere. Some are minor poets, to be sure. But each has inescapably unique qualities, notably:

- Mabel Mercer, the consummate cabaret singer about whom Alec Wilder said, "When she sings a song it is instantly ageless . . . no longer a swatch of this season's fashion but a permanent part of vocal literature." I am forever grateful that I carry the portfolio of a broadcaster or I might never have had the chance to sit in Mabel Mercer's Hudson Valley living room as the doy-

enne of popular song tugged on a beer. God, she was regal even then, and I should have told you about her.

- Julius LaRosa, who is such a nice guy that you can forget he is a singer of great sensitivity.
- David Allyn, an obscure crooner of considerable gifts and the greatest interpreter of Jerome Kern songs. Oh, to hear him sing, "Whenever I run through for roses, and lately I often do, it's not a rose I touch, it's always you." But only disc jockeys and musicians know him.
- Robert Merrill, Metropolitan Opera star. When he is not touring concert halls, he hangs around the local bagel shop, regaling the old men of the neighborhood with stories of the days when he gave Sinatra voice lessons. He has adopted our radio station as his own, and he never says no to any community endeavor.
- Neal Travis, the New York *Post* gossip columnist who never hurts anybody. I've seen press agents and other tellers of tales try to peddle nasty stories to him. So he knows all the dirt, but he doesn't traffic in it.
- David Hinckley, critic-at-large for the New York *Daily News*. He writes brilliantly about a range of subjects and once a week about radio. Don Imus, a colleague, decries this extravagant waste of talent, saying, "In the pecking order of the newspaper business, writing about radio is just a step up from delivering the paper." Hinckley is a certifiable genius and also a lovely guy.
- Richard Fraser, a dazzlingly bright and world-renowned surgeon, who has operated on Whitneys, Rockefellers, and heads of state. But if the son of the receptionist at the American Yacht Club were to have a fever in the middle of the night, Fraser would go, like family doctors of old. He does not endear himself to the medical establishment of our time when he says 80 percent of surgery is not necessary, but that shows his integrity is as steady and sure as his hands. You'd want him there if you needed to go under the knife.
- Richard Pisano, a family practitioner also from the old tradition, who still sits up all night with sick patients. In an age of faceless HMOs, he is an independent family

practitioner. He and his wife, Kathy, a nurse, run a kind of mom-and-pop, hands-on medical office. He doesn't just do cameo appearances. He is a guy you could trust your life to. I do.

- Hugh Aloysius Doyle—Hughie—New Rochelle city councilman and the nicest man I ever met in politics. He is remembered at the local senior center, which bears his name. He deserved an essay to himself, though.
- Ted Dunn, a multimillionaire from Wall Street who could not overcome his WASP reserve to touch the minds and hearts of voters. He spent $3 million, including $2 million of his own money, trying to become Westchester County executive, a public office with a modicum of prestige and modest clout. Still, he hasn't soured on public service. He accepted an appointment to the Metropolitan Transportation Authority and took on the chairmanship of Mercy College, which serves a diverse population of people seeking higher education in Westchester.
- Tom Mullen, former mayor of the remote village of Waverly, up in the Penn-York Valley between Binghamton and Elmira, New York. He is a darling Irishman with unshakable faith in the Democratic Party and the fundamental goodness of people. Whenever my cynical self is in danger of taking over, I call Mullen.
- Andrew P. O'Rourke, Westchester County executive for nearly fifteen years through much of the eighties and nineties. He was one of the original brainy Quiz Kids of radio and grew up to be a man of more culture and sensitivity than many in public office. He is a rear admiral in the Naval Reserve and a published author of swashbuckling novels. He ran for governor against Mario Cuomo when Cuomo was at his peak of popularity. O'Rourke lost with grace and turned around to team up with Andrew Cuomo, the governor's son, to build housing for homeless people in Westchester.
- Andrew Spano, elected Westchester County executive after O'Rourke. He is equally at home in all of West-

chester's disparate neighborhoods. He brings sincerity
and a great persona to local government in my home
heath, and like Governor Pataki, he doesn't hold
grudges.

- Jacob K. Javits, senator from New York. Haughty
 though he was, he became a towering figure in the U.S.
 Senate and a great presence in New York State in my
 time. He was one of the two great senators from my
 home state whom I was privileged to know, the other
 being Daniel Patrick Moynihan, of course. Javits had
 brain power and intelligence equal to Moynihan's,
 about whom I also should have said much more.

- William Plunkett, the Cardinal Richelieu of New York
 State politics in the nineties. Like that eminent French-
 man at the court of Louis XIII, Plunkett travels easily
 with ranking churchmen and serves as mentor to Gov-
 ernor George Pataki. His law school roommates were
 Lamar Alexander, who went on to become Governor of
 Tennessee, and Paul Tagliabue, who became commis-
 sioner of the National Football League. I've always
 thought that Plunkett himself would be a great gover-
 nor. He is universally respected, a man of great distinc-
 tion and probity, a future justice of the U.S. Supreme
 Court, perhaps.

- Nita Lowey, the member of the House of Representa-
 tives from my home district. She has a smile that lights
 up all New York, which everybody loves. But she also
 has great dynamism, energy, and enthusiasm. She's
 one of the hardest workers in the House, and one of
 the most effective. With each year, she grows in stature
 among her House colleagues and her constituents. I'm
 nuts about the lady. In the political game, where mean-
 ness so often predominates, she hasn't a mean bone in
 her body.

- Alfonse D'Amato. When he ran against Jack Javits I
 broadcast one of the meanest editorials I've ever aired.
 But I grew to respect D'Amato as he became New
 York's "necessary" senator. And I should never forget

that Senator D'Amato gave Westchester a federal judge of great gifts named Dick Daronco.

- Andy Albanese. He grew up dirt poor in the land of plenty. He and his brothers, John and Ray, actually went to school with trousers made from flour sacks. But for almost thirty years—all through the sixties, seventies, and eighties—Andy Albanese ran Westchester's most famous pizza place. It was a hangout for politicians and the place suburban fathers took their youngsters after Little League and soccer games. Nobody ever accused Albanese's of having great food. But it had Andy. He was a vivid, beguiling fellow of such charm they elected him to the county board and sent him up to White Plains to represent the millionaires of Scarsdale and Bronxville. Andy even became chairman of that board, a most Republican entity. And his colleagues did not like it one damn bit the night he handed me a pizza *and* one thousand dollars for Mario Cuomo's gubernatorial campaign. He compounded this sin by announcing the very next day that he was endorsing Cuomo for governor because he had not seen anyone as splendid in the entire state for a good, long time. I once lost the McDonald's advertising account because of my enthusiasm for the Democrat governor. But it was nothing compared to the scorn heaped on Andy by the elders of the Republican Party for his little heresy. Now retired to the Arizona desert, he went out with the high rollers eating from *his* generous hands. He could do a lot more than flip a pizza during his time.

I also think I might have told you something of my current admiration and enthusiasm for the public work of several contemporary figures:

- George Latimer, the dedicated chairman of the Westchester County Board of Legislators.
- Noam Bramson, a young New Rochelle city councilman with a bright future.
- William Mulrow, the central casting managing partner

of Rothschild & Co., who is fast becoming a civic leader of considerable note.

- Ernie Davis, the mayor of Mount Vernon, who, with his dreadlocks and English suits, is restoring confidence in his city and its people.
- John McCain, the U.S. Senator from Arizona, who looks right at you when he speaks.
- Phil Reisman, the feature columnist for Gannett's *The Journal News*. He looks like the playwright Sam Shepard with his cowboy boots and tight jeans and he writes like an angel. Or sometimes like Mark Twain.
- Andrew Mark Cuomo. He is his father's son. And so much more. Now a U.S. Cabinet secretary, Andrew grows in wisdom with each day. Here we go again.
- Governor George Pataki. Although I did everything to try to beat the guy when he ran against Mario Cuomo, as soon as the election was over I received a very gracious note from Governor-elect Pataki—showing that he doesn't hold grudges. He is a class act. Bill Plunkett and Mike Finnegan have been telling me for years not to underestimate this fellow, and as we go to press, the *New York Observer*, my favorite weekly, is raving about his intelligence and strength. My Westchester neighbor Pataki has been a superb governor and is ready to play on the national stage. I won't abandon him again.

I want to end as I began, talking about Mario Cuomo, because he is still the most compelling man in public life. I've enclosed plenty about his Albany years and his campaigns for governor, but as former President George Bush once wrote to me in a personal note, "There really is life after politics . . . a very good life." And so it occurs to me I haven't done enough about what's happened since to Mario Cuomo.

Cuomo is now a partner at the prestigious New York law firm of Willkie, Farr & Gallagher, where he confounds the other partners by refusing to be merely a rainmaker or figurehead. He's also well into a second career, debating the likes of Jack Kemp, Dan Quayle, and Bill Bennett. (I've told him that he's going to be locked up for beating up on his inferi-

ors.) And even as I was writing this, he was on the phone talking about taking on Paul Weyrich, a religious conservative from a Washington think tank, over separation of Church and State. Here we go again, I thought. It would be Notre Dame all over again . . . his landmark speech, "Religious Belief and Public Morality," specifically on abortion and Catholics, which he delivered at that most Catholic of universities.

The way he continues to confront the great issues with intelligence, wisdom, and wit, I'm sure we have not heard the last of him as a public man. And we should be grateful, for we are enriched by his thinking and his words. But whether he is to be like Winston Churchill, who did some of his greatest work after age sixty-five, or like his hero Thomas More, a martyr because of his highly principled but often unpopular beliefs, I have no idea.

I just know that I have never met anybody like him.

Finis, which is Jesuit book talk for "30."

Thank you for listening to me on the radio.
And in this book.

Index

11/18